Asian Women

Asian Women Artists

A Biographical Dictionary,
2700 BCE to Today

Mary Ellen Snodgrass

McFarland & Company, Inc., Publishers
Jefferson, North Carolina

ISBN (print) 978-1-4766-8925-8
ISBN (ebook) 978-1-4766-4698-5

LIBRARY OF CONGRESS AND BRITISH LIBRARY
CATALOGUING DATA ARE AVAILABLE

Library of Congress Control Number 2022046172

Front cover: (clockwise, from top left) Wang Zhaojun, Zeb-un-Nissa
(Metropolitan Museum of Art), Sushma Shimkhada (Deepak Shimkhada),
Armen Ohanian (Emile Bernard), Bubusara Beyshenalieva (Shutterstock),
Zarsanga, Mirabai, Whang-od (Lee Marq), Murasaki Shikibu (Tosa Mitsuoki),
Siona Shimshi (National Photo Collection of Israel)

Printed in the United States of America

*McFarland & Company, Inc., Publishers
Box 611, Jefferson, North Carolina 28640
www.mcfarlandpub.com*

For Mary Canrobert

Acknowledgments

Appalachian State University Library, Boone, North Carolina
Dana Al Sajdi, Boston College, Boston, Massachusetts
Library, University of North Carolina at Chapel Hill

I am amazed at the ready answers from reference librarian Martin Otts at Patrick Beaver Library, Hickory, North Carolina. He has been scrupulous in the translation of Asian languages and titles. Special thanks to Mark Schumacher, retired reference librarian, UNC–Greensboro, and to my publicist, Mary Canrobert, a supporter of whatever direction my writing takes.

Table of Contents

Although the self may be reflected in a mirror
 the mirror image will not match the self.
What a miracle to see oneself reflected through
Another; this miracle is given by God.
 Gulbadan Begum, ca. 1560

I danced in the fire—
Behold me, the Flame!
I danced in abysses—
Behold me, the Wind!
Armen Ohanian, 1921

Preface

This survey of the styles and presentations of Asian artists covers regional women's creativity from a wide variety of milieus, people, and media. Arranged chronologically by birth date from Leizu's Chinese sericulture in 2700 BCE to the March 10, 2021, exhibition of murals by Malaysian painter Caryn Koh, the compendium covers a wide range of names familiar (biblical war poet Deborah, Judaean dancer Salome, Byzantine Empress Theodora, and Myanmar freedom fighter Aung San Suu Kyi, creators known for prophecy, dance, epic, and oratory) and lesser known (for instance, nineteenth-century BCE Assyrian wool weaver Lamassi of Mesopotamia; thirteenth-century poet and travel writer Abutsu-ni of Sado City, Japan; and sixteenth-century hermit singer Habba Khatoon of Chandrahar, Kashmir).

Because these women achieved what they did in the face of patriarchy that strangled women's creativity, their achievements take on additional poignance. Consider the case of ninth-century Byzantine hymnographer Kassia, who defied the Emperor Theophilos's iconoclasm. Or seventeenth-century Indian poet Zeb un-Nissa of Delhi, whose father, Mughal Emperor Aurangzeb, imprisoned her for life for composing love plaints. Or, a century later, Syrian journalist Nazik Khatim al-'Abid Bayhum of Damascus, who launched a women's magazine defying arranged marriage and obligatory veiling. With less drama, in the 1930s, Gamar Hajiaga Almaszadeh of Baku, Azerbaijan, became the first professional Muslim ballerina, a dance form at odds with Islamic notions of female body image and comportment.

As an aid to women's historians, artists, students, teachers, and researchers, *Asian Women Artists* appends a historical chronology, a century-by-century study of imaginative efforts: translating Persian folk tales from the *Sanduq* (treasure chest) into a Kyrgyzstani ballet and correlating ephemeral Chinese silk embroidery with painting and calligraphy. Entries identify artisans by time and place, some as antique as Canaan, British Burma, and Ottoman Syria. The appendix of Artists by Place separates from modern geography the countries and cities no longer in existence, as with Anatolia/Turkey, Hanseong/Seoul, Judaea/Israel, Siam/Thailand, Persia/Iran, and Imperial China/People's Republic of China and Taiwan. The appendix of Artists by Genres interweaves the familiar photographer, columnist, and novelist with the mythologist, lino artist, dombra player, aphorist, ikat specialist, and lyrist. A listing of 116 artistic styles encompasses children's works, food studies, sculpture,

and textbooks as well as Indian dollmaker Anurupa Roy's glove and stick puppets and set and costume designs for the stage, the métiers of Israeli theatrical artist Siona Shimshi and dramatist Dara Rasmi, the adapter of *Madama Butterfly* for Siamese audiences.

Translation of unfamiliar terms explains the style and nature of memorable performances, as with the classic Arabo-Persian song "Syunsu (The Bride's Lament)," the sculptural pose "Pietà (Devotion)," the South Korean manual *Naehun* (Instructions for Women), and the 2007 stage show "Nocturnes d'Asie sur les Routes de la Soie" (Asian Night Songs of the Silk Road). Glossing identifies traditional instrumentation by language—for example, the Iranian zarb, Urdu darabukka and tabla, Korean p'ansori, Tamil mridangam, and Pashtun dholak, which are all types of drums. The most varied names apply to lutes, called dombra in Kazakhstan, dutar in Uzbekistan, sarakaner in Armenia, rabab among the Pashtuns of Afghanistan, and komancha in Persian Farsi. Similarly, the Hindu Sanskrit veena, Vietnamese dan bau, and Japanese koto refer to a zither. Some terms identify complicated identity and expertise:

> *presenter*: Jyrau, diaspora, xiushi, hafiza, lakhon, Polovtsian, sabra
> *method*: backstrap loom, pointillism, kyeezee, alpana, en pointe, heddle
> *style*: anime, Zeitgeist, transgressive art, tableau vivant, kirikira, filigree
> *product*: Kabuki, kitab, haiku, baqsy, broadside, chasu, holograph, raga

Other entries define religious and liturgical forms that prompt worship, e.g., Malayo-Polynesian ullalim (chants), Armenian ktsurds (antiphonal anthems), Hindi ghari (prayer recital), and Sanskrit sutra (scripture) of Hinduism, Buddhism, and Jainism holy works. Most challenging for the reader, names for versification set the Kashmiri voje (refrain) apart from the five-line Japanese waka (poem), Indo-Aryan landau (couplet), and the Hindi dastangoi (narrative).

The bibliography presents primary sources issued by the artists, notably, Saudi Arabian fiction writer Raja'a Alem, Pakistani theologian Riffat Hassan, Burmese short story author Khin Myo Chit, and Iranian comic Fatemeh Sadeghi. A lengthy summation of secondary works places books before shorter commentary. Articles, chapters, and essays derive from such on-the-scene publications as timely as *Amnesty International*, *Monumenta Nipponica*, *Manila Times*, *Aramco World*, *Phnom Penh Post*, *Eurasianet*, *Haaretz*, *The Hindu*, and *Cambodia Daily*. Listing concludes with electronic sources, some of them essential studies of antique works—particularly Gu embroidery, traditional harps, medieval hymnography, and images of glass, stone, and metal art.

As a guide to identifying artistic eras and creators from all parts of Asia, *Asian Women Artists* offers a broad spectrum of media and presentation.

Indexing, both primary and secondary, incorporates a wealth of subjects from global arts history:

agencies: United Nations, Red Crescent, Nobel nomination, UNESCO, Kremlin

artists: pastelist, videographer, quilter, mosaicist, woodcut artist, chanter, linguist

faiths: Sikhism, Judaism, Islam, Zoroastrianism, Buddhism, Hinduism, Sufism

genres: threnody, storytelling, waka, exegesis, ta'lik, aphorism, epic, divination

instrumentalists: taburist, sitarist, flautist, lyrist, tambourinist

people: Lady Hyegyeong, Shayn, Jamileh, Arnimal, Larisa Dodkhudoeva

places: Bhutan, Bengal, Sumer, Georgia, Bahrain, Ur, Uighur Autonomous Region

secondary listings: names for China, types of history, fiction, dance, and acting

titles: Alexiad, *The Tale of the Genji, Humayun-Numa, The Tales of Gilgamesh*

The volume relieves unfamiliarity with parts of the world poorly represented in art history and focuses on Asian female artists passed over in global surveys.

Introduction

People stories are the best kind. *Asian Women Artists* examines the creativity of 108 exemplars dating as far into the past as silkworm culture in 2700 BCE and as current as yesterday's graphic comics, anime, and manga. Artists' media juxtapose pastels, illustration, opera, and dictionary compilation with belly dance, adapted folklore, Christian liturgy, and tattoo. Career studies, arranged in time order by the artist's birth date, search myth, legend, scripture, and biography for the spark that enticed Chinese Empress Leizu to invent silk reeling and weaving, Miwnay to compose letters of desperation in Sogdian to her mother and husband, and matrilineal Japanese dancer Iso no Zenji to teach traditional steps to her daughter Shizuka-Gozen. From unique, personal experiences, Amannisa Khan Nafisi of Xinjiang, China, anthologized indigenous Uighur music; Javanese manifesto composer Raden Adjeng Kartini crusaded for female education in the Dutch East Indies. In Tibet, street muralist Haifa Subay exemplified the painter as activist curbing riots and wars.

As remains true of artists throughout time, the *Zeitgeist* instills the motivation and purpose for imagination, such as Turkish calligrapher Fatima Zahra Hanim's transcription of her son Osman Saib Bey's medical texts, Leyla Zana's prison writings about the Turkish torture of minority Kurds, and Omani graphic designer Safiya al Bahlani's campaign for artistry featuring the disabled. Examples disclose the wrongs of the day: Azerbaijani actor Izzat Orujova's role as an abused wife in the movie *Sevil*, widowed Siberian physician Anna Nikolaevna Bek's memoir on the losses of World War II, Lebanese builder Simone Kosremelli's preservation of heirloom architecture, and Taiwanese nun Cheng Yen's media and print sermons and meditations on compassion. During the reign of Saddam Hussein, Nuha al-Radi mimicked and satirized the Iraqi despot in ceramic sculpture. For the United Nations, Laotian weaver Bouakham Phengmixay promoted the reinstatement of pre–Vietnam War production of heritage silk patterns.

A portion of the artists chose the rehabilitation of Asian traditions as their aim, for example, Bahraini historian Nancy Dinah Elly Khedouri's chronicle of Judaic culture, Pashtun folksinger Zarsanga's rescue of shepherds' folk tunes in British India, and Ruth Kark's tribute to Jerusalem's welcome to refugees and diasporas. For Palestinian poet Shin Shifra, the revival of Akkadian epic inspired a translation

of *Gilgamesh* for young readers. Historian Lee Shermay followed her matrilineage in reintroducing heirloom foodways and holiday ritual among immigrants to Singapore. In an inspiring act of ethnic harmonizing, South Korean computer artist Kyungah Ham smuggled embroidery patterns to unknown stitchers in North Korea to bolster spirits and lift hopes of reunification and an end to dictatorship. Another preservationist, Andaman islander Boa, Sr., joined a project to record prehistoric African word patterns still viable in a polyglot of songs and storytelling.

In a merger of art with heroics, some Asian artists have risked all in the creation of wartime landmarks, as with Byzantine Syrian poet Khawlah bint al-Azwar's war cries of epic verse at the Battle of Ajnadin in 634 CE and Mona Saudi's Jordanian posters surveying the Palestinian Revolution in the film *Testimony of Palestinian Children in Wartime*. Iranian cartoonist Marjane Satrapi turned memories of the Iran-Iraq War and the ouster of Shah Mohammad Reza Pahlavi, Iran's last king, into the graphic classic *Persepolis*. During the covid quarantine, Bengali muralist Anjoli Ela Menon painted a communion table shared by amicable diners from disparate races and faiths. In the autobiography *Sorrow Mountain,* Tibetan nun Ani Pachen presented the female side of guerrilla warfare against Chinese imperialism and religious suppression. Vietcong ophthalmic surgeon Dang Thuy Tram survived combat against U.S. troops long enough to inscribe *Last Night I Dreamed of Peace,* a daybook of battlefield encounters. In a climate of assassination threats and the murder of journalists, Sri Lankan editor Frederica Jansz reported the corruption at the crux of the island country's twenty-five-year civil war.

Whatever the motivation and purpose of individual works, their existence leaves evidence of faith in the arts as peacemakers and repositories of beauty for its own sake. At a tense time in Anatolian-Egyptian relations, Hittite Queen Puduhepa composed letters spreading positive messages to Pharaoh Ramses II. The Byzantine Empress Theodora championed fellow peasant dancers at Constantinople by codifying laws emending the lowly circumstances of female entertainers. At Bali, Mahendradatta composed prayers, chants, and invocations to Durga, the Hindu deity of motherhood. Similarly devout to a female power, Armenian hymnographer Sahakdukht Siunetsi of Dvin inscribed devotionals to the Virgin Mary. To deflate the ego of male Heian era social climbers, Murasaki Shikibu, the world's first novelist, satirized intrigue and corruption in the Japanese court romance *The Tale of Genji*. A brave royal pawn, Chinese lute player and calligrapher Wang Zhaojun plucked strings and sang on her horseback ride to wed a Hun nomad promising to ease border hostilities.

As viewers of human interaction, female seekers grasp opportunities to promote tranquility, rapport, and justice, the purpose of the Virgin Mary's Magnificat and the intent of Uighur singer and taburist Ayshemgul Memet to enter a folk career dominated by men. From surmounting daily challenges to domestic life, with energy and passion, they shape an ethos to resemble childcare and amity with neighbors. Rich in empathy and good will, their crafts take on the serenity of kinship and

tolerance. Models of pro-woman, pro-family principles draw art lovers to the scholarship of Pakistani theologian Riffat Hassan, Mongolian cartoonist and graphic artist Narantulga Buriad's feminist comic books, and the womb carvings of Nepal's first female sculptor, Sushma Shimkhada. As an emblem of unity, Saudi twin artists Raja'a and Shadia Alem epitomized the coming to knowledge that feminine art inspires.

1

Ancient Era

Leizu (2700 BCE)
weaver
Imperial China

A legendary figure in Sichuan Chinese women's history, inventor and weaver Leizu (also called Xi Ling-Shi, She Ling-shih, or Si Ling Chi) discovered the natural properties of silkworm cocoons and wove their thread into the world's oldest luxury fabric. The principal consort of Huangdi (also Hoang-ti or Wu Di), the mythic Yellow Emperor of China, the beloved Yuan princess from Yanting (or possibly Xiping) on the Yangtze River profited from his progressive attitude toward medicine, fine sericulture, and the arts. She reared two of the Yellow Emperor's twenty-five sons at the Xuanyuan compound—Changyi, founder of the Chang clan of Henan Province, and Xuanxiao, resident of Qingyang in the Chiang River valley. She was also grandmother of the peace-loving son of Changyi and Changtsu, twenty-year-old Emperor Zhuanxu, who ruled for seventy-eight years and rid the superstitious of shamanism and incestuous marriage.

Out of curiosity, Leizu watched a silkworm (*Bombyx mori*) exude a fiber from its mouth and wind it around its body. She observed a cocoon of the larva falling from a mulberry tree into a cup of tea. As steaming water killed the caterpillar and dissolved the cocoon, she tugged at a loose thread. The empress began separating silk filament from the layered insect casing into sixteen ethereal, raw fibers that were more malleable for sewing than leaves or pelts. At first, she used the gossamer lengths for knitting, ribbons, and rope before conceiving of a filmy, yet warm material for court garments. Silk became known as the queen of textiles for its sensuous outline of female curves in motion and contribution to erotica among Chinese royalty.

Observing the thread's softness, strength, and sheen, the Emperor encouraged domestic cocoon gathering by providing a grove of white mulberry (*Morus alba*), a fast-growing fruit tree that feeds the wild silk moth. To unwind and organize airy, stretchy, translucent strands, Leizu created a reel that could hold some 800 meters of raveled mulberry silk per spool from a single cocoon. By inventing a silk loom, around 2640 BCE, she introduced the Chinese to sericulture, a symbol of the nation's elegance and esoteric tastes.

The Yellow Emperor advanced mulberry and larval culture as well as dyeing silk fabric and using fiber for embroidery. He condemned to death any traitor from divulging Leizu's secret process. It remained hidden for three millennia until 300 CE, when Indian weavers at Assam and the Khmer Empire learned the lucrative handcraft. The shimmering textile served in ceremonial robes and gifts and gave its name to the Silk Road, source of a Chinese monopoly on the fabric trade as far west as Constantinople, Italy, France, and Iberia. Eventually reaching Africa and Arabia, mulberry silk held a reputation for higher quality than either cashmere or vicuna silk from the Peruvian Andes.

Revered as the Silkworm Mother and Goddess of Silkworms, the Empress Leizu became goddess of silk, an approximation of the name Si Ling Chi. According to Shanshan Yang, a scientist at Arizona State University, as "a women's exemplar that reinforced women's traditional gender roles" and vocations, she represented female divinity at the Leizu Temple on Xiling Mountain in Chengdu, Sichuan (Yang, 2016, 102). In Huzhou, Zhejiang, she receives reverence every April 5 on Ancestor Day at the Qingming Festival.

Source

Mao, M.A.O., and Huang Chunbao. "Application of Leizu Culture to Interior Design," *Journal of Landscape Research* 9:3 (June 2017): 33–36.

Yan Fei. "Legend of Silk," *China Daily* (3 September 2011).

Yang, Shanshan. "Emperor Wu Zhao and Her Pantheon of Devis, Divinities, and Dynastic Mothers," *Journal of Global South Studies* 33:2 (2016): 102–105.

Enheduanna (ca. 2334–2251 BCE)
poet, hymnographer, psalmist
Akkadia

The world's first author and woman known by name, the first to write in first person, and one of the earliest war protesters, Enheduanna of Akkadia (modern Iraq) earned the title of "Shakespeare of Sumerian Literature." In a family of five, she was the paternal granddaughter of a high priestess and the only daughter of Tashlultum, a clergywoman of southern Mesopotamia. Her father, Sargon the Great of Kish (Sumer), became the first ruler of Akkadia after 2334 BCE and the builder of Babylon. A native of the Fertile Crescent west of the Euphrates River, Enheduanna was born in the forty-ninth year of Sargon's reign over lands that evolved into modern Crete, Cyprus, Iraq, Jordan, Lebanon, and Syria.

An asset to Sargon's Bronze Age empire from the Mediterranean Sea to the Persian Gulf, from 2254 BCE, the writer of creation hymns, anthems, invocations, and doxologies bore the ceremonial name of Chief Priestess and Heavenly Ornament. For four decades, the sophistication of her rhetoric and philosophy indicated a quality education reading and writing cuneiform texts and mastering mathematical systems, magic numbers, and planetary motions. Period art depicted her in gathered

dress and a clerical turban, an indication of her marriage to the moon god, for whom she burned coals in a censer for purification and awaited celestial inspiration. At a height of lyrical powers, she launched a twelve-line exaltation of Inanna, goddess of beauty and fate, calling her an enchanting, glorious pilot of destiny.

THE TEMPLE MANAGER

Enheduanna filled her writings with personal observations and sensuality. The ordination title honored her compassion and devotion to the moon god Nanna (or Sin), the heavenly illuminator, sage, unifier, and provider. She aimed her hymnography at veneration of plain and mountain, adoration of wetlands and foaming rivers, adulation of the blue of lapis lazuli and the holy city of Ur, and reverence for the pure love of the shepherd god Dumuzi for Inanna, queen of the moon and stars with lions and owls at her feet. The priestess's prestige allowed for a cult following, office staff, the financial manager Adda, the scribe Sagadu, and hairdressing by Ilum Palilis, a wise confidante. Enheduanna's duties as adviser and astronomer involved her in trade, education, divination, and monitoring the location and orbits of heavenly bodies for the plotting of calendars.

The princess superintended the creation of a holy pantheon at Ur, where she maintained the sanctuary compound and spread her liturgy to the temples of ancient Eridu, far northern Esnunna, and Sippar, in the north between the Euphrates and Tigris rivers. The merger of Sumer's gods with Akkadian deities strengthened Sargon's rule at a network of sanctums that she identified, including her own office at Ur's Nanna shrine. The poet produced forty-two incantations rich with hyperbole, rhetorical questions, and exclamations on the topics of war and mortality, allegiance to the divine, and hopes and frustrations for her nation's survival. To the monstrous god of combat, the poem "Lament to the Spirit of War" identified battle horrors—land poisoned by greed and anger and blood coursing down mountains. As a writer, she originated sacred liturgy by setting the parameters of prayers, psalms, and verse and their manifestation of godhood. She considered her imagistic work an advance over previous liturgy and signed it with her name.

HONORING DIVINE POWERS

Central to Enheduanna's theology, the god Nanna and his daughter Inanna/Ishtar's control of love, sex, and conquest stood out as earthly priorities. Literary historians prize the 274 lines of *Inninsagurra* (The Stout-Hearted Mistress or The Hymn to Inanna), the 153 lines of *Ninmesarra* (The Exaltation of Inanna), and *Inninmehusa* (Goddess of the Fearsome Powers), the songs by which Enheduanna elevated Inanna to supreme dominion. The poet may have adapted the Sumerian poem *The Descent of Inanna*, in which she identified the Sumerian Inanna as the Akkadian Ishtar, Sargon's protector in battle and the prototype of Astarte/Aphrodite/Venus.

Because the models allied Akkadians and Sumerians with dual divinity, over more than four millennia, the poems influenced subsequent classics—the Babylonian epic *Gilgamesh* of 2100 BCE, Hebrew scriptures from 1200 BCE, Homeric hymns from the 600s BCE, the Virgin Mary's Galilean canticle Magnificat (My Soul Magnifies the Lord) in Luke 1:46–55, and the hymnody of early Christianity from 30–325 CE as well as sculpture and fresco.

At the attack of King Lugal-Ane from Uruk, a Sumerian usurper of Sargon's empire, Enheduanna survived a coarse sexual proposition and witnessed sudden destruction of holy rituals and the Eanna temple itself at Uruk on the Fertile Crescent. As devotee of Inanna, she stated in lines 67–76 of the poem *The Exaltation of Inanna* the need for help from Anu, the all-powerful sky deity. She attested that the invader "expelled me from the temple. He made me fly like a swallow from the window—my life was consumed…. My driven, divine wild cow, drive out this 'someone,' capture this someone!" ("Concept," 2001). After suffering exile on the steppe, the priestess exulted at the anarchist's downfall and her own trial for unnamed sins, a disciplinary action in the form of disease. At the double reinstatement at Ur of Inanna and her priestess, Enheduanna rejoiced in female endorsement: "The Goddess and her poet have both prevailed. Once exiled, they have been restored to their rightful places and they are both wrapped in the beauty of transcendent feminine energy and power" (Binkley, 1998).

For a personal relationship with a female deity, Enheduanna set a unique example in the history of female clerics by praising Inanna for heeding her prayer after the moon god Nanna deserted her. Triumphant lines declare, "No one can look at her fierce fighting, the carnage, the engulfing water, raging, sweeping over the earth, she leaves nothing behind" (*ibid.*). In contrast to the goddess, the hymnographer expressed humility with a rhetorical question, "I, who am I among living beings?" After Sargon's death in 2251 BCE, she held the post as chief priestess during the turbulent nine-year reign of her brother Rimush and the assassination of young sibling Manishtushu. At her death in 2251 BCE, she lay among the former devout of Inanna in a temple cemetery within the expansive Giparu (cloister) complex at Ur. Her precedent progressed in Mesopotamian culture to demigoddess and her verse to wisdom literature set to drum and tambourine.

Source

Anderson, Becca. *Book of Awesome Women Writers: Medieval Mystics, Pioneering Poets, Fierce Feminists and First Ladies of Literature.* London: Mango Media, 2020.

Binkley, Roberta. "Biography of Enheduanna, Priestess of Inanna," www.cddc.vt.edu/feminism/Enheduanna.html, 1998.

"The Concept of Personal God(dess) in Enheduana's Hymns to Inanna," www.angelfire.com/mi/enheduanna/Enhedwriting.html, 2001.

Glaz, Sarah. "Enheduanna: Princess, Priestess, Poet, and Mathematician," *Mathematical Intelligencer* 42:2 (2020): 31–46.

Tetlow, Elisabeth Meier. *Women, Crime, and Punishment in Ancient Law and Society.* New York: Continuum, 2004.

Thomas, Ariane, and Timothy Potts. *Mesopotamia: Civilization Begins.* Los Angeles: Getty, 2020.

Zgoll, Annette. "Nin-Me-Sara: Lady of Countless Cosmic Powers," www.angelfire.com/mi/enheduanna/Ninmesara.html, 1997.

Lamassi (ca. 1900–1875 BCE)

weaver

Assyria

During the rise of a city-state to the early Assyrian Empire, Lamassi, a piecework artisan at Assur after 1900 BCE, contributed one hundred pieces of fine wool weaving to Bronze Age trade. At the time, some two thousand residents of Assur engaged in commerce with Anatolia (modern Turkey). Residing on the left bank of the Tigris River in Mesopotamia (modern Iraq), she lived in a period of progress for women who operated looms and spindles for their own and their family's enrichment.

As primary wife, Lamassi fermented beer and kneaded bread for the seven-member household, consisting of daughter Ahaha, a priestess, and sons Ashur-muttabbil, Ikun-pasha, Buzazu, and Sueyya. Her sedentary husband, a licensed fabric agent, headed a lucrative *karum* (trading depot) one thousand miles southeast at the merchant colony of Kanes (also Kanis or Kanesh, modern Kültepe in central Turkey). As was his right, he took a secondary wife or concubine.

THE COTTAGE WEAVER

An active fabric maker, Lamassi kept up steady cottage crafting and correspondence while her husband traded in gold, silver, copper, tin, and wheat as well as cheap Turkish wool. She composed letters in cuneiform to relatives. Her writings on clay tablets revealed limited wool supplies that Sutean herders sheared at Suhum and marketed at Assur midway on the Fertile Crescent. To her husband, Pusu-ken, partner of Salim-ahum, she petitioned for supplies hauled north from Anatolia on donkey caravans. The Turks preferred her quality weaving to the local *pirikannu* (fleecy saddlecloth), which was illegal in Assyrian markets. Her career total reached a half talent of silver (approx. $12,673.30).

The production of woolens required Lamassi to clean ten minas (eleven pounds) of raw fiber at the rate of 125 grams or a quarter pound per day. She hung raw pelts outdoors to air. After removing tangles and burs and straightening the pile with teasel and comb over some forty days, she spun the fiber on a spindle whorl into thread. Because Pusu-ken rebuked her for weaving small lengths and asked her to average 5.5 pounds to each piece, she assured him that she had followed his instructions. She sent the loom products by two transporters—the denser textiles by Iasar and previous weaving by Urani.

Female Correspondence

At the request of Pusu-ken, Lamassi wrote him to expect a personal garment made out of costly wool from Surbu to the southeast. She warned that the fuller had not cleaned the fiber, which would arrive on a subsequent caravan. He asked servants to bundle the fabric lengths by fives. Lamassi had difficulty arranging shipping with cameleers El and Iddin-Suen, but hauler Kulumaya agreed to deliver nine pieces. Lamassi ensured delivery by having Pusu-ken acknowledge the receipt from trader Assur-malik of three *kutanum* (napped) lengths and one *kamdum* (brushed) fabric. In addition to commercial goods, Lamassi made wagon upholstery, children's clothes, adult wardrobes, and garments for servants and for relatives in Kanes. Under stress to produce more, she wrote Pusu-ken, "I will send you with later caravans whatever textiles I can manage" (Michel, 2013).

Within some twenty-four months, Lamassi, aided by daughter Ahaha, prepared thirty-three lengths, which traveled south at the rate of twenty miles per day. She demanded ten silver shekels (2.5 ounces) for her labor, which equaled 2.5 days' wages for a laborer. Her husband concealed the coins in bales of wool. He computed taxes and profit on twenty woven lengths and sent the proceeds to Lamassi, who spent the cash on groceries and more raw wool. She died after 1875 BCE.

History puzzles over Pusu-Ken's reputation. He rewarded Lamassi with pectoral jewelry, bronze utensils, and gold and silver chalices for her own table or for barter. He spent time in the Kanes jail for smuggling until he bribed the city's crown prince to release him. Lamassi charged him with neglecting the family. He eventually divorced her, perhaps because of the stress of living far from home, interest in his second wife and her family, and accusations that Lamassi lived extravagantly.

Source

Chanda, Nayan. *Bound Together: How Traders, Preachers, Adventurers, and Warriors Shaped Globalization*. Cambridge, MA: Yale University Press, 2007.
Michel, Cécile. "Assyrian Women's Contribution to International Trade with Anatolia," *Carnet de Refema* (11 December 2013)
Moore, Karl, and David Lewis. "The First Multinationals: Assyria circa 2000 B.C.," *MIR* 38:2 (1998): 95–107.
Veenhof, K.R. "Some Social Effects of Old Assyrian Trade," *Iraq* 39:1 (Spring, 1977): 109–118.

Puduhepa (ca. 1290–1200 BCE)
letter writer, religious writer
Anatolia

A rare royal wife and queen for thirty years and dowager queen for twenty-eight more, in the late Bronze Age, Puduhepa (also Putuhepa or Pudu-Kheba) reared a family while composing hymns and maintaining personal and diplomatic correspondence from Anatolia to Egyptian dignitaries. The daughter of Bentespharri (or Pentipsarris), the high priest of Ishtar at the trading hub of Lawazantiya, Kizzuwatna

(later called Cilicia in southern Anatolia), Puduhepa was born around 1290 BCE and received a name meaning "sired by the sun goddess" (Singer, 2002). She emulated her father's devotion for the Hittite goddess who governed love, sex, power, and beauty throughout Mesopotamia.

In the turmoil preceding the collapse of the Hittites at the dawn of the Iron Age, Puduhepa was a teenager when Pharaoh Rameses II (1279–1213 BCE), Egypt's greatest monarch, raided her homeland in late May 1274 BCE. Warfare involved some six thousand chariots at the Battle of Kadesh, Syria, west of the Orontes River, which united Syria with Lebanon. At battle's end, Hattusili, a Hittite general, marched from Egypt through Lawazantiya, which she referred to as "cedar land" (Puduhepa). Following a dream from Ishtar, after the clash, he wed fifteen-year-old Puduhepa.

Under a hieroglyphic seal, picturing Puduhepa in modest headdress and sinuous veil, she managed the couple's residences. She ordered chief scribe Urmahziti to collect religious tablets from her homeland outlining cultic *hisuwa* (purification) festivals, which she directed. According to surviving records of Hittite law courts and foreign policy, she stamped treaties, judged murder cases, and ordered reimbursement for a sunken ship. In superintending caravan trade before 1270 BCE with King Niqmepa of Ugarit, a seaport in northern Syria, the queen charged him with shortchanging annual tribute to the Hittites.

Altruistic Monarch

According to the autobiography *Apology of Hattusili,* the king named Puduhepa first wife among his companions and concubines. Without rancor, she served as friend to widows, a midwife and stepmother to others, and fosterer of military careers for stepsons. After Hattusili seized the Hittite throne in 1265 BCE and became Hattusili III of the New Empire, Puduhepa began her royal career. The imperial couple resided at Buyukkale (Great Fortress), a royal compound he reclaimed from war damage to the north in Hattusa (Bogazkale, Turkey), Anatolia, 80 miles south of the Black Sea.

Perhaps because of the king's chronic ill health in eyes and feet, Queen Puduhepa aided his reign by supervising diplomacy with Pharaoh Rameses II and, in 1258 BCE, co-signing history's first peace treaty. Rameses sent her duplicate letters of his correspondence with the king and urged in one letter that his sister "be good" (Yildrim, n.d., 15). Through the exchange of fifteen congenial letters, she sealed a Hittite alliance with the Egyptian dynasty, the supreme power of the southeastern Mediterranean. The alliance inaugurated the age of *Pax Hethetica* (Hittite Peace).

A Fervent Worshipper

Similar to the Hebrew psalmist's personal requests to Yahweh in the *De Profundis* (out of the depths, Psalm 130), a candid intimacy with divinity marked

Puduhepa's sacred vows, confessions, anthems, prayers of intercession, and *argumenta ad deum* (discussions directed to god). She composed a defense of her "orphan king" husband against slander and exalted him for retaking, defending, and rehabilitating Nerik, home of the storm god Zippalanda on the Black Sea coast (Singer, 2002, 11). In the regalia of chief priestess, at Firaktin, Cappadocia (central Anatolia), she reverenced the sun god Arinna, the Hurrian deity of her homeland. Following a major archival process and organization of scripture and liturgy, the queen enabled Hittites to syncretize their mother goddess Hepat with Arinna.

Most important to the queen's own household, she wrote prayers for her husband's health. To Arinna, "in travail" she promised perpetual commitment to sun ritual: "Your festivals, O gods, my lords, shall never be stopped again" (Puduhepa). She thanked Arinna for blessing an amicable marriage and for creating the couple's home at Nerik. To secure favor for Hattusili, Puduhepa's invocation reminded Arinna: "No one made the attempt to capture the city of Nerik. However your servant Hattusili, even when he was not a king but only a prince—it was he who captured the city of Nerik" (Bryce, 1998, 285).

In reference to a folk adage, the queen believed that gods favored the supplications of women who had given birth or the midwives who aided delivery. She prayed specifically that her husband triumph in his campaign against Arzawa (Ephesus) in central Anatolia. For Hattusili's well being, she made poignant vows to Liliwani, goddess of the underworld; Zintuhi, granddaughter of the storm god at Nerik; and the storm god's children Mezzulla and Zippalanda. Her promises named specific gifts: a great ornament for Zintuhi, a full-size gold and silver effigy of the king for Liliwani in exchange for "long years, months and days" for Hattusili (Singer, 2002, 104). She bribed Mezzulla with a village settled by deportees, who became her official servants. A stronger plea to Zippalanda promised a gold shield and the town of Puputana in the Hittite heartland. To the Sumerian reed goddess Ningal, Puduhepa pledged gold oil cruets set in lapis lazuli if Ningal healed the king's feet.

AMBASSADOR OF PEACE

Under the king and their son, Crown Prince Tudhaliya, Puduhepa's skill at letter writing and religious liturgy elevated her above former Hittite royalty to goddess-queen. Her letters spoke openly of strife and alerted Egyptian officials to looting and vandalism at the Hattusa royal treasury. By arranging betrothals, making travel arrangements to Egypt, and securing dowries, she ensured the stability of Hattusili's dynasty. Before 1255 BCE, she corresponded with Egyptian queen Nefertari, Rameses's chief wife, about peace and sisterhood and received a reply containing a gold necklace and enough dyed linen to make a dozen garments. To a rebuke from Rameses II about a marital alliance linking her younger son Tudhaliya IV with a sister of King Kudur-Enlil of Babylon (Iraq), after 1254 BCE, Puduhepa riposted that the Egyptian monarch was ill-informed about regional affairs.

A savvy mistress of detente, Puduhepa maintained the balance of power with the skill of Britain's Queen Victoria, who used her children as pledges to rival states. Puduhepa curried favor in Egypt via betrothal of daughter Maathorneferure (also Manefrure) to Rameses in fall 1246 BCE, when she promised him a royal princess capable of mothering. Exchange of letters with Rameses III reported a fire in the palace, which delayed the betrothal. Following the princess's anointing, Puduhepa requested that her daughter assume the post of head wife. A sign of international accord, the two-nation wedding took place in the great temple of Abu Simbel on the Nile in southern Egypt. She sent daughter Kilus-Hepa to Babylonian king Kadashman-Enlil II, whom she visited in person to arrange the girl's nuptials with King Ari-Sarruma of Isuwa on the upper Euphrates River. Her eldest son Nerikkaili wed the daughter of Bentesina, vassal king of Amurru on the border of Lebanon and Syria.

At Hattusili's death in 1237 BCE after a three-decade reign, Tudhaliya IV ruled a shrinking empire for 28 years with the aid of Dowager Queen Puduhepa, whom he equated in majesty with his father. His seal proclaimed her a great sovereign of Hatti, the favorite of the Hurrian goddess Hepat. She continued composing letters until age 75, around 1215 BCE. Before the collapse and abandonment of the Hittite kingdom when invading Sea People destroyed trade routes in parts of northern Anatolia and Syria, Puduhepa's grandsons—Arnuwanda (1209–1207 BCE) and Suppiluliuma II (1207–1178 BCE)—held the imperial throne. The Bogazkoy Archive of 25,000 clay tablets retains Puduhepa's writings.

Source

Apology of Hattusili, https://lrc.la.utexas.edu/eieol/hitol/60.

Bryce, Trevor. *Kingdom of the Hittites.* Oxford, UK: Clarendon, 1998.

_____. *Letters of the Great Kings of the Ancient Near East.* New York: Routledge, 2003.

Hoffner, Harry, ed. *Letters from the Hittite Kingdom.* Atlanta, GA: Society of Biblical Literature, 2009.

_____. *Perspectives on Hittite Civilization.* Chicago: University of Chicago, 1997.

Polo, Susana Soler. "Inside One of Egypt's Biggest Royal Weddings," *National Geographic History* (1 November 2016).

Puduhepa. "The Prayer of Queen Puduhepa to the Sun Goddess or Arinna Tablet," https://libdigitalcollections.ku.edu.tr/digital/collection/GHC/id/694/.

Silver, Carly. "From Priestess to Princess," *Archaeology* (June 2010).

Singer, Itamar. *Hittite Prayers.* Leiden: Brill, 2002.

Yildrim, Idil. "The Role of Women in Politics in Hittite Society," *core.ac.uk/download/pdf/11726036.pdf*, n.d.

Deborah (1107–1067 BCE)
poet, prophet, hymnographer, chanter
Israel

A bulwark of faith, counsel, and nationalism to the floundering Hebrews, the seer and war hymn writer Deborah (also Debora, Debbora, D'vorah, or Dvora) served the Israelites as the sole female adjudicator, intercessor, and visionary.

Introduced in Judges 4 and 5, during the Late Bronze Age, she was the wife of Lapi-doth and a contemporary of Israel's King David, who was born in 1092, when she was fifteen. She succeeded Israelite wise men—Joshua, a notable arbitrator and spy on Canaan during the Exodus around 1575 BCE and the high priest Eli and the noble seer-judge Samuel after 1075 BCE. Named "the honeybee" and possibly "woman of torches," around age thirty-two, Deborah interpreted honey-sweet messages from Yahweh. She provided wicks during religious study to brighten the Shiloh taberna-cle, the West Bank tent sanctuary where Moses housed the Ark of the Covenant in 1576 BCE.

In a hopeless era of outlawry and economic collapse, Hebrew prophets claimed an understanding of godly truth and tribal warfare unequaled by high priests and monarchs. Delivering judicial decisions outdoors under a date palm between Bethel and Ramah at Mount Ephraim, Deborah avoided forbidden indoor meetings with males while she mediated grievances and disputes between the righteous and back-sliders. A paradigm of godliness, she coaxed reluctant Hebrews to rebuild their faith by reading the Torah and worshiping Yahweh in houses of communal prayer. For her attention to duty, Yahweh promised to elevate her in Jerusalem and throughout Judah.

The Prophet in Action

Because of twenty years of enemy oppression following Joshua's death, around 1070 BCE, Yahweh stirred Deborah to action against a coalition of northern mon-archs. She stated, "I, Deborah, arose" (Judges 5:7). To King Barak's dilly-dallying, according to theology and ancient history professor Tammi Joy Schneider at Clare-mont Graduate University in California, she added to judicial responsibility accept-ing military power. In the role of infantry strategist, she agitated the Benjamite and Ephraimite infantry to a holy war against Canaan, the idol-worshipping forerun-ner of Phoenicia, Palestine, Lebanon, Syria, Transjordan, and Israel. At the time, the tyrant Jabin (or Yavin) of the city-state of Hazor, Canaan, commanded nine hundred iron chariots, but faced a scathing augury of losing to a woman.

A parallel female triumph anticipated Deborah's redemption of her people. Typical of prophecy in eleventh-century-BCE Israel, the ambiguous reference in Judges 4:9 speaks not of the prophet Deborah and her war, but of the assassin Jael (or Yael), a nomadic Kenite, who sold metalwork from the Sea of Galilee to the Gulf of Aqaba. Without help, Jael enticed Captain Sisera, Canaan's commander in chief, into her tent for a nap and a cup of milk, a motherly image to an unsuspecting victim of womanly guile. She slaughtered him by hammering a tent peg through his temples into the ground.

King Barak exhibited less courage than the assassin or his prophet, but agreed to Deborah's challenge on the condition that she fight the enemy alongside him as chief commander of the Israelite army. As the king's superior, Deborah mustered

more Hebrew tribesmen from Issachar, Manasseh, Naphtali, and Zebulun and undertook a five-day march to the field at Kedesh (or Qedesh) on the Kishon River in upper Galilee (modern Lebanon). After the ten thousand warriors engaged Jabin's Canaanites in the Jezreel Valley at Mount Tabor in northern Israel, Yahweh intervened, a miracle hyperbolized as turning night to day and dispatching the stars to aid the Hebrews. As a result, Jabin's confederacy shattered when Barak's forces destroyed the royal capital at Kedesh. Beyond scriptural poetic embellishment, the lopsided victory resulted in death in hand-to-hand combat for all Canaanite soldiers and glory to Yahweh. For his valor, Barak acquired a name meaning lightning.

Singing to God

According to rabbinical writings, Barak modestly declined honors in favor of his prophet, Deborah, who had correctly predicted a female win over Sisera. Shouldering the praise set her above other women in the Torah as its only female combat chief. She composed a triumphal paean reverenced as the bible's oldest document that retained its original form. The lyrics that she chanted on the killing grounds stated a pious aim: "I will sing to Yahweh" (Judges 5:3). She pictured the Israelites summoning her to recite war chants to toughen Barak's wobbling will and to celebrate his win. For contrast, ironic verses portray Sisera's mother as a grasping seeker of post-war spoils, which included one or two sex slaves for each Canaanite soldier. Deborah's glimpse of another woman involved in the fray epitomized the enemy's crass overconfidence.

Alongside an historical text, Deborah's poetic scenes and themes displayed the reordering of a chaotic situation similar in significance to the victory verse of Egyptians and Mesopotamians. Because Yahweh sent a rainy deluge, the Canaanite chariots slipped in mud and washed away in the Kishon River. The Israelite victory over Canaan remained firm for four decades and substantiated Deborah's title of "the Mother in Israel." The Old Testament exults with cogent repetition: "The children of Israel prevailed more and more against Jabin the king of Canaan, until they had destroyed Jabin the king of Canaan" (Judges 4:24).

Deborah's song in Judges 5, one of the earliest models of Hebrew verse, stood out from scriptural text as a special warning to men like overreachers Sisera and Jabin—"So may all Your enemies perish, O Lord" (Judges 5:31). The anthem contributed to Jewish liturgy a battlefield ode equal in momentum to the militaristic songs of Moses, David, and Solomon. In Psalm 83, David rejoiced at the Israelite win over Canaan and called for future overthrow of despots:

> Let them be confounded and troubled for ever; yea, let them be put to shame, and perish: That men may know that thou, whose name alone is Jehovah, art the most high over all the earth [Psalms 83:17–18].

He advocated that devout Jews apply themselves to learning such educational hymns as the heroic Song of Deborah and to bless Yahweh for His goodness and forgiveness.

Source

Coogan, Michael E., and Cynthia R. Chapman. *The Old Testament and Literary Introduction to the Hebrew Scriptures.* Oxford, UK: Oxford University Press, 2017.

Mayfield, Tyler. "The Accounts of Deborah (Judges 4–5) in Recent Research," *Currents in Biblical Research* 7:3 (2009): 306–335.

Schneider, Tammi Joy. *Judges.* Collegeville, MN: Liturgical Press, 2000.

2

Late Classical Era

Wang Zhaojun (52–31 BCE)
calligrapher, painter, lute player, dancer
Imperial China

During the Western Han dynasty, a poor rural girl, Wang Zhaojun (also Wang Chiang or Qiang), gained a reputation for great beauty, refinement, and musical talent on stringed instruments. Born in 52 BCE in Baoping, Hubei Province, she was daughter of an aged farmer who marveled at her loveliness, wit, and intelligence. A skilled performer, she flourished at painting, dancing, calligraphy, board games, and the *guqin* (seven-string zither). In early summer 36 BCE, she departed her home as a lady-in-waiting to join the three thousand concubines of Emperor Yuan in Chang'an, the Han capital in north central China. The emperor did not see her face, but chose her despite an unflattering portrait by artist Mao Yanshou. Consequently, she remained unclaimed and unloved.

In the thirteenth year of his reign, Emperor Yuan received a request for a wife from Xiongu ruler Hu Hanye (also Huhanxie), a 43-year-old nomadic Hun from Southern Xiuongnu Province on the Han north border. His reasoning was political: he wanted to be the emperor's son-in-law. On previous visits, the emperor had maintained cordial relations with the Huns by giving Hu Hanye fifteen horses, 77 outfits, 8,000 bales of silk, and 200,000 cash. The Han people classed the Huns as barbarians, a malleable race that depended on the Han Chinese for arranged nuptial alliances with their cultured dynasty. The emperor chose Wang Zhaojun because of her plain features but was so startled by her actual appearance that he executed the painter. He also bribed Hu Hanye with three more wives and ordered him to observe the Great Wall of China as an official boundary.

On Wang Zhaojun depended a fragile de-escalation between the Han Empire and nomadic Huns. At age seventeen, she left home on horseback with little hope of a prosperous union. Because of sorrow at the arranged nuptial, north along the Zhidao military highway, she played melancholy airs on the *pipa* (four-stringed lute). Legends describe how geese flying south became so entranced with her sad tunes that they dropped out of the sky. Nicknamed "Fells Birds," she met Hu Hanye in autumn 33 BCE, when he arranged their union. As a royal wife, Wang Zhaojun bore four children: Princess Yimuo and

Princess Dangyu Juci, Prince Yituzhiyashi and his brother, who did not survive infancy.

After Hu Hanye died in 31 BCE, the Han dynasty observed the international reconciliation for sixty-four years until 33 CE. Homesick for China, Wang Zhaojun asked permission to return to the Han court. The emperor refused for diplomatic reasons and forced her to wed her stepson, who sired two more daughters. At death, she lay buried at the Emerald Mound in Hohhot, where residents hold an annual mid–August festival commemorating her lute compositions. Her hometown carries the name Zhaojun Village. From as early as 100 CE, the romantic story influenced writers, storytellers, poets, song and opera composers, painters, and embroiderers. Monuments to the refined Han princess mark the Silk Road.

See also Han Ximeng, Miao Ruiyan, and Gu Lanyu (1634).

Source

Bulag, Uradyn E. *The Mongols at China's Edge.* Lanham, MD: Rowman & Littlefield, 2002.
Gan, Lin. *A General History of the Xiongnu.* Salt Lake City, UT: American Academic Press, 2020.
Makinoda, Toru. "Trip Through Time: Legendary Beauty's Final Resting Place," (Tokyo) *Japan News* (10 October 2013).
Zhao, George Qinzhi. *Marriage as Political Strategy and Cultural Expression.* New York: Peter Lang, 2008.

Salome (ca. 10–60 CE)
dancer
Judaea

An enigmatic artist of the Herodian dynasty, Salome exists in Judaean history and the arts alongside ghoulish tales of dancing with the decapitated head of the itinerant prophet and evangelist John the Baptist. The genealogy, incorporating the New Testament gospels of Mark 6:21–29 and Matthew 14:3–11 and the *Jewish Antiquities*, which the Jewish historian Flavius Josephus, a Roman adoptee, completed in 94 CE, raised doubts about details. The great granddaughter of Herod the Great and granddaughter of Aristobulus IV and Bernice I, Salome was the niece of Herod V, a Roman client king, and Herod Agrippa, the Judaean monarchs in the book of Acts 12:1. She was born around 10 CE to Herodias, the twenty-five-year-old wife of her half-uncle Herod II. Named for a maternal great grandmother, Salome I, she received a Greek birth name meaning "peace." Salome married her uncle Philip, ruler of Iturea and Trachonitis north of Galilee. At his death in 34 CE, she chose as second husband her cousin Aristobulus of lower Armenia.

Salome established her reputation for dance before the fatal presentation. In 29 CE around the age of nineteen, she performed a seductive dance before Herod Antipas with the head of the cousin and forerunner of Jesus on a silver salver. The motivation for the beheading and performance lay with Herodias's grievance against the famed preacher for defaming her for divorcing Herod II and wedding his brother, Herod Antipas (or Antipater), the tetrarch of Galilee in northern Israel and south

Lebanon and of Perea on the eastern shore of the Jordan River. To achieve the union, Herod Antipas, then in his late forties, had shed his wife Phasaelis, a double violation of Jewish laws against incest and divorce and against a man marrying his dead brother's widow.

To placate Herodias, Herod Antipas ordered John's arrest in 27 CE for condemning the royal marriage and jailed him for two years at the Machaerus Palace near the Dead Sea. Herodias appears to have blamed her new husband for failing to kill John immediately. Nonetheless, Herod Antipas hesitated to sever the head of John, whom he revered for his sanctity. Instead, shortly before the Passover on April 11, he sent a servant to the prison to carry out the death order. The notorious solo performance occurred before guests celebrating her stepfather's birthday. French historian Christiane Klapisch-Zuber evaluated the legal difference between murder and salacious female dancing before men: "The deleterious charms of Salome draw the male gaze but led the king to the worst of sins," an impromptu execution (Klapisch-Zuber, 2017, 196). Matthew's version implies that Herod Antipas avoided breaking his oath to reward Salome lest the Galileans disapprove and rebel.

Whatever the court scenario, Salome passed the grisly prize to her mother, who rid herself of fears that John could turn Jews against her. Simultaneously, Herod Antipas incurred the anger of Phasaelis's father, King Aretas of Nabataea, who destroyed Herod's army. By 37 CE, Herod Antipas had lost favor with the Roman Emperor Caligula, who exiled the imperial appointee to Gaul for attempting to boost his title from tetrarch to monarch. The dancer bore into current times a mythic reputation for lascivious, amoral behavior and shameless dancing as well as the actions of a femme fatale obeying a deviant mother.

See also Armen Ohanian (1887).

Source

Klapisch-Zuber, Christiane, and Susan Emanuel. "Salome's Dance," *Clio* 46 (2017): 186–197.

Lassley Knight, Jennifer. "Herodias, Salomé, and John the Baptist's Beheading: A Case Study of the Topos of the Heretical Woman," *International Social Science Review* 93:1 (2017): 1.

Weren, Wim J. "Herodias and Salome in Mark's Story about the Beheading of John the Baptist," *HTS Theological Studies* 75:4 (2019): 1–9.

Miwnay (fl. 313–314 CE)
letter writer, calligrapher
Sogdia

Shayn (fl. 313–314 CE)
letter writer, calligrapher
Sogdia

In a personal missive written in stylish calligraphy, Miwnay (also Miunai) manifested the desperation of an abandoned Sogdian wife left in a foreign country with

a female child to support. From two paper letters disclosed by British archeologist Aurel Stein in Dunhuang, China, in 1907, literary historians deduce that she and well educated daughter Shayn (also Saina) were left penniless around 313–314 CE in an oasis, a major post on the Silk Road surrounded by the Mogao caves, Buddhist temples, and stretches of the sandy Gobi desert. Traveling by camel train, the husband and father Nani-dhat moved on along the famed trade route that extended from India over the Himalayan Mountains to southern Siberia.

The Sogdian diaspora failed Miwnay. Nani-dhat left her and daughter Shayn at an outpost where silk, silver, and luxury items enriched a stream of buyers and sellers. However, the web of Sogdian migrants appeared unable or unwilling to reunite the family by transporting them home or paying for their upkeep. Tattered phrases hint that commerce had made the household secure and well supplied, even funding literacy training for Shayn, a spirited girl who expressed herself well in grammar and handwriting. Both mother and daughter relied on a postal system that communicated domestic and business concerns over international boundaries.

MAKING DO

The women composed two single-receiver letters stating an untenable situation. For three years, they struggled to survive far from their Sogdian roots in Samarkand, an ancient Iranian settlement in southeastern Uzbekistan and western Tajikistan once ruled by Persian conquerors Cyrus the Great, Darius I, and Xerxes and Macedonian globe trotter Alexander III the Great. At the time that Miwnay wrote to her husband, the eastern end of the trade route foundered from warfare in Gansu Province south of Mongolia. The resulting famine in the ancient Chinese capital of Luoyang and imperial chaos while the Wei and Jin dynasties vied for power did not bode well for a pair of lone, powerless females.

Written in an Indo-European language spoken in Samarkand and among multilingual Sogdian emigrants from Bukhara and Tashkent in Central Asia to northwestern China, the first letter implored Miwnay's mother, Chatis (also Catisa), to locate someone to transport Miwnay and Shayn to Chatis's house. Reliance on the mother implied that Chatis lived alone and solvent. With no source of loans or money to buy food and clothes, Miwnay and Shayn had been depending on handouts from a priest who appears to have adhered to the second prayer of the Zoroastrian faith promising to assist the poor as proof of fealty to God's kingdom.

A longer conjugal letter blasted Nani-dhat, a long-distance merchant familiar with the diaspora between Samarkand and Dunhuang. Miwnay stated that she obeyed him as a wife should and came to Dunhuang at his command, even though Chatis and her two sons advised against the chancy trip across borders. The letter writer feels lifeless and assumes that the gods disapproved of a venture that required sanction by male relatives.

FORCEFUL WRITERS

Women's history specialists identify Miwnay as a free woman educated in courtesy and humility and skilled at modulating tone and writing in ink on paper. Analysts note the anger in the wife of Nani-dhat, who would opt for wedlock with a dog or pig than with a negligent husband who didn't support her or answer her letters. Additional pleas to councilor Sagharak got no response from agents Artivan or Farnkhund. The latter absolved himself of responsibility for a domestic situation which he may have caused by embezzling from Nani-dhat. To Sagharak's "wait and see" approach to the absent husband and father, Miwnay anticipated a life of penury and bondage for herself and Shayn as domestics in a Chinese home, where owners typically abused servants.

Unidentified by age or physical details, Shayn followed her mother's example and penned an addendum explaining her own view of the predicament. She took work as a herder of farm animals and chastised her father for preventing her and Miwnay from repaying Farnkhund's debt of twenty staters (roughly $40). Missing from the surviving messages is any reference to the husband's circumstances, such as his survival of roadway brigands, raids on Ye and Luoyang, or combat between the Chinese and nomadic Xiongnu horse rustlers from the Mongolian steppes. The discovery of Miwnay's letters in an abandoned postal pouch at the Jade Gate, a Dunhuang watch tower, betokened the futility of writing pleas about an abandoned woman left to fend for herself and a daughter.

Source

de la Vaissière, Étienne. *Sogdian Traders: A History*. Leiden: Brill, 2005.

Rose, Jenny, "The Sogdians: Prime Movers between Boundaries," *Comparative Studies of South Asia, Africa and the Middle East* 30:3 (2010): 410–419.

Whitfield, Susan. *Life along the Silk Road*. Oakland: University of California Press, 2001.

Macedonia (490–?)
actor, dancer
Byzantium

Antonina (495–565)
actor, dancer
Byzantium

Theodora, Empress (500–June 28, 548)
actor, dancer, mime
Syria

A child prodigy of Cypriot descent, Theodora rose from a despised profession in burlesque, mime, and striptease to the first woman-and-man throne partnership in

world history. Born in 500 to bear trainer Acacius in Mabbug northeast of Aleppo, Syria (or possibly Cyprus or Paphlagonia on the Black Sea), she was the second of three daughters of an unidentified actor and circus dancer. To earn a living for her widowed mother and sisters Anastasia and Comito, she, at age four, wrapped her naked body in garlands and ribbons and led cheers for a chariot racing team in Constantinople's hippodrome, which held thirty thousand viewers. When her mother remarried, she switched from support for the Greens, the working-class party, to the Blues (*Venetoi*) because they aided Theodora's stepfather in finding employment in the circus.

For eighteen years, Theodora danced, mimed, and acted until her conversion to Christianity. She gained a reputation for nudity and sexual license. In lewd *tableau vivant* stage performances, geese nibbled barley from her bare midriff and genitals to depict the mythical Leda and the Swan. She bore a son, Joannes, whom she tried to abort. His father kidnapped the baby and fled to Arabia. Around 515, she gave birth to an illegitimate daughter. She emulated older sister Comito and worked in a brothel. To elevate the social status of theater troupes, she established a patronage of the dancer Antonina, daughter of an actress and a charioteer in Constantinople and Thessalonica, Macedonia.

A SURVIVOR

After traveling to eastern Libya in 516 as mistress of Hecebolus of Tyre, governor of Pentapolis, Cyrenaica, Theodora began a four-year residence at the 100-room Apollonia Palace of the Dux (commander). At age twenty, she escaped Hecebolus's sexual abuse and made her meandering way back to Constantinople. Around 522, she became a Christian ascetic among desert hermits in Alexandria, Egypt. Dancer Macedonia, the mistress of a Blue driver and reputed imperial spy at Antioch, Syria, helped Theodora and her daughter return to the Byzantine capital.

Because of Macedonia's imperial connections, Macedonia introduced Theodora to the Emperor Justin I's 39-year-old nephew Justinian, a fan of Blue team charioteers. Theodora, in her early twenties, presented a sedate picture of the wool spinner at home near the palace. Smitten by her wit and beauty, in 525, Justinian changed a law forbidding patricians from marrying actors. Despite advice by his aunt, the Empress Euphemia, to give up romance with a low-class actor, he wed Theodora. He advanced to the throne in 527 at the Hormidas Palace on the Sea of Marmara and reared her illegitimate daughter and grandson Athanasius as his own.

As *Augusta* (Empress), Theodora learned to manipulate court politics to boost her husband's authority through guile and piety. She relied upon advice from friend Antonina, whom she named chief lady-in-waiting and employed as agent and spy. Upon Joannes's appearance at court to claim the empress as his mother, Theodora ordered his murder. A vigorous builder, Theodora invested time and effort in infrastructure and constructed the Sykae monastery in the Galata district and

the Metanoia (Repentance) convent on the Dardanelles overlooking the Aegean Sea to house the homeless and rehabilitate five hundred reformed prostitutes. Among twenty-five new churches, the Hagia Sophia (Church of Holy Wisdom), location of the imperial coronation on April 1, 527, epitomized the era's soaring architecture and elegant mosaics, dome, gilt scrollwork, and marble pillars.

The Imperial Feminist

When the Blue and Green political parties sparked the week-long Nika (Victory) riot of thirty thousand dissidents and arsonists on January 13, 532, the empress fought back. She refused to flee the palace, which was next door to the hippodrome, or to sail out of Constantinople harbor. With the aid of General Flavius Belisarius, the imperial army suppressed turmoil and destruction in the city center and executed Hypatius, Justinian's rival. Her courageous speech won the emperor's lasting love and thanks for rescuing his throne and the Great Palace. She sealed exits and executed Hypatius and some thirty thousand rebels and their senatorial backers. Together with Justinian, she began adorning the Hagia Sophia, a lavish cathedral commemorating their successful overthrow of the Nika rioters.

Like Theodora, Antonina bore a sullied reputation for giving birth to son Photius. Nonetheless, she married Belisarius and bore daughter Ioannina, mother of Antonina's granddaughter. The former dancer followed the general and his seventeen thousand troops on the Vandalic War campaign in June 533 to Algeria, Libya, Sardinia, and Tunisia. With Antonina's help, Theodora foiled the plots of the tax agent John of Cappadocia and had Pope Silverius exiled for betrayal to the barren island of Palmarola. The emperor's scribe, Procopius, spared no spite in demonizing Antonina and Theodora for their lives on the Byzantine stage and in questionable politics.

Empress and Saint

During the emperor's codification of the Justinian code in November 533, Theodora closed brothels, banned pimps and forced prostitution, fought for harsher punishments of rapists and human traffickers, and defended female rights to custody of their own children and to the property of their persecutors. Under her laws, wives could institute divorce and survive court charges of adultery. Girls on the run could find safety at Theodora's convents. She ordered rapists killed and shielded unwanted babies from death by exposure. Because Belisarius tried to smear Antonina's standing, the empress saved her friend from a charge of adultery and sheltered her daughter and grandchildren. Antonina elevated her own reputation for loyalty by hiring a fleet in 537 to bear grain and five hundred fresh troops from Naples to Ostia and upriver to Rome. To heal a breach between the dancer and Belisarius, the empress intervened and restored the general to master of the Eastern military. Completing

the picture, after 542, Antonina's daughter Ioannina wed the empress's grandson Anastasius.

At age forty-eight, Theodora died of breast cancer on June 28, 548, leaving her husband in a gush of tears. Out of respect for her religious leanings, to the end of his thirty-eight years of rule, he labored to institute religious tolerance and to unite warring Christian sects until his death on November 14, 565. Gilded mosaics in the Basilica of San Vitale of Ravenna, Italy, pictured the imperial pair—Theodora and Justinian I the Great—as a governing unit. Libyans in Cyrenaica named a city Theodorias in her honor. Each November 14, the Eastern Orthodox Church reveres Theodora as a saint.

Source

Baker, G.P. *Justinian, the Last Roman Emperor.* New York: Cooper Square Press, 2002.

Evans, James Allan. *The Empress Theodora: Partner of Justinian.* Austin: University of Texas Press, 2002.

Procopius. *The Secret History.* Hollywood, FL: Simon & Brown, 2018.

3

Late Byzantine-Islamic Era

Khawla bint al-Azwar (fl. 634–639)
poet
Syria

A legendary woman warrior of Byzantine Syria, Khawla bint al-Azwar (also Kawleh bent Al Azwar) rallied other female fighters by quoting motivational war verse. A member of the patrilineal Bani Assad tribe, she and brother Diraar (also Dhiraar, Dirar, Derar, Zarrar, or Zirrar) followed the example of their father, Chief Malik (or Tarik) bin Aws, a devout Shia Muslim known as "al-Azwar (the Azure)." From her brother, the commander and scout of the thirteen thousand men of the Rashidun Caliphate Army, she learned swordsmanship, martial arts, and field maneuvers. Following him everywhere, she studied the *karr wa farr* (hit and run) tactic of soldiery and his psychological boast to the enemy by stripping to the waist, a daredevil pose that earned him the nickname "the naked warrior."

As a rescuer and medic for the military, Khawla bint al-Azwar gathered bandages and drinking water for a field hospital. Under 42-year-old Captain Khalid bin Walid, nicknamed the Drawn Sword of God, she joined a fateful charge at the Battle of Ajnadin outside Jerusalem in July 634. During protracted combat with Byzantine Roman legionaries of the Emperor Heraclius at the Battle of Sanita-a-Uqab, fought in Syria's Qalamoun Mountains on September 19, 634, she joined her father's troops. She equipped herself with a knight's leather scale armor and leather shield. She took up a curved scimitar and eight-foot lance and obscured her face in a black cloth and her small waist and breasts in a green shawl wound around the black attire. Khalid discovered her soaked in blood and commanded that she unveil.

Forced to reveal a female face and name, Khawla bint al-Azwar followed orders to pursue the routed Romans and liberate Muslim captives, particularly her brother, who lost his spear and fell to the enemy during the Siege of Damascus. She quickly outfitted herself in his bloody uniform and headed alone to the *muqaddimah* (vanguard). A historian compared her to a hawk pouncing on a sparrow. In view of her determined attacks against detachments of pursuers, Syrian warrior Rafe' Bin Omeirah Al Taei imitated her valor without recognizing her gender. Others believed her to be Captain Khalid himself, who stated admiration for so doughty a fighter.

Her example shamed lesser fighters and rallied them to return to the field and emulate the women's squad.

Because of a fall from a wounded mount and a break in her spear, at the six-day Battle of Yarmouk on Syria's border with Jordan on August 20, 636, Khawla bint al-Azwar fell into enemy hands. At a camp for female prisoners, she refused to service the Roman general Theodore Trithyrius in his bed. Inciting the other comfort women with epic poems about honor and liberty, she distributed tent poles and dashed at Byzantine guards. The general offered her marriage and prominence in Damascus. She shouted her preference for a cameleer over the pompous Byzantine Roman and vowed to have his head. Her female phalanx managed to kill thirty enemy sentries. She slew five knights, including the general she rejected. She continued to build a warrior's reputation in Jordan and Palestine, where Khalid's army massacred some three thousand Byzantine knights in one hundred battles.

Khawla bint al-Azwar married Ali ibn Abi Talib, the cousin, son-in-law, and companion of the prophet Mohammed. At her death in 639 during the plague of Emmaus, Syria, that killed her brother as well, she was enshrined with Muslim martyrs at Sermin. Her name survives in a female unit in the Iraqi army; a girls' academy in Al Nasiriya City; a civil rights society; and the Khawla bint Al Azwar Training College in Abu Dhabi, United Arab Emirates, the first institute of female soldiery in the Gulf states. Around 1912, Egyptian sculptor Mahmoud Mukhtar shaped her likeness wielding a spear from a rearing horse and placed it in Cairo. In 2011, Jordan placed her portrait on a postal stamp in full charge on a prancing mare. Vandals destroyed her grave in 2014.

See also Bayhum, Nazik Khatim al-'Abid (1887).

Source

Booth, Marilyn. *Infamous Women and Famous Wombs*. New York: Palgrave Macmillan, 2001.
Haas, Mary E. "Women and War" in *Women in the Third World: An Encyclopedia of Contemporary Issues*. New York: Garland, 2014, 1716.
Husn, Ma'n Abul. "Khawla Bint Al Zwar," *Al Shindagah* (May–June 2003).

Akhyaliyya, Layla al- (ca. 635–708 CE)
poet, satirist
Arabia

A pre–Islamic author of elegiac love verse, lamentations, invective, and lampoon, Layla al-Akhyaliyya exposed in verse a thwarted passion and grief for an inaccessible lover. She was born at Najd to the Banu Uqayl division of the Banu Amir tribe around 635 CE, the granddaughter of a famous knight, al-Akhyal, in western Arabia on the Red Sea coast. During extensive travels, she refused to ride in a modest curtained litter. An urbanite, she reached a height of popularity in 650 as a public performer. The chief event of her life, love for Bedouin poet, womanizer, and camel rustler Tawba al-Humaiyyar, earned a rebuke from her father, who arranged

a betrothal to Abi al-Athia, a future wife beater. Because the caliph forced the outlaw Tawba out of her life, lingering recriminations caused Abi al-Athia to reject her.

A self-assured, scathing-tongued noble at the Umayyad court of Hajjaj ibn Yusuf (660–714), governor of Iraq and eastern Arabia, Layla al-Akhyaliyya married poet Sawwar ibn Awfa al-Qushayri, who sired a large family. On a negotiated court salary as tribal poet, she received cash, camels, and silk garments in payment for facile verses, such as her classic glimpse of desert steeds and grouse watering their young and her Keatsian musing on mortality. Critic Dana al-Sajdi, a history professor at Boston College, credited the unconventional thinker with "pushing the boundaries of gender-determined poetic norm" (al-Sajdi, 2000, 121).

By age twenty, in the style of the Roman Catullus, the poet provided aristocrats with snappy repartee and sexually explicit verse couched in classical language and polythematic structure. Of a proud tribe, she boasted, "The sword knows we are his brothers,/thirsty, when it starts cutting bones," a salute to weaponry similar to King Arthur's reliance on Excalibur (Jacobi, 2005, 89). After 656, she wrote an elegy on the death of Caliph Uthman ibn Affan of Mecca, a gesture of respect to the Umayyad line and the son-in-law of the patriarch Muhammad.

MOUNTING FAME

From 660 to 683, the poet engaged the anti-marriage female satirist Humayda bint Numan ibn Bashir and the sneering, ignoble Nabigha al-Ja'di of Basra in pornographic slams. The clash began with her husband Sawwar, who was unable to outperform Nabigha. Her sexual innuendo on horse breeding demeaned Nabigha for emitting a meager "streamlet between mountains in an unknown desert," an ambiguous reference to urine or ejaculate and an allusion to his poor performance with women (*ibid.*, 88). By expressing fierce opinion in risqué satire, she bested them all. Panegyrics included a salute to Hajjaj, the merciless governor of Hejaz in western Arabia, whom she compared to a comet ripping through the dark. She also praised caliphs Muawiya, the Umayyad founder; Marwan I, governor of Medina; and Abdal-Malik, Hajjaj's son who soldiered in Syria.

Layla al-Akhyaliyya transgressed trends by violating social norms, ignoring public fanaticism for Islam, and rebuking male-on-male violence and retribution, the causes of wars and vengeance codes. She boasted her tribe's overthrow of King al Jahjaha: "We are Banu Khuwaillid without compare;/the battle does not lie nor trifle" (Disse). According to Renate Jacobi, an Arabist at Berlin University, the poet composed a wistful recall of her father and uncle's campsite "between Adh and Jubjub in bygone times/Now their campsite is desolate,/the winds whirling about it everywhere" (*ibid.*, 86). Because Tawba was her kinsman, her regret for the tribe's departure extends to her lover, who left her vulnerable, but unbowed. Of her need for a trusty messenger, she asked for "a rider/whose words are believed, when he speaks

the truth./He mounts a camel of my possession, swift in its stride," an allusion to her pride in decisive language (*ibid.*).

A LOST LOVE

After 694, when Tawba continued to visit and dedicate poems to Layla Akhyaliyya, her late-in-life fascination with a marauder brought queries from her brothers, tribal authorities, and Caliph Hajjaj. Her curt reply indicated strict secrecy and a rejection of Hajjaj's flirtation. She reported Tawba's subtle request for intimacy, of which she wrote, "His wish was dear to me, but it could not be" (*ibid.*, 85). After the outlaw died in a tribal raid in 699, Layla devoted 51.5 percent of her output to Tawba. She imagined sharp Indian swords surrounding him and slicing gashes that poured blood. One elegy thanks Abdullah, Tawba's brother, who rescued the gory remains from birds of prey. She mourned at her lover's tomb and awaited his promised reply from beyond the grave through the call of a soulbird (owl).

Layla al-Akhyaliyya composed an articulate dirge for the memories that plagued her on dark nights, a pun on the meaning of "Layla" (dark). Her poignant lines incorporated visual stimuli—a camel mare in labor, cooing doves, honeycomb, and wine—as well as memories of a valiant sweetheart far more admirable than his reputation: "Bravo the man, O Tauba, as neighbor and friend/Bravo the man, O Tauba, as you excelled" ("Laila"). Command of the *ritha* (elegy) allowed her to subvert patriarchy and, in ten poems, publicize a doomed yearning that an androcentric society forbade of unmarried women. She reflected on Tawba's verbal expertise for "rhymes/like spearheads" ("Laila"). On a family trip in 704 (or 709) to Khurasan, Iran, to visit a younger cousin, Governor Qutayba ibn Muslim of Najd in central Arabia, she died around age sixty-nine and was buried in Samawa southeast of Baghdad, Iraq. An anthology of three hundred of her verses reaped fame in ninth-century Arabia and eleventh-century Spain.

Source

Al-Sajdi, Dana. "Trespassing the Male Domain: The Qasīdah of Laylā Al-Akhyaliyyah," *Journal of Arabic Literature* 31:2 (2000): 121–146.

Al-Udhari, Abdullah. *Classical Poems by Arab Women*. London: Saqi Books, 2017.

Disse, Dorothy. "Laila Akhyaliyya—Female Voice of Antiquity," fleurtyherald.wordpress.com/2015/02/03/laila-akhyaliyya-female-voice-of-antiquity.

Jacobi, Renate. "Laylā al-Akhyaliyya-an Umayyad Feminist?," *Figurationen* 6:1 (2005): 79–94.

"Laila Akhyaliyya," www.poemhunter.com/poem/excerpts-from-laila-s-poems-for-tauba/#content.

Shahin, Aram A. "Reflections on the Lives and Deaths of Two Umayyad Poets: Laylā al-Akhyaliyya and Tawba b. al-Ḥumayyir," *The Heritage of Arabo-Islamic Learning*. Leiden: Brill, 2016, 398–443.

Talib, Adam, Marlé Hammond, and Arie Schippers, eds. *The Rude, the Bad, and the Bawdy*. London: Gibb Memorial Trust, 2014.

Siunetsi, Sahakdukht (675–736 CE)
hymnographer, poet, lyrist
Armenia

A prominent eighth-century-CE singer and lyrist and founder of medieval Armenian Christianity, Sahakdukht (also Sahakdukht of Siunik, Sihaktoukht, Sahaduxt, and Sahakduk), became the nation's first female poet, music therapist, and writer of *sarakaner* (hymns). The oldest daughter of Sahak (Isaac), a bishop at the archdiocese at Dvin, the capital city and agrarian and religious center, she was born in Eurasia on the eastern Turkish border. She came of age during the contention between Arabs and Byzantines and the fortification of the city with wall, gates, and moat. She grew up in a musical family, studied at the local cathedral school, and mastered the art of singing and playing the *knar* (lyre), a favorite instrument in ancient Greece.

During rule under the Umayyid Caliphate, the assassination of Sahakdukht's younger brother, hymnographer, musical theorist, and mystic poet Stephanos Siunetsi on July 21, 735, plunged her into despair. She withdrew to the rugged Garni Gorge east of Yerevan, Armenia, a basalt declivity gouged out by the Goght River. Cherished for being a gentle, pale-skinned virgin and anchorite, she limited herself to cave living and wrote *sharakan* (ritual songs and chants) and *ktsurds* (antiphonal anthems) that she performed for feast days, holidays, and music therapy. Her religious verses and meditative chants aided dejected people, who sought relief of depression at her cave. Behind a curtain to shield her modesty, she plucked the lyre to sooth melancholy visitors, including her sister, and played sweet, consoling ecclesiastical and secular melodies, much like David the Shepherd for King Saul during chronic headaches in I Samuel 16:14–23.

HYMN TO THE VIRGIN

Deeply spiritual, Sahakdukht contributed to an evolving church art of poetry set to music on subjects of Christology, the nativity, hagiography, Mariology, and veneration of the cross. She composed *Srbuhi Mariam* (Saint Mary) with nine verses rhyming acrostically with first letters spelling the title:

> Saint Mariam jug of gold
> And the ark of the covenant
> That the bread of life may be lifted up
> You gave to my hungry nature.
> Always intercede with him:
> For the atonement for our sins ["Musician"].

The verses extol Mary, mother of Jesus, with lines from the Annunciation (Luke 1:26–38), and remind worshipers to glorify her as holy virgin and Jesus as eternal lord. The imagery introduced into conventional liturgical writing the terms "divine light," "temple incorruptible," and "tree of life," a natural metaphor dating to ancient

Mesopotamia. The hymn entire did not enter Armenian liturgy, but survived in murky notation for singing on Wednesdays at compline (evening prayer) in the second half of Lent.

Sahakdukht allied veneration of Mary with women suffering birth pangs. She characterized the virgin as heaven's door, conduit for God's presence on earth, and "mediator of peace, who lifted the curse of the first mother Eve by the death of the Lord" (Nersessian, 2001, 69). The text of the pro-female poem credited Mary with easing the contractions of Eve in labor, the world's first birthing, thus negating the notion of "woman's curse" and exonerating Eve as the fount of all mortal iniquity. The final couplet of the six-line poem revisits the annunciation and repeats "Blessed are you among women" (Hacikyan, 2002, 218).

An Innovative Composer

Before 735, Stephanos Siunetsi adapted individual hymns into liturgy. In the 1700s, music historian Stephanos Orbelian of Syunik in southern Armenia recounted Sahakdukht's value to church music. Her first song reached print in a 1951 issue of *Hask* magazine, a Lebanese-Armenian monthly issued in Beirut. She also composed "Zamanali e Indz" (It Is Amazing to Me), which researchers incorrectly attributed to another hymnographer. The threnody esteemed Prince Vahan of Goghtn (modern Azerbaijan) and praised his religious work and asceticism. Muslims beheaded him in 731 for renouncing Islam in Syria.

Sahakdukht taught pilgrims and spread her holy repertoire to music and theology students. At her decline and death in 736 CE, she was still singing sacred airs with the last of her strength. Her grave became a healing shrine. Singer Laura Mello promoted Sahakdukht's vocal art in "Lamento da Caverna" (Mourning from the Cave), a reverberating monody suggesting the timbre of the hymnographer's voice as echoed in her cave home.

Source

Greene, Roland, ed.-in-chief. *Princeton Encyclopedia of Poetry and Poetics*. Princeton, NJ: Princeton University Press, 2012.

Hacikyan, Agop J., coordinating ed. *The Heritage of Armenian Literature*. Detroit: Wayne State University Press, 2002.

"Musician: Theory and Exchange of Experience," yerajisht.wordpress.com/2013/11/23/female-musician/

Nersessian, Vrej. *Treasures from the Ark*. Los Angeles, CA: J. Paul Getty Museum, 2001.

"Sisters in Song: Women Hymn Writers," sistersinsongwhw.wordpress.com/tag/sahakdukht/

Utidjian, Haig. "Esprit d'Arménie," *Early Music Review* 150 (October 2012): 12–14.

Rabia of Basra (714–801)
aphorist, religious writer, poet
Iraq

For a life of holy introspection, celibacy, teaching, and dedication to God, the Iraqi prophet Rabia of Basra known as Rabia Basri, Hazrat Bibi (Lady Notable) Rabia

Basri, or Rābiʿa al-ʿAdawiyya al-Qaysiyya, the first female saint, attained the sobriquets "Basra's jewel" and "the queen of worthy women." Named Rabia (Fourth) for her place among three sisters, she was born in 714 north of Kuwait City and the Persian Gulf at the convergence of the Euphrates and Tigris rivers. Her family belonged to the clan of ʿAdi ibn Qays, a Sunni tribe from Upper Arabia. A birth legend describes the absence of lamp oil and a swaddling cloth to welcome the baby. Muhammad intervened with a ruse requiring Amir ʿIsa Zadhan to pay the destitute father four hundred dinars (27¢). The prophet claimed the newborn as a future Muslim leader and Allah's beloved, a forerunner of Sufis.

A mystic, practitioner of miracles, and friend of the philosopher and polemicist al-Jahiz of Basra, Rabia recognized in her teens the ineffable powers of God. Her nightly prayers on the roof allowed complete oneness with Allah. She raced through town with a flaming pot and a bucket of water, one to burn paradise and the other to quench hell. Her theatrics exalted God as the only divine power. According to thirteenth-century Persian poet and hagiographer Farid al-Din ʿAttar of Nishapur, Iran, she entered slavery in girlhood for a purchase price of six dirhams ($1.63). During a flight from the master, she fell in the dust and dislocated her wrist, an impediment to flute playing. Because of a free-floating aura surrounding her during fasting and devotions, the master freed Rabia from bondage.

Earthly Frustrations

Rabia's orphanhood preceded a famine in Iraq. She rejected suitors with a fourteen-line poem:

> My peace, O my brothers, is in solitude,
> And my Beloved is with me always,
> For his love I can find no substitute [Smith, 2016, 12].

She described pure maidenhood as necessary for satisfying the heart and healing the soul. Instead of marrying, the poet ventured west to live in a cell with her servants ʿAbda bint Shuwal and Mariam of Basra among wild goats and gazelles pastured in the al-Hajarah Desert, which stretches from Kuwait and Saudi Arabia to Syria and Turkey. The abstemious life of a hermit focused on repentance, humility, and meditation.

During long years of ritual abasement, Rabia asked that Allah declare her an exemplary woman. In addition to short wise ghazals, she composed two mystic poems, "The Collection of Information" and "The Treasury of Lights." Her definitive poem "Two Types of Love" began with confession: "I have loved Thee with two loves, a selfish love and love that is worthy" (ibid., 102). She concluded with prayer:

> O Beloved of hearts, I have none like unto Thee,
> Therefore have pity this way on the sinner

who comes to Thee.
O my Hope and my Rest [*ibid.*, 55].

To understand the concept of pure love, male and female disciples made regular visits to her cell for instruction. She denounced to needy pupils the praises of tongue and hand and exalted a wakened heart. One follower, the jurist Sufyan al-Thawri of Khorasan, Iran, an expert on jurisprudence and ethics, treasured the Iraqi teacher as his only comfort for the chronic intestinal complaint that killed him at Basra in 778.

Rabia's Canon

The mystic wrote educational verses on sin, intimacy, yearning, hope, fear, and attainment. Her philosophy of love esteemed Allah as the only source of spiritual unity with the almighty, the focus of sufism. In the eighth century, an era of affluence, Hasan al-Basri, the Arabian theologian of Medina, chose Rabia as a model of self-denial for such kindness as giving her last two loaves to a beggar and embracing poverty by rejecting a merchant's gift of a bag of gold. An anecdote credited Allah with reviving her dead camel to carry her to Mecca to visit the Kaa'ba, God's house, a structure that Muhammad sent out to greet her. Even though another story pictured a magic door closing on a thief who tried to steal her robe, she avoided identification as a miracle worker. Other incidents depicted scattering a flight of locusts from her garden, summoning flames from her fingertips, boiling water in an unheated pot, receiving onions from a bird, visits from houris, the virgins of paradise, and jinns, mythic spirits, and her flying prayer mat. A head blow to a stone wall and a thorn in the right eye made no intrusion on her concentration.

Rabia ate little, drank from a broken pitcher, slept on a rush mat with a brick for a pillow, and kept her shroud nearby to remind her of mortality. Out of devotion rather than fear, she spoke directly to God about the sins and blessings of her life:

Thou hast bestowed upon me nought
 but good in my life time.
O God, if my sins have made me afraid,
Verily my love to Thee has protected me [*ibid.*, 147].

A final illness required 'Abda bint Shuwal's nurse care. At Rabia's death in 801 CE at age eighty-seven, she lay at eastern Jerusalem's Mount of Olives in the stone tomb of Zawiyat al-Adawiya, a circular mosque. As a messenger from Allah, she made multiple post-death appearances as a visionary spirit to 'Abda and others. Her verse provided Muslims with some of their favorite odes and hymns.

Source

Cornell, Rkia Elaroui. *Rabi'a from Narrative to Myth*. London: Oneworld, 2019.
Smith, Margaret. *Rabi-a the Mystic and Her Fellow Saints in Islam*. Cambridge, UK: Cambridge University Press, 2010.
Smith, Paul. *Rabia of Basra: Selected Poems*. Victoria, Australia: New Humanity, 2016.

Starr, Mirabai. *Wild Mercy: Living the Fierce and Tender Wisdom of the Women Mystics*. Boulder, CO: Sounds True, 2019.

Kassia (ca. 805–865)
hymnographer, poet, composer, aphorist
Byzantium

Intellectual Byzantine hymn writer Kassia (also Cassia, Kasiane, or Kassiani) won respect as the first female composer of the Western world. A native of Constantinople (modern Istanbul), she was born to a prestigious military officer around 805 and enjoyed aristocratic ties to the imperial court of Emperor Nikephoros I. She received thorough theological training along with lessons in scripture and the apocrypha, meter, versification, and Greek classics by Homer and Palladas, an Alexandrian epigrammatist. Skilled at alliteration and word play, she specialized in liturgical music and occasional poems for feast days such as "On the Birth of Christ," a Christmas ode that she issued under her own name. According to Australian expert Andrew Mellas, she revealed piety by stressing "salvation through the prism of the human heart that desires a life of holiness" (Gador-Whyte and Mellas, 2020, 132).

According to legend, in May 830, Kassia competed in a bride show before Emperor Theophilos, who chose the future empress from a line of nubile women. She angered him by taking the pro-female side in a debate of the "fortunate fall": Eve's sin and woman's part in producing God's son to save humankind from hell. For her Marian devotion, musical historians suspect that she wrote the Akathist Hymn, a devotional to the Virgin Mary during the angel Gabriel's annunciation. The concise diction, style, and structure became propaganda refuting the violent iconoclasts (image smashers) and influenced other chants to Christ, the cross, and Saint Barbara the Martyr of Heliopolis, Egypt, and other female exempla.

TRAINING NOVICES

Because of Kassia's conservatism toward honoring church statuary as godly testimonials, the anti-icon Emperor Theophilos ordered her scourged. Exiled to Italy, she continued to challenge iconoclastic laws until his death on January 20, 842, and replacement by Emperor Michael III. Perhaps with family funding, Kassia established an abbey in 843 to the west of the River Lycus at Xerolophos, Byzantium. As the mother superior, she ruled a monastic community of nuns rather than lone hermits living in solitude. Under the mentoring of liberal Abbot Theodore the Studite, she supported a monk during his imprisonment. She gained fame for wise witty quips in Greek, for example "Knowledge in the stupid is a bell on a pig's snout" and "I hate silence when it is time to speak." Of worldliness, she warned, "Wealth covers sin—the poor/Are naked as a pin," "Better a fight than a furtive love," "One should prefer a drop of luck than great beauty," and "Wealth does not gain grace." Her

sage advice against "merrymaking with irrational fools" equipped nuns for service during a religious crisis stemming from the rise of Islam.

In addition to gnomic aphorisms and liturgical responses authorized throughout Byzantium, the nun notated heavily ornamented melody to accompany spiritual verse, producing the "The Lyre Lit by the Lamp" and "Presentation of the Lord in the Temple." In addition to writing the four-part ode "Tetraodion for Holy Saturday," she earned fame for composing *Troparion* (Refrain), an annual solo chant for the Easter Wednesday morning mass. The 24-line penitential ode honors Mary Magdalene, the female myrrh-bearer who mourned at Christ's tomb. For its reverence of fallen women, the hymn became popular with prostitutes and appeared in Episcopalian anthologies as "O Lord, How the Fallen Woman Wept."

VERSE IN SONG

One of Kassia's influential hymns contrasted the earthly power of the Roman emperor with the divine power of Christ. She produced in aabbccd structure the *Doxastichon* (Eastern Orthodox Doxology) "When Augustus Reigned" for Christmas Eve vespers, one of nine lyrics for the nativity, and the *Triodion* (three-part seasonal rite) for Easter Thursday. She dramatized an antiphon (one-sentence response) between John the Baptist and Jesus in a vesper hymn, the "Forefeast of the Theophany," a celebration of God in the flesh. For memorial services, she composed Easter vigil songs and extended the *Canon for the Departed* to 32 parts honoring martyrs. Her work continued in retirement to Kasos, an island east of Crete.

For defending female worth and liturgical reverence to holy statues and relics, Kassia received letters of support. She achieved sainthood and annual commemoration on the first Sunday in Lent. During the modernizing of Byzantine worship manuals at the Studios monastery in Avrupa, Turkey, editors carefully preserved her contribution of 23 hymns to Western hymnography, such as "We Praise Your Great Mercy, Oh Christ," "Edessa Rejoices," "Using the Apostate Tyrant as His Tool," and "Now the Voice of Isaiah the Prophet." She honored a Syrian venerable tortured and beheaded in the third century with the female-centered "Christina, the Martyr, Holding the Cross."

Source

Gador-Whyte, Sarah, and Andrew Mellas. *Hymns, Homilies and Hermeneutics in Byzantium.* Leiden: Brill, 2020.
Sherry, Kurt. *Kassia the Nun in Context.* Piscataway, NJ: Gorgias Press, 2013.
Silvas, Anna Margaret. *Kassia the Nun c. 810–c. 865: An Appreciation.* Farnham, UK: Ashgate, 2006.

4

Middle Ages

Mahendradatta (961–1011 CE)
chanter
Bali

During the turbulent classical era in Hindu-Indonesian history, Balinese queen Mahendradatta earned a reputation for traditional chant. A granddaughter of King Mpu Sindok of Mataram, the daughter of King Makutawangsawarddhana, and princess of the Isyana Dynasty, she was named Gunapriya Dharmapatni (Virtuous Godmother) at birth in Kediri, East Java, in 961 in the declining years of the Medang Kingdom. Because of volcanic activity in Mount Bromo at Malang, in the late 900s, worship syncretized reverence for Buddha with adoration of deified ancestors and the Indian Siva, a divinity of destruction, resurrection, sacred monarchs, and ghosts. Instability caused people to monitor closely the blessings and curses that attached to the royal family. After 909, they synthesized a unifying ritual and national myth explaining the existence of Mount Marapi (also Merapi, Fire Mountain), Indonesia's most explosive stratovolcano.

As recorded on the Pucangan Inscription on the Calcutta Stone, a royal biography inscribed in ancient Javanese in 1041, Mahendradatta and older brother Dharmawangsa lived in the Watugaluh palace, which their grandfather Sindok located at Jombang on the Brantas River in 943. Pledged in 988, Mahendradatta, then age 27, entered an arranged marriage to Udayana of Bali (963–1001), an introit to the island's golden age. She gained attention for elegance and refinement. Citizens celebrated the birth of her first son in 991 by erecting a temple at Jolotundo near a healing spring on Mount Penanggungan in northeastern Bali. Her brother, who advanced to the Medang throne in 990, ruled for 26 years, after which Sumatran enemies vandalized and burned the family palace and destroyed the capital city of Watugaluh.

MAHENDRADATTA IN POWER

The product of superstition and xenophobia, stories of evil workings linked Mahendradatta with Durga's sacred female power. She bore three future kings— Airlangga (or Erlangga, 991–1052), Marakata (1022–1049), and Anak Wangcu (1050– 1078)—although scandal rumored that Airlangga was the child of a divorce when his

mother settled at Bali as queen regent. In 1045, her grandsons Janggala and Kediri ruled separate realms. She groomed Airlangga for kingship and patronage of the arts and chose to complete his preparation in Java under his uncle Dharmawangsa. Because she fostered the Durga (fortress) cult, which propitiated a Hindu mother goddess of war and destruction of demons, she influenced Bali to import Javanese philosophy and styles. Temple art favored Durga's feminine form and unconquerable eight arms, each brandishing a weapon.

The queen earned a reputation for religious devotion, preference for the Old Javanese language, and wisdom in introducing to the Balinese a liturgy of Hindu and Buddhist tantric mantras (chants or invocations). Inscriptions from 989 to 1001 listed her name above that of Udayana, another reason for the islanders to suspect the foreign queen's intent. To stem conflict, around 1001, she and the king attempted a fusion of sectarian powers at a religious summit held in the Pura Samuan Tiga Temple complex at Bedulu in southeastern Bali. Udayana's twelve-year reign ended in 1007 with either death in battle or separation from Mahendradatta after he violated their marriage contract and wed a second wife.

VENGEANCE VS. SACRED INVOCATIONS

According to the thirteenth-century *Calon Arang* manuscript, at the downfall of the Javanese-Balinese union, Udayana cited the practice of magic as reason for repudiating the queen, who awed the court with her incantations to Durga. In widowhood, she called on the mother avenger to curse Balinese officials for Udayana's misjudgment of her recitations and for political attempts to discredit her rule with charges of sorcery. In Balinese myth and storytelling, her imprecations against patriarchy and misogyny caused her to take on the persona of Rangda, the mythic child-eating widow.

After Airlangga exiled Mahendradatta and daughter Ratna Menggali to the forest, the ousted queen received well-wishers and students of magic rituals. Tattered and unkempt, she summoned jungle demons to bring a tsunami, famine, and epidemic on Bali and recompense against her eldest son for betrayal. Half the population died. The catastrophe survives in Indonesian culture in shadow puppetry. The sacred Barong Dance turned the tale into a masked theatrical accompanied by the gamelan orchestra of percussion, bamboo flute, and xylophones to dramatize Mahendradatta's witchy necromancy. At the queen's death in 1011 at age fifty, she attained duality with Durga at the Gunung funerary shrine on Mount Kawi overlooking the Pakerisan River in east central Bali. Following her cremation at the Pura Bukit Dharma Durga Kutri temple at Buruan, Blahbatu, in southeastern Bali, a focal statue embodied her grandeur.

Source

Amazzone, Laura. *Goddess Durga and Sacred Female Power*. Lanham, MD: Hamilton Books, 2010.

Christie, Jan Wissman. "Under the Volcano: Stabilizing the Early Javanese State in an Unstable Environment," *Environment, Trade, and Society in Southeast Asia.* Leyden: Brill, 2015, 46–61.

Kinney, Ann R. *Worshiping Siva and Buddha: The Temple Art of East Java.* Honolulu: University of Hawaii Press, 2003.

Weiss, Sarah. "Rangda and the Goddess Durga in Bali," *Fieldwork in Religion* 12:1 (2017): 50–77.

Murasaki Shikibu (973–1031)
novelist, poet, diarist
Japan

One of the world's first novelists, court lady-in-waiting Murasaki Shikibu earned fame in 1010 at the height of Japan's late classical Heian period. Originally named Fujiwara no Kaoriko (or Takako), she was born in 973 at Heian-Kyo (modern Kyoto) to an aristocratic clan that claimed as grandfather Masarada and uncle Tameyori, both poets, and great-grandfather Fujiwara no Kanesuke, a classic *waka* poet of five-line verses composed of thirty-one syllables. Her learned father, college-educated poet Fujiwara no Tametoki, a mid-rank bureaucrat with the ritual ministry, tutored Crown Prince Morosada. He encouraged his daughter's love of language and regretted that she was more scholarly than her brother Nobunori. After his wife's death, he remarried and produced another family.

The novelist lived on Teramachi Street with a sister, brother, and three half-siblings and studied calligraphy, music, and Asian poetry with the males. Fluent in classical Chinese and Japanese, in her late teens, she may have flirted with Fujiwara no Michinaga, the statesman who dominated court functions and admired her erudition. Still unwed in her twenties, she accompanied her unemployed father in 996 to a governor's post in coastal Echizen Province. She married a cousin in his forties, Fujiwara no Nobutaka, around 998 and bore a daughter, Kenshi, the next year. Her husband died in 1001 during a cholera epidemic. Their daughter became the noted poet Daini no Sanmi.

Purposeful Writing

In an era when the Japanese evolved a written language, Murasaki Shikibu may have used as a relief from grief and ennui the personal verse of *Poetic Memoirs, The Diary of Lady Murasaki,* Buddhist aphorism, and fiction writing in the *kana* script. Her poems gravitated toward romantic melancholy, separation, and lasting memories, often ensconced in dew, rain, falling leaves, wild birds, and icy frost. Her journal revealed, "The thought of my continuing loneliness was unbearable" and that she "[found] solace for my idleness in foolish words.... I was tasting the bitterness of life to the very full" (Murasaki, 1985, 33–34). Her diary recorded the influence of Sei Shonagon, the author of the miscellany *The Pillow Book* around 1002, who varied styles with anecdotes, lists, essays, and verse. Because of Sei Shonagon's pretensions of intellectualism and wit, Murasaki Shikibu denigrated

her rival's work as ostentatious and artificial. In envy of Murasaki's sedate manners and refined education, a jealous court lady named her "The Lady of the Chronicles."

At age thirty-two, along with poet and letter writer Izumi Shikibu and poet-historian Akazome Emon, Murasaki Shikibu joined the staff of sixteen-year-old future empress Shoshi at the Heian Palace. As the girl's companion and tutor, Murasaki Shikibu surreptitiously taught her Chinese, a language thought suitable only for businessmen. *The Diary of Lady Murasaki* followed no timeline, but grouped vignettes with *précis*, Buddhist ritual, and a long letter. The action summarized Shoshi's pregnancy with her first son, Prince Atsuhira-shinno, who lived to age twenty-seven and died on May 15, 1036.

Completing an Epic Saga

An unfulfilling existence in elite court society offered Murasaki themes, costumes, feasting, and situations for her writing as well as opportunities for satire. She and Shoshi retreated to Ishiyama-dera, a Shingon temple a few miles east at Otsu on Lake Biwa, where she began the epic novel in August 1004 in her late thirties. Involved in esoteric Buddhism that spread from India to Japan and China through meditation, gestures, and mystic rituals, she remained apart from the Kyoto court from 1011 and welcomed a granddaughter in 1026. She appears to have died in 1031 at age fifty-eight.

Around 1010, Japanese readers heaped fame on *The Tale of Genji*, a three-part *monogatari* (epic saga) distributed chapter by chapter to friends and to calligraphers for transcription. The anti-hero, Prince Kaoru Genji, a motherless boy and widower, contributed to the author's views on status rivalries and exile as a punishment and enhanced her parodies of drunken, loutish, amoral courtiers. Like the male Chinese court novelist Cao Xueqin, author of *The Dream of the Red Chamber*, Murasaki Shikibu's text contains interconnected events played out by some four hundred characters, both titled and peasant. The author completed the work in 1021, when publishers gave it the *orihon* (accordion) shape rather than the traditional scroll. Literary historians have suggested that daughter Daini no Sanmi helped write the last ten chapters of the epic saga, a landmark of Heian literary achievement.

See also Abutsu-ni.

Source

Burge, Marjorie. "The Tale of Genji: A Japanese Classic Illuminated," *Japanese Language and Literature* 55:1 (2021): 383–390.

Khabibulina, Alfiya Ildarovana. "The Role and Place of Nature in the Novel of Murasaki Shikibu 'Genji Monogatari,'" *Journal of Central Asian Social Studies*, 2:2 (2021): 46–56.

Murasaki Shikibu. *Murasaki Shikibu: Her Diary and Poetic Memoirs*. Princeton, NJ: Princeton University Press, 1985.

_____. *The Tale of Genji*. New York: W.W. Norton, 2016.

Komnena, Anna (December 1, 1083–1153)
biographer, epicist, historian
Byzantium

The war correspondent of medieval Constantinople (now Istanbul), Anna Komnena (also Comnena or Komnene) was the world's first female historian and an advocate of women's learning. In the only medieval biography compiled by a woman, she lauded her father, Emperor Alexios I Komnenos, with an epic, the Alexiad, a major source of Byzantine and crusader history during the Komnenian dynasty. Firstborn to seventeen-year-old Empress Irene Doukaina in the Porphyria Room of the imperial palace on December 1, 1083, the author was literally born to the purple and readied herself for monarchy by studying Aristotle under scholar Michael of Ephesus. She looked to her paternal grandmother, Anna Dalassene, for a model of probity, altruism, and sage oratory. The princess admired her mother's posture and grace and her parents' loving relationship, which produced five daughters and four sons. In return, Irene supported Anna and son-in-law, Caesar Nikephoros Bryennois, as heirs to the throne.

With family encouragement, Anna Komnena anticipated succeeding her father on the Byzantine throne until the birth of brother John in 1087. More siblings followed: Maria, Isaac, Evdokia, Andronikos, Theodora, Manuel, and Zoe. During seven years of fostering by Maria of Alania, Georgia, she received a thorough grounding in language and literature, philosophy, theology, history, science, and math. Her intellect proved equal to the management of a 1,000-bed hospital and orphanage and to classroom teaching in medicine. In 1097 at age fourteen, she married Nikephoros, whom she described as handsome, smart, and well-spoken. From 1102–1107, she bore four sons and two daughters—Alexios Komnenos, John Doukas, Andronikos, Constantine, Irene Doukaina, and Maria Bryennaina Komnene. Of the six, Maria, Andronikos, and Constantine died in childhood.

INTO THE FRAY

With her husband's approval, the historian continued to develop scholarly pursuits and strengthen the House of Komnenos. After the emperor's death on August 15, 1118, rumors of plots and conspiracies against the crown prince, John II, marred the family's reputation for unity. At forced retirement with the empress to the Theotokos Kecharitomene Monastery in the north end of the capital, the princess received the ministrations of twenty-four nuns funded by her mother. Widowed in 1137, at age fifty-five, she completed her husband's Byzantine chronicle in Athenian Greek in which she aimed "to lament the events that befell the Emperor" (Komnena, 1969, 419). In Homeric and Virgilian style, she entitled it the Alexiad, literally "sons of Alexis." Her high epic writing style mirrored that of Greek authors Polybius, Herodotus, Thucydides, and Xenophon. She included praise for the Christian evangelist Paul and sorrow at the loss of her parents and husband. At her father's death, she

reported in the prologue, "Dizziness overwhelms my soul, and tears blind my eyes. Oh! what a counsellor the Roman empire has lost" (*ibid.*, 4).

Essential to the author's fame, the fifteen-volume history opens with an understanding of the chronicler's tenuous position:

> He who undertakes the "role" of an historian must sink his personal likes and dislikes, and often award the highest praise to his enemies when their actions demand it, and often, too, blame his nearest relations if their errors require it [*ibid.*, 2].

She offers confidential views of palace intrigues and the only Byzantine eyewitness account of the First Crusade (1094–1097), which she fleshed out with events from retirees in monasteries who composed war memoirs. The text depicted Alexios's quandary during the Turkish invasions, when Pope Urban II dispatched hard-handed Frankish and Norman warriors to the capital.

Composed in the scriptorium, the biographer's images gave immediacy to siege engines and combat strategy and particulars of leaders Godfrey, Count of Bouillon, the future king of Jerusalem, and Norman general Robert Guiscard, who captained a fleet to Brindisi, Italy, and on to Illyria. Particularly caustic in describing Bohemond I, Guiscard's younger son, she typifies him as bitter, erratic, and "untamable"—an oversized scrapper whom she portrayed at the October 1097 siege of Antioch as a wicked brute (*ibid.*, 37, 278). Of the Frankish contingent, she generalized that the undisciplined force lacked sanity and control. In contrast, Alexios focused on achievable goals—despoiling small towns, collecting prisoners and loot, and returning victorious to Constantinople, leaving Count Baldwin, Godfrey's brother, to mop up the remaining Arabs, Armenians, Babylonians, and Saracen Turks.

A FALLEN EMPEROR

In the falling action of the Alexiad, Anna Komnena surveys the centrality of charity to Christians. She decried widowing and the "bitter evil of orphanhood," which the emperor alleviated by selecting worthy parents and demanding education for the children (*ibid.*, 409). He financed grammar schools and colleges and built a neighborhood near the Acropolis in Athens for the poor, crippled, and blind and supplied "everything for his food and shelter from the imperial hand" (*ibid.*). "Vexed" at heresy, Alexios completed his good deeds by demanding a massive pyre in the Hippodrome for the immolation of a villainous monk, Basil, the unrepentant Bogomil who "spued out the dogmas of his heresy" (*ibid.*, 136, 413). The emperor completed suppression of the "pernicious sect" by imprisoning Basil's disciples and mystics (*ibid.*, 418).

Looking over the Eastern Roman Empire, Anna Komnena ventured into diagnoses of her parents and an overwrought response to their demise. In the last paragraphs of her epic, the emperor explained to his "dearest soul" how asthma weighed

like a "very heavy stone … lying on my heart" (*ibid.*, 420). Aesclepian physicians diagnosed stress, but could not alleviate the pain and edema with bleeding, cautery, or diet. She insisted on honoring him with a noble biography because "matters of such importance should not be left unattested for future generations" (*ibid.*, 1). According to her obituary by scholarly bishop George Tornikes, the epicist died in 1153, leaving Constantinople before a chaotic sacking by mercenaries and clergy eager to pillage the city's wealth.

Source

Gouma-Peterson, Thalia, ed. *Anna Komnene and Her Times*. London: Routledge: 2000.

Kolovou, Ioulia. *Anna Komnene and the Alexiad: The Byzantine Princess and the First Crusade*. Yorkshire, UK: Pen & Sword History, 2020.

Komnena, Anna. *The Alexiad*. New York: Penguin, 1969.

Neville, Leonore. *Anna Komnene: The Life and Work of a Medieval Historian*. Oxford, UK: Oxford University Press, 2018.

Iso no Zenji (fl. 1160s–1170s)
singer, dancer, costumer
Japan

Shizuka-Gozen (1168–June 15, 1189)
court dancer, drummer
Japan

"Lady Shizuka" Gozen of Aminochō north of Kobe survives in a Japanese history, *Azuma Kagami* (Mirror of the East), and in literary cycles as a teenage *shirabyoshi* (white rhythm performer), a medieval court dancer capable of entrancing powers. One of the seven princesses of Tango province north of Kyoto, she became a martyr to love, jealousy, and civil conflict. She was the daughter of dancer Iso no Zenji, originator of shirabyoshi performances and singer of the song "Sukimono no Shosho" (The Amorous Lesser). The mother taught Shizuka Gozen traditional movements and costuming and booked performers for court dates. In the Heian era, Shizuka Gozen outpaced her mother by gaining a reputation as the most beautiful female and mesmerizing dancer of her time.

During public staging, Shizuka Gozen developed passion for Minamoto no Yoshitsune, a Japanese samurai (warrior) and musician, who took the seventeen-year-old dancer as his mistress. His brother, Shogun Yoritomo, conspired to unseat the ruler Kiyomori Taira and usurp his throne. Rather than fight his own battles, the shogun dispatched his brother to slaughter the Taira clan. At the sea battle of Dannoura north of Kyushu on March 25, 1185, during the five-year Genpei War, the enemy changed from archery to boarding crews and hand-to-hand combat on the Inland Sea. The successful battle defeated the Tairas, causing them to commit suicide at the Byodo-in (Temple of Eternity) near Kyoto. Replacing the former gold

and silver moon flag, the first red and white Japanese sun flag celebrated the samurai victory in the Land of the Rising Sun.

Devoted Love

At the wish of emperor Go-Shirakawa, at the beginning of the Kamakura era, Yoshitsune, Japan's admired commander, seized the shogunate and quelled imperial control with rising samurai power. The plotter Yoritomo mustered soldiers against his swordsman brother, who fled to Tokyo. When Shizuka-Gozen tracked her lover through the deep snow at Mount Yoshina, he urged her to stay out of range of assassins, who might murder her and their unborn child if it were male. Iso no Zenji prayed to Buddha to transform the fetus into a female. On December 18, 1185, monks from Zaodo rescued Shizuka from snowy woods and transported her to Kamakura southwest of Yokohama. Yoritomo had her arrested and incarcerated on March 30, 1186, and interrogated along with her mother, who danced before the ruling family. His men abducted Shizuka-Gozen to court, where, on May 5, 1186, the shogun commanded her to perform in the traditional Japanese style.

At the Tsurugaoka Hachiman Shinto Shrine, the pregnant dancer, perhaps at her mother's insistence, appeared in a white or plain uniform of loose pleated trousers, cap and apron, a long sword at the waist, floor-length hair, and white facial makeup while gesturing with a folding fan. As she performed to drum and flute, she set adagio steps to a modern, easy tune valorizing the general for his courage and yearning to reunite with him. Her headdress slipped to the floor, causing an ill omen. Yoritomo raged at his brother's lover and condemned her to death. The shogun's wife, Hojo Masako, calmed his anger and interceded to save the court dancer and her unborn child.

Long-lived Tragedy

Shizuka-Gozen gained a repeal at age eighteen. On September 21, 1186, she bore a son and passed him to his grandmother for safekeeping. Yoritomo ordered her infant boy dashed against a rock and his remains hurled into the ocean at Yuigahama beach. The dancer pursued her lover once more until she learned that Yoritomo killed him in combat in 1189. His beheading left evidence for sanctifying at a Shinto shrine in Fujisawa. In grief, she tonsured her hair and joined a Buddhist convent near Kyoto as the "Priestess of Tamayori." In her third month of service as a nun, Yoritomo had her killed. She died on June 15, 1189, at age twenty-one with Yoshitsune's name on her lips. A less vengeful account of her death described her suicide by drowning in the Himekawa River at Otobe, Hokkaido.

Legendary shrines sprang up in the 1300s honoring the lovers and their dead son, notably, a hometown landmark in Aminocho in northern Kyoto. Along with

string puppet plays, woodcuts, video games, manga comics, parades, and Kabuki, a stylized dance-drama, Shizuka-Goven's story recurred in the Noh play *Funa Benkei* (Benkei in a Boat) and the five-act bunraku puppet drama *Yoshisune Senbon Sakura* (Yoshitsune and the Thousand Cherry Trees), in which the dancer plays a ceremonial drum. The plot inspired the national classic *Heike Monogatari* (The Tale of Heike) and the conventional war episodes of *Gikeiki* (The Chronicle of Yoshitsune). In the latter, after ninety-nine dancers at the Shinsen-en Garden at Kyoto failed to bring rain, Shizuka-Gozen performed for the retired emperor Go-Shirakawa to ward off a three-month drought.

Source

Morris, Ivan I. *The Nobility of Failure: Tragic Heroes in the History of Japan*. New York: Holt, Rinehart and Winston, 1975.

Oyler, Elizabeth. "Tonsuring the Performer: Image, Text, and Narrative in the Ballad-Drama Shizuka," *Japanese Journal of Religious Studies* 36:2 (2009): 295–317.

Strippoli, Roberta. *Dancer, Nun, Ghost, Goddess: The Legend of Giō and Hotoke in Japanese Literature, Theater, Visual Arts, and Cultural Heritage*. Leiden: Brill, 2017.

Waterhouse, David. "Woodcut Prints by Suzuki Harunobu as a Source for the History of Japanese Dance," *The World of Music* 30:3 (1988): 85–107.

Yokota, Gerry. "Archetypal Literacy for Intercultural Communication: From Noh to Anime and Beyond," *Rhetoric, Metaphor, Discourse: Language and Culture*. Osaka: Osaka University, 2018.

Abutsu-ni (1222–1283)
diarist, poet, letter writer, autobiographer, travel writer, essayist, editor
Japan

A medieval writer of travelogue, verse, and letters, Abutsu-ni combined literary genres for her famous diary, *Izayoi Nikki* (Dairy of the Waning Moon). The stepdaughter of Taira no Norischige, governor of Sado Island, west of Niigata, Japan, she and her two sisters lost their father, a Kyoto native, in infancy. They gained a stepfather when their mother wed the governor. Abutsu-ni grew up in the capital, Sado City. Because her mother died, the child entered the care of a wet-nurse, who later appeared in Abutsu-ni's twelve-page prose autobiography *Utatane* (Fitful Slumbers), a lament for failed love to an elitist male begun around 1240.

The remainder of Abutu-ni's life grappled with introspection, insecurity, and scholarship, a dominant theme in her 800 poems and *Utatane*. To relieve a bitter obsession with a married nobleman, she worshipped at the Uzumasa temple, a landmark northwest of Kyoto. The failed affair with the aristocrat caused her to shelter temporarily in a nunnery to heal body and spirit. She returned by way of the salt beds of Narumi Bay to the governor's country villa at Totomi. She based *Utatane* on ethereal descriptions of her journey to the Pacific shore and an inability to escape yearning for an unattainable love.

PROFESSIONAL BEGINNINGS

In her twenties, some years after the golden age of court pageantry, the writer served the future Empress Ankamon-in as lady-in-waiting at a women's literary salon in Kitayama southeast of Osaka. Another lover sired daughter Ki Naishi and sons Ajari and Rishi, future Buddhist priests. In 1250, Abutsu-ni retreated to the aid of Abbess Jizen at the convent at Hokkeji, Nara, in south central Japan, who assigned the nun to court poet and tutor Fujiwara no Tameie. At age twenty-eight at Tameie's villa at Ogura south of Tokyo, while editing the world's first novel *The Tale of Genji*, written by Heian poet Murasaki Shikibu of Kyoto around 1021, Abutsu-ni acquired an outdated vocabulary replete with medieval concepts. By 1260, she gained prominence as a lecturer on Shikibu's canon.

As second wife, Abutsu-ni wed Fujiwara no Tameie, a fifty-two-year-old anthologist. Their sons, Jogaku, Tamesuke and Tamenori, born in 1258, 1263, and 1265, rose to court positions. The union provoked animosity with Tameie's oldest son Tameuji and enhanced arrogance in the author, who aided her husband's work and demanded academic respect. She gained a reputation for verse, encompassing prayers at ten shrines and "Abutsu Kana Fuju (Abutsu's Recitation at Kana)," a threnody at Tameie's demise at the northern woods of Hokurin, Jimyoin. She instructed her daughter on court courtesy in the essay "Menoto no Fumi (A Nurse's Letter)" and, in 1279, advised writers on updating composition with realism in "Yoru no Tsuru (The Night Crane)," an epistolary treatise. In the text, she established her literary acumen by citing classic medieval verse by two Japanese women, eleventh-century *waka* specialists Koshikibu no Naishi and Suō no Naishi. The uplifting atmosphere of the journal *Izayoi Nikki* and her pilgrimage to Mount Miyaji suggest that maturity and objectivity replaced an earlier fretfulness at her first lover's inconstancy.

LASTING FAME

Abutsu's verse first appeared in the twenty-volume anthology *Shokukokin Wakashū* (Collection of Ancient and Modern Times Continued), which her husband edited for former emperor Go-Saga in 1265. A private fourteenth-century compilation, *Fuga Wakashu* (Collection of Elegance), incorporated fifty-nine of her poems. In 1312, another twenty-volume tome, *Gyokuyō Wakashū* (Collection of Jeweled Leaves), of waka poems composed by line counts varying from five to seven syllables received imperial approval by Emperor Hanazono.

Widowed at age fifty-three and endowed with moral outrage, in 1275, the poet traveled on foot to a Buddhist convent. She adopted the name Abutsu-ni (Abutsu the Nun) and shaved her head for the ritual tonsure. She devoted herself to building temples, restructuring worship ritual, and educating her children. An inheritance tangle forced her to present holographs from Tameie at the military court bequeathing their son Tamesuke a steward's rights to the Hosakawa estate in Harima north

of Kobe and control of Japan's national literature. Over two weeks in winter 1279, she journeyed five hundred miles inland past Mount Miyaji once more to friends' homes in the piney woods of Hamamatsu before reaching Kamakura. On the shore, she wrote letters to her older sister's little boys and sent beach combings to her younger sister.

At a court devoted to armies rather than lyric verses about ocean tides, Abutsu-ni launched a notorious legal battle by petitioning Emperor Yohito and the shogun, Prince Koreyasu, to examine the signed documents. A second Mongol invasion at Hakata Bay caused a seven-year wait for a verdict. She suffered recurrent fever and died in 1283 at age sixty-one. The inheritance plea for land received a negative vote in 1286, but poet Tamesuke attained rights to family ownership of valuable Japanese scrolls.

Source

Abutsu-ni. "Fitful Slumbers," *Monumenta Nipponica* 43:4 (winter, 1988): 399–416.

Esteban, Eric. "The Night Crane: Nun Abutsu's Yoru no Tsuru," *Japan Studies Review* 19 (2015): 135–166.

Laffin, Christina. *Rewriting Medieval Japanese Women: Politics, Personality and Literary Production in the Life of Nun Abutsu*. Honolulu: University of Hawaii Press, 2013.

Miner, Earl. *An Introduction to Japanese Court Poetry*. Stanford, CA: Stanford University Press, 1968.

Wallace, John R. "Fitful Slumbers: Nun Abutsu's Utatane," *Monumenta Nipponica* 43:4 (Winter, 1988): 391–398.

5

Renaissance

Insu, Queen (October 7, 1437–May 11, 1504)
textbook writer, moralist, aphorist
Korea

In the late middle ages, the writer of a textbook on personal conduct, Queen Insu, became Korea's first female author and a pioneering champion of education for women of all classes. An aristocrat at birth in Hanseong (Seoul) on October 7, 1437, she was the sixth daughter of the nine children of Lady Namyang Hong and Han Hwak, a court counselor and diplomat. Additional respect derived from her uncle, the Yongle Emperor Zhu Di, an advocate of Chinese culture. Reared a devout Buddhist, she received the name Crown Princess Han Jeong, an indication of her position in the prominent Han clan during the Joseon dynasty. After she married Crown Prince Uigyeong, the grandson of Sejong the Great, around age fifteen, from 1454 to 1457, she bore sons Wolsan and Seongjong and daughter Myeongsuk. Her filial responsibility earned high praise from her father-in-law, King Sejo, a usurper of the throne.

In the realm of studies usually limited to men, Queen Insu became fluent in Chinese, Korean, and Sanskrit, possibly through studying with her brothers and their tutors. Throughout a period of court turmoil called the First Literati Purge, she read Buddhist holy books and classic biographies of outstanding Chinese women. Within months of her father's death, she was widowed at age nineteen on September 2, 1457, reputedly after Uigyeong saw the ghost of a dead queen and collapsed. The loss left Queen Insu with two toddlers and a two-week-old infant. After 1469, she ruled for eight years as co-regent with her mother-in-law, Queen Jeonghui.

UPLIFTING KOREAN WOMEN

To guide females in politesse and right thinking, in 1475, queen mother Insu compiled in vernacular Korean a national treasure, *Naehun* (Instructions for Women). At a time when her son, King Seongjong, popularized neo–Confucian morality, she drew examples from a 1407 Chinese handbook by Ming Empress Hsu, who based her work on a Buddhist sutra (scripture). Insu's interpretation set a precedent for didactic commentary on gender expectations and on male-female relations

throughout the Joseon state. She prefaced the three-volume text with the importance of training girls in chastity and judgment, beginning home training at age six, memory work in Confucianism the next year, and a seven-year program of studies embarked on at age eight. For paradigms of self-perfection, she chose exemplary royal Chinese consorts listed in Confucian primers.

The first to pose gendered concerns about Confucian philosophy, Queen Insu carefully organized her thinking on the courtesies and ethos of admirable Koreans. She urged the prudent to "Inscribe these teachings in your heart, engrave them on your bones and strive every day to follow the sages" (Kim-Renaud, 2004, 31). The first volume instructed readers, whether male or female, to reverence matrimony, the institutional basis of the state. The guidebook outlined prim boundaries of public intimacy: "Men and women should not sit together; they should not hang their clothes together; they should not use the same washcloth or comb; and they should not be familiar with each other" (*ibid.*, 38).

Specifics urged women to set an example for men through worthwhile conversation and forgiveness of slight wrongs. She detailed proper demeanor, especially not filling the mouth with food or slurping, coughing, hiccupping, sighing, sneezing, or yawning in the presence of in-laws. The second volume focused on the domestic relationship as it applied to wives. She pictured the married woman coordinating food, drink, and wardrobe and serving husbands in meaningful, but discreet roles as advisers and confidants. She stressed, "Looking at the superior men of today, all they know is that they must lead their wives and not lose their dignity" (*ibid.*, 39). The last volume espoused thrift, honesty, and a cheery harmony, a responsibility of women as mothers and citizens.

A View of Womanhood

Aimed at the *neap'yon* (inner sphere or consciousness), Queen Insu's commentary noted the basic goodness of humankind, but recorded female deficiencies of materialism and weak will. She lauded men for inborn rectitude and scolded women for pottering about with the quality of embroidery floss rather than informing themselves on urgent needs for uprightness and decorum. Because learning improved and empowered all women, from peasant housewives and weaving girls to royal concubines, it edified their morals and prepared them for the supportive roles of consort or wife, mother, and daughter-in-law. The instructive character of *Naehun* made it popular among the era's readers of the original and seven subsequent editions. Preliterate females trained themselves in Queen Insu's precepts by memorizing and reciting her exhortations as aphorisms on soft speech and demure etiquette. A barnyard example warned aggressive women, "Never be like the hen that crows at dawn and brings disaster" (*ibid.*, 43).

At Queen Insu's rise in influence to mother of the nation, her contemporaries valued her for broadening expectations for female steadfastness and agency in the

home and society. The Changyeong Palace, rebuilt in north central Seoul in 1483 with main gate, throne room, and bridge, honored her royal position as mother of King Seongjong. During her son's reign, in 1492, she supported reverence for Buddhism and protested elitism in the rejection of commoners as candidates for monasteries. She educated her five grandsons in Buddhist and Confucian tenets of wisdom and righteousness that she recited from memory.

The accession of grandson Yeonsangun to the throne on January 20, 1494, earned her the title Queen Sohye, Grand Queen Dowager of Joseon. Yeonsangun, an infamous despot and sybarite, attacked his grandmother, who died in the palace on May 11, 1504, at age sixty-seven. At the Gyeongneung Royal Tomb, the queen's compound and ringed mound outranked her husband's honors. In 2020, the queen's great niece, South Korean author and musician Terra Han, a 38-year-old master of the sitar, *shamisen, koto,* and *kayageum* (autoharp or plucked zither), translated the *Naehun* into English.

Source

Haboush, JaHyun Kim. *Women and Confucian Cultures in Pre-modern China, Korea, and Japan.* Berkeley: University of California Press, 2003.
Han, Hee-sook. "Women's Life during the Choson Dynasty," *International Journal of Korean History* 6 (December 2004): 113–161.
Kim-Renaud, Young-Key. *Creative Women of Korea: The Fifteenth Through the Twentieth Centuries.* New York: Routledge, 2004.

Mirabai (1498–1546)
poet, hymnographer, tanpurist
India

During an era of religious conflict and female suppression by superior Brahmins and Sanskrit experts, Princess Mirabai (also Meera, Meera Bai, or Mira) evolved from mystic dialect poet to controversial seer and saint of the vernacular. A native of Rajasthan on the eastern border of modern Pakistan, she was born at Kutki, Jodhpur, in northwestern India around 1498, contemporary with the arrival of Portuguese trader Vasco da Gama. Her great grandfather, clan chief Rao Jodha ji Rathore of Mandore to the north, founded Jodhpur and built the Mehrangarh Fort, a seven-gated stronghold consisting of five palaces. Her father, Ratan Singh, flourished as a clan warrior under Shah Jahan, the fifth Mughal Emperor.

At age three, Mirabai acquired a Krishna icon from the poet-activist Ravidas of Varanasi, a teacher and social reformer in the Punjab. All her life, she treasured the token as "The Dark Dweller," an everlasting symbol of indestructibility and deathlessness mentioned in her poem "Unbreakable." In "Torn in Shreds" and "Your Slander Is Sweet," she viewed the deity as mountain sustainer, king, and multiple kindred—husband, parent, brother, relative. She later described her *bhakti* (frenzy) for the supreme god in "I Am Mad," "Sleep," "Don't Go, Don't Go," and "I Send Letters." The lines of her most intuitive manifesto state, "In bhakti I was joyful, in the

world I wept" (Levi, 1997, xvii). "Keep Your Promise" compared a manic amorous mental state to shipwreck. For "In a Sudden," she became too god-crazed to stir the housewife's curd pot. "The Plums Tasted" pictured her swept away by the chariot of rapture, which she described in "We Do Not" as an element of transmigration of souls, a Hindu tenet of reincarnation.

WORLDLINESS AND LIBERATION

While growing up at Merta in the feudal kingdom of Marwar, Mirabai's legend placed her among minor Rajput royalty. At her mother's death in 1502, she lived with her grandparents, Rao Dudaji and Raghav Kanwas Shekhawat, and escaped household scrutiny by tying saris into a rope for climbing out the widow to visit a holy untouchable. Wed by arranged betrothal to Prince Bhoj Raj Singh Sisodia, heir apparent of Mewar, one of the world's oldest dynasties, after 1516, she demoted him to a platonic companion and engrossed her being in holy ardor. She bore no children and, as stated in the poem "Do Not Leave Me Alone," pledged herself to the joys of Krishna, her holy lover and mate. She meditated, composed *bhajans* (prayerful hymns) in the Braja dialect, and wrote mystic and sensuous *raga* (improvisational melodies) and verses on spiritual fervor and martyrdom. Stanzas stated longing to sacrifice her *atman* (soul) and sink into the *paramatman* or universal soul of Krishna, the dark lord and focus of "The Dagger," "I Have Found," and "Strange Is the Path of Love."

Clacking castanets, vibrating ankle bells, and dressing in holy garments inappropriate for a princess, Mirabai danced ecstatically in public for the delight of commoners, who embraced her manifestations of persecution and yearning. Some revered her as an embodiment of Radha, Krishna's holy consort. Her unescorted travels stoked rumors of infidelity. She miraculously survived assassination attempts by snake and liquid poison, the subject of "Nothing Is Really Mine." Mirabai's husband shielded her from complaints of in-laws—his parents Rani Dhan Kunwar and Rana Sangram Singh I and sister Udabai of Chittorgarh—all devotees of the war deity Durga and of Kali, a destructive goddess. Prince Bhoj indulged Mirabai by adding a Krishna temple to the royal compound at Chittorgarh fort, where a statue pictures her plucking the long-necked *tanpura* or *veena,* a monotone lute or stick zither dating to 1000 BCE.

THE ETERNAL SONGSTRESS

At age twenty, Mirabai entered widowhood after the prince died of war wounds incurred in 1518 against the Islamic Delhi Sultanate. Rather than burn herself in a voluntary ritual of *sati* (self-immolation) on the prince's funeral pyre, she cut her hair, replaced her jewels with wildflowers, and became a nomadic *sanyasi* (mendicant pilgrim) over northern India. She sought Hindu teachings at Vrindavan, the

birthplace of Krishna in north central India. At temples, she taught others about the god through original songs and some 1,300 praise anthems. After the deaths of her father and father-in-law at the Battle of Khanwa in 1527, her brother-in-law, Maharana Ratan Singh II, exiled her for exhibitionism; violating the aristocratic caste; and, as viewed in "The Saffron," immodestly debating holy men. From 1531, she roamed from shrine to shrine in Chittor, Rajasthan, Gujarat, Braja, and Uttar Pradesh. She died at age forty-eight in 1546 at Dwarka, Gujarat, on the shore of the Arabian Sea, leaving behind simple *pada* (stanzas) and refrains for anthologizing in the *Padavali* (Song Collection).

The poet-saint survives in Indian oral lore as a woman of conviction and a disciple of the mentor Ravidas. Her poem "Strange Are the Decrees of Fate" contemplates the paradox of power among apostates. "Drink the Nectar" warns of sinful behaviors and urges hearers to dye themselves black, Krishna's color, a trope she repeats in "I Danced Before My Giridhara (mountain holder)." In "Mine Is Gopal (baby Krishna)" and "All I Was Doing Was Breathing," she declares herself a handmaiden surrendered to Krishna in a mystic matrimony that lifted mountains. In 1585, scripture writer Nabha Dass incorporated her biography in the *Bhaktamal* (devotee), an overview of godly residents of northern India. Another commemoration, philosopher Gobind Singh's *Prem Ambodh Pothi* (Love of the Innocent Granddaughter), issued in 1693, linked her to sacred Sikhs (disciples). Her legend of liberal Hinduism and the otherworldly passion and evangelism in "The Flute" and "Mira Has Finished with Waiting" permeates modern fiction, art, television, and Hindi and Tamil film.

Source

Alston, A.J. *The Devotional Poems of Mirabai*. Delhi: Motilal Banarsidass, 2008.
Bly, Robert, and Jane Hirshfield. *Mirabai: Ecstatics Poems*. New Delhi: Aleph Books, 2017.
Chandrakant, Kamala. *Mirabai*. Mumbai: Amar Chitra Katha, 2016.
Levi, Louise Landes. *Sweet on My Lips: The Love Poems of Mirabai*. New York: Cool Grove, 1997.
Mirabai. *Ecstatic Poems*. Boston: Beacon Press, 2009.
_____. *Phraseology*. St. Pete Beach, FL: Palm Leaf Press, 2017.

Gulbadan Begum (ca. 1523–February 7, 1603)
biographer, poet
Mughal Empire

The youngest daughter of a great warrior-king, the Emperor Babur (1483–January 5, 1530), Gulbadan Banu Begum, a descendant of Genghis Khan and Timur, flourished as a prominent scholar and the only female author of the sixteenth-century Mughal Empire. She received the name "princess lady rosebud" at birth in 1523. Two years later, Babur seized Hindustan from the Afghans and founded the Mughal Empire. Born to the Timurid dynasty in Kabul, Timur (modern Afghanistan), to Dildar Begum, one of Babur's seven wives, Gulbadan was the adoptee of Maham Begum, the head wife, who also fostered three-day-old Hindal Mirza. After the deaths of her younger children, as mother of Humayun, Maham taught

Hindal languages and astronomy. In this same period, Gulbadan learned Arabic, Persian, history, literary classics, and theology. While she lived in Kabul and India until age five with two sisters and two brothers, she amassed a scholarly library and became a devout Sunni Muslim.

Gulbadan and Maham Begum received open affection from Babur, who favored Maham's son Humayun as his heir. During his absence in combat to subdue Samarkand, a Silk Route emporium in Uzbekistan, late in 1525, after crossing the Indus River, Babur summoned the females of his family from Hindustan to Kabul. He sent dancing girls as gifts to his women along with "ruby and pearl, carnelian and diamond, emerald and turquoise, topaz and cat's eye" (Begum, 1902, 95). The women thanked God for his success on April 20, 1526, northwest of Delhi in a battle at Panipat against Ibrahim, sultan of Delhi, who died in the fray. Gulbadan made detailed note of Babur's distribution of booty from the treasuries of five kings.

Bilingual in Turkish and Persian, Gulbadan grew into a writer of *qaseeda* (odes) and a sophisticated observer of dynastic politics and households. She related family episodes and recited Persian aphorisms such as "Everything reverts to its original type,/Whether pure gold, or silver, or tin" (Gulbadan, 1902, 109). During tribal looting at Agra, Gulbadan's brother Kamran snatched her away from the other women and settled her at Lahore. By stating her case in a letter to her 22-year-old brother Humayun, the seven-year-old passed to his protection after their father died on January 5, 1530, of severe intestinal complaint from alcohol and opium abuse, an addiction he shared with his son.

After Maham's death, Gulbadan mourned at re-orphaning. She loved her squabbling brothers Kamran and Humayun, but favored the older sibling, Hindal Mirza. In her writing, she noted an indicator of the advance to womanhood— replacement of her girlish cap with a muslin coif. In 1540, at age seventeen, she wed a second cousin, Khizr Khwaja Khan of Chagatai, Moghulistan, in south central Asia. With their son Sa'adat-yar Khan, she resided at Kabul and Jui-shahi (modern Jalalabad, Afghanistan), her husband's estate.

The Mughal Chronicler

Commissioned as a storyteller by a nephew, the Emperor Akbar (1542–1605), in 1557, Gulbadan became the first Mughal female to write professionally. She moved to Akbar's residence at Agra in north central India along with older sister Gulchehara Begum, who died within the year. In vernacular Persian, Gulbadan began composing the *Humayun-Numa* (The History of Humayun), a chronicle of her father and half-brother, Emperor Humayun (1508–1556), who lived in exile in Afghanistan and Persia (Iran). Favoring subjectivity, she stressed clan connections and the resonance of power within generations.

During thirty years of woman-centered composition, Gulbadan witnessed males at hunting, banquets, verse performances, and wine and opium retreats.

However, according to Rebecca Ruth Gould, a specialist in Persian literature at the University of Birmingham, the chronicle "dwells not on battle and royal genealogies, as did its male-authored predecessors but rather on domestic scenes of birth, love, and other aspects of daily life" (Gould, 2011, 187–188). Specifics avoid boasts of sovereignty and, instead, outline a humble breakfast on March 16, 1527, of bread and mutton and sherbet with fruit, and wayside refreshment of milk, curds, and syrup. She explained that she preferred "a space within which the line between history and memory comes to be blurred and questioned" (*ibid.*, 188–189).

Although Gulbadan knew little about Babur, she extolled him as a courtly respecter of women, especially the elderly, whom he visited weekly at Agra and sheltered with architectural additions to their residences. Her father's stone chair surrounded by a pond gave him a quiet place to write a memoir. She covered his militarism, grief for Humayun's deadly fever, and, in 1526, the emperor's near-poisoning on a meal of bread, fried rabbit, and carrots. After Humayun's crowning in 1530, she tweaked hindrances on the road to Kandahar with 200 ornery pack camels, which refused to travel the Indus Valley alongside horses.

RESPECT AND GRIEF

With a controlled tone, Gulbadan's text avoided male glory and viewed events refined by the memory of generations. She revealed the nuances of Humayun's kindness to elderly aunts, his courtship with thirteen-year-old Hamidi Banu Begum, and the siring of their son Akbar the Great who extended Mughal territory across the Indian subcontinent. Susie J. Tharu, a professor at the English and Foreign Languages University at Hyderabad, and K. Lalita, women's studies director at Osmania University, stressed the female perspective: "The emperor's travels are charted through the minds of the women in his household. We watch with them from the ramparts as the men ride away to war and anxiously scan the horizon for them to return" (Tharu & Lalita, 1991, 99). On June 26, 1539, a military loss to Sher Shah Suri at the Battle of Chausa in northeastern India cost Humayun four thousand wives. Some of the harem chose to die in prison or battle against the Afghans or to drown in the river. Gulbadan revealed a bitter sibling power war with Humayun after his brother Kamran Mirza murdered their 33-year-old brother Hindal Mirza on November 20, 1551. Kamran fled in 1552 muffled in a *burqa* (woman's hood and robe). Gulbadan lamented: "O well-a-day! O well-a-day! O well-a-day! My sun is sunk behind a cloud" and remarked that Kamran's destiny never prospered (Gulbadan, 1902, 196).

The biography reported women's power to have Kamran's go-between, Begi Bibi, torn apart. Gulbadan related his punishment—blinding—for conspiracy with Afghans and for sending an assassin against the Emperor Humayun, who survived an arrow wound to the shoulder. The manuscript stopped mid-line before revealing Humayun's accidental death in a Delhi fortress after he tangled his foot in a

robe during prayers and fell against a marble step. He expired within three days from a head injury. The task completed in 1587, Gulbadan's tattered manuscript lost some chapters before its recovery in 1868 by a female Persian scholar in the British Museum. Annette Susannah Beveridge translated it into English in 1901; it appeared in 2006 in Bengali.

The Woman's View

A social observer in the Punjab, Gulbadan scrutinized the harem's strains and backbiting on Babur's wives and daughters, whom restriction forbade to name males outside the family. Guarded by eunuchs, they passed newborns to wet-nurses, spent idle time embroidering pillows, sewing tents and liners, and attempting to keep peace among the contentious brothers. When men introduced captive Hindu dancers into the enclosure, women expressed jealousy in catty remarks. On Tuesdays and Sundays, the court settled in the quadrilateral Chahar Bagh gardens at Lahore along the Ravi River, a branch of the Indus. Servants arranged tents and bamboo screens among pools and fountains according to female hierarchy, with Dildar holding third place.

In a summary of Maham Begum's Mystic Feast in spring 1533, Gulbadan drew attention to ninety-six women attending, special light in glass globes, and gambling at cards. She surveyed the 1547 New Year's festivities simultaneous with Akbar's circumcision. Her text described varied female interests, including female archers, musicians, horseback riding, and polo as well as cross-dressing, and riding into battle with the army. Women enjoyed late-night conversation and offered detailed advice on betrothals and family discord. Of the competition between women, one anecdote tells of Humayan's wife, Maywa-jan, who pretended an eleven-month hoax pregnancy to win her mother-in-law's affection. In 1558, Gulbadan returned to Agra with granddaughter, aphorist Salimeh Sultan Begum, and lived alternately at Lahore and Sikri south of Agra.

In November 1575, when negotiation eased the threats of Portuguese traders, the biographer, then aged fifty-two, made a 3,000-mile all-woman *hajj* (pilgrimage). The convoy traveled from Surat on India's western coast by the ship *Ilahi* (Divine). After shipwreck caused a year's halt at Aden, the pilgrims crossed the Red Sea and Arabia to Mecca and Medina, birthplace and burial cities of the prophet Muhammad. Accompanied by granddaughters Salimeh and Umm-Kulsum Khanum, two widows, two nieces, and Babur's Circassian concubine Gulnar Aghacha, Gulbadan repeated the holy trek three times and visited a Sufi shrine at Ajmer, Rajasthan, to mystic saint and clairvoyant Minuddin Chishti.

Upon arrival in Arabia, the female entourage drew a crowd by distributing cash and jewels, which Akbar funded. On Gulbadan's return to Agra in April 1582, she lived another twenty-one years, earning the regard of future emperor Jahangir. After establishing a reputation for generosity and kindness to the poor, she received

the ministrations of Hindal Mirza's daughter, Empress Ruqaiya Sultan Begum, the longest-serving Mughal queen. Gulbadan died of fever on February 7, 1603, leaving Akbar in grief for the rest of his days.

See also Anurupa Roy (March 10, 1977–).

Source

Begum, Gulbadan. *The History of Humayun*. London: Royal Asiatic Society, 1902.

Gould, Rebecca. "How Gulbadan Remembered," *Early Modern Women* 6 (2011): 187–193.

Lal, Ruby. *Empress: The Astonishing Reign of Nur Jahan*. New York: W.W. Norton, 2018.

Mukherjee, Soma. *Royal Mughal Ladies and Their Contribution*. New Deli: Gyan, 2001.

Murshed, Yasmeen. "The Humayun Nama: Gulbadan Begum's Forgotten Chronicle," (London) *Daily Star* (27 June 2004).

Rawat, Sugandha. *The Women of Mughal Harem*. Chhattisgarh, India: Evincepub, 2019.

Ruggles, D. Fairchild. *Women, Patronage, and Self-Representation in Islamic Societies*. Albany: SUNY, 2000.

Sharma, Parvati. "Gulbadan Begum's Story," (Chennai, India) *The Hindu Business Line* (21 June 2019).

Tharu, Susie J., and K. Lalita. *Women Writing in India 600 BCE to the Present*. New York: Feminist Press, 1991.

Amannisa Khan Nafisi (1526–1560)
singer, chanter, poet, taburist, calligrapher
Uighur Autonomous Region

Ayshemgul Memet (1970–)
singer, taburist
Uighur Autonomous Region

A legendary Uighur singer and culture conservationist, Amannisa Khan Nafisi (Amanissah, Aman Isa, or Amanni Shahan) mastered the instrumental techniques, rhythms, and melodies of a Turkish-speaking minority. Her collection, the *Uyghur on Ikki Muqami* (Uighur Twelve Muquams), preserved Eurasian theatrical narratives as models of ethics and right thinking from the *muquam* (homeland). She was born of semi-nomadic Dolan heritage on the Tarim River in Xinjiang, western China, in 1526 to father Muhamode (also Mahmut), a woodcutter, and a mother lost in childbirth. After her father's exile to the Taklamakan Desert because of a controversy over the death of Sultan Said, he gave up playing elitist music, but welcomed progressive artists to perform *muquams*.

A frisky shepherd, Amannisa Khan Nafisi earned the nickname Nafisi (Exquisite). She came of age during the foundation of the Omar and Turdi Akhun families, a clan of respected folk musicians who preserved the primitive music and the late fifteenth-century verse of Uighur poet Nizamidden Elishir Nawayi, a linguist fluent in ancient Turkic dialects. While learning the intricacies of heritage verse and song from the poet's 1498 textbook, *Majolis un–Nafois* (Anthology of Nawayi Gezele), she admired 459 literary biographies. Even though Muslim fanatics called the arts

profane, she studied Uighur arts and practiced playing, singing, and dancing to folk music.

In 1539 in the sixth year of a twenty-seven-year reign, Sultan Abdurashid (or Abd' Rashid) Khan of Aksu, a son of Sultan Said Khan and descendant of Genghis Khan and Mogul Empire founder Timur, halted a hunting trip to cross the Yarkand River and enter the family hut with a companion. A skilled archer and musician and a fan of peasant culture, at age thirty-one, he posed in a commoner's disguise to conceal his royal status while he studied the living conditions of individual families. He requested that Amannisa, then age thirteen, strum the five-string tabur (also tambur) and sing for him. Her original ghazal, the Panjiga (almanac) Muqam, praising the khan's just rule, won his affection and a place in the imperial harem as concubine. At ease for twenty years in the Yarkent Khanate in Xinjiang, Amannisa overcame Sufist suspicions of peasant music and in-house conflict with Yadigar, the first royal wife.

Royal Court Musician

To elevate the khan's standing among peasants as a peacemaker and reviver of Uighur traditions, Amannisa Khan Nafisi gathered young apprentices to study Uighur songs. She became the only court artist to devote her talents to calligraphy, composition of the narrative *Diwan-i Nafisi* (Nafisi's Treasury), ornamented songs, and formulaic chanting. She danced in the Uzbek and Tajik styles that peasants performed in isolated villages. With her aide, Yusup Qadirxan, she compiled poems, edited three books—*Exquisite Psalter, Beautiful Sentiment,* and *Consultation of Heart*—and founded a Uighur school of muquam, a traditional Turkic folksong mode belonging to a suite of twelve entertaining, relaxing styles. The tripartite songs favored the performer's head, torso, and legs as repositories of intellect, heart, and spirit.

From colleagues, Amannisa Khan Nafisi collected, refined, arranged, and wrote classical muquams, the foundations of ethnic nationalism that the khan memorized. Each set contained three hundred sixty melodies accompanied by percussion and long-necked stringed instruments. After suffering dystocia (a twisted birthing) in 1560, about the time that the Khan sickened and died at age fifty-two in the Khotan oasis, east of Tajikistan, she expired at age thirty-four. Highly honored, she lay interred alongside her husband and other Yarkent royalty.

Uighur Archives

An indigenous form of patterning begun by nomads north of Tibet along the Silk Road, the muquam took shape during the Han dynasty after 206 BCE. The poetic form consisted of the Rak, Čäbbiyat, Segah, Čahargah, Pänjigah, Özhal, Äjäm, Uššaq, Bayat, Nava, Mušavräk, and Iraq muquams. In couplets, the pattern

preserved folk wedding music, mashrap (harvest celebration) dances, and the bal-
lads and storytelling of the Tian Shan (White Mountains) of northwestern China.
In addition to organizing songs, Amannisa Khan Nafisi purified oral lore of Arabic
Sufist and Persian influence to authenticate Uighur history, ballads, and lore. Per-
formed on satar (Uighur long-necked bowed lute) and tanbar (or tanbour, a Kurdish
lute), the music style gained popularity after 618 CE during the Tang dynasty.

Translation of Uighur scholar Molla Ismatulla binni Molla Nematulla Mojiz
(or Mujizi)'s *Tarikhi Musiqiyun* (History of Musicians) from 1854 preserved Queen
Amannisa Khan Nafisi's name and achievements. Uighur style achieved a renais-
sance in 1956 reflecting female self-empowerment. In 1983, Chinese bureaucrat
Saifuding Aizezi composed a bio-drama, *Amannishahan* (Amannisa the Poet),
about her residence as the khan's wife. The adapted play became the subject of a 1993
Chinese film and of a seated statue picturing her bowing the tabur. In the 1990s,
admirers erected a domed mausoleum of blue and white tile near her home at the
oasis city of Kashgar (modern Kashi, China), a trading post on the Silk Road. For
edifying children with noble virtues and courtesies, UNESCO listed the Uighur
muquam in 2004 among the world's Intangible Cultural Relics.

In 2011, female Uighur musician and ethnomusicology professor Ayshemgul
Memet of Shixo (Wusu, Xinjiang), in the Uighur Autonomous Region, recorded the
classical repertoire that Amannisa Khan Nafisi preserved. Educated at the Xinjiang
Art Institute from 1992 to 1996, Ayshemgul Memet studied central Asian muquam
in Uzbekistan. In Paris in 2002, she became one of the first female soloists and
taburists in a minority folk art dominated by men. She earned the 2007 Interna-
tional Chinese Music citation in Beijing and earned an advanced degree in folk her-
itage at Tashkent music conservatory. In mid–March 2015 at Baku, Azerbaijan, she
performed at the International World of Mugham Festival.

Source

Anderson, Elise. "The Construction of Āmānnisā Khan as a Uyghur Musical Culture Hero,"
 Asian Music 43:1 (Winter/Spring 2012): 64–90.
Harris, Rachel. *Situating the Uyghurs: Between Central Asia and China.* London: Routledge
 (2007): 69–88.
Mukaddas, Mijit. "Musique Ouïghoure. Muqam Nava Abdukerim Osman Chimani," *Cahiers
 d'Ethnomusicologie* 28 (2015): 285–286.
"Musical Treasure of the Uygurs," *China Daily* (24 December 2002).
The Story of Amanishahan, https://elkitab.org/wp-content/uploads/2018/04/3007_29.pdf.
The Tarikhi-I-Rashidi. Srinagar, Kashmir: Karakoram Books, 2009.

Habba Khatoon (1554–1609)
poet
Kashmir

Muslim poet Habba Khatoon (or Haba Khaatun) earned the sobriquets "Moon
Queen" and "Kashmir's Nightingale" for her oral lore, ascetic tastes, and influence

on the claustrophobic musicality of the Sufiana Kalam (devotional poets). She was named Zooni (also Zoon or Zun, Moon) at birth in 1554 in Chandrahar on the Jhelum River at Pampore in north central Kashmir to peasant farmers Janam and Abdi Rather (or Abdul Rathar). In girlhood, she learned Islamic songs and stripped them of fanaticism to inspire limpid poems and pure melodies, poetry's soul. She improvised *ragas* (melodies) and composed a symphony in Arabic harmony (melodic minor) for performance by female *hafizas* (singers), who amused themselves while they collected firewood.

The writer became the rare peasant girl to receive literacy training from the local *moulvi* (scholar) in Persian, Arabic, and the Koran. At her parents' insistence, she entered a short arranged marriage to an illiterate village carpenter, Aziz Jan, who criticized her poetic gift. Her married life began with disgust at intimacy, beatings, and confinement to a sheep pen, a symbolic diminution of female liberty and humanity. Retreating from a bossy mother-in-law and sister-in-law, she fled to a field of saffron, an iconic aphrodisiac and restorative.

MATTERS OF THE HEART

While singing under a *chinar* (plane tree) at the Gurez peak, Habba Khatoon entranced a huntsman with her beauty. Her words contained what English odist William Wordsworth's "Preface to the Lyrical Ballads" called the "spontaneous overflow of powerful feelings" (Wordsworth, 2018, cover). She fled to her parents' home during a snowstorm and begged Sultan Ali Shah Chak to intervene in domestic misery. To settle the case of marital discord and spousal abuse, she proved she was still a virgin. After a divorce and elopement to Gulmarg, she was happily wed at age sixteen to the unknown outrider—Prince Yusuf Shah Chak, an introspective Shiite poet and Kashmir's last emperor.

While rearing a daughter during six years of rule, Zoon renamed herself Habba Khatoon (Woman's Celebration). A favorite with rural folk, she hybridized Iranian-Kashmiri music with a soulful, lustful subjectivity uncommon in female writing. After 1570, she revamped the spiritual Sufi school of poetry into the romantic *lol* (love and longing) school, which based verse on the common Kashmiri language rather than classical Persian. She contributed to Kashmiri literature the *watsun,* a three-line stanza followed by a one-line *voje* (refrain). Convention limited each poem to a single mood and single theme of romance and yearning. The upgrade launched Kashmir's literary renaissance.

A FALL FROM GRACE

Because King Akbar murdered the sultan in a game of polo in 1578, lured Prince Yusuf to a peace conference at Lahore in 1579, and seized the Kashmiri kingdom as a part of the Mughal Empire, Yusuf entered exile in Bihar and died in 1586. The queen

spent the remainder of her career as a religious vagrant composing mystic, aching verse at her hermitage at Panda Chok on the Jhelum River. The former empress constructed a hovel; begged for a living; and collected freedom slogans, laments, and candid stanzas under the title *Loal* (Lyrics). Her expression of the soul's liberty consoled a nation in bondage to the Mughal Empire.

Unlike previous Sufist adulation of piety, rigid sectarianism, and mystic spirituality, for twenty years, Habba Khatoon's folksongs reverberated with open-ended sensuality, carnal hunger, and spontaneity, the predecessors of Kashmir's romantic realism. "Vwolo Myaani Poshe Madano" (Pray Come, My Lovely Love) and "Cholhama Roshay, Roshay Walo Myaani" (Having Snatched My Heart, You Have Gone) integrated a poignance that permeated women's weaving tunes and the work songs of river workers and plowmen. The first tune spoke of rumor and criticism that defamed and mocked the poet. The second asserted the heartbreak of severance from her true love.

Songs of Evanescence

Rather than muse on the destiny of muffled females, the innovator preferred optimistic activities—singing free-flowing verse and ambling through the 68-mile valley in search of elation and release from sorrow. Along the way, she gathered spring garlands, dandelions, jasmine, lilacs, wild roses, and violets, emblems of nature's bounty and female delicacy. Enwrapped in mountain scenery, in "Lajy Phulai Anda Vanan" (The Distant Meadows Are in Bloom), she imagined the upland blossoming as a visible summons to her lover. She repeated the imagery in "Phwaliviniyi Zyia Thoo" (O Emerging Spring, I Beg You Come), a plea for reunion with Yusuf before she turned gray and lost the glow of youth. The subtext mourned the loss of Kashmiri autonomy to Indian oppressor Akbar the Great.

The poet accepted the soul's transient life on earth and anticipated an existential loss of physical loveliness and material goods. In "Ratshi Ratshi Retakol Chhum Soraanai" (With Summer Steadily Ebbing), she recognized the dangers of time's passage: she envisioned herself as a pomegranate flower that would soon wither and die. Her mortal premonitions reached a detailed prospectus in "Maalinyi Gari Noo" (When the Middlemen Arrive), a poetic glimpse of the dismantling of her home and former life.

Burdened by sorrow and loss, Habba Khatoon died with her child in a Kashmiri blizzard in 1609 at age fifty-four. Rural admirers banked their fires in honor of her joyful poems. Beside an obscure gravesite, mother and babe lay buried at Athwajan outside Srinagar. Revered as medieval Kashmir's Philomel, a mythic Athenian rape victim transformed into a bird, Habba Khatoon lived on in Urdu film and televised serials, in flute and string renditions, in a revived native tongue, and in the anguished, disillusioned writings of other female poets, who imitated her alliterated, heavily rhymed plaints. The greatest is Arnimal, a Kashmiri Brahmin writer from

the 1780s. Because Habba Khatoon's verses avoided strict structure and complicated themes, after four centuries, they find favor with readers and singers. The pyramidal Habba Khatoon peak in Gurez, a Mughalpura underpass, and a ship of the Indian Coast Guard celebrate her name.

Source

Bhargava, Kavita. "A Grave Mistake" (India) *Tribune* (3 June 2000).

Kalla, Krishan Lal. *The Literary Heritage of Kashmir.* New Delhi, India: Mittal, 1985.

Mohi-ud-Din, Akhtar. "Social Ideals and Patriotism in Kashmiri Literature (1900–1930)," *Indian Literature* 20:3 (1 May 2020): 80–89.

Shaw, Asma. "Lyricism and Desire for Freedom: Habba Khatoon," *Criterion* 7:5 (October 2016): 29–39.

Wordsworth, William. *The Collected Poems of William Wordsworth.* Overland Park, KS: Digireads, 2018.

Zeb un-Nissa (February 15, 1638–May 26, 1702)
poet, calligrapher, translator
Mughal Empire

A prodigy of prose and entrancing love verse at the height of the Mughal Empire, Zeb un-Nissa (also Zib al-Nissa) left evidence of a self-motivated scholar and poet. She chose Makhfi (Hidden One) as her pen name in admiration of the seventeenth-century poet Nur Jahan. A native of Daulalabad east of Aurangabad, India, she was the firstborn on February 15, 1638, of sixteen-year-old Dilras Banu Begum, head wife of the twenty-year-old emperor Aurangzeb, a fundamentalist Muslim. Her lineage ranged from Genghis Khan and Timur to the Safavid dynasty of Persia (Iran), and maternal grandparents Emperor Shah Jahan and Mumtaz Mahal, the honoree of the Taj Mahal, the architectural gem of the Mughal Empire. A raven-haired beauty in girlhood, she dressed simply in white and pearls, wore no makeup, and veiled herself in black in public. For the humid climate, she adapted the Turkish dress into the *angya kurti*, a knee-length shirt worn over trousers.

The name Zeb un-Nissa (glory of womankind) became an ironic prophecy of her relationship with her Sunni Muslim father, a puritanic misogynist and legal expert who held females secondary to males. To her father's delight, she received tutoring in weaponry, astronomy, math, philosophy, literature, Persian, Arabic, and Urdu and memorized the Koran in three years, earning the title *hafiz* (guardian of scripture) by age seven. Her father held a state banquet to praise his brilliant daughter and declared a two-day national holiday. Under the influence of a paternal aunt, Jahanara Begum, a newly indoctrinated Sufist, Zeb un-Nissa supported the *hajj* (pilgrimage) to Mecca and Medina and aided orphans and widows, but eschewed a sterile orthodoxy. She mastered *nastaliq* (sloping), *naskh* (rounded), and *shikastah* (broken) calligraphy and applied each to her letters. When she began writing scriptural commentary, her pious father halted the project as inappropriate for a female.

CREATIVE OUTLETS

In addition to musical composition and singing, letter writing, and landscaping the Chauburji Garden at Lahore, site of her public kitchen for the poor, Zeb un-Nissa collected books on theology, history, law, and literature. To preserve antique Arabic works, she had them translated into Persian in her scriptorium to add to a massive library, which contained Hindu and Jain holy books, the Hebrew bible, and Greek mythology. By age fourteen, she recited Persian verse aloud. While her father charged poets with deceit and fawning and forbade the recitation of verse in boys' schools and among women at court, she enjoyed the repartee of fellow writers. At her salon, she engaged in verse tournaments and endured jests that she remained unmarried. Echoing the regrets of poets Catullus and Keats for a wasted life, she repined, "Mine is the 'shame' (they say) to love unloved:/Going on, suffering wrong, until under soil my fame, name, song are nothingness" (Zeb un-Nissa, 2019, 103).

Like the individualized portraiture of Mughal artists, Zeb un-Nissi's Sufist *ghazals* (couplets) and *rubai* (quatrains), written in Arabic and Persian, spoke tantalizingly of the search for God's love. Simultaneously, they hinted at a strong libido in need of an earthly lover like the mythic Layla for the madman Majnun. Her allusions strayed to Noah, Jacob, Potiphar's wife Zulaikha, King Solomon, the Abbasid al-Mansur (the Conqueror), founder of Baghdad, the Kaaba (shrine) at Mecca, dervishes, the Parthian sculptor Farhad, and Khizr, the Koranic adventurer seeking the fountain of life. Her *rekhta* (macaronic) diction mixes languages, evidence of the Mughal syncretism of the Arabic and Persian civilizations.

Zeb un-Nissa's versification tended toward eloquent rhetorical questions and answers about humanity and passion, as though the poet debated with herself. Often she rebuked her introspective side—"makhfi"—for impatience. Her text encapsulated in a cryptic atmosphere the question of piercing a pearl with a diamond and compared love to a raider dripping the blood of scalps over the earth. Other images characterized a taste for intoxicating red wines, fragrant bowers, and curls and dimples. She stated in a fervid meditation: "I am a candle that with an inner passion/ slowly and silently, keeps burning away" (Makhfi, 2012, 59).

FATHER AGAINST DAUGHTER

During court debates of controversies between Sunni and Shia, Zeb un-Nissa supported her mother's Shia faith, which grew in public popularity during the last years of the Mughal Empire. On September 11, 1657, the nineteen-year-old princess lost her mother to puerperal fever resulting from the birth of a fifth child, the future Emperor Akbar the Great. Zeb un-Nissa fostered the boy, whom Aurangzeb adored. By age 21, she advanced to court adviser to the emperor, even though he disliked her liberal bent. Because of his intransigence, he quashed the courtship of Sulaiman Shikoh and had the 27-year-old prince poisoned and strangled.

On her own, Zeb un-Nissa surveyed other suitors. She spurned Mirza Farukh, a self-important Iranian prince who insulted her with double entendre. To a courtier urging her to uncover her face for him alone, she asserted in verse: "Me the world can see only in my poetry:/I will not lift the veil … me you will not see" (Smith, 2016, 446).

The father-daughter relationship fractured in 1662, when the imperial family moved to Lahore for the emperor's health. At age 24, she aroused Aurengzeb's anger by reputedly engaging in an affair with Akil Khan Razi, governor of Lahore. Her promotion of Prince Muhammad Akbar for heir to the throne reduced her to imperial enemy for allying with a rebel who relayed forbidden love notes from Akil and who prayed daily for the emperor's death. In January 1681, Aurangzeb imprisoned his daughter in Delhi at Salimgarh Fort, a UNESCO World Heritage site on the Yamuna River. He confiscated her belongings and reduced her to penury. She felt dirtied by the charges and mourned, "So bound by chains of despair I think, 'Can I ever be free?'/I feel like I wear a collar around my neck, band of slavery, a bind" (Zeb un-Nissa, 2019, 101). Nonetheless, she found the stamina to declare, "Makhfi, sing on, never cease" (*ibid.*, 100).

Zeb un-Nissa remained for the next two decades composing wistful, anguished verses about shackles, solitude, and public alienation. She dedicated 15,000 couplets to Allah. Her religious inclinations incorporated strands of Hinduism and Zoroastrianism. In addition, she completed *Monis-ul-Roh* (Comforting Spirit), a survey of hagiography; *Zeb-ul-Tafasir* (Home Exegesis), a commentary on the Koran in Persian; and *Zeb-ul Monsha'at* (Home Creation), a collection of letters to literati. After a week's illness, on May 26, 1702, she died in her Delhi cell at age sixty-four. Aurangzeb mourned her at a state funeral and entombed her remains outside the Kabuli city gate in her aunt Jahanara's garden. Admirers collected the surviving 425 poems in 1724 in the anthology *Diwan-i-Makhfi* (Book of the Hidden One). A publisher added more works in 1730 as well as illuminations.

Zeb un-Nissa survives in literary history martyred by patriarchy and imperial rancor. Scandalous fabrications of carnal intrigue circulated at Lucknow during the Romantic era. Mughal ghost stories picture the poet decked in a black mantle and singing her ghazals and rubai to the full moon. Copies of her manuscripts, housed at Delhi, Tehran, Paris, London, and Tübingen, Germany, continue to delight readers in India, Tajikistan, and Uzbekistan.

Source

Gould, Rebecca. "How Gulbadan Remembered," *Early Modern Women* 6 (2011): 187–193.

Kumar, Rakesh. "Women and Literature in Medieval India," *International Journal for Social Studies* 4:12 (February 2018): 1–6.

Lal, Ruby. *Domesticity and Power in the Early Mughal World*. Cambridge, UK: Cambridge University Press, 2005.

Makhfi. *Makhfi: The Princess Sufi Poet Zeb-un-Nissa*. Victoria, Australia: New Humanity, 2012.

Smith, Paul, trans. *Mahsati, Jahan & Makhfi, Three Great Female Sufi Persian Poets*. Victoria, Australia: New Humanity, 2016.

Zeb-un–Nissa. *The Diwan of Zeb un-Nissa*. London: John Murray, 1913.
_____. *Selected Poems of Zeb-un-Nissa*. Victoria, Australia: New Humanity, 2019.

Han Ximeng (fl. 1634–1641)
embroiderer, painter, writer
Imperial China

Miao Ruiyan (fl. 1634–1641)
embroiderer, painter
Imperial China

Gu Lanyu (fl. 1650–1680)
embroiderer
Imperial China

A student of painting reared among literati, Han Ximeng (also Han Hsi-meng) flourished at transforming pen and ink, brush art, and calligraphy into *guxiu*— intricate embroidered scenes on silk tapestry. At the ancient village of Luxiang near Lake Taihu in Suzhou, she lived in the extended household of a local squire, Gu Minshi, with her devout Buddhist husband, Gu Shouqian, the master's grand-son, who supported her career. Apparently humble and dedicated to needle art, she worked with other women in courtyard sewing sessions. She taught her daughter the craft and issued a history of stitchery. A portrait embroidery pictured her seated on a low stool, one fragile hand elevated in the air, and, in natural light, mending a cloak draped over one knee. An elderly court minister examined her handwork and declared Lady Han's stitchery sublime.

Introduced by Miao Ruiyan, concubine of Gu Huihai, the son of Gu Minshi, the process of halving silk floss into a fine filament preceded silhouetting divine beings and enlightened Buddhists in ethereal stitchery. A scroll 31.3" × 10.6" of a victory report in 1632 to the prime minister highlighted an iconic upthrust of rock contrasting the delicacy of a pagoda and sinuous blue dragon. Miao Ruiyan mastered the application of couching to create texture on horse flesh. The method, which accompanied the Gu clan to eastern Shanghai, elevated needlework from decoration to gendered art endowed with a feminine airiness rather than masculine majesty and grandeur. Among the household, Han Ximeng out-performed Miao Ruiyan and earned the sobriquet "Saint Needle." She retained fame for two classic topographical studies, "Donghsan (East Mountain)" and "Landscape by Mi Fu," a twelfth-century poet and painter.

Creative Techniques

Near the end of the Ming dynasty around 1640, the style of transitioning glistening needlepoint and the *qi laoxian* (contour stitch) over straight lines into

painting in neutral colors and ink outlines burgeoned in Suzhou. At her height, Han Ximeng signed her pieces *Wuling xiushi* (Master Embroiderer of Wuling). To assert the feminine artistry of pre–Renaissance embroidery painting, Han Ximeng adapted techniques with basket stitch, bristly lines, Chinese knot stitch, brocade, overlap, crackling (or cross) stitch, textured and padded couching, satin stitches, a *jin*-silk-like brocade effect, and varied lengths along curves. The finished pieces preserved on fabric eight court paintings of the imperial palace in the Song (960–1279) and Yuan (1281–1368) eras, which she traced on fabric.

Han Ximeng's earliest collection of ten works depicted four historical events—diplomat Su Wu parting with good friend Li Ling to enter exile in Mongolia in 99 BCE, the legendary Chinese beauty, calligrapher, painter, and instrumentalist Wang Zhaojun traveling with her *pipa* (four-stringed lute) in 33 BCE to marry a nomadic Hun in the Eurasian steppes, the poet and calligrapher Cai Wenji leaving her husband and son for prison in 207 CE, and general Li Guangyan in armor accepting a peace treaty outside Lulong in 821 CE from Wang Tingcou, a Tang general. Han Ximeng's naturalistic scenes focused on the realistic colors and contours of deer; a dried tree; a bathing horse; bamboo and craggy rocks; a bird, camellia, and plum blossoms; squirrels with grapes; a falcon on a willow sprig; and crabapples near a songbird. To energize settings, she blended some nine hues for effect and applied the hairy stitch to texturize the underside of birds.

Viewers marveled at minuscule stems and petals, feathers, and human likenesses created through subtle innovations in needle design and thread. Underpainting and ink outlines augmented the methods of copying precious art. Double-sided stitches created a two-faced image on translucent silk mounted in a frame or screen or hanging in a scroll. Han Ximeng excelled at concealing thread ends and knots and, for visual appeal, tempered long with short stitches in identifiable nature scenes: Autumn singing cicada with blue blossoms; Carp and catfish swimming in duckweed; Dragonflies over hyacinth beans; Waterweed in a pond with shrimp and bulrushes; Peony extended from a single stem; and Rocks, sweet William, and butterflies.

Surviving Cultural Change

When master Gu Minshi died in 1644, the Gu women supported the family by selling genteel silk embroidery, which male artists emulated. His great-granddaughter, Gu Lanyu, conducted workshops throughout the region and taught distinctive color and stitch methods in 1650 at a tent academy that survived for three decades. Innovators—most of them men—added notching, networks, and bicolored fibers to their scenes, which featured court banners, theatrical costumes, shrouds, bed valances, and official robes. The mystic grace of waves, smoke, clouds, mist, fish, insects, and birds duplicated painting styles and continued to attract cottage craft needleworkers in the Qing dynasty, which ended in 1911.

The splendor of Gu embroidery appealed to royalty. In the imperial collection at the Forbidden City, Han Ximeng's works became collectors' items valued like other luxuries for export via the British East India Company. Other examples survive at the Palace Museum and National Museum. At auction, her garden scene scroll, valued at £30,000 ($41,050), surveyed nature downward from an occluded sun and lowland hills to a home setting in an enclosed garden secured by a double door. Commercialization of the Gu tradition resulted in counterfeit works that devalued copies. The cultural revolution of 1966 charged needleworkers with clinging to the past. In 2006, embroidery painting gained listing by UNESCO among China's national intangible cultural heritage. Shanghai University revived the folk heritage of elegant embroidery painting on campus and through public school instruction to elementary pupils.

See also Wang Zhaojun (50–31 BCE)

Source

Gao, Bingqing. "A Brief Discussion on the Themes of Women's Embroidery in the Ming and Qing Dynasties," *Asian Culture and History* 2:2 (2010): 71–81.

"Gu Embroidery," https://trc-leiden.nl/trc-needles/regional-traditions/east-asia/china/gu-embroidery

Huang, I-Fen. "Gender, Technical Innovation, and Gu Family Embroidery in Late-Ming Shanghai," *East Asian Science, Technology, and Medicine* 36 (2012): 77–129.

Yang Meiping. "University to Train Embroidery Teachers" (Shanghai) *Shine News* (23 May 2019).

Ying Yu. "Gu's Embroidery," *Asian Social Science* 6:1 (January 2010): 1–79.

6

1650s–1880s

Tokhi, Nazo (1651–1717)
poet
Afghanistan

Zainab Hotaki (fl. 1700–1730s)
poet
Afghanistan

A heroic nationalist and poet in the Pashto language, Nazo Tokhi (also Nazoo Anaa or Anna) deserved the byname "Mother of the Afghan Nation." Born in 1651 on the Balochistan border at Spogmayiz Gul near Thazi, Kandahar, she claimed prominence in a Pashtun tribe governed by her father, Sultan Malakhai Tokhi of Ghazni, a cultural center in southeastern Afghanistan. In the east central part of the country, the sultan hired scholarly elders to educate his only child. One romantic myth reported by British historian George P. Tate in *The Kingdom of Afghanistan, a Historical Sketch,* declared she eloped with Husen, her father's shepherd, and lived in the wild for a year before giving birth to a son. The match found favor with the sultan, who forgave both the poet and his unofficial son-in-law.

History reported a more realistic life for Nazo Tokhi during the Afghan tribal uprising against the Safavid regime. At age 21, she wed Salim Khan Hotak, a caravan master and trader between Delhi, India, and Isfahan, Persia (modern Iran). When the sultan and eight hundred of his men died in combat at Sur Ghar (Red Hills), she joined her brother, Haji Adil Tokhi, in arming against the six thousand troops of Aurangzeb, the Mughal expansionist emperor who attacked the fort and village. A painting captures her in soldier's uniform and boots as she wields a lance from the back of a white horse at full gallop toward the invaders. Her poem "The Cheeks of the Narcissus" idealized morning dew as tears at dawn regretting her people's fate.

MOTHER OF WARRIORS

Against the tradition for noblewomen, Nazo Tokhi insisted on breastfeeding her children. At Kandahar City, she reared Abdul Kader Khan, Abdul Aziz Khan,

Yahya Khan, and the prestigious founder of the Hotak dynasty in April 1709, Miwais Khan Hotak, defender of the Pashtun against Mughal and Persian religious fanaticism. Because of a prophetic dream of a folkloric hero, Nazo Tokhi counseled the eldest son Miwais to serve the country with honor, reverence, and integrity. He passed the qualities to her grandsons, Persian King Mahmud Hotaki and Hussein Hotaki, a Pashtun monarch and poet. Her second son, Abdul Aziz Khan, assumed the throne after Miwais's death in November 1715 and sired the fourth ruler, Ashraf Hotak, a soldier and shah of Persia from 1725 to 1729.

A cultural icon, Nazo Tokhi revered the pre–Islamic Pashtunwali code of self-respect, independence, justice, hospitality, love, forgiveness, revenge, and tolerance. During the chaos that seized Afghans at the death of Emperor Aurangzeb on March 3, 1707, when Safavid Persians tried to annex Kandahar, she insisted that traditional ideals govern the Pashtun confederacy. As a result of internal unity, the four hundred tribes regained control of Kandahar Province from the Persians twice more, on April 21, 1709, and again in May 1713. In cold weather, she welcomed the homeless and caravans at the fort and housed, fed, and clothed hundreds of outlanders from Kosan, Iran, to Khybar, Arabia. To unite Afghans against the Persian Safavids, she mediated tribal squabbles between the Ghilji and Sadozai. Along with her daughters, Nazo Tokhi died at age sixty-five in 1717 at Kandahar in the fight to rescue Mirwais Hotak's dynasty, which pass to the weakling Abdul Aziz after Miwais's death in November 1715.

Poignant Themes

Among some two thousand couplets, Nazo Tokhi composed an elegy to fleeting beauty, youth, and mortality, a sentiment that regretted her people's constant duress under the imperialist Safavids and the patricide of Abdul Aziz Hotak in 1717 by his nephew Mahmud Hotak. Her granddaughter, Zainab Hotaki, daughter of Mirwais Hotak, received intense tutoring and served on the khan's advisory board. She taught women in her father's harem and continued the family tradition of writing original poetry in Pashto and Dari. The name "Nazo Ana" (Grandmother Nazo) survived in a Kabul obstetrical clinic, the Afghanistan Women Council's Hospital, and an elementary school and high school.

Zainab Hotaki inscribed lines regretting Persian overthrow of Hotaki sovereignty. On April 22, 1725, she composed an elegy on the execution of her brother Mahmud, who had suffered insanity for years:

> It's now the sound of wailing brought by the wind;
> The old and the young are all mournful,
> Brother, may God make heaven thy abode!
> May He give you peace after death ["The Poetry Work"].

In April 1738, she joined her brothers in fending off conquest before conferring on surrender to Nadir Shah Afshar, the Persian shah of the Afshar tribe who exiled

Hotaki tribesmen. An original verse, "The Bright World," viewed the future of Kandahar as a dark void and her heart as a martyr impaled on a sword tip. She shared Hotaki grief over the loss of independence to Persia. For her contributions to Pashtun security and culture, a kindergarten bears her name.

Source

Habibi, Abd al-Hayy. *The Hidden Treasure: A Biography of Pashtoon Poets*. Lanham, MD: University Press of America, 1997.

Kakar, Palwasha. "Tribal Law of Pashtunwali and Women's Legislative Authority," http://www. law. harvard. edu/programs/ilsp/research/kakar. pdf (2004).

"The Poetry Work of Zeinab Hotaki," https://www.facebook.com/notes/afghanistan/the-poetry-work-of-zeinab-hotaki/165822743444288/

Tate, G.P. *The Kingdom of Afghanistan, a Historical Sketch*. London: Bennett Coleman, 1911.

Zhwak, Mohammad Saeed. "Women in Afghanistan History," *Afghan Digital Libraries* (1995).

Hanim, Fatima Zahra (1792–early 1847)
calligrapher
Turkey

During the modernization of the Ottoman Empire into Turkey, Sharifah Fatima Zahra Hanim earned respect for elegant rounded and sloped calligraphy of the *ta'lik* (also ta'liq) script, a thirteenth-century Arabic cursive style suited to Persian transcription. The granddaughter of Sheik Seyyid Osman Uveysi, a judge, an imam at the Nishanci Mosque in Constantinople, and student of ta'lik script, she was born to Kulahizade Tahir Efendi in 1792. The family descended from Veysel Karani of Yemen, a martyr to Islam at the Battle of Siffin on the Euphrates River from July 26–28, 657, an Arab-Syrian clash over selection of an Islamic capital. Her life span coincided with updating during the rule of military and legal reformer Sultan Mahmud II and his son Abdulmejid I, the abolisher of slavery and introducer of a Western style parliament, paper money, the Ottoman flag, and a national anthem.

A proponent of learning, Fatima Zahra Hanim excelled at the refined loops, ligatures, and spacing of royal correspondence, books and verse, and official documents, which demonstrated the *ta'lik* (suspension or slope) of descending lines. During the rise of European scholarship, she received extensive training in languages. In 1801, she wed Muglali Hoca Abdurahim, a palace teacher of Ottoman royalty. Their son, court astrologer Osman Saib Bey, the empire's first anatomy and physiology lecturer, received a thorough education in math and calendar preparation, at the Suleymaniye Medical Madrasa in Tiryakiler Street, the largest Ottoman building project.

The calligrapher, in her late twenties, advanced in artistic reputation and accepted commissions, including copying *hilye-yi serif* (manuscripts). The diamond panel that she inscribed in gold ink on a blue background at age twenty-six in 1818 contained an eyewitness description of the prophet Muhammad for the enlightenment of those who didn't witness him in life. The example positioned lettering in

varying font sizes. Her husband, an ascetic at a central Constantinople *madrasa* (school), abandoned the family and remained in seclusion until his death on March 23, 1837. The absence left Fatima Zahra Hanim to survive financial abandonment and rear her son alone on the proceeds from lettering panels. She received an annual state salary of 500 kurus or five Ottoman lira, approximately 4.5 British pounds (currently worth $541.45).

At a time when French became the official academic language of science and technology, on March 14, 1827, Osman Saib Bey joined the faculty of Tibhane-i Amire (Royal School of Medicine), the empire's first Western-style school, founded by Sultan Mahmud II and chaired by his personal physician to train surgeons, dentists, pharmacists, and veterinarians. By 1834, Osman's written works and translations of French manuscripts passed to his mother for copying. Two years later, Fatima Zahra Hanim executed in script her son's medical text and the Diwan-i Ali (supreme court abenda).

Source

Kazan, Hilal. "A Woman Calligrapher in the Nineteenth Century: Sharifah Fatima Zahra Hanim," *Calligraphy* (25 June 2017).

Bek, Anna Nikolaevna (December 9, 1869–1954)
memoirist, biographer, essayist
Siberia

A remarkable life story, the memoir of Anna Nikolaevna Zukhova Bek depicts the work of the intellectual scientist during Russia's shift from an imperial tsarist state into a Communist stronghold. Born on December 9, 1869, in Transbaikalia in the Russian colony of eastern Siberia near Kazakhstan and Lake Baikal, she was the peasant-class granddaughter of a blacksmith and a farmer. She claimed semi-literate parents—Agrafena Afanasevna Savinskaya and Nikolai Mikhailovich Zhukov, a director of the Taiga mine in the village of Gornyi Zerentui. At age eleven, she moved with her family to Gugda in the Kultumin district, a mineral-rich repository of granite, silver, lead, bismuth, gold, and radioactive torianite. Two years later, despite having to manage domestic chores for her mother, she attained top honors in Greek, Latin, French, and German at a boarding school, the Eastern Siberian Institute for Noble Girls in Irkutsk north of Mongolia.

At age twenty-five, Anna Bek gained her uncle's support of an academic career in pediatrics. She broadened her research into underprivileged children at Women's Higher Courses in St. Petersburg. In summer 1895, she aided starving Tatars in Ufa north of Kazakhstan before traveling to the medical school at the University of Nancy, France. She deepened physiological knowledge from six years at the Women's Medical Institute in St. Petersburg. Banishment for one year to Siberia on May Day 1901 punished the physician for defying the military draft and organizing a student strike in support of a peasant revolution.

The Two Beks

In summer 1901, at age thirty-two, the physician resettled in Nerchinsk Zavod, Manchuria, and fell in love with Evgeny Vladimirovich Bek, whom she met at a hospital to the east of Ufa. Their romance grew from her translation of French writings for his use and their mutual hobby of classical music and Georges Bizet's opera *Carmen*. Eight months later, they wed and partnered in researching *Osteoarthritis deformans endemica,* a common skeletal disease that caused premature aging in teens and skewed limbs, possibly from minerals in drinking water. Released from exile, she returned to studies in St. Petersburg, where she bore a child who died in infancy of gastroenteritis and dehydration.

Again in Siberia, in 1904, the medical couple spent a year treating injured combatants of the Russo-Japanese War. During 1905 in St. Petersburg, Anna Bek bore Lyudmila Bek, a healthy daughter nicknamed Lyusya. While Evgeny set up a practice among Cossacks in Aksha on the Mongolian border in 1906, in 1909, Anna Bek established a community center to aid at-risk children. She read texts by William James, Maria Montessori, and Ivan Pavlov on psychophysiology, the interdisciplinary science of physical diseases exacerbated by emotional stress on the immune system. Local citizens honored the altruistic couple by naming a hospital for Evgeny. At age forty-three, Anna Bek combined medical practice in Chita to the north with classroom teaching of physiology, psychology, science, and adult literacy. In retrospect, she wrote the personal essays "A Year in Nerchinsk Zavod" and "Recollections of Life in Aksha." The outbreak of world war in 1914 forced Evgeny into the Russian military. While Anna continued her dual career in Chita, her husband contracted typhus from imprisoned Turks and, in 1915, at age fifty, died of tracheal obstruction.

The Doctor Alone

During the Russian Civil War, Anna Bek centered her expertise in Chita among Cossacks. In 1919, she managed the area's mental hospital while shielding local school supplies from invasive anti–Bolshevik rogues. With the victory of Red Russians against White Russians in November 1920, she relocated to Irkutsk near Lake Baikal with fifteen-year-old Lyudmila, who gave birth to Anna's grandson, Evgeny Konstaninovich. During the rise of the New Woman in the 1920s, Anna Bek and other female intellectuals expected liberation from patriarchy. She managed to publish scholarly treatises—"The Process of the Development of Thought" and "Basic Landmarks in Sex Education," but incurred professional harassment for radical theories of impairment in child learning.

For seven years, west of Chita, Anna Bek served the staff of Irkutsk University as professor of psychology and pedology, the holistic study of physical and intellectual development in children. By 1927, she headed the pedology department and chaired pedology farther south in Novosibirsk in 1930 at an institute safeguarding

child and teen health. On the Ob River, a similar post in Tomsk in 1932 during the Great Purge resulted in her brother's arrest by Stalin's army and their father's death in a Siberian labor camp. Despite a period of political scrutiny of her academic philosophy, she reassured her daughter and son-in-law of her safety. At age sixty-five, she resigned.

CAREER'S END

The physician moved to Novosibirsk to chair research in children's health at a kindergarten and clinic. On July 4, 1936, a Communist evaluation of her theories of mind and body condemned pedology as fake science. The author refused to accept party views on the concept and lost her job in the psychology department. For seven years, while living in a barrack apartment, she treated patients at a children's clinic and industrial trade school and lived out World War II as a day care consultant near her daughter's family. After arthritis disabled her, she began compiling memoirs at age seventy-nine and died in 1954. Of a committed life, she concluded, "How pleased my father would be if he were alive" (Bek, 2004, 117).

Anna Bck's personal reminiscences indicate less grief over periods of hunger, widowhood, and penury and fear of surveillance and professional betrayal than joy in four grandsons and tender reflections and verses dedicated to Evgeny. She respected Bolshevik philosophy, but declared conferences dull and pointless. She admitted, "One of my shortcomings was that I always evaluated people according to their moral qualities and not according to their political convictions" (*ibid.*, 99). Perhaps from policy clashes of the tsarist, Marxist, and Stalinist eras, she grew apolitical in the essays "1952," "On the Adaptation of Men and Women to Life Together as They Enter Marriage," and a biography, "The Life of Evgeny Vladimirovich Bek."

During frequent moves, Anna Bek honored the great-heartedness of neighbors, colleagues, and strangers who eased her travel with free lodgings. Her feminism extolled Russian women who sought dignified work as outlets for their intelligence and ingenuity, especially the valid training of handicapped children. In 1995, a plaque on the Beks' former Aksha residence acknowledged her social activism and dedication to pediatrics and industrial trade schools.

Source

Bek, Anna. *The Life of a Russian Woman Doctor.* Indianapolis: Indiana University Press, 2004.
Hutton, Marcelline. *Resilient Russian Women in the 1920s & 1930s.* Lulu.com, 2015.

Dara Rasmi (August 26, 1873–December 9, 1933)
playwright, costumer, linguist, singer, dancer, fabric artisan
Siam

A royal Siamese wife and talented musician, Princess Dara Rasmi (also Rarsami or Rasami) introduced Bangkok to the stage plays of the northern Thai. A native

of Chiang Mai Province on the Ping River in northwestern Siam, she was born on August 26, 1873, in a jungly district overrun by tigers and elephants and infiltrated by teak loggers from England. Her parents, Queen Thip Keson (or Kraisorn) and King Inthawichayanon, educated her in northern and southern Thai and English and in complicated court courtesies, song, and dance. After the childhood death of a sister, Chanthra Sopha in 1868 from a failed vaccination, Dara Rasmi allegedly came to the attention of Queen Victoria, who considered adopting her. One of ten royal siblings, she lost her mother in 1884, when her father sank into grief and despair. For two years, she passed to the care of Aunt Ubonwanna, an historical scholar, folklorist, and skilled silk weaver who taught Dara Rasmi storytelling and fabric design.

To stave off potential fostering in England, on February 4, 1886, at age twelve. Dara Rasmi became the ninth consort of 33-year-old Chulalongkorn, Siam's polygamist ruler Rama V, who acquired 150 consorts during his reign. She arrived by houseboat to a state dinner at the summer palace and received introduction to nobles. The marriage united the Chakri royal house with Dara Rasmi's lineage, the Chet Ton dynasty, which dominated the northern provinces. Historians surmise that the union had inspired her parents to heighten her value by spreading rumors that Queen Victoria wanted to add her to an imperial British household.

The new royal wife and her ladies in waiting ignored mockery of their northern origin and long hair and charges that the ethnic minorities reeked like fish paste. In the women's compound, they played cards; swam; sang and danced; smoked cigars; and played the fiddle, flute, drum, mandolin, and piano. On private jaunts with the king, Dara Rasmi bicycled and picnicked on the river. At age sixteen at the Grand Palace in Bangkok, she produced an only child, Princess Vimolnaka Nabisi, who survived two years and eight months and died on February 21, 1892. To prevent grief, the royal mother reared nieces and nephews and had them educated in England and France.

A RISING STATUS

At age thirty-five, Dara Rasmi accepted promotion as fifth wife and high queen, translator, and consultant at court meetings with visitors from the north, including an annual diplomatic call by her brother. She gained permission to visit her family in the north and journeyed by train and boat to Chiang Mai. On departure through the Samsen depot, she unpinned her hair and spread it to wipe the king's feet, an extreme public gesture of fealty. For the ten-week itinerary, Chulalongkorn insisted that she have two male chaperones, one of them the king's brother.

In step with her husband's vision, Dara Rasmi set out to modernize her homeland. On arrival, royalty and the military welcomed her home. The king filled the six-month absence with seventeen gossipy, yearning letters and thirty-four telegrams. Following her rehabilitation of Buddhist temples and construction of government housing, a movie theater, hospital, and orphanage, she relocated ancestral

bones to a new clan cemetery at War Suan Dok. Chulalongkorn organized a 100-boat reception on her return. The couple retreated to the summer palace for a private two-day reunion.

The king endowed Dara Rasmi with a European-style two-story house in Dusit (Celestial) Garden in central Bangkok featuring gray brick sheltered by a red tile roof. A state portrait featured her olive-shaped eyes and composed features in Victorian high-neck dress with puffed sleeves, pearl choker, red sash, and royal star-burst medal and cordon with understated crown above waist-length hair mounded in a bun. A formal photo displayed her blended outfit—a northern Thai tube skirt in border print and lacy white overblouse in English style. The outfit acknowledged her ability to integrate multiple cultures.

Dara on Stage

Introduction to Bangkok theatricals in the 1890s inspired Dara Rasmi to import northern *lakhon* (dance theater), a stage show displaying the harmonizing of outside entertainments in Siam. The king composed *Ngo Ba* (Wild Man) in 1906 envisioning the civilizing of a jungle boy and incorporated tribal music. Dara Rasmi facilitated an original palace adaptation of *Sao Krua Fa* (Lady Krua Fa), a favorite of Chulalongkorn since his spring-summer 1906 tour of Teatro Regio in Turin, Italy, where Arturo Toscanini conducted the score of Jacomo Puccini's East-West opera *Madame Butterfly*.

Key to the Lao-style melodramas, the queen's dressing of the cast in northern costumes and training actors in Lao speech and intonation appealed to audiences as exotic touches. The orchestra mixed Burmese, Chinese, Cambodian, Indian, Malay, Javanese, and European instruments and phrasing to accompany Buddhist candle choreography and the northern fingernail dance, requiring five-inch finger extensions ending in sharp curving points. She scripted musicals and produced an original romance, *Phra Loh Waen Kaeo* (Lady Crystal Ring), a Romeo-and-Juliet tragedy ending in suicide. In summer 1909, she aided dramatist Narathip Praphanphong, Chulalongkorn's brother and head of the royal company, in readying a script for the stage tragedy *Phra Law* (King Law) for performance at the Pridalai Theatre, Siam's first permanent playhouse.

Three years after Chulalongkorn succumbed to sepsis and kidney failure on October 23, 1910, Dara Rasmi repatriated to Chiang Mai only five months before the onset of World War I. At Daraphirom Palace, built in 1913, she remained faithful to official duties and appearances and patronized northern stage traditions, textile artistry, and folk history. She continued refining competence on musical instruments and erected a weaving pavilion for making her signature shoulder bags. She superintended a dance rehearsal hall, the training ground of foster daughter Chatrsudha Wongtongsri and a sixteen-member youth troupe. In 1931 at her truck farm, she modernized cultivation of hybrid roses, tamarind, carrots,

beets, bamboo shoots, cabbage, apples, cherries, and mangosteen, a sweet-sour fruit.

In June of Queen Dara Rasmi's fifty-ninth year, a respiratory illness recurred, for which she received traditional and Western medical care. At age sixty on December 9, 1933, she died at her brother's modest estate at Khum Rin Keaw in Chiang Mai. The naming of Hospital Dararatsami and Dara Academy preserved her memory. A portrait statue at her residence, Suan Chao Sabai (Garden of the Princess's Happiness), captured a sincere expression and serene pose. Local Siamese celebrated her August birthday with Buddhist chants and staged dance.

Source

Woodhouse, Leslie Ann. *Light of a Northern Star: A Foreign Concubine in the Siamese Palace*, staticl.squarespace.com/static/5b03626845776e606944deea/t/5b200b17352f537875aa4 16f/1528826773781/Woodhouse+Dissertation.pdf

_____. *Woman Between Two Kingdoms: Dara Rasami and the Making of Modern Thailand.* Ithaca, NY: Cornell University Press, 2021.

Devi, Shukumari (1874–1938)
embroiderer, alpana painting
Bengal

Devi, Pratima (1893–1969)
costumer, alpana painter, fresco artist, ceramicist, batik artist, stage designer, lino artist, embroiderer, writer
Bengal

Devi, Shanta (1893–1984)
quilter, oil painter, novelist, short story writer, translator
Bengal

Ghose, Indusudha (1903–1995)
embroiderer, painter, lino artist, writer
Bengal

Bhanja, Gouri (1907–1998)
embroiderer, batik artist, leather worker, alpana painter
Bengal

Chanda, Rani (1912–1997)
painter, ceramicist, watercolorist, leather and metal worker, batik artist, woodcut and lino artist, travelogue writer, memoirist, biographer, short story writer
Bengal

Sen, Jamuna (1912–2001)

fresco artist, painter, lino artist, alpana painter, embroiderer, batik artist, dancer
Bengal

Chowdhury, Chitranibha (1913–1999)

photographer, painter, pastelist, watercolorist, woodcarver, muralist, portraitist and woodcut artist, memoirist, essayist, singer, sitarist
Bengal

A multitalented female coterie at Santiniketan, Northeast of Calcutta, India, the students of artist Nandalal Bose vitalized the Bengal School of Art. By expressing silenced ideals, his pupils developed Bengali folk styles into modern nationalism. In 1919, the teacher mastered ceramics, needlework, decoration, printmaking, fresco, and painting techniques at Kala Bhavana, the fine arts institute of Visva-Bharati University in Santiniketan west of India's border with Bangladesh. Favored by poet Rabindranath Tagore, the Bard of Bengal, Nandalal Bose based curriculum on such ancient principles as idol making and applied them to illustration of the constitution.

In pure Indian design, Nandalal Bose educated his daughters to "[reignite] the indigenous paint style and [popularize] pan–Asian art" (Chowdhury, 2020, 71). Born in 1907 to Sudhira Devi and Nandalal, a prestigious devotee of classical Indian murals and principal of experimental art classes, art teacher Gouri Bose Bhanja grew up under British colonialism, but learned innovative arts in her hometown. A younger sister, Jamuna Bose Sen, became a fresco artist, painter, modeler, and lino cutter, imitator of woodcut on a sheet of linoleum. Jamuna specialized in indigenous tempera, chalk, crayon, watercolor, and dance under Nandalal and Tagore and later joined the university staff. Gouri's batik style of merging color with wax emulated brown and gold Javanese designs and introduced northern India to the lost wax method, which reverses painting by applying melted paraffin to a surface to resist dyeing. She added katha (storytelling) stitchery to colorful embroidery by recycling older pieces and quilting them together.

The sudden illness and death of Shukumari Devi in 1938, a 64-year-old teacher and bold colorist in needlework and alpana ritual and celebratory art, pressed Gouri Bhanja into a faculty post while she managed marriage to Santosh Bhanja and their five-year-old daughter Kalyani and son Pradyot. For thirty-five years, she built on her father's teaching and on Shukumari Devi's classroom work in stitchery and alpana images of deities of the Puranas, Sanskrit literature from 500 BCE. Her skill at alpana painting demonstrated the blending of flour and rice powder into a paste for painting traditional mortality and rebirth motifs with a bamboo slat, jute stick, or date palm thorn. Under founder Tagore, she decorated the school for celebrations. She also taught students leather working, needlework, and batiking, a craft she

introduced to the curriculum. After her death at age ninety-one in 1998, the nationalism of Santiniketan in West Bengal returned to prominence in the 2000s with the Philadelphia Museum's show "Rhythms of India: The Art of Nandalal Bose."

New Adherents

A third neophyte, Rani Dey Chanda of Midnapore west of Calcutta, studied art, woodcut, and paint blending from natural materials. In addition to mastering ceramics, brass and pewter molding, batiking, and leather work, she performed in Tagore's stage shows. Under his direction, she made art prints, adapted stories into a collection, *Ghorora* (Domestic), and became his scribe. After jailing at age thirty during the 1942 Indian Freedom Movement, she summarized the experience in the prison memoir *Jenana Phatak* (The Army's Gate). Her travelogues, *Purnokumbho* (Waterpot) and *Pothe Ghate* (On the Road to the Pier), related adventures with her husband, poet Anil Kumar Chanda, in Russia and Eastern Europe. In the biographies *Alapchari Rabindranath* (Tagore in Conversation) and *Manush Nandalal* (Nandalal's People), she described the teacher's classroom use of anecdotal lessons. She encouraged other artists with the advice book *Shab Hote Apon* (Be All You Can Be).

In a colonial British era dominated by oil painting, Chitranibha "Nibhanani" (Sparkling) Basu Chowdhury, a pupil from Murshidabad in northwestern Bengal, studied alpana and other indigenous art in Tripura in eastern Bengal. She performed Tagore's verse and songs and sketched theatrical scenes from plays. After marriage at age fourteen to a nationalist, from 1927 to 1935, she painted while tending preschooler son Ranajit and daughter Chitralekha. With a box camera, she evolved a more vibrant style of landscape viewing from Nandalal and Tagore at Kala Bhavana at Santiniketan, where she taught for a year as the first female professor. The school preserved her mural "Shiber Biye" (Shiva's Wedding). At the dawn of female enfranchisement in the Indian arts, her watercolors appeared in the journal *Jayshree* (Victory Goddess).

While conservatives viewed female self-expression as unnatural and subversive, Chitranibha Chowdhury gained an audience for her massive murals, elaborate alpanas, ceramics, and unconventional yellow and green pastels and watercolors of Durga worship and botanical settings. She made pencil portraits of Gandhi, Pratima Devi, Nandalal, and Tagore surrounded by his devotees. Her media ranged from woodcarving to competence on the sitar, bowing the eshraj (stringed instrument), and plucking a veena (zither). Her memoir *Rabindrasmriti* (Memories of Tagore) encapsulated an artistic link to the poet. After 1937, she defended women's liberation with the essay "In the Bower of Art." To emancipate more females, she founded art and music schools at Noakhali and Calcutta for the poor and elderly and managed craft festivals. At Lamachaur in the Himalayas of north central India, she founded her own academy.

Teachers and Artisans

Another pupil of Nandalal during the *swadeshi* (independence) movement, Indusudha "Indu-Di" Ghose (or Ghosh), got a start in photography at Mymensingh (modern Bangladesh), where she completed high school. A quiet freedom fighter who boycotted colonial goods and wore cotton saris rather than silk, she progressed to embroidery, linocuts, and painting in 1926 and entered the all-male Kanushangha art guild. Her stitchery motifs filled the union journal *Shiboni* (Shiva); she submitted "Alankarik Shilpa (Decorative Art)" to the winter 1930–1931 issue of *Visva Bharati University Quarterly*. She chose a classroom profession at Sister Nivedita Girls School in Calcutta. As a lure to more young enrollees, she received appointment in 1930 at age twenty to Kala Bhavana. At age 35, she dedicated herself to instructing poor women at Allahabad south of Nepal to support themselves with crafts.

Another Nandalal protégé, Shanta Devi of Calcutta, a quilter and oil painter born in 1893, mastered English as well as avant-garde painting elements. She deviated from traditional Indian motifs to unique designs in rice paste painting and quilting. While earning a degree from Bethune College, she issued *Hindusthani Upakatha* (Hindustani Legends), a fiction anthology of translated lore, and wrote the story "Sunanda (Lovable)" for *Prabasi* (Expatriate) journal. She taught "Brer Rabbit" tales to nursery school classes. With sister Sita Deva, Shanta composed the serial *The Eternal,* the social survey *Purbasmriti* (Old Memories), and the novel *Udyanlata* (The Garden), which highlighted characteristics of India's "new woman."

The most diverse of Nandalal's students, painter Pratima Devi of Calcutta, Tagore's daughter-in-law, acquired esthetics from an artistic household and from mentoring by the poet himself. She studied in Paris and added batiking, ceramics, and fresco art to her media. She wrote art books—*Nritya* (Dance), *Smritichinha* (Memorabilia)—and compiled a verse anthology *Chitralekha* (Image Writing). For Tagore's dance dramas—*Valmiki Pratibha* (Anthill Talent, 1881), *Kalmrigaya* (The Fatal Hunt, 1882), *Mayarkhela* (Maya's Game, 1888), *Chitrangada* (Illustrations, 1913), *Shrabangatha* (River Story, 1934), *Shapmochan* (Snake Curse Redemption, 1934), *Chandalika* (The Wretched, 1938), and *Shyama* (Blue-Black, 1939)—she designed stage sets and costumes.

Source

Biswas, Prarthita. "Sita Devi-Shanta Devi and Women's Educational Development in 20th Century Bengal," *Paripex* 1:4 (January 2012): 23–24.

Chowdhury, Chitranibha. "In the Bower of Art," *Art in Translation* 12:1 (January 2020): 71–81.

Das, Shilpi. "Indusudha Ghose: Between Art and Revolution," www.theheritagelab.in/indusudha-ghosh-between-art-and-revolution/

Ghose, Indusudha. "Alankarik Shilpa," *Visva Bharati Quarterly* 8 (Winter 1930–1931).

Haq, Fayza. "The First Woman Painter of Bangladesh," (Dhaka) *Daily Star* (20 December 2013).

Mahoney, Ursula. "Batik Is Painting in Reverse," *New York Times* (8 June 1975).

Sarkar, Sebanti. "Print the Legends," *Business Line* (16 June 2017).

"Women Artists of Bangladesh," www.wikiwand.com/en/Women_Artists_of_Bangladesh.

Kartini, Raden Adjeng (April 21, 1879–September 17, 1904)
letter writer, essayist
Dutch East Indies

An anti-colonial freedom fighter in a polygamous household, Raden Adjeng Kartini pressed for equality and economic independence for the Javanese female. The eldest of three daughters and five sons of Ngasirah of the House of Madeira and Ario Samingun Sosroningrat, a Dutch East Indian bureaucrat and chief of Mayong in east Java, she was the granddaughter of Prince Ario Tjondronegoro IV of Damak, a proponent of Javanese independence. Her mother had a limited education in untranslated Koranic verses and minor phrases in Malay and trained her family in the aristocracy's stiff formal etiquette. A higher rank than her mother, Raden Adjeng Kartini was born to privilege in Jepara, central Java, on April 21, 1879. Complex proprieties required younger siblings Roekmini and Kardinah to kowtow and give preference to their older sister but never to exchange sweet talk or kisses.

Trained to age twelve in a free Dutch school for affluent Eurasian and Dutch pupils, the letter writer sparred for post-primary education, which colonial officials denied. While confined in the "box" (home) to practice embroidery and cookery, she could not cross the road in front of the house, which seemed like a prison (Kartini, 1919, 592). To end women's arbitrary social and educational restraints against meeting friends and learning European languages, she directed a campaign of letters advocating the edification of Dutch colonists. Her crusade stated the rights of females to learning, travel, and career opportunities.

Because her father married a second spouse, Raden Ayu Moerjam, of a higher class, Raden Adjeng Kartini's birth mother was reduced to concubine and moved from the main house. During four years of home detention, the daughter's urgent demand for women's education and elevated self-esteem began with a Dutch pen pal and intense reading of Western media, European magazines, and nonviolent feminist fiction. Her father remained adamant in denying her medical training in Holland, but relented on schooling for girls by allowing teacher training in Batavia (modern Jakarta). From daily visits to feminist mentor Mevrouw "Marie" Ovink-Soer, she and her sisters learned feminine crafts. With younger sister Ayu Rukmini Raden, she traveled to Tokyo to examine classroom opportunities. Her brother Kartono superintended all in-house reading.

READING THE WORLD

Literature broadened the author's knowledge of world issues, notably, Marie Ovink-Soer's articles for *De Hollandsche Lelie* (The Dutch Lily), a socialist women's magazine. From Eduard Douwes Dekker's satiric novel *Max Havelaar; or, The Coffee Auctions of the Dutch Trading Company,* she gained insight into colonial corruption and worker oppression. She welcomed a new Dutch language newspaper for islanders and sent articles to the *Hollandsch Revue* and *Suara Merdeka* (Voice of Freedom),

the media outlet of Semarang, Java's capital. By advertising for a pen pal in the *Dutch Lily,* after May 25, 1899, Raden Adjeng Kartini corresponded with Jewish feminist Estell "Stella" Helena Zeehandelaar, a Dutch postal officer. Her forceful opinions proclaimed to Estell beliefs in God, wisdom, beauty, humanitarianism, and national pride and denounced the arrangement of marriages between strangers.

Within months, the letter writer added Puerto Rican activist Rosa Manuela Abendanon-Mandri, a women's rights advocate, to her missives and proposed a comprehensive school system enrolling rural and laboring-class women. She stressed arts, sciences, and character development in a closed society where "not to marry is the greatest sin that the Mohammedan woman can commit" (*ibid.,* 593). Of the injustice of polygamy, she asserted that "age-long traditions that cannot be broken hold us fast cloistered in their unyielding arms," yet hesitated to rebel lest she hurt her beloved parents (*ibid.,* 592). She entered a new correspondence with French teacher Anneke "Annie" Glaser and linguist Dr. N. Adriani, a Christian minister who wrote earnest advice to her.

In April 1902, Raden Adjeng Kartini shared with engineer Henri Hubert van Kol, a socialist leader, a flair for spiritualism. Her séances incorporated Islam with Javanese animism, a reverence for saints and ancestors at cemeteries. He proposed that parliament permit her to enter a school in Holland to spread views on obliterating colonial hegemony in the Dutch East Indies, but her father's reaction convinced her to reject a government grant. In addition to choosing vegetarianism as a religious lifestyle, she upheld faith in women in January 1903 by composing "Educate the Javanese," a manifesto written to the colonial governor, Willem Rooseboom, to enlighten commoners and to train European overlords in the history and culture of the Indies.

A Conventional Life

At age twenty-four, after securing permission to enroll in a Batavian school, on November 8, 1903, Raden Adjeng Kartini entered an arranged wedlock to fifty-year-old Chief Raden Adipati Joyodiningrat of Rembang, a husband to three wives and father of seven children. Against the narrow traditions of her homeland, she nurtured plans to develop Javanese woodcarving and to write a book. Her husband enabled her career goal of opening a girls' elementary academy for the daughters of regents on his office porch. She bore a son on September 13, 1904, and died four days later at age twenty-five. Within months, her father also died.

Adherents of the "new woman" funded a school effort, which spread girl's academies at Batavia, Bogor, Buitenzorg, Cirebon, Madiun, Malang, Semarang, Soerakarta, Surabaya, and Yogyakarta. Her self-education undergirded the Kartini Schools and three published letter collections: *Out of Darkness to Light, Letters of a Javanese Princess,* and *Women's Life in the Village.* The first volume, issued at the Hague in 1911, preceded five Dutch editions and an English version, *Letters of a*

Javanese Princess, published in 1920. The *Atlantic Monthly* serialized her letters in the November 1919 issue with "The Old Life and the New Spirit." The series featured "A Javanese Wedding" in December and "The New Woman in Java" in January 1920.

Raden Adjeng Kartini's heroism spurred three sisters and their brother Boesono to continue dignifying Javanese women through opportunity and roused Governor-General Joannes Benedictus van Heutsz to open vocational and craft schools to make females self-supporting. Brother Roekmini delivered Javanese woodcrafts to retailers in European shops and shows. The activist inspired the 1950 formation of Gerwani, the Indonesian Women's Movement, and earned a portrait on a five-rupiah banknote and, in 1985, on a 10,000 note (worth 70¢). In 1964, President Kusno Sukarno proclaimed her a national hero and named her birth date *Hari Ibu Kartini* (Mother Kartini Day), a celebration of gender equality.

Source

Bijl, Paul, and Grace V.S. Chin. *Appropriating Kartini: Colonial, National and Transnational Memories of an Indonesian Icon.* Singapore: Yusof Ishak Institute, 2020.

Kaptein, Nico J.G. "Two Unknown Letters from the Kartini Family to M.J. de Goeje," *Archipel* 93 (2017): 109–117.

Kartini, Raden Adjeng. *Kartini: The Complete Writings 1898–1904.* Melbourne, Australia: Monash University, 2014.

_____. *Letters of a Javanese Princess.* Scott Valley, CA: Create Space, 2012.

_____. "The Old Life and the New Spirit," *Atlantic Monthly* 124:2 (November 1919): 591–602.

Swaim-Fox, Callan. "Kartini Day," *Meridians* 19:1 (2020): 136–146.

Bayhum, Nazik Khatim al-'Abid (January 18, 1887–1959)
journalist, columnist, publisher, orator
Ottoman Syria

A feminist magazine columnist and anti-colonialist, writer Nazik Khatim al-'Abid Bayhum (also Naziq Beyhum) enacted gender precedents for Syrian Muslim women. Born of mercantile roots on January 18, 1887, in Hayy al-Akrad, the Kurdish district of Damascus on Mount Qasiyun, she was the daughter of Mustafa Pasha al-'Abid, an administrator and ambassador to Kirkuk and Mosul, Iraq. As the niece of Grand Vizier Ahmad Izza al-'Abid (also al-'Abed), publisher of the newspaper *Damashq* (Damascus) and counselor of Sultan Abdul Hamid II, she made connections to Arab nobility. Private tutors and schools in Istanbul educated her in literature and languages. During her family's exile to the largely Greek city of Smyrna (Izmir) on Turkey's Aegean coast in 1908, she mastered French and German at American, French, and Turkish academies and completed an architecture degree at Istanbul's Women's College.

In her mid-twenties, Nazik Khatim al-'Abid stirred feminist followers by collecting books for a public library and submitting articles to magazines denouncing the Young Turks faction for unseating Sultan Abdul Hamid II on July 24, 1908. For backing the 1914 women's movement and condemning militarization of the empire,

Governor General Jamal "the bloodthirsty" Pasha exiled the author to Cairo for four years, until the overthrow of the Ottoman regime on October 30, 1918. During the conflict, she volunteered to tend Arab wounded. In January 1919, she rode horseback in jodhpurs and boots to small towns and delivered speeches on justice. Her themes derogated the Ottoman occupation, anti–Arabism, and the partitioning of Syria. Editorials posted under a male pen name in her journal *Nur al-Fayha'* (Light of Damascus), the name of the first feminist organization in Damascus, offered a sounding board for opinions on arranged marriage and head-to-toe veiling. The editorial office immediately received a flood of submissions from Syrian feminists.

With a strongly Arab stance, in February 1920, the journalist's column stated that op-ed articles "will arrive at truths worth expressing, and so lift this wretched nation from the ruin of misery ... that shame and despair bequeathed to us" (Thompson, 2000, 121). In June, she proposed an end to sectarian hatred and the inclusion of women in consortia planning a secular state. At a high point in allied discussions before the King-Crane Commission in Turkey of Syria's secular future, before twelve female cohorts, she ripped off her hijab in the presence of U.S. President Woodrow Wilson and American diplomats and inveighed against a proposed French seizure. By the fall, the author's mother joined her and the journal staff in public unveiling.

Soldier and Medic

The author gained post–World War I homage on July 7, 1920, by equipping a pan–Arab field hospital and forming the Syrian Red Star Association, the forerunner of the Syrian Red Crescent Society and International Red Cross. The organization alleviated suffering while demanding respect for all victims. Prince Faisal I promoted her as the first woman *naqib sharaf* (honorary general) of the Syrian Arab Army for marching in the streets in an army uniform and leading a medic battalion. The female phalanx clashed with rebel forces along the Beirut-Damascus highway on July 21, 1920, at the four-hour Battle of Maysalun, a defeat for Faisal by 9,000 French forces. Nonetheless, Syrians printed her veil-less photo in newspapers and proclaimed her the nation's Joan of Arc and the Sword of Damascus. Admirers ranked her on a par with seventh-century female poet-warrior Khawla bint al-Azwar, who incited women fighters with epic verse and treated the wounded in July 634 after the Battle of Ajnadin, Israel.

Faisal's ouster and the cessation of Nazik Khatim al-'Abid Bayhum's magazine in July 1920 caused her to flee to Jordan and take up feminist writing and humanitarianism. In 1921, the French granted her amnesty to return home. She revived issues of women's needs in 1922 by opening the *Nur al-Fayha'* school for female war orphans to learn sewing, textiles, and English and joined Lebanese feminists in creating the Women's Union. Her military role in a Syrian rebellion on Jabal al-Duruz (Druze Mountain) in 1925 preceded her role as outlaw, combat medic, and smuggler of munitions, weapons, and food and medical supplies to guerrillas hiding in

Damascus. The French threatened imprisonment and forced her to seek asylum in Lebanon.

PEACETIME ACTIVIST

During Nazik Khatim al-'Abid's banishment, at age forty, she wed Arab-Lebanese historian and delegate to the 1919 Syrian Congress Muhammad Jamil Bayhum al-Itani of Beirut, a Sunni women's suffrage advocate and author of *The Evolution of Thought on the Subject of Arab Women during the Twentieth Century*. With her husband, the author offered craft training to rural widows, lectures, and hospital visits through the Damascene Women's Awakening Society. The couple funded publication of *Al-Sufur wa al-Hijab* (Veiling and Unveiling). Written by Nazira Zayn (also Zain) al-Din, the scandalous treatise rallied women's liberation from male ownership. The Druze Lebanese free thinker declared the hijab mentally stagnating and un–Islamic, a proclamation that outraged Muslim clergy. She promoted unveiling as an advancement to learning and social life.

A year after her cousin, Mohammed Ali Bay al-'Abid, became Syria's president, in 1933, Nazik Khatim al-'Abid joined her husband in founding the Association for Combating Prostitution, a sex trafficking practice espoused by the French. She established *Niqâbat al-Mar'a al-'Amila* (The Association of Working Women), a Kurdish organization that lobbied to elevate housewives. She intended to free lower class women from financial bondage by offering sick leave, maternity pay, and equal salaries. At age sixty-one, she chaired a Beirut employment agency to aid Palestinian refugees of the 1948 Arab-Israeli War and raised money for a children's hospital. She remained active in both projects until her death in free Syria 1959 at age seventy-two. Her widower survived to 1978 and continued their egalitarian campaigns. In 2011, a postage stamp featured her pensive portrait.

See also Khawla bint al-Azwar.

Source

Bamyeh, Mohammed A., ed. *Intellectuals and Civil Society in the Middle East*. London: I.B. Tauris, 2012.

Din, Nazira Zayn al-. *Unveiling and Veiling: On the Liberation of the Woman and Social Renewal in the Islamic World*. Toronto: University of Toronto Press, 1928.

Moubayed, Sami. *Steel & Silk: Men and Women Who Shaped Syria 1900–2000*. Seattle, WA: Cune, 2006.

Sachs, Fruma, and Sharon Halevi. *Gendering Culture in Greater Syria*. New York: Bloomsbury, 2015.

Thompson, Elizabeth. *Colonial Citizens*. New York: Columbia University Press, 2000.

Ohanian, Armen (1887–1976)

dancer, choreographer, actor, poet, memoirist, novelist, translator, producer, director, travel writer, essayist

Armenia

A multitalented writer of fifteen books, lecturer on poetry, and promoter of heritage arts, Armen Ohanian influenced dance and culture centers in Armenia, Russia,

France, England, and Mexico. A Christian from Shamakha in east central Armenia (modern Azerbaijan), she was the daughter of an illiterate Georgian embroiderer, Koutchoulou, and poet Emanuel Pirboudaghian, an Armenian leader, and sister of math expert Anahide, folklorist Heguine, Marian, and Katarine, who died in childhood. During a cholera outbreak, Armen Ohanian studied arithmetic, geography, and French in Toutou Se and spent quarantine time playing the tambourine and *thar* (lyre).

After an earthquake rattled the southern Caucasus on February 13, 1902, and demolished her hometown of Shamakha, at age fifteen, Armen Ohanian relocated to the Caspian seacoast at Baku, Azerbaijan, an oil-rich city that became the new capital. To survive famine, her family cached their limited food stores. They endured incursions by nomadic Tatars, a Turkic race. During Russian pogroms instigated by Tsar Nicholas II, Cossacks shot her father in the 1904 persecution of Jews. A year-long marriage to Armenian-Iranian physician Haik Ter-Ohanian preceded her flight south to Persia (Iran) and mastery of highly gendered exotic dance and costume, a taste of home to alleviate the exile.

A New Woman

In 1906, at age nineteen, Armen Ohanian dropped her birth name of Sophia Emanouely Pirboudaghian for a gender-neutral identity. In Moscow, she studied at Lidiia Nelidova's School of Choreography, a groundbreaking introduction of budding ballerinas to Bolshoi methods and a source of recruits for stage impresario Sergei Diaghilev. She debuted as a dancer at Moscow's State Academic Maly Theatre of Russia and singer at the Georgian National Opera at Tbilisi. Taking advantage of liberalized women's rights, she co-founded Tehran's Persian National Theater and performed for Reza Shah Pahlavi, the 31-year-old founder of Persia's Pahlavi dynasty. Before his throne, she recalled the solo: "I rose, spreading my veils like transparent wings, and advancing into the open space, began my dance" (Ohanian, 2018, 198). In May 1910, she played a governor's daughter, Marja Antonovna, in Nikolai Gogol's *The Government Inspector*, a satire of imperial corruption performed in Farsi under Armen Ohanian's direction.

The Armenian dancer performed Eastern steps and gestures in the intuitive style of American dancer Isadora Duncan, a European sensation. A tour took Armen Ohanian from Iran to Alexandria, Jerusalem, and Athens and before the Armenian Khan Yeprem in Constantinople. She continued to London on a one-year contract that boosted her to stardom. In Cairo, she quailed at the bestiality of cabaret belly dance, which aficionados revered as a tribute to mothers in labor. Shocked, she charged, "The spirit of the Occident had touched this holy dance, and it became the horrible *dance du ventre* (dance of the stomach), the *hoochie-koochie*" (*ibid.*, 246). Audiences in Belgium, Germany, Italy, Bulgaria, and Spain warmed to the ethnographic appeal of her more tasteful Shamakhi or Caucasian sinuosity in "At the

Temple of Anahit," "The Great Khan of Shamakha," "Haschich (Hashish)," "The Matchmaker," "Towards Nirvana," "Treason," and "Salome," a biographical imitation of the granddaughter of Herod the Great of Judea and the scriptural execution of John the Baptist in Matthew 14:6–11.

GLOBAL FAME

From touring the United States and Mexico, Armen Ohanian relocated to France in her mid-twenties to give recitals and perform for the Société des Savants (Intellectual Society), comprising Far and Near Easterners from India, Egypt, Persia, Caucasus, and Armenia. She settled in a Paris attic and, with the encouragement of elderly French journalist Anatole France, began writing verse and memoir. She started with a classic, *The Dancer of Shamakha*, which flourished in England in Rose Wilder Lane's translation from the French, and in Finland, Germany, Spain, and Sweden. Scenes from her childhood interpreted Asian folklore and contrasted Christian simplicity with the morose wailings of Muslims:

> All Asia lay at our feet beneath the stars, Asia, with its profound melancholy, its languor, its mysticism, its vague desire for death and its ardent love of life.... These voices brought a sense of beauty and of pain, and the mystery of existence [*ibid.*, 30].

Beyond themes of physical decline and death, her observations promoted religious ecstasy and respected the evening rosaries and storytelling by Uncle Ter-Barsegh, a Christian priest. The text characterized her oriental dance as a reverencing of motherhood, a primitive glimpse of infant life issuing from the sacred chalice of the uterus. In December 1921, she published in the *Asia* journal her uncle's Christmas Eve sermon, a dazzling anti-woman jeremiad on Adam and Eve and the fortunate fall preceding Jesus's martyrdom on the cross to redeem sinners.

After marrying economic analyst, author, and translator Makedonio Garza in 1921, Armen Ohanian traveled New York, Paris, the Soviet Union, and Armenia. They made their home in Mexico, where she promoted Communism. She followed with four more autobiographies, the travelogue *In the Sixth Part of the World: Journey into Russia* in 1928, and, in 1929, the novel *The Soloist of His Majesty*. At age forty-nine in 1936, she opened a folk dance school in Mexico City and translated Russian texts into Spanish. A Canadian documentary by Saboteur Productions, *Dear Armen,* toured North American cities in 2014 and screened the details of her life at the 2016 Chicago LGBTQ and International Film Festival and Seattle Queer Film Festival.

Source

Blanchard, Pascal. "Les mondes coloniaux et exotiques dans les grandes expositions parisiennes," *Dix-Neuf* 24:2–3 (2020).

Holtz, William. "The Little House on the—Desert," *Aramco World* 35:6 (November/December 1984).

Ohanian, Armen. *La Danseuse de Shamakha*. Paris: Bernard Grasset, 1918.

———. "My Uncle Ter-Barsegh," *Asia* 21 (December 1921): 998–999.

7

1890s–1920s

Fan Tchunpi (March 3, 1898–September 16, 1986)
painter, ceramicist
Imperial China

A modern era impressionist, Fan Tchunpi (also Fang Junbi or Chun Pi) made history as a Chinese innovator. She synthesized elements from French impressionists Claude Monet, Paul Cezanne, and Auguste Renoir with ancient Chinese *guohua,* a painting style outlining brush strokes in oils and watercolor with pencil and sumi ink made from lampblack. Born to a large family of anti-imperialist Republican elite in Fuzhou, a seaport southwest of Shanghai, on March 3, 1898, she enjoyed the prosperity of the commercial class of tea traders during the fall of the Qing dynasty and the instatement of Republican China. Her younger brother Fan Shengtong, at age twenty-four, died a martyr at the April 1911 Canton Revolution. Her parents abandoned foot binding, taught her Asian tradition from storytelling to strummed accompaniment, and educated her beyond the meager schooling offered to girls.

On scholarship, at age fourteen, Fan Tchunpi traveled to Toulouse, France, with sister-in-law Tsen Sing and sister Fan Tchunying, a school principal and rebel leader, and settled in Montargis southeast of Paris. In company with the post–World War I Lost Generation, the painter abandoned high school and enrolled at Rodolphe Julian's progressive art academy near Place Vendome at 51 Rue Vivienne, the first coeducational sculpture and painting school in the capital city. In a global mix of pupils from Australia, Britain, Canada, Chile, Egypt, Finland, Germany, Hungary, Russia, the United States, and Venezuela, she studied under Spanish portrait artist Amélie Beaury-Saurel. With bourgeois colleagues, she became the first female artist to exhibit works in national fine arts and Salon Society showings.

New Challenges

Progressing to neoclassical and Renaissance influences in January 1917 at l'Ecole des Beaux-Arts (Fine Arts School) in Bordeaux, Fan Tchunpi worked in oils with live models to learn anatomy and chiaroscuro, the subtle contrast of light against shadow. She enrolled in coursework on Assyrian and Babylonian myth and Buddhism. After graduation in 1920, she married her brother-in-law, author and poet

Tsongming Tsen, at Chaparon, on September 4, 1922, and painted a visual feast of color in "Sunset on Lake Annecy," a landmark of their honeymoon south of Geneva, Switzerland. In a period of social and economic uncertainty, her father died and sister Fan Tchunying drank a fatal dose of morphine. *Les Annales,* a prestigious art magazine published at Cambridge University, chose for its cover "The Flute Player," her 1924 rendering of a female instrumentalist dressed in aubergine tunic and ivory slacks. The painting contributed to more canvases featuring womanly facial expressions at a range of ages in traditional and modern dress.

On repatriation to China in 1925, the painter taught the Beaux-Arts tradition at the National Kwongtung University and Zhixin College in Guangdong Province. She mounted a showing in Guangzhou featuring "Dragging a Rattan Leisurely on and Gazing over the Fence." Again in China at Nanjing after a tour of Italy, Spain, and Switzerland, she collaborated with innovators of the Lingnan school, an eclectic art movement from Shanghai integrating French impressionism with Han Chinese ideals from the Yellow River basin. Her canvases expressed an artistic nationalism by reclaiming ancient methods and glimpses of patriotism and still life of squash, melons, banana trees, plum and cherry blossoms, grapes, pomegranates, peonies, wisteria, carnations, lotus, magnolia, chrysanthemum, hibiscus, jasmine, and orchids.

Self-Exile

In 1926, the artist traveled alone to Paris to an atelier at Avenue de Saxe south of des Invalides, painted city roofs, and studied under French painter Paul-Albert Besnard. Four of her works achieved critical acclaim at Jeu de Paume (The Tennis Court) at the Tuileries. At the Académie de la Grande Chaumiere (School of the Big Cottage) at Montparnasse, in 1929, she painted "Girl in Red Dress"; "Reclining Nude"; "The Reading Lesson"; and a nuanced oil study of the female form, "Nu de Dos" (Nude from the Back), a glimpse of glowing flesh against variant green shades. She summarized national poverty in the watercolor and ink work "Blind Beggar with Child," a visual regret for suffering tinged with delight in the traditional sounds of flute and lute.

Before the births in Hong Kong of sons Meng Chi, Wen-ti, and Chunglu Tsen in the 1930s, Fan Tchunpi painted her husband in a studious pose. She toured European studios and focused on landscape art in "A Thread of Sky"; animal realism in "Cat & Flower"; and portraits of Madame Lin, "Meng Chi with Toy Cars," and herself in glossy black. In 1937, she settled in Hong Kong and completed two harbor scenes from variant perspectives. Her endeavors in 1938 included an anthology, *Collection of Fan Tchun Pi's Paintings.*

During an attempted coup at Hanoi in French Indochina (now Vietnam) on March 20, 1939, Fan Tchunpi was widowed and gravely wounded in the thigh and lung by machine-gun fire. She recuperated in Nanjing and Japan and added a sketch of Mount Fuji to her portfolio. At a height in the early 1940s, she produced a likeness

of Mlle. Wang, "Gilded Lion in the Forbidden City," "Willow Tree of the Lotus Lake," and "Still Life with Fish and Vegetables." She began a five-year span of solo art shows, including a Shanghai exhibit honoring her martyred husband.

AFTER THE REVOLUTION

Because of political pressures on artists as a result of the Chinese Civil War in 1949, the painter ended training in Beijing under mentor Qi Baishi and retreated to the safety of Hong Kong. At Montparnasse, she sketched the Notre Dame Cathedral and displayed canvases at the Grand Palais in Paris, other works in Japan and Hong Kong, and thirty oils and watercolors in spring 1951 at the Galerie Lydia Conti in Paris. She showed paintings in Hong Kong in April 1954 and began a two-year survey of Japan, Malaysia, Singapore, and Thailand. In Florence, Italy, she sketched "Italian Landscape" and "Rooftops, Florence," a view of tiled roofs and a single church tower. More exhibits introduced her style in Bangkok, Kyoto, Osaka, Penang, Tokyo, and Singapore, including a watercolor of female oil painter Sun Duoci, "Gnarled Tree, Kyoto," "Temple of Yasaki, Japan," and "Louvre Guard" in pencil, sumi ink, and watercolor.

At age fifty-nine, Fan Tchunpi immigrated to son Meng Chi's home in Brookline, Massachusetts. She concentrated on ceramics and landscape, which she rendered outdoors. She taught at Boston and Cambridge and traveled the United States by VW bus. She and her children donated a valuable collection to the Boston Museum of Fine Arts. Her 1960 ode in oils to widowhood, "The Marshes Have Many Fragrant Grasses," added a simmering effect to New England water and sky. She captured "Peonies in a Vase" in pencil, ink, and watercolor. For "Autumn Moon over Pidan" in pen and ink alone, in 1966, she created a diagonal escarpment of North Korea beneath an impressionistic sky and full moon.

A MASTER ARTIST

The artist completed a masterwork, "White Mountain Landscape," a graceful, but austere view of the New Hampshire peaks emerging from mist. New England provided the impetus for others—"Early Morning," "Autumn in New Hampshire," and "Snow in New England." Out of exile, she traveled Republican China after 1972 and completed one hundred canvases, notably, "Pine Branches" and "Wind in Pine," two simple pencil drawings enhanced with sumi ink. In 1979, Fung Ping Shan Museum at the University of Hong Kong mounted a retrospective of her career. In failing health, she spent her last three years at son Chunglu's home in Geneva.

Two years before her death on September 16, 1986, Fan Tchunpi displayed paintings and ceramics in Paris northeast of the Arc de Triomphe at the Cernuschi (Asian Art Museum) show "Between Tradition and Modernity." The sixty selections characterized the artist's predicament during political upheaval and revolution. Her 1935

painting "Cat & Flower" sold for $31,200 in May 2005 at Christie's Auction; others of her oeuvre have brought $1,217,101. Over September 7–December 8, 2013, a retrospect of 24 canvases at the Hood Museum at Dartmouth College, in Hanover, New Hampshire, reiterated her dynamic transition during the rise of Communist China.

Source

Hanson, Alex. "At the Hood: Natural Beauty, Political Danger" (Lebanon, NH) *Valley News* (10 October 2013).

Lee, Lily Xiao Hong. *Biographical Dictionary of Chinese Women: Twentieth Century*. London: Routledge, 2016.

Taylor, Michael. *Between Tradition and Modernity: The Art of Fan Tchunpi*. Hanover, NH: Hood Museum of Art, 2013.

Chua Jim Neo (February 17, 1907–August 8, 1980)
cultural historian
Singapore

Lee Shermay (1975–)
cultural historian
Singapore

A witness to change during a period of migration to the Malay Peninsula, food historian Chua Jim Neo (also known as Mrs. Lee Chin Koon) captured the impact of diasporas on the Singaporean diet. Born to a family of thirteen on February 17, 1907, in the British Crown colony era, she grew up in a former Dutch port dominated by Malays and southern Indians during statesman Sun Yat-Sen's revolt against the Qing Dynasty. Her paternal grandsire, Chua Eng Cheong, from Malacca, derived from Fujian in south China and maintained conservative Confucian ideals. Her parentage epitomized the blending of disparate Asian cultures when spiffily dressed Javanese merchant Chua Kim Teng, in three-piece suit and tie, married third wife Leong Ah Soon, a Hakka-Chinese Indonesian, whose mother came from Dutch Borneo.

On May 20, 1922, at age fifteen, Chua Jim Neo entered an arranged marriage to Lee Chin Koon, a clerk and depot manager for Shell Oil Company. The couple resided on Tembeling Road before settling at 93 Kampong Java Road on the Singapore River in the Novena section among Indians, Arabs, and Javanese vegetable sellers. An ill-tempered mate, he spoke impeccable English, dressed in European jacket with handkerchief, but maintained traditional ancestor worship. A proponent of life-long education, Chua Jim Neo spoke Malay patois; English; and Hokkien, a native tongue in Singapore, Malaysia, Indonesia, and Philippines. For her five children, she advocated reading rather than toys.

Chua Jim Neo's eldest, Lee Kuan "Harry" Yew, Singapore's first prime minister, gloried in his mother's heirloom cookery. On the fifteenth day of the new year, he anticipated her spread for *Chap Goh Meh* (Lantern Festival), when she braised

brined chicken in shallot and tamarind sauce. He remembered his paternal grandmother Liem Nio as the family disciplinarian and his mother as the loving nurturer and keeper of her Straits heritage recipes. She guarded wedding jewelry, gifts from her parents sometimes demanded by her husband, a wastrel and abusive gambler at blackjack.

Educating a Family

To ensure the family's future, the resourceful mother cached money and inherited jewelry to finance British schooling among Christians at the Anglo-Chinese School and twice weekly classes in Mandarin. Her caution ensured Lee Kuan Yew's law degree from Cambridge, partially paid for with his black-market profits. The younger sons added three professional degrees for attorney Dennis Lee Kim Yew; financier Freddy Lee Thiam Yew; and Cambridge-educated physician Lee Suan Yew, the household memoirist. To investor Monica Lee Kim Mon, her daughter, who later cooked for Lee Kuan Yew, Chua Jim Neo taught economic favorites:

- *achar* Indian pickled vegetables and fruits in spiced oil and vinegar
- *gado gado* Indonesian potato, boiled eggs, and bean salad with peanut sauce
- *me siam* Malay (originally Thai) fried noodles in spicy gravy with shrimp
- *lidah kuching* Indonesian meringue cookies
- *kueh belanda* Singaporean coconut egg rolls
- and almond cake to mark the Chinese lunar new year.

Chua Jim Neo garnered praise from her children and grandchildren for energy, family devotion, and exceptional talents at seasoning entrees with coconut milk and the piquant hallmarks of Nyonya cuisine—freshly crushed *rempah* (coriander, tamarind, ginger, lemongrass, galangal, turmeric, wild pepper, mint, curry, cardamom, anise, clove, chili, and cumin). During the Japanese occupation in 1943 and the decline of Nyonya society and culture, she raised chickens and bought small amounts of pork. In place of glutinous rice, jackfruit, bananas, starfruit, durian, and canned beef and mutton, she cooked with maize and millet and unfamiliar concoctions of sweet potatoes and tapioca, an ingredient mixed with palm oil to make gum. She aided Lee Kuan Yew's project of refining the gum for sale. At war's end in August 1945, the family resettled at a shady eight-bedroom cottage at 38 Oxley Road, a former nutmeg plantation.

Treasuring the Past

Just as son Lee Suan Yew promoted Mandarin as the language to unite all ethnicities on the Malayan peninsula, Chua Jim Neo advocated Malay cookery in one of the world's busiest trade nexuses. She feared for the future of ancestral dishes:

"In my lifetime I have seen ... so many changes," notably alterations in women's schedules as they entered the work force (Lee, 1974, foreword). At age sixty-seven, she compiled *Mrs. Lee's Cookbook,* a meticulous source of historic southeast Asian diet. She asserted benefits to the next generations: "It has been one of my ambitions to write a book about Straits Chinese food so that the younger generation, including my grandchildren and later their grandchildren, will have access to these recipes which were usually kept within families as guarded secrets" (*ibid.*).

The rise of Peranakan cookery endorsed the diverse blend of Hokkien Chinese with Javanese and Malayan or Indonesian ingredients and cooking styles, a hybrid identity dictated by Asian history. After informing other Singaporeans of its nutritional birthright, in 1977, she demonstrated stovetop cooking for the tourism alliance. Her nationalist compendium became legendary in Cambodia and Australia. Restaurateur Violet Oon expanded on the purpose of historic foods as a form of family and clan solidarity: "Each recipe has a story behind it. And this story will give an insight into (the) cultural soul" (Oon, 1998, 7).

After two weeks of intensive nurse care, at age seventy-three, the author died of heart attack at Singapore General Hospital on August 8, 1980, preceding her widowed husband by seventeen years. To the family, she left handwritten notes on labor-intensive Asian food origins, a matrilineage that daughter Monica pursued for celebrations, festivals, and daily fare. In 2003, the author's granddaughter, banker Lee Shermay, a chef and food consultant, issued one hundred recipes in a new edition of *Mrs. Lee's Cookbook*, winner of the Gourmand World Cookbook Award. The importance of Chua Jim Neo's food research earned a place in 2015 in the Singapore Women's Hall of Fame and a spot on airline and restaurant menus in Australia, Hong Kong, and Vietnam.

Source

Cheung, Sidney, ed. *Food and Foodways in Asia: Resource, Tradition and Cooking.* Abingdon, UK: Routledge, 2007.

Chien Y. Ng, "Historical and Contemporary Perspectives of the Nyonya Food Culture in Malaysia," *Journal of Ethnic Foods* 3:2 (June 2016): 93–106.

Lee Chin Koon. *Mrs. Lee's Cookbook: Nonya Recipes and Other Favorite Recipes.* Singapore: Eurasia Press, 1974.

Lee Kuan Yew. *The Singapore Story.* Singapore: Marshall Cavendish, 2015.

Lee Suan Yew. "Lee Kuan Yew, Singaporean," *Peranakan* 1 (2015): 8–15.

Oon, Violet. *A Singapore Family Cookbook.* Singapore: Pen Publishing, 1998.

Orujova, Izzat (September 16, 1909–April 22, 1983)
actor
Azerbaijan

A feminist leader in a Eurasian country lying between tsarist Russia and the Ottoman Turks, Izzat Orujova (also Izzet Orucova) set an example of civil rights and artistic independence for Azeri females. The first of five born in her family in

1909, she claimed as her hometown Baku on the Caspian Sea. With young sisters, she rejected the *chadrovaya* (veil), a Persian tribal restraint placed on girls and women. She was eight years old when Russia's October Revolution of 1917 precipitated the freeing of the Caucasus on April 28, 1920, and the incorporation of the country as a republic of the Soviet Union. In high school, she breached the gender divide by studying chemistry, a male-only course, and worked as a typist for AzNeft gas and oil developers to support her household.

At age twenty, Izzat Orujova became the first woman in the Azerbaijan Democratic Republic to act by starring in *Sevil*, a feature movie about female independence in Baku in 1918. Dramatist Jafar Jabbarli, a major scenarist, searched for a lead to play an illiterate single mother and persisted against the advice of producer Alibek Nazarov until he located a native Azeri. The title role depicted a sad-eyed thirteen-year-old bride of Balash, a peasant who demeans her humble manners. Anvar Almaszade, brother of Gamar Almaszade, Azerbaijan's first ballerina, created the costumes. For bearing a daughter instead of a son, Sevil suffers scorn. Under Islamic law, Balash abandons wife and child. His rise as a financier among White army brass awards him social stature and a mistress, Dilber the singer. The climax pictures his rage at his father and sister, who humiliate the *nouveau riche* capitalist in front of a posh gathering. After Dilber seizes his assets and leaves him broke and rejected, Sevil rips off her veil and immigrates to Moscow to study and rear her daughter.

Changing the Future

While Eurasian women aimed to use World War I chaos as a basis for seizing gender rights, the actor envisioned herself as an artistic emancipator and rebel against male superiority. On International Women's Day, March 8, 1927, Joseph Stalin promoted the *hujum* (assault), a public burning of veils and defiance of gendered religious laws condoning female illiteracy, male promiscuity, honor killings, child brides, limited inheritance, and polygamy. When the film debuted in 1929, Azeri women promoted liberation from social repression and seclusion by taking public jobs, dressing in factory uniforms, gaining an education, and joining the Communist Party. Adding to the actor's acclaim, when the movie opened in the Caucasus, her appearance on the screen without a hijab generated public approval and a backlash from Muslim mullahs. Viewers snatched off veils in the theater and discarded them and the patriarchal control they symbolized.

With a degree from the Azerbaijan Petroleum Institute at the National Oil and Industry University in Baku, at age twenty-three, the actor chose a career in essential research as a lab technologist and teacher of adult academic classes. After marrying her neighbor, Movsum Ismayilzade, she returned to movie making in 1935 as the title figure in *Almaz* (Diamond), adapted from a Jafar Jabbarli play. Triumph as Azerbaijan's first female screen star ended with the playwright's death on December

31, 1934. After giving birth to son Yilmaz Ismayilzade on January 5, 1936, she abandoned acting and worked for seventeen years supporting sustainable growth at the Azerbaijan Research Institute in oil refinement and lubricant use. In 1949, she progressed to director of Baku's Institute of Petrochemical Processes of the Academy of Sciences of the Azerbaijan SSR.

From Actor to Scientist

In 1970, Izzat Orujova's expertise yielded a doctoral dissertation, an academic degree, and the State Prize of Azerbaijan Soviet Socialist Republic, a gold medal honoring the arts and engraved with the hammer and sickle, icons of the peasant laboring class. A year later, she focused lab work on oil additives for the Institute of Additive Chemistry at the Academy of Sciences east of coastal Baku. Her innovations led to the formulation and processing of chemicals that altered pure lubricants. In her sixties, she earned membership in the Academy of Sciences and the Order of Lenin, a medal on a red and gold ribbon awarded to civilians for service to the state.

Communist surveillance resulted in the arrest of the researcher's husband among other liberal intellectuals. Declared a national enemy of the Bolsheviks, he abandoned her to rear their son alone. A divorce in 1937 freed her from persecution as a traitor's wife. After a lengthy banishment, he returned to Azerbaijan, but remained exiled from Baku and from reuniting with his ex-wife. He remarried and located his family at Mingechevir in north central Azerbaijan. She died on April 22, 1983, at age seventy-three. Influenced by the powerful screen heroine, in the Baku center city in 1960, sculptor Fuad Abdurahmanov erected a statue, "To an Emancipated Woman."

See also Gamar Hajiaga Almaszadeh.

Source

Heyat, Farideh. *Azeri Women in Transition: Women in Society and Post-Soviet Azerbaijan*. London: Taylor & Francis, 2014.

Istrate, Dominik. "Izzat Orujova: Azerbaijan's Pioneering Movie Star," *Emerging Europe* (21 September 2019).

Kamal, Sufia (June 20, 1911–November 20, 1999)
diarist, poet, children's author, editor
Bengal

An esteemed moral activist, poet, editor, children's author, and diarist, Sufia Kamal supported formation of an independent Bangladesh and emancipation of Bengali women. An aristocratic native of Shayestabad, Barisal (also Barishal) in south central Bengal, she was born to Sabera Banu and attorney Sayed Abdul Bari, an idealistic Sufi. She received home schooling from her mother and uncle in Hindi and Urdu, the lower- and upper-class languages of India. At a local mosque, she

learned Arabic and heard Sanskrit verse and myths read aloud by her uncle. After her father deserted the family on a religious quest, she lived with her mother, older brother, and maternal grandparents and learned Bengali from household servants. At age seven, her meeting with feminist educator, fiction writer, satirist, and journalist Rokeya Sakhawat Hossain in Calcutta introduced her to the need for female learning and outlets for creativity. During a heightened challenge to patriarchy, she engineered the building of Rokeya Hall, a women's dormitory at Dhaka University.

Sufia Kamal married law student Syed Nehal Hossain in 1922, resided at Barisal, and bore daughter Amena Kahar, the first of five children. Her acquaintance with Mohandas Gandhi at age fourteen introduced the concept of simple dress in white cotton sari devoid of jewelry as a protest of colonialism in British India. At age twelve, she published the short story "Shainik Bodhu" (Soldier's Bride) in the *Taroon* (Youth) magazine. In 1926, she submitted a poem, "Bashanti" (Of Spring), to the Bengali literary journal *Saogat* (Gift) in Calcutta, reflecting grief at losing her husband to tuberculosis.

Poet and Advocate

Sufia Kamal's feminism dates to 1931, when she became the first Bengali Muslim elected to the *Bharatiya Mahila* (Indian Women's Federation), one of the first leagues demanding female social justice. From age 21, she lived five years in widowhood and relocated to Calcutta to teach school after a flood of the Bador River destroyed her home. She collected original stories in the anthology *Keyar Kanta* (Thorns of Care) and, in 1937, wed writer and translator Kamaluddin Ahmed Khan. At home at Road 32, Dhanmondi, she accomplished literary success with a verse collection, *Sanjher Maya* (Evening Magic), and extended her canon with *Maya Kajol* (Tipsy Work), *Mrittikar Ghran* (The Smell of Soil), *Sonirbachito Kobita Sonkolon* (Collected Poems), *Sovieter Dinguli* (Russian Days), and *Itol Bitol* (Cool Beetle). The couple produced sons Shahed and Sajed and daughters Saida and Sultana Kamal, an attorney, child advocate, and human rights author and activist educated at the University of Dhaka.

For educators of the young, Sufia Kamal wrote *Ajikar Shishu* (Today's Child). About the time that she volunteered at the Lady Brabourne College shelter in 1946 and opened a kindergarten in Calcutta, her verse themes shifted from the romanticism of *Ontorongo Attovasha* (Intimate Talk) and *Sahasi Prema* (Love Timid) to socio-economic and political issues, the subject of *Karantarale Jamila* (Jamila Boxed In). In defiance of Islam, she posed unveiled for a photograph. After July 20, 1947, she co-founded and edited Bengal's first women's monthly news magazine, *Begum* (Queen). At the collapse of British colonialism, the magazine preceded the Hindu-Muslim uprising of October 1947. In the crisis, the author formulated an anti-patriarchal manifesto: "Be poor or middle class or upper class, the violence against women … was always there" (Martin, 1999).

While organizing seminars in Chittagong, Comilla, and Dhaka, the author empowered the Peace Committee, chaired the *Purbo Pakistana Mohila* (East Pakistani Women), and the 1952 Bengali Language Movement to replace Urdu with Bangla words and script as the official tongue of Pakistan. Her poem "Our Language" asserted, "The simple language of a simple people/Will meet the demands of this our land" (*ibid.*). In salute to the *Sanskritik Swadhikar Andolon* (Cultural Outreach Movement) and in support of Communist labor ideals, she led the February 21, 1952, Martyrs Day procession and composed "He Mahan Neta" (O Great Leader). She exulted, "Joy joy joygaan kaste-haturir!" (Win victory, sickle and hammer) ("Sufia," *Poem Hunter*).

Daring Exertions

Under the slogan "Our people are courageous; our leaders are not," the author pressed for female equality (*ibid.*). *Begum* magazine fostered Bengal's first women's club in 1954. Two years later, she founded *Kanchi-Kancher Ashor* (Scissors-Glass Assembly), a pro-child agency, and advocated for *Chhayanaut* (Shadow), a Bengali culture renaissance. She protested the 1961 ban on the verse of Rabindranath Tagore, Bengal's national poet, a courageous act that won her the 1961 High Privilege citation and 1962 Bangla Academy Literary Prize. After encouraging a Soviet-Pakistan alliance, at age 58, she joined the public denunciation of usurper president Ayub Khan by chairing the Women's Struggle Council and by insulting Khan publicly as the king of beasts. The Soviet Union awarded her the 1970 Lenin Centenary Jubilee Medal for valor.

At age 60, Sufia Kamal and her daughters championed freedom and humanism during the late 1971 Liberation War by opening a food and medicine depot at her home and funneling supplies by rickshaw to the Agartala hospital. In retaliation, the Pakistani Army murdered her son-in-law, Kahar Chowdhury. She summarized the era's mayhem in *Ekatturer Diary* (Diary of '71) and *Mor Jaduder Samadhi Pare* (May My Magic Be Buried). The author's crusade fueled the rehabilitation of female war victims and, from 1972 to 1980, the chairing of BRAC, even after her second widowing in 1977. For ongoing benevolence, she received the 1976 Twenty-First Medal, 1977 Nashiruddin Gold Medal for literature, and 1982 Freestyle Prize. At age 79, she led defiance of martial law by marching during curfew.

Sufia Kamal's literary works aiding the poor and fighting religious fundamentalism looked to the past in the anthologies *Ekale Amader Kal* (Our Time Alone) and *Benibinyas Samay to Ar Nei* (No Time for Plaiting). Her verse called all to account with the cry "Awake, Adam and Eve! Defeat the Evil,/Spread the message of peace across the earth!" (Hoque, 2012). Her altruism earned the affectionate sobriquet Khalamma (Auntie). Late in life recognition included the 1986 Czechoslovakia Medal, 1995 National Poetry Council Prize, a 1996 Begum Rokeya Medal and Deshbandhu gold medal, 1996 World Peace Crest, and a 1997 Independence Day Award

of 20,000 takas ($288). She died on November 20, 1999, in Dhaka, Bangladesh, where she became the first woman to lie in state with full honors. The Dhaka public library bears her name. In 2016, son Sajed Kamal issued a collection of his mother's verse.

Source

Basher, Naziba. "Begum: How One Magazine Began a Revolution" (Dhaka) *Daily Star* (20 May 2016).

Hoque, Mofidul. "Sofia Kamal: Her Journey Towards Freedom," *Forum* 6:7 (7 July 2012).

Kamaker, Protiva Sani. "'Taharei Pore Mone'—Reminiscence of Begum Sufia Kamal," (Dhaka) *Daily Star* (20 June 2020).

Martin, Douglas. "Sufia Kamal, Poet and Advocate, Dies at 88," *New York Times* (28 November 1999).

"Sufi Kamal," *Poem Hunter,* www.poemhunter.com/sufia-kamal/biography/.

Almaszadeh, Gamar Hajiaga (March 10, 1915–April 7, 2006)
ballerina, autobiographer
Azerbaijan

Born to an encouraging mother and strict Muslim father, Gamar Haji-aga Almaszadeh (also Almaszade) became the world's first Islamic ballerina. At her birth in Baku on March 10, 1915, she entered the working-class household of midwife Maryam and shoemaker Mashadi Hajiaga Almaszadeh. In childhood, she identified with balletic grace and defied the religious code requiring women to conceal their legs and avoid public displays. With friend Shura Stepanova, at age ten, Gamar began taking private lessons at the Kivorkov Ballet Studio, which she paid for with five manats ($2.94), one manat short of the enrollment fee.

The preteen concealed dance from her disapproving father as gym courses. In 1926, her brother Anvar announced to the audience that she performed a doll's role in Leo Delibes's *Coppelia*. News of her disobedience plunged her father into a tantrum. He threatened to kill her lest she humiliate a devout Muslim parent. At age fifteen, Gamar Hajiaga Almaszadeh completed choreographic training and entered a short-term marriage to theater director Afrasiyab Badalbeyli, to whom her father relinquished control of her career.

While enrolled in education courses at the Pedagogical Technical School, Gamar Hajiaga Almaszadeh joined the troupe at the Akhundov Azerbaijan State Academic Opera and Ballet Theater, a membership she concealed from her father. Wordlessly, he began attending performances. Two years later, she studied at the Bolshoi Theater in Moscow, took classes at the Leningrad Choreographic School in St. Petersburg, and debuted in the folk-classical tradition in Azerbaijan. She danced in Reinhold Glière's opera *Shakh-Senem,* the Marxist story of a libertarian musician who wins the love of the shah's daughter and frees his people from tyranny.

From Russia to Baku

At St. Petersburg, Gamar and younger sister Adila Almaszadeh studied under Maria Romanova-Ulanova, the mother of Galina Sergeyevna Ulanova, a prima ballerina at the Mariinsky Theatre, later known as the Kirov. Adila, who was less robust than her sister, died of consumption. Gamar, nicknamed Almaz (Diamond), survived a shooting by an Islamic fanatic into her high-heeled shoe, leaving her unharmed. She advanced to soloist and continued playing leads as Medora in Adolphe Adam's *The Corsair,* adapted from Byron's poem about the French-Haitian pirate Jean Lafitte and his wife Medora, who dies of grief.

In 1937, the dancer returned to Baku to establish and direct the Azerbaijan State Folk Song and Dance Ensemble, a troupe specializing in fierce drumming and gymnastic wedding choreography. Anvar Almaszadeh promoted his sister's success by designing traditional Azeri dress with chiffon sleeves and ballet tights. Her mentor, the nation's first classical composer, Uzeyir Hajibeyov, promoted authentic folk melodies accompanied by the traditional *kamancha* (bowed lute), *tar* (long-necked Iranian lute), and *zurna* (small oboe). For authenticity, she surveyed villagers' steps and gestures to teach her troupe.

A Champion of Folk Art

Gamar Almaszadeh thrived at lead roles: the kidnapped princess Maria who is stabbed to death in Asafiyev's *Bakhchasaray Fountain* in 1939 and the title role in Alexander Glazunov's *Raymonda,* a Hungarian countess. The commanding double part of Odette and Odile in Peter Ilyich Tchaikovsky's *Swan Lake* suited her rise to world-renowned ballerina. At age thirty-five, she danced the ingénue part of Masha in Tchaikovsky's *Nutcracker Suite.* In 1940, she starred as Gulyanag in the debut of Badalbeyli and his wife's *Giz Galasi* ("The Maiden Tower"), the first professional ballet written in Azerbaijan. The plot introduced back-country choreography at a wedding. The setting featured a twelfth-century landmark of old Baku, the site of Gulyanag's suicide to avoid her father's incestuous demands.

Closely watched by the KGB in France, Gamar Hajiaga Almaszadeh met Rudolf Nureyev, a Soviet defector. She toured India, Iraq, and Nepal, danced Pani Ayshe's stirring waltz in Gara Garayev's *Seven Beauties*, and received the 1952 Soviet State Prize and the 1959 People's Artist of the USSR. As chief balletmaster of the choreography school, before retiring from the stage at age forty, she produced Soltan Hajibeyov's *Gulshan*, Riccardo Drigo's comic dance *Harlequinade,* Ashraf Abbasov's story of death by snakebite in *Nigella,* and Tchaikovsky's classic fairy tale *Sleeping Beauty.*

In addition to staging Adan's ghost-ridden tragedy *Giselle* and Ludvig Minkus's Spanish epic *Don Quixote,* the dance instructor coached a diva, Leyla Vakilova, in Glière's *The Red Poppy.* Gamar played the part of Tao Hoa, the Chinese innocent

exploited by the villain Li Shan-fu, a crafty capitalist. Vakilova followed Gamar as administrator and ballet teacher. In 1970, Gamar began instructing a Baghdad company in peasant dance and established the Iraqi National Folklore Group. One of the dancers, Mikhail Baryshnikov, defected to Toronto in 1974 and became world famous. She remained influential in the dance realm until her eighties and died on April 7, 2006.

Source

Almaszade, Gamar. "My Life as Azerbaijan's First Ballerina," *Center Stage* (Fall 2002), 56–59.

Luo, Michael. "On Dangerous Footing in Iraq, Where Dancing Is a Courageous Act," *New York Times* (30 October 2006).

Mikeladze, Galina. "Ballet—A Worthy Component of Azerbaijani Culture," https://irs-az.com/new/pdf/201301/1358948248505125213.pdf.

Snodgrass, Mary Ellen. *The Encyclopedia of World Ballet.* Lanham, MD: Rowman & Littlefield, 2015.

Khin Myo Chit (May 1, 1915–January 2, 1999)
short fiction writer, journalist, editor, historical novelist, mythologist, autobiographer
British Burma

A popular author and media figure, Khin Myo Chit earned the title La Grande Dame (The Great Lady) de la Myanmar Writing for her respect for country and culture. The daughter of U Taw and Daw Than Tin and maternal granddaughter of editor U Ba Pe, leader of the Nationalist Party, she was born Ma Khin Mya on May 1, 1915. Her paternal grandfather, U Nyunt, was an official of Bombay Burma, a teak trading company. She, a sister, and three brothers grew up northwest of Mandalay near the Irrawaddy River in Sagaing, British Burma. From paternal grandfather U Phay, an archeologist, she learned temple history, epic drama, ancient lore, court theatricals, and classical music. At age five in the Pyay national school, she studied English under the colonial British. A poet by age seventeen, she graduated from Meiktila high school on Meiktila Lake, issued the verse "Patriotism" and a translation of Walter Scott's long narrative "Lay of the Last Minstrel" in 1932, and wrote short fiction for *Dagon* magazine in 1934.

On an old Remington typewriter for *The* (Rangoon) *Sun,* in 1936, Khin Myo Chit serialized a debut novella, *College Girl.* During the 1300 Movement, a women's protest of tyranny, she joined partisans, began writing political articles in English for her column in the *Deedoke Journal* and *Burma* journal, and altered her name to Khin Myo Chit (Miss Lady Patriot). After marrying U Khin Maung Latt of Monywa, an English professor at Rangoon University, in 1939, she bore son Khin Maung Win. From 1942 to 1945, the family lived at 24 Zabuyit Street in Rangoon's Sanchaung district under Japanese tyrants, whom she epitomized in *Three Years under the Japs* as arrogant and conceited.

JOURNALISM AND FICTION

After World War II, Khin Myo Chit graduated from the University of Rangoon. To end a period of despair and doubt, she practiced meditation at a monastery and composed a pamphlet, "A Buddhist Pilgrim's Progress," introduced by grandson Junior Win. While editing the *Guardian Daily,* she brought out "13 Carat Diamond," a popular wartime reflection on joblessness, hunger, trade, and barter. Bantam anthologized the memoir in the 1965 collection *50 Great Oriental Stories,* available in English, German, Gujarati, Italian, and Yugoslav. Other genres—the ghost yarn "Home-Coming," the "too-late-smart" story "The Ruse," the feminist remembrance "The Egg and I," and the coming-of-age flashback "The Golden Princess"—proved facile and readable for all ages. The stories prefaced a rise in popularity after she serialized *Heroes of Old Burma* (1963) and forty-five essays in *Quest for Peace* (1968), which the *Working People's Daily* serialized and published with the propaganda piece "Writers and Awards." She assembled a compendium, *13 Carat Diamond and Other Stories,* in 1969, a miscellany of her oeuvre.

Citations and recognition compensated the author for clarifying Buddhist wisdom and Burmese concepts of Karma and astrology. She depicted worship in stupas and pagodas as "[treading] the noble path to that state where the best of human nature will have a fair chance to manifest itself" (Khin, 1976). Publications outlined virtuous behavior and worthy deeds of compassion, generosity, and kindness and compiled examples of symbol and ritual in *Festivals and Flowers of the Twelve Burmese Seasons.* In a short fiction competition, *Horizon* magazine chose "Her Infinite Variety," the lead narrative in a collection of six stories drawn from the author's experience.

BURMA AND ITS CULTURE

In *Folk Tales of Asia,* UNESCO featured "The Four Puppets," a happily-ever-after story of Khin Myo Chit's preparation for a journey with four marionettes—a divinity, demi-god, ogre, and hermit. The fictionalized biography of Michelangelo reached print in Myanmar; Rangoon's *Working People's Daily* serialized the historical novel "Anawrahta of Burma." It reprised love stories she heard from Grandfather U Phay, an expert on Burmese stone inscriptions. The novel revealed the staunch Buddhism and deeds of Anawrahta the Great, the eleventh-century-CE father of the Pagan dynasty, whom she commemorated with an affectionate narrative.

In addition to *Introduction of Europe Culture and Art,* the author stressed components of her native land in *Colourful Burma* (1976), a UNESCO selection describing hair styles, rice meals, and changes to customs in wartime and afterward. *Burmese Scenes and Sketches* (1977), an illustrated text, named festivals and discussed such daily activities as betel chewing, eating relish and jackfruit, the lives of women and children, *zat pwe* (stage plays), and puppetry. The essay "Shinpyu

(Initiation)" summarized the introduction of her nine-year-old son Khin Maung Win into monastic life. The couple collaborated on a textbook, *Learn English*. Another personal revelation, a letter to her grandchildren and other essays described grandson Pyone Cho at Bassein College in Rangoon.

After submitting "Kyaikhtiyo (Golden Rock)," a glimpse of the Kyaikhtiyo Pagoda in Mon State, to a 1980 issue of *Asia*, the magazine followed in 1981 with "A Pagoda Where Fairy Tale Characters Come to Life." At the end of a half century of writing, Khin Myo Chit's fervor for Burmese culture yielded *A Wonderland of Burmese Legends* (1984) and *A Gift of Laughter* (1995) excerpted from *Pyinsa Rupa* (Five Forms) magazine named for a mythic animal composed of a white carp, goose, elephant, lion, and water buffalo. Following widowhood in 1996 and her death at age 83 on January 2, 1999, a posthumous work reached print, *Stories and Sketches of Myanmar* (2005). The Voice of America commemorated her patriotism with a tribute on July 25, 2008, lauding "La Grande Dame de la Myanmar Writing" (Khin, 2004, 92).

Source

Junior Win. "A Memory of My Grandparents," juniorwin-english.blogspot.com/2014/05/a-memory-of-my-grandparents-u-khin_29.html.

Khin Myo Chit. *Burmese Scenes and Sketches*. Rangoon: U Thein Tan, 1977.

_____. *Colourful Burma*. San Francisco, CA: Moemaka Media, 1976.

_____. *Her Infinite Variety and Other Stories*. Rangoon, Myanmar: Parami Bookshop, 2004.

_____. *13 Carat Diamond & Other Stories*. Rangoon, Myanmar: U Kyaw Oo, 1965.

Oggay, Whang-od (February 17, 1917–)
tattooist, flautist, dancer, chanter
Philippines

The last of traditional east Asian *mambabatok* (master skin artists), for eight decades, Whang-od (Maria) Oggay has offered folk tattooing, a ritual Filipino body inscription nearing extinction. A Butbut highlander born on February 17, 1917, at Buscalan, Kalinga, in the Cordillera Central mountains of northern Philippines, she grew up in the Chico River Valley. Tattooing was introduced around 1000 CE to the wrists, legs, backs, and chests of head-hunting tribesmen, which she preserved among indigenous rice farmers and crafters. In her teens, she pursued the male tradition with inked sleeves, geometric epaulets, and a semicircular collar featuring snakeskins and caterpillars, animistic body armor, and strong ancestral roots. The addition of cryptic signs of former lovers archived personal lives.

In island history from March 17, 1521, Spanish explorers named the Philippines "Las Islas de los Pintados" (The Islands of the Painted Ones). Despite discouragement from colonial and Catholic hierarchies from Spain and the Americas, which labeled body art barbaric, Whang-od Oggay's father, a master tattoo artist, passed on the spiritual, military, and cultural art to his fifteen-year-old daughter. The apprenticeship within bloodlines prevented infection in the designs, yet violated the man-to-man transmission by commissioning a girl. After observing other artists,

Whang-od Oggay tapped in a first image, completed in the remote village in 1932, picturing a python and ladder. She completed the session with a coconut oil massage. In addition to marking body parts, she raised pigs and chickens and played the bamboo *tongali* (nose flute), which has a range of twenty notes.

The artist extended her hospitality, even providing overnight stays for outsiders, who have included cinema crews from *National Geographic* and the *Discovery Channel's* "Tattoo Hunter." Her services for tribe members involved comforting *ullalim* (epic chants), intricate dance, and prophecies derived from interpretation of skin patterns and animal omens. In addition to growing rice and feeding livestock, she trained a cadre of female skin decorators that included twenty girls and several grandnieces. For her sweetheart, Ang-Batang, she immortalized his first kill in hand-to-hand combat in traditional warrior code. Because the tribe disapproved of their union, Ang-Batang wed Hogkajon, Whang-od's friend.

WORKS IN PROGRESS

In 1932, the artist began hand tapping Bontok headhunters on the torso with a geometric *chaklag* (torso pattern) from shoulder to nipples to ennoble a head taken from an enemy or invader. Equipped with carabao (water buffalo) horns, a foot-long bamboo stick and hammer, and bitter lemon tree thorns, she sat on a low bench for a better view of each client. The workday started at dawn in a thatched hut by pushing a thorn horizontally through a reed. By lunchtime, she had completed fourteen tattoos by adding events, biography, and patchwork at the biceps and adorning skin swellings and medical anomalies to promote healing. Each jab drew blood and caused pain.

Pre-colonial legendary figures pictured owl masks and epic adventures of Banna from Lubo, a python shapeshifter who embedded the legs of his lover Edonsan with snake scales. Boys began their skin adornment with a modest cross on the cheek or nose. As they matured, they displayed more crosses, undulations across the forehead, and circles about the chin and jaws. For a soldier who slew an enemy, she chose a symbolic eagle shape admired for intricacy and symmetry. Some of the men she tattooed survived guerrilla war against the Japanese after their invasion on December 12, 1941.

For esthetic reasons, Bontok women accepted tattooing as a rite of passage. They favored *fatok* patterns—ferny, lacy marks of beauty, prestige, prosperity, and reverence for nature encircling the arms from elbow to knuckles. For outlining, the artist dissolved *olla* (cook pot) soot or pine charcoal in water. Using a thorn from a pomelo plant (grapefruit or shaddock) or calamansi (kumquat) branch, Whang-od Oggay pricked the motif, then sprinkled blacking and pressed it into the incisions. The marks—three dots encompassing one inch—raised itching lesions. For the price of one session, the beloved village *Apo* (Grandmother) charged one pig or a *dalan* (rice bundle).

ART REVIVAL

In 1942, when Whang-od Oggay's former love died from a logging mishap, she chose not to marry or produce children who would inherit familial artistry at story-telling on human skin. After the government promoted an end to skin art, she offered her services to tourists and outsiders, who, by 2015, paid her 5,000 Philippine pesos ($105) per day for up to thirty clients. On a board, she displayed dozens of naturalis-tic choices—diamonds, spiders, sunbursts, weather vanes, and stylized topography. The basic motif, three dots, symbolized collaboration with two young tattoo artists, grandniece Grace Palicas and another relative, Ilyang (or Elyang) Wigan. Through-out the Polynesian tattoo renaissance around 1998, young Filipino-Americans began replicating her Pacific rim body art. By 2016, some 170,000 tourists had requested tattooing by the world-famous Whang-od.

The twenty-first-century tattoo craze raised Whang-od's village from poverty and introduced the world to Bontok skin branding and the imparting of individual identity and accomplishments. On April 2, 2016, at the Royal Ontario Museum, her work anchored the exhibit "Tattoos: Ritual, Identity, Obsession," which surveyed examples from France, Canada, Japan, Switzerland, and Polynesia. On October 21 in her 100th year, Whang-od Oggay's talents earned nomination from the U.N. for the *Gawad Manlilikha ng Bayan* (National Living Treasures Award), which carried a purse of 100,000 Philippine pesos ($2,100) plus 14,000 Philippine pesos ($499.80) stipend per month. She traveled to Manila in 2017 to demonstrate the skin pricking of several volunteers. Her dexterity at the anthropological tradition yielded a 2018 *Dangal ng Haraya* (Achievement Award) from the National Commission of Cul-ture and the Arts of 200,000 Philippine pesos ($4,200) and 50,000 Philippine pesos ($1,050) per month. She thrived on a vegetarian diet, and pledged to continue the craft as long as her vision lasted.

Source

"Angara Wants National Living Treasures Award for Whang-od," *MENA Report* (27 February 2018).

Cheval, François, and Natividad Sugguiyao. *Jake Verzosa: The Last Tattooed Women of Kallinga.* Göttingen, Germany: Steidl, 2018.

Clariza, M. Elena. "Sacred Texts and Symbols: An Indigenous Filipino Perspective on Reading," *International Journal of Information, Diversity & Inclusion* 3:2 (2019).

Krutak, Lars. *Kalinga Tattoo: Ancient & Modern Expressions of the Tribal.* Glattbach, Germany: Edition Reuss, 2010.

Wilcken, Lane. *Filipino Tattoos: Ancient to Modern.* Atglen, PA: Schiffer, 2010.

Kalandadze, Ana (December 15, 1924–March 11, 2008)
poet, translator
Georgia

An understated verse crafter self-liberated from Soviet dogma, Ana Kalandadze issued seven hundred poems of elegant intricacy that influenced the modern literary

period. A native Georgian, she was born on December 15, 1924, at Khidistavi Valley outside Chokhatauri, Guria, on the eastern Black Sea coast. She claimed ancestry with Poles entering the Caucasus in 1856 after the Crimean War, when Imperial Russia began gradually annexing the country. From girlhood, she acquired the Gurian folk dialect and the classic verse of poet Anna Akhmatova, a Russian anti–Stalinist.

A translator fluent in Russian, Ana Kalandadze admired Georgian versions of William Shakespeare, Dante Alighieri, François Villon, and Edgar Allan Poe. She applauded a skillful Russian version of Emily Dickinson's canon, including an edition of William Luce's biographical play *The Belle of Amherst*. Quiet and unassuming, she focused poetic impressions on Guria's natural beauty and serenity. Of the demands of writing, she observed, "It's always come easily to me" through concentration before the final phase (Osborne, 1986, 12). In 1935, the eleven-year-old wrote "First Moon," an impression of moonrise inspired by her aunt's storytelling.

Learning Georgian

During World War II after Germany invaded the Soviet Union, the poet's educated parents—a teacher and a pharmaceutical scientist—encouraged her to pursue higher learning than women typically achieved. At Ivane Javakhishvili Tbilisi State University, an institution offering progressive opportunities for females, she referred to training as a period of fermentation: rather than major in language, she studied linguistics while writing secretly. She mastered the extant inscriptions and eight manuscripts of Old Georgian, a palace language with a 36-character alphabet dating to the 400s CE. From the classical era in the 800s, she read histories and philosophy. At age twenty-one, she completed a Caucasian language degree and remained alone in Tbilisi.

After poet and colleague Simon Cikovani invited Ana Kalandadze to read her restrained, musical verse at the Writers' Union, she became an instant luminary for reviving literary titles among peasant reciters. For "Mulberry Tree," she transformed appreciation of a deciduous, fruit-bearing tree into a yearning for romance. In the aftermath of fascism in 1946, her first poems reached print in Tbilisi's *Literatura da Khelovneba* (also Xelovneba) and the literary magazine *Mnatobi* (Fort). She issued precise two-line verses in haiku and stressed amity over totalitarianism. Lilting personal encounters with females yielded "Gipsy Woman" about an ebullient beach stroller, "Hey, Tatar Girl" recognizing a female love of jewelry, and "Are You Arab?," a rhetorical question to a Yazidi (Kurdish) flower merchant. Some verse appeared in English, French, German, Polish, and Russian. Of the quality of translated poems, she preferred versions without rhyme. She reasoned, "This is better than not to try for the music at all," such as the restrained lines of "Speak, Ladybug" (1945) and the longer work "Tamar in the Distance" (*ibid.*, 14).

Subtle Poems

In a campaign for a unified Georgian language, Ana Kalandadze joined the Writers' Union, an arm of the state culture ministry, and co-edited its journal, *Literary Georgia*. She issued *Poems,* the first of six collections in 1953 and continued creating minimal lines and images until age sixty-one. She reached a height of acclaim in the 1960s, when socialist realism began to drain from Georgian pages. Citizens elected her to the city council and workers' commission and an order of merit. Her simple demeanor suited a day job as lexicographer at the Linguistics Institute of the Georgian Academy of Science adding entries to the Georgian National Dictionary. She also served the Academic Council of the Institute of Linguistics and the Georgian Language Permanent Commission and anticipated her country's independence from Soviet Russia.

Critics and readers admired the writer's interlinking rhythms, the patriotism of "Where Is Another Georgia?" and "You Are So Deep, Georgian Sky," and subtle political resistance, which eluded Soviet censorship. Another model, "Sun of the Dead," established personal despair. One example, "January Flowers at Uplistesikhe" (Lord's Fort), she set in an east Georgia town carved from rock. The stanzas imply that Soviet overlords—"Stone-heart cliffs, malignant winds—so they seem to us—stand guard"—while folk continue to thrive underground awaiting a chance to emerge (*ibid.,* 21). Devoid of imitation or derivation from Russian literature and ideological sloganeering, her nationalistic, romantic, and topographical themes gained popularity when set to music. One example, "Saqartvelo Lamazo" (Beautiful Georgia), illustrates the solace of wind through willows, an abstract of freedom. In 1972, a Moscow publisher issued "Mravalzhamier Stikhi (Poems to Long Life)," based on a drinking toast that alludes to Slavonic liturgy from the Byzantine era.

Following publication of *I Am Little Branch* and two more volumes named *Poems,* Ana Kalandadze received two citations in 1985—the Shota Rustaveli State Prize, Georgia's highest honor, and Galaktion Tabidze Award from the Writers' Union. She completed *Dorogoe Imya* (Dear Name) in 1987. In 1994, she co-authored the essay "Our Flag Was Named Gorgasliani (Competition)." The anthology *The Country Expands with Love* (1996) selected original prose from interviews, memoirs, and diaries and preceded a condensation of the Writers Union philosophy. Her ode to Themis in "Gratuitous Is Your Inner Voice" (2004) saluted the demi-goddess of law, equity, and order. In 2006, the TBC Bank conferred on her a silver feather, its third South Asian Bar Association lifetime achievement award for contribution to Georgian literature. At her death from cerebral hemorrhage at age eighty-three on March 11, 2008, the "queen of Georgian verse" received acclaim at her tomb at the Didube Pantheon of Writers and Public Figures in Tbilisi on Mount Mtatsminda.

Source

Osborne, Karen Lee. "Interview," *Literary Review* 30:1 (Fall 1986): 5–23.
Ratiani, Irma. "From War to Peace: The Literary Life of Georgia after the Second World War," *Primary Literature* 42:1 (2019): 89–102.
Rayfield, Donald. *The Literature of Georgia: A History.* London: Routledge, 2013.

Boa Sr. (1925–January 2010)
linguist, singer, storyteller
Andaman Islands

A reservoir of Aka-Bo (also Aka-Jeru and Ba), one of the world's Paleolithic languages, Boa Sr. retained Andaman Islands heritage in narrative, wisdom, and song dating to 63,000 BCE. At her birth at the Mayabunder jungle in 1925 to Renge, a Jeru father, and To, a Bo mother, she received a name meaning "land." The name identified an aborigine who hunted boars, bird eggs, and turtles in the jungle and gathered wild potatoes. In the north central part of an archipelago cluster pioneered by British colonials in 1858 in the Bay of Bengal some 750 miles from India, she grew up unschooled. In girlhood, she learned a version of Hindi. She married Nao Jer, a native Jeru, but bore no children. A fellow tribe member named Boro Sr. called a daughter Boa Jr. in her honor.

Boa Sr. recognized the racial bias introduced by the first wave of British colonials, who turned the islands into a penal colony. She admired the beauty of dusky-skinned Andamans and their energetic dancing and questioned the arrogance of people with lighter complexions who stole native land and slaughtered or demeaned primitive tribes. To her eyes, the pale insurgents looked like skinned animals. She sang the lyrics of folk melodies about hunter gatherers—a husband and wife laboring to cross a canal, killing a pig with bow and arrow, picking ripe fruit from trees, roasting a turtle in its shell, and steadying a boat at high tide. An autobiographical song described how her husband was jailed for six months; another reminded the young to esteem ancestors, a vital connection to their African genealogy.

Obstacles to Islanders

Events of Boa Sr.'s past included epidemic tuberculosis, cholera, measles, influenza, and broncho-pneumonia. After March 1942, Japanese occupation forces murdered 750 islanders in a single roundup. In her late forties, both parents died, leaving her the oldest surviving Andaman of ten marginalized tribes and the last Bo or Aka-Jeru speaker of India's fifth language family after Indo-Aryan, Dravidian, Austroasiatic, and Tibeto-Burman. Around 1975, she and other natives entered a tribal reservation near Port Blair on Strait Island, an assimilation defamed in a native tune. They occupied tin-roofed concrete billets governed by police and welfare staff and sufficed on a £6.80 ($9.51) monthly stipend. One song posed an ominous hint that roadside housing was unsafe.

Boa Sr.'s diet added to bird eggs, turtles, seafood, and venison locally grown tamarind, mango, and coconut. The Indian government supplied dal (split peas), cooking oil, spice, rice, tea, milk powder, sugar, soap, and kerosene, but no indigenous language classes for minors. Of 150 infants born at the Andaman Home compound, all died by age two. Adults succumbed to alcoholism. Disheartened, Boa Sr. wanted to return home, where her native language relieved stress and inferiority.

Again in danger from the Indian Ocean tsunami and earthquake, at age 79, Boa Sr. survived high water by retreating to a jungle hillock and climbing a tree. Her memoir of December 26, 2004, contributed action verbs to a growing Bo dictionary as well island prescience of disaster through insight into waves and fish. She recalled the inundation that rose ankle high and filled cottages. In a pre-neolithic language that originated before African migration to Asia, New Guinea, and Australia, she repeated elders' alerts about surviving an earthquake, which her songs pictured as a feller of trees. After two days, the flood subsided.

Linguistic Treasures

In aboriginal phrasing, Boa Sr. preserved Andamanese names for places and for plovers and sea eagles, some of the birds embodying the spirits of black forebears. She identified powerful plant juices that stunned fish, bruised skin, and stimulated human breast milk in new mothers. Her stories recalled funeral customs and tonsuring of newborns as well as a mythic *jirmu* (giant cow) and a vine that calmed rip tides. From the first modern humans, she performed rhythms linked by meter and stress to African musicology. The earliest lore distinguished headhunters and cannibals as supernatural mankillers. Her friend Licho added the term *raupuch*—someone whose siblings have died.

With vision dimming, Boa Sr. collaborated with anthropologists and widely published language historian Anvita Abbi of Delhi's Jawaharlal Nehru University, who compiled *Vanishing Voices of the Languages of the Andaman Islands*. Boa fretted about the future of the Bo language family:

They don't understand me. What can I do? If they don't speak to me now, what will they do once I've passed away? Don't forget our language, grab hold of it. Don't ever let it go [Abbi, 2013, 1].

Working with Boa Sr., the historian sought from 2005 to annotate Bo fables, tales, story-songs, and anecdotes in Hindi, island dialect, and creole.

The loss of friend Boro Sr. at age 74 in November 2009 limited outreach to other islanders, causing Boa Sr. to relieve isolation by talking to birds, avatars of African progenitors. At her death at age 85 in Port Blair hospital on January 26, 2010, only around fifty Great Andamese survived, but the Bo language and lore did not. Lost to Indian and world history, most of the songs and chants linking southern Asia to its prehistoric African roots and revealing medicinal plants and climate change

died without transcription or recording. Through Boa Sr.'s contributions, in 2011, the researcher managed to issue the *Great Andamanese Dictionary*, an interactive English-Great Andamanese-Hindi compendium.

Source

Abbi, Anvita. *Endangered Languages of the Andaman Islands.* Munich: Lincom-Europe, 2006.
_____. *A Grammar of the Great Andamanese Language.* Leiden: Brill, 2013.
_____. *Vanishing Voices of the Languages of the Andaman Islands.* Leipzig: Max Planck Institute, 2003.
Ali, Asad. "An Indian Academic's Lone Fight to Save the Great Andamanese," *TRT World* (8 September 2020).
Boa Sr. "Voices of the Great Andamanese," www.youtube.com/watch?v=LRCpuuHXwn0.
Dasgupta, Debarshi. "Mourning the Death of a Language amid the Pandemic," *Straits Times* (3 June 2020).

Beyşenalieva, Bübüsara (September 15, 1926–May 11, 1973)
ballerina, film star
Kyrgyzstan

A peasant dance diva known by her first name, Bübüsara (also Bibisara) Beyşenalieva brought fame to Kyrgyzstan by founding the nation's first ballets. A native of Vorontsovka (now Tash Debe) in the southwest on the Uzbekistan border, she was nicknamed Gyoko (Blue Eyes). After recruiters observed her skill at jumping rope in the schoolyard, she followed the career path of great Russian dancers by learning the rigorous Vaganova method, derived from nineteenth-century ballet-master Marius Petipa's blend of Russian athleticism, Italian stagecraft, and French romanticism. Trained in Leningrad at age ten in the style of the Imperial Russian Ballet, she developed flexibility, versatility, and stamina under teacher Agrippina Yakovlevna Vaganova at the Vaganova Ballet Academy. Viewers thrilled to Bübüsara Beyşenalieva's flying leaps, light frame, and character mimicry.

In Moscow's Theatre Square, Bübüsara Beyşenalieva was thirteen when she debuted as Zainure in *Selkinchek* (Swing) at the Bolshoi Theatre, a prestigious venue since 1825. She introduced classic steps and postures in Kyyrgyzstan, one of the last Eurasian countries to support classical dance. At age eighteen in 1944, she earned the position of prima ballerina of the Kyrgyz company with the title role of *Cholpon* (Morning Star), a gothic story that blended Mongolian, Slavic, and Tartar elements. Choreographed by Bermet Artykbaeva with music composed by Mikhail Rauhverger, the three-act story-dance featured the prima ballerina in knee-length black braid, netted cap, ropes of pearls, and a glittering red bare-waisted costume adorned with sequined tatters. The nation's signature ballet, it marked the beginning of a youthful art movement led by Bübüsara.

CHARACTER PARTS

In 1948, the dancer resided in Leningrad to refine techniques under Vaganova and returned in 1949 to teach choreography at the Bishkek Ballet School. During the

residency in Russia, she had an affair with Kyrgyz author Chinghiz Aytmatov. They spent winter nights walking along the Neva River, but she rejected his marriage proposal. Later, she traveled with her son Ermek. Stage roles revealed her in a range of personae, including the title figure in the Suyunbai Eraliev's popular lyric dream poem *Ak Mur* (Love Ode). She mastered Peter Ilyich Tchaikovsky's most popular ballets: the dual part of Odette and Odile in *Swan Lake*, the tragic heroine in *Romeo and Juliet*, and the fairy tale allure of Aurora in *Sleeping Beauty*.

Hundreds of fans trailed Bübüsara Beyşenalieva as she rehearsed gestures along Dzerzhinsky Boulevard. Ballet buffs crowded theaters to reward her latest part with flowers. For Alexander Pushkin's Stalin era love triangle *Bakchisaray Fountain,* she simulated the martyrdom of Maria, whose rival stabs her to death. For the four-act *The Red Poppy,* to the gongs and strings of composer Reinhold Glière, she exuded the liberation of the title martyr, who rescues a sea captain from a cup of poison. For the title part of the chaste virgin in white dress and feathered red cap in Vladimir Vlasov and Vladimir Fere's *Anar* (Pomegranate), she drew massive applause. In 1955, she attended the International Youth Festival in Warsaw, Poland, where protestors decried imperialism.

At the Kyrgyz Academy of Sciences in Bishkek, the dancer addressed the "Advocacy of Peace" consortium. After presenting *The Lotus Dance* in Beijing, China, in 1956, she appeared at the Bolshoi Theatre during the concert tour of Kyrgyz artists in Moscow and Leningrad. From the title roles of Petipa's three-act *Raymonda* and the romantic lead of Dulcinea in Petipa's *Don Quixote,* Fanny in Frederic Chopin's *Grande Valse,* the pirate's beloved Medora in Adolphe Adam's *Corsaire,* and the tragic star of Sergei Rachmaninoff's *Francesca da Rimini,* in 1959, she advanced to Tchaikovsky's *Esmeralda,* a vengeful gypsy tale based on Victor Hugo's novel *Notre Dame de Paris.*

At a pinnacle of Bübüsara Beyşenalieva's career, on January 1, 1958, at the Maldybaev Theatre in Bishkek, she portrayed the evil witch Ai-Dai in *Morning Star,* a folk tale of murder and cannibalism from the Persian *Sanduq* (treasure chest). At the Decade of Kyrgyz Art and Literature in Moscow, a 1959 reprise of *Morning Star* earned Russian ovations for its drama and contrast of female performers, who alternate settings on a battlefield and in an underground chasm. The presentation earned the USSR Supreme Council Presidium Citation of People's Actress. Filmed by director Roman Tikhomirov at the Kyrgyz State Academic Opera and Ballet Theater the following year, the folk story featured a vampirish hag shapeshifting into the form of Morning Star to seduce Prince Nurdfin, played by actor Uran Sarbagishev, her reliable partner for eighteen years.

GLOBAL FAME

The 75-minute Lenfilm Studios movie in Sovcolor traveled to theaters in 111 countries, shocking some audiences with nude scenes. When it opened in the United

States in mid–August 1962, a *New York Times* critique admired the fast-paced plot and the terror of the title figure, the ingénue Reina Chokoyeva. A drama critic concluded, "The incredibly mercurial Bibisara Beishenalieva, as the sorcerer, goes the whole company one better by suggesting that she's about to take off into space" ("Russian," 1962). She acquired more fans for soloing to Maurice Ravel's passionate *Bolero,* choreographed in 1960 by Maurice Bejárt.

After global tours that elevated Kyrgyz national arts, the dancer served two terms as People's Deputy to the Supreme Council. Because of a stage injury when a partner dropped her, she retired to teach at the Kurenkeev school of choreography and the Kyrgyz National Ballet School, where she directed a young actors' troupe. In 1970, she accepted the Toktogul State Medal for dancing the title role of Chinghiz Aitmatov's *Asel,* a story of unrequited love. In 1972, R. Kh. Urazgeldiev composed the biography *Bibisara Beyshenalieva.*

At age 46, the famed ballerina suddenly sickened with cancer and died in the city hospital of Bishkek (also Frunze) on May 11, 1973, leaving her lover in grief. Citizens dubbed her "Our Bubusara" and "Heavenly-born Talent" and hailed her with a statue outside the state ballet and opera hall in Bishkek in north central Kyrgyzstan. The life-size figure in tutu and cape, sculpted by Turgunbai Sadykov, poses *en pointe* with arms raised. The five-*som* note (5¢) pictured her in a head-and-shoulder portrait that hangs in the national museum. On May 15–21, 2016, an international festival of ballet in Bishkek commemorated Bübüsara Beyşenalieva's ninetieth birthday. A Bishkek street, Kyrgyz State Institute of Arts, and the Republican Ballet College preserve her name.

Source

Dzyubenko, Olga. "U.S. Criticizes Kyrgyzstan in Hotel Fence Row," *Reuters* (30 July 2008).

Ismayilova, Laman. "Azerbaijan to Join Int'l Festival of Ballet Art in Bishkek," *Azernews* (11 May 2016).

"Russian Imports: 'Violin and Roller' and Ballet Film Open," *New York Times* (20 August 1962).

8

1930s

Shifra, Shin (1931–February 9, 2012)
poet, editor, children's author, textbook author, translator
Palestine

Among prodigies, Assyriologist Shin Shifra excelled at a full complement of writing projects. A sabra—a native-born Israeli Jew—before the partitioning of Palestine, she was born Shifra Shifma Shmuelevitch, a preface to multiple pseudonyms. A native of coastal Tel Aviv born in 1931, she and seven siblings grew up near a citrus grove to the east in the orthodox agrarian community of Bnei Brak (Son of Barak), an ancient city of the tribe of Dan named in the Tanakh in Joshua 19:45. Her grandparents had lived in the Ottoman-controlled capital of Jerusalem since the 1850s and passed on reverence for Judaism. With pride of place, she stated, "We are still children of the region whose recorded history began with the invention of writing in Mesopotamia, at least 2000 years before we wrote the Old Testament" (Rubin, 2012).

The fifth child of a Russian mother and one of Old Jerusalem's first teachers during a period of ethnic unrest, Shin Shifra absorbed her father's readings of dramatist Nissim Aloni's satiric play "The Emperor's Clothes," "The Gypsies of Jaffa," a poetic drama in which a fortune teller predicts intercultural marriage, and "The Bride and Butterfly Hunter," the comic tale of a runaway bride. She learned Yiddish from her grandparents and Arabic from her parents, who hid domestic secrets in a foreign language. A writer of songs, tales, and poems, she graduated from a military girls' high school and earned a teaching degree in Jaffa at the Levinsky Seminar. She deepened her understanding with coursework at the University of Jerusalem, the antique language department at Bar-Ilan University at Ramat Gan, and Tel Aviv University. The need to write overtook her at odd moments, even on the bus or in dreams. Under titles redolent with gendered relationships—"That Made Me Woman," "A Stranger," "Moonstruck," "Shame"—she submitted impressionistic and experiential works in 1951 to literary journals.

A HOST OF HONORARIA

Shin Shifra's interest in conservative Judaism led her to philosophy, Hebrew literature, and Kabbalah mysticism as well as Akkadian and Sumerian, the antique

languages of the Fertile Crescent that lent continuity to the region. To access mid-twentieth-century literary criticism, she learned German. She valued the mentoring of Polish author and idealist Yonatan Ratosh, founder of the Canaanism movement to reoccupy the Fertile Crescent, and edited his periodical *The New Keshet* (Rainbow), which merged with *Jewish Mosaic* in 2010. From him, she gained respect for archaic diction, mythic themes, and chanted rhythms. Her classroom duties began with high school creative writing and ancient Near Eastern literature at Levinsky College and Tel Aviv University. An advocate for volunteerism, she founded a reading center for children at the Arab Academic College in Haifa.

At age thirty-three, Shin Shifra wed Matityahu "Matti" Shmuelevitch, a leader in the Zionist paramilitary jail bust at Acre Prison on May 4, 1947, and office director for Prime Minister Menachem Begin. She completed Hebrew verse in *A Woman's Song,* a daring carnal leap for conservative times. A study of femininity in "Songs of Garment" traced her thoughts on the removable persona and the inner ache of wounded bones. There is a note of secrecy in her collection of boxes and of chiding in "Daughter of a King," the story of a freedom-loving mistress, the sexually liberated woman who earns her own way. She followed with *The Next Step* and *Desert Poems* and a critical article for the May 1972 issue of *Aleph,* "No Intercourse and With No Delight: On the Problem of the Alien Lover in Israeli Literature," issued under the masculine pen name Yosef Dotan, an allusion to the Palestinian pasture where Jacob's son sold their brother Joseph to Ishmaelite merchants.

The author added an introduction, bibliography, and commentary for Ratosh's text *Jewish Literature in the Hebrew Language,* issued in 1982 along with *The Beginning Days* and a nonfiction collection, *From the Oven to the Pool.* By 1987, she had collected twelve years' worth of poems in *Drimias Memorial Candles,* source of the first of three successive Prime Minister's Awards. After contributing her feminist advocacy to a 1989 PEN Conference in Yugoslavia, she filled *The Sand Street* with short stories. The collection earned a 1992 Society of Authors, Composers and Music Publishers in Israel citation and the 1997 Leah Goldberg Prize for literature.

Unraveling the Past

As a specialist in ancient languages, Shin Shifra collaborated with Jacob Klein for fifteen years translating Akkadian and Sumerian verse. They compiled the text *In Those Far Days,* a 1996 verse anthology set at the Tigris and Euphrates confluence. Her choices focused on the Ishtar-Tammuz (or Inanna and Damuzi) romantic song cycle from 4000 BCE, the Gilgamesh saga, written in Mesopotamia around 2100 BCE, and the Babylonian Enuma Elis (Genesis creation story and flood myth) from 2000 BCE. To give Gilgamesh a workable platform, she invented an Assyrian storyteller, Kerdi-Nergal, who entertained Neo-Assyrian King Ashurbanipal after his accession east of Judah in 669 BCE. The anthology won the Tchernichovsky Prize for translation into Hebrew. The poems "To Your Image," "Goat," and "A Woman Who

Practices How to Live" contributed to the comprehensive 1999 volume *The Defiant Muse: Hebrew Feminist Poems.*

Shin Shifra gained a following in 2000 for translating from Akkadian a young reader's version of *The Tales of Gilgamesh,* another award winner of the Ze'ev Prize for works intended for children and tweens and a 2001 Hans Christian Andersen honor listing. In 2002, she reflected on the source of the essay "In the Meadow in the Soft Grass." Her enthusiasm for teaching resulted in a mythology textbook for teens in 2003, *From Ancient Stories to Kings and Prophets.* Her last verse writings filled *A Woman Who Practices How to Live* in 2001, a winner of the Yehuda Amichal verse award, and, in 2007, *Whispering Silk,* recipient of a Brenner Prize from the Hebrew Writers Association. In between, Israeli composer Gil Shohat set to music her song cycle *Michal,* a motet for children's voices, the fantasia *A Mother and Son,* and the oratorio *Bathsheba* for a 2008 world debut in Milwaukee, Wisconsin.

Fans favored the author's radio broadcasts collected in *Words as Magic and the Magic in Words* in 2008 and, the next year, *The Tales of Anzu the Great Eagle,* a children's storybook about a demonic stormbird. A series of honoraria—a 2004 President's Prize for Israeli Literature and the Amichai Prize for Poetry, and a 2010 EMET Prize—crowned her career. The poems "Blessed Be He Who Made Me Woman" and "Sabbath Prayer" revealed a yearning for children to bear the names of her ancestors. At age eighty, she died childless on February 9, 2012. A posthumous short fiction work, *Woman Is Just an Arena,* and young adult mythology, *The Descent of Ishtar to the Underworld,* coincided with her death.

Source

Cohen, Leon. "MSO to Premier Israeli Composer's Oratorio," *Wisconsin Jewish Chronicle* (31 March 2008).

Rubin, Riva. "Interview," *Esra* 149 (24 November 2012).

Sela, Maya. "Award-Winning Poet, Translator Shin Shifra Dies," *Haaretz* (10 February 2012).

Pachen, Ani (1933–February 2, 2002)
autobiographer, orator
Tibet

A colonial Buddhist nun/chieftain and guerrilla warrior, Ani Pachen summarized Chinese barbarity toward a Tibetan outlaw. Born to Chief Pomda Gonor and one of his two wives in eastern Tibet on the Sichuan border in 1933, she was a privileged native of Gonjo on the slopes of the Hengduan Mountains. In a memoir, she claimed her homeland as the world's roof, the home of dynamic spirits. Reared like a boy, she dedicated herself to Tibetan Buddhism in 1941. To elude an arranged marriage to the son of neighboring chief Rushok Pontsang, in 1950, she convinced a servant to help her escape over the roof.

On horseback for three days, the teenager fled to a monastery at Tromkhog to study under teacher Gyalsay Rinpoche and take holy vows like her aunt, Ani Rigzin,

another runaway. She changed her name from Pachen Lemdha to Ani Pachen (nun, big courage). Because her father relented on forced engagement, servants brought her home. In a violent era, she viewed the Chinese crossing of the Jinsha River to invade Kham, murder Tibetans, and dissolve monasteries. To fend off encroaching socialism, at age eighteen, she began shooting firearms supplied by India, riding, and freedom fighting with Khampas, the residents of Kham.

At age seventeen, Ani Pachen accompanied her mother to the Tromkhog monastery to meditate on religious pacifism for six months. She abandoned a vow of nonviolence and, as the family's only child, replaced her deceased father. As the sole female chief of the Lemdha clan, on horseback and poorly armed with antique rifles, she led six hundred guerrilla warriors west to a union with two clans assembled at Lhasa. With CIA special ops, she fought the Sino-Tibetan invasion and its obliteration of Buddhism via the murder of monks, bombing of monasteries, and arson at religious libraries. Her methods involved waylaying convoys, delaying Chinese road builders, and seizing camps. Her followers exulted at an American parachute drop of food, clothes, cash, grenades, rifles, pistols, and radios. She slept under sheepskin and accustomed her eyes to viewing vultures pecking dismembered bodies.

A crush of Chinese Communist soldiers pushed the warrior chief leading Granny, Mama, and Aunt Rigzin south over snowy 20,000-foot passes in the Himalayan Mountains toward India. After the Battle of Chamdo on October 7, 1950, China annexed Tibet and massacred 456,000 citizens. To smash the monastic influence on Tibetans, the enemy captured all four women and marched them west in a group of one hundred captives. Along the way, she heard herself cheered as the Tibetan Joan of Arc.

YEARS IN A CELL

Jailed in abandoned buildings at Deyong Nang for a period of "reeducation," Ani Pachen survived questioning while hanging upside down, shoulder dislocation, jailing in sewage, starvation, lashings, and a week's suspension by her wrists. She detailed the pain as "flame shoots through my shoulder, bile fills my mouth. I swing, senseless" (Pachen, 2000, 3). While she labored in laundries removing lice from prison uniforms, religious beliefs impelled her to survive on earthworms and share food with elderly prisoners. She grieved for Chinese captors and prayed to take on the pain of others, even Chairman Mao.

Upon the release of other female prisoners, Ani Pachen remained in custody at Lhodzong on the northern Indian border. Transfer east to a Chamdo prison required leg shackles and more questioning. At age thirty, she entered Silthog Thang, a maximum-security prison on the Za Que River, and served nine months in an underground cell for challenging a guard and continuing to prostrate herself to Buddha. In constant prayer, she begged to deliver Tibet from evil.

To rejoin her mother, Ani Pachen requested that a sympathetic guard help her

move southeast to Kongpo. On her mother's deathbed, the family found a red shirt and bags of barley, gifts to end her daughter's cold and hunger. After the poisoning of her aunt and grandmother and the destruction of their Gonjo home, she entered Drapchi at Lhasa, a massive political prison. Until January 1981, she obeyed draconian restrictions against praying, speaking Tibetan, or following native customs. In place of her own clothing, she wore black Chinese inmate uniforms. From transfer to Tramo Dzong in Nyingtri, she gained release at age forty-eight. Living for a while in a cave, she suppressed anger that family members had starved to death.

A religious odyssey took Ani Pachen to war-torn monasteries and temples. For eight months, she resided at Samye, an eighth-century-CE religious house rebuilt in the shape of the cosmos after the death of Mao Zedong on December 9, 1976. From the hermit Amdo Jetsun, she adopted an austere adherence to Buddhism called Chöd, a twelfth-century practice requiring the severance of reliance on reality to interpret fear. In time, she attained a calm essence, a non-self. Unconvinced by the philosophy, she revived the fight for an independent Tibet at non-violent demonstrations in September and October 1987 and March 1988.

A BID FOR FREEDOM

When authorities threatened to arrest Ani Pachen, at age fifty-six, she mapped a trail over Mount Kailash to exile in Nepal. She traveled by plane to Dharamshala and met Tenzin Gyatso, the exiled Dalai Lama, a master guru and proponent of a free Tibet. He urged her to record Tibetan tragedy and individual persecution. At the end of her pilgrimage, with other nuns fleeing the 1966 Chinese Cultural Revolution, she made a home in India at the nearby Ganden Choeling (Residence of Devotees) Convent and studied Buddhist truths. To rouse sympathy for Tibet, she delivered orations in the U.S., Great Britain, France, Italy, and Switzerland on her country's sufferings.

Despite compromised health, in 2000, the former guerrilla warrior began compiling an autobiography, *Sorrow Mountain: The Journey of a Tibetan Warrior Nun.* At the heart of her ambivalence toward war, she admitted committing murder because "I was bound by duty to carry on my father's work" (*ibid.,* 123). Motivated by spirituality, she vowed to preserve Tibet's sacred Buddhist canon. In the months before death from cardiac failure in her sleep at age sixty-eight on February 2, 2002, at Dharamsala, she urged audiences to support Tibetan sovereignty. Because of her resentment against twenty-one years of imprisonment, she regretted not attaining "enlightenment—the absence of negative feelings" (Martin, 2002, B7).

Source

Martin, Douglas. "Ani Pachen, Warrior Nun in Tibet Jail 21 Years, Dies," *New York Times* (18 February 2002): B7.
Pachen, Ani. *Sorrow Mountain: The Journey of a Tibetan Warrior Nun.* New York: Kodansha International, 2000.
Schulters, Alexandra W. "Subjectivity Politics in *Sorrow Mountain,*" *Genders* 44 (2006).

Wakita, Haruko (March 9, 1934–September 27, 2016)
actor, historian, editor, dramaturge
Japan

An esteemed dramaturge, author, and child actor, Haruko Wakita specialized in the medieval history of Japanese women and the East Asian myths and legends that inspired stage narrative. Through analysis of Nara and Heian literature in the 700s CE, her research corroborated the uncertainty and loneliness of wives who lost the matriarchal control accorded them in ancient Japan. She was born to poet Keizo Asano at Nishinomiya City west of Osaka on March 9, 1934. At age six, she joined a stage troupe performing Noh, classical drama about commoners' lives. At the time, Japanese theater included female performers in dancing and chanting. For its use of traditional costumes, drum and flute music, and masking of mortals and divinities dating to 1350 CE, the Japanese claimed medieval drama as a cultural intangible.

Haruko Wakita married historian Osamu Wakita and bore a son, economist Shigeru Wakita. Involvement in Noh staging encouraged her to enroll in Japanese history at Kobe University. By age thirty-five, she attained additional degrees from Kyoto University, to which she submitted the dissertation "Medieval Commerce and Industry." From faculty positions at Kyoto Tachibana Women's College, Naruto University of Education, and Osaka University of Foreign Studies, she advanced to founder of the *Nihon Joseishi Kenkyukai* (Japanese women's history research group) and editor of its house journal, *Joseishigaku* (Female Private School). To supplant androcentric bias with a balanced view of gendered conditions during colonialism and empire, in 1995, she taught women's, urban, commercial, and industrial history at Shiga University at Hikone on Lake Biwa. Simultaneously, she collaborated with dramaturges in France and Italy and with American Noh experts at the University of Michigan.

AN ACADEMIC LIFE

The scholar applied years of investigation to a list of renowned writings about patriarchy and polygamy. She published a first title, *Study of Japanese Medieval Commercial Development History,* in 1969 and "Towards a Wider Perspective on Medieval Commerce" for the spring 1975 issue of *Journal of Japanese Studies.* At Iwami Ginzan silver mine at Oda northeast of Osaka, she led an academic analysis of tree planting and land reclamation and promoted the locale as a UNESCO World Heritage Site. Research for the article "Marriage and Property in Premodern Japan from the Perspective of Women's History" posited that heavily involved females joined their husbands in managing family business. Although she outlined the success of a female silkworm investor, her text conceded, "It is probably unlikely that female management of business enterprises was common" (Wakita, 1984, 80).

In 1984, Haruko Wakita followed with "Marriage and Property in Premodern

Japan," a perusal of the Muromachi Period (1338–1573) which summarized the collapse of primitive communities, the seventh-century rise of the ruling class, and patrilineal bequeathing of property. The text stressed the iconic glorification of virginity, chastity, and motherhood and aspersions against adulterers. She commented that "Warriors considered the integrity of the family unit, including its property, so important that the estate could be allotted to the mother as well as to daughters" (*ibid.*, 88). She added, "The mother commanded great respect, imbued as she was with a strong sense of honor" (*ibid.*, 92).

The historian reached a height of productivity in her late fifties with investigations of Asian androcentrism, medieval city growth, and veneration of maternity after the Heian Era (794–1185). She completed a comprehensive women's history in 1987. To inspire the younger female generation, she proposed a women's history award. To refute overemphasis on high culture, in 1991, she compiled an overview, "Town Festivals: Medieval Towns and Seigniorial Authority in Medieval Japan." Her next three volumes delved more thoroughly into gender issues: *A Study of Japanese Medieval Women's History: Gender Role Division and Motherhood, Home Economics, Sexual Love* (1992), *Japanese Gender History* (1994), and *Women Living in the Middle Ages* (1995). In the midst of composition, she contributed contrasting views of wedlock to *U.S.-Japan Women's Journal* in the essay "Women and the Creation of the *Ie* (House) in Japan," a rising demand for marital cohabitation after 1000 CE.

Feminist History

In 1997, Haruko Wakita produced "Fêtes et Communautés Urbaines dans le Japon Médiéval: La Fête de Gion à Kyôto (Festivals and Urban Communities in Medieval Japan: The Festival of Gion at Kyoto)." The monograph outlined parades and purification rites suppressing epidemics by placating the gods. She coedited for Osaka University Press the feminist reflection *Gender and Japanese History: Religion and Customs, the Body and Sexuality.* Her research for the University of Michigan Center for Japanese Studies yielded *Women and Class in Japanese History,* which contained the essay "The Medieval Household and Gender Roles within the Imperial Family, Nobility, Merchants, and Commoners."

At age sixty-seven, the scholar served Josai International University at Togane as a visiting professor and published *Emperor and Medieval Culture* and the essay "The Character of Japan's Trade with Ming." She returned to her childhood joy in stage play with *The Origin of Female Performing Arts: Puppeteer, Kusemai* (unconventional dance), *Shirabyoshi* (court singers in drag). The promotion of Japanese arts and her scrutiny of medieval Japanese discrimination earned a 2003 Kadokawa Kenshiro Award and a 2005 Person of Cultural Merit. Her 2006 treatise *Women in Medieval Japan: Motherhood, Household Management, and Sexuality* speculated that autonomous females in the Middle Ages enjoyed expanded careers in convents and commerce, household management, vending, pottery, entertainment, and court

life. After she directed the Ishikawa History Museum in Kanazawa and submitted to *Women's History Review* "The Japanese Woman in the Premodern Merchant Household," a lifetime of academic writing on female success in merchant houses won her the 2010 Order of Culture and a lifetime annuity. She died on September 27, 2016, at age eighty-two.

Source

Scholz-Cionca, Stanca. "The Noh Ominameshi: A Flower Viewed from Many Directions," *Asian Theatre Journal* 22:1 (Spring 2005): 154–158.

Wakita, Haruko. "Marriage and Property in Premodern Japan from the Perspective of Women's History," *Journal of Japanese Studies* 10:1 (Winter 1984): 73–99.

———. *Middle Ages as Seen from the Noh.* Tokyo: Daigaku Shuppankai, 2013.

———. *Women and Class in Japanese History.* Ann Arbor: University of Michigan Press, 1999.

Shimkhada, Sushma (January 1, 1936–February 5, 2018)
sculptor
Nepal

A Hindu feminist and Nepal's first female sculptor, Sushma Shimkhada (also Simkhada) began art training with photography before switching to radical gendered applications for sculpture. She was born on the first day of 1936 at Darkha, Nepal, northwest of Kathmandu, the seventh child of Kausalya Devi and Ratna Prasad Shimkhada. She developed a life-long devotion to Kali, the Hindu deity of creation and destruction. The artist interpreted natural and personal disasters as the result of any kind of supremacy or dominion over women, nature, and the poor and vulnerable.

Given in marriage in 1950 to a man nine years her senior, Sushma Shimkhada remained the required four days after the Hindu ritual before abandoning him. No record of maltreatment survives, only reluctance toward wedlock. Though only fourteen, the disgruntled bride received respect from her parents, who defended her rights of inheritance in divorce. At age twenty-two, she and her family relocated to Kathmandu, where she reveled as a playmate with nieces and nephews. Because she was barren, the relationships inspired the artistic theme of divine innocence in youngsters, whom she cherished as "Little Gods and Little Goddesses" (Shimkhada, 2019, 291). She revered the underage as a bridge between the uterus and the mother.

At the Maharaja Sayajirao University of Baroda on the Cambay Inlet of western India, during a fertile era of Nepali art, Sushma Shimkhada found her niche in the fine arts under the teaching of Dean Sankho Chaudhuri, a master of cubist mobiles, female nudes, and bas reliefs. Her younger brother Deepak described her concepts as rebellious. He acknowledged that "her journey wasn't an easy one. In Nepal, the profession of sculpture belonged traditionally to males—and as one of the first female sculptors, she constantly combatted this" (*ibid.*, 290).

COMMITTED TO FEMINIST ART

With dual certification in photography and sculpture, Sushma Shimkhada launched a professional career in the 1970s that featured female torsos and motherhood, a dominant subject among feminists. In addition to teaching children's art classes at Bal Mandir Orphanage, Kathmandu's largest and oldest child rescue center, and Lalit Kala Academy of Art in New Delhi, she shaped sculptures that inspired positive critiques worldwide. On International Women's Day, March 8, 1976, she won first prize at an exhibit of the Nepal Association of Fine Arts, a promoter of painting, traditional arts and crafts, sculpture, folk art, architecture, and alternative and creative arts. Two years later, she showed projects at the 1978 Fourth Triennale-India in New Delhi, a humanistic effort to broaden expression.

The sculptor gained critical admiration for a somber monochromatic portrait "Spiral Journey in the Cosmic Mother," the path of all living things through the birth canal. Analysts remarked on the metallic glow and tripartite views of "Womb," a representation of the Tri-Loka, the Hindu cosmological depiction of deep space, the solar system, and earth. The concept of maternity dominated the two sculptures, revealing her absorption of Purana myths and Hindu epics—the Ramayana and the Mahabharata—and their deference to sacred spheres, the equivalent of earth. On the sublimity of gestation, she commented, "A womb is our home, our universe. We were all created in the womb and we return to it" (Shimkhada, "Womb"). The intent was to symbolize the nurturance of female energy and creativity in the *yoni* (female genitals), the bases of womanly principles. At center, she placed a sheathed *linga* (phallus), a single masculine element dwarfed by three conjoined uteri. The three-to-one numerology articulated the ability of the male member to fertilize more than one female at a time and the buttressing of females after conception through shared experience and emotion.

VIEWING KALI

Arthritis impaired Sushma Shimkhada's mobility at the age of fifty and limited facility with hammer and chisel. For extended days and nights, she sought Kali's blessing at the Subha-Bhagavati Temple in Durbar Square. To sustain courage, she prayed to the goddess, on whose power over evil she frequently meditated. In January 2015, she experienced an upsurge in cultural influence after earning the Mahakavi (epic) Devkota award for fine arts, an honor from the government named for Laxmi Prasad Devkota, Nepal's prestigious dramatist, poet, and fiction writer. Because of foot surgery, she remained immured in her apartment on April 25, 2015, during a 7.8 earthquake that killed 9,018 in Nepal, India, China, and Bangladesh. The womblike atmosphere corroborated her faith in the Atharva Veda and the Upanishads, sources of mantras espousing spiritual understanding of the inner self.

Sushma Shimkhada lived with a brother in Kathmandu until his death, then

lived alone. A decade before she died on February 5, 2018, at age eighty-two, her younger brother, the religion teacher and children's book author Deepak Shimkhada of Darkha, compiled one of her primordial themes in *The Constant and Changing Faces of the Goddess*. In the 2015 book *She Rises: Why.... Goddess Feminism, Activism and Spirituality?*, which scrutinized female agency, he endorsed his older sister's artistic mirroring of the life-giving uterus: "Because of the important role a woman plays in reproduction and nurturing, she is elevated to the position of all-powerful Goddess" (Shimkhada, 2019, 287).

Source

"National, Regional Literature Awards Announced" (Anamnagar, Kathmandu) *Himalayan Times* (20 June 2015).
"Rethinking Nepali Art History," www.youtube.com//watch?v=m.
"A Revealing Look at Our Women and at What They Say," *Vasudha* 13:10 (1976): 5–7.
Shimkhada, Deepak. *She Rises What*. Chicago: Mago Books, 2019, 287–293.
_____. "Womb: The Creative Genesis of Sushma Shimkhada," *Rising Junkiri*, https://risingjunkiri.com/womb-creative-genesis-sushma-shimkhada/.

Cheng Yen (May 14, 1937–)
media orator, biographer, aphorist
Taiwan

A Mahayana Buddhist monastic and theologian, Cheng Yen turned spirituality into a world charity and a wealth of orations and wisdom books. Named Chin-Yun Wong (Bright Cloud) at birth on May 14, 1937, she lived in Kiyomizu in the Taiko (modern Qingshui) district of Taiwan as adoptee of a childless aunt and uncle. On the shore of the Taiwan Strait, until the end of World War II on September 2, 1945, her family observed the devastation of Japanese bombings. Drawn to Buddhist humanism, at age fifteen, she embraced vegetarianism to relieve her mother's gastric ulcer and prayed for enlightenment to explain her father's sudden death from brain hemorrhage and her brother's eight months of hospitalization. She secretly enrolled at a temple in 1960 and again in 1961 after her mother forced her to return home. The Chi Lin Temple in Kowloon, Hong Kong, rejected her, but did not stifle her bent to teach others how to express Buddha's compassion.

Cheng Yen underwent ordination at age twenty-six in service to humankind and the spread of tolerance, charity, and reverence in everyday affairs. In February 1963 in Taipei, she sought discipleship under Yin Shun, a scholarly monk born in Zhejiang, China. He committed her to foster all earthly life and named her Huizhang (headmistress). Training in Buddhist metaphysics continued in May at the Pu Ming Temple at Hualien, where she plowed a vegetable garden and planted peanuts. Dedicated to poverty and secular altruism, in Hualien, Taiwan, the 29-year-old nun avoided sectarian dogma and ritual. For a more beneficial outcome to the needy, she turned activism to community service in the mode of Catholic convent charities. Her precepts called for morality and avoidance of politics and addictions and for the

nurturing of serenity and happiness for the disadvantaged through financial aid and medical care.

CHENG YEN'S FOLLOWERS

The theologian recruited a groundswell of disciples and, in 1968, donated $8,800 to fund a permanent building, the Jing Si Abode at Hualien. To support the mission, she inspired followers to knit sweaters and make and sell baby shoes and advised thirty housewives to give daily by setting aside 2¢ from each day's food allotment in a bamboo box to aid the poor. The first year's funds helped fifteen refugee families. In 1970, she expanded the concept by conceiving the Buddhist Tzu Chi (Compassion Relief) Foundation, a global outreach to residences, hospitals, schools, and disaster sites. Under the aegis of the U.N. Economic and Social Council, the organization built shelters, classrooms, and worship centers for any denomination, concentrating on the eastern Taiwanese sick and elderly.

Volunteers offered free medical treatment in 1972 and, on Taiwan's east coast, opened a 600-bed hospital near the mission in 1986 to serve the nation's largest aboriginal populations of 'Amis, Atayal, Bunun, and Truku. Four more hospitals uplifted the sick at Dalin, Guanshan, Xindian, and Yuli, earning her the 1986 Huashia Medal of the First Order. A minority nursing school opened in September 1989 for free and scholarship students. Victims of the eastern Chinese flood in the Chu, Huai, and Yangtze rivers from September 1991 to January 1992 received aid in Anhui, Henan, Jiangsu, and Zhejiang. After three thousand died, 367,000 fled damaged homes in 14,600 villages to dwell in unheated tents. From the Philippines, she accepted the 1991 Ramon Magsaysay Award for Community leadership and, from Hong Kong's Chinese University in 1993, an honorary Ph.D.

SUCCESSFUL MISSIONS

In 1994, the Tzu Chi Foundation reached four million members, who supported the rebuilding of flood-damaged towns and a bone marrow registry for leukemia patients and stem cell research. At age 63, Cheng Yen dispelled superstition about organ and body donations. The surge in donors aided anatomy students at Tzu Chi University. A growing admiration worldwide won her the 1994 Eisenhower Medallion, a 1995 Taiwanese Cultural Award, and a 1996 First Class Honorary Award, Foreign Affairs Medal of the First Order, and the Huaguang Award of the First Order.

Cheng Yen developed media programs to comfort and encourage positive actions in hearers, a mission that achieved the 1998 International Human Rights citation. Her essay and aphorism books *The Essence of Infinite Meanings, The Path to Awakening,* and *Dharma as Water* restated Buddhist guidance. In January 1998, she founded *Da Ai* (Great Love) television, an outlet for lectures on virtue and for biographies of people who redirected their lives. In a daily A.M. address "Wisdom at

Dawn" and an evening essay, she encouraged charitable goals and assistance to the lowest class. An outpouring of global respect to Asia's Mother Teresa included a 2000 Noel Foundation Life Award, a 2001 Heroes from Around the World recognition from the Philippines, a National Medal from El Salvador, a doctorate from Hong Kong University, and Thailand's 2002 Outstanding Women in Buddhism achievement. More kudos produced a 2004 Asian American Heritage Award for Humanitarianism and a 2007 Japanese Niwano (In the Garden) peace prize of $188,000. In 2011, the *New York Times* identified the nun as one of the world's one hundred most influential people.

Cheng Yen's concept of low-key, unpublicized altruism reached out to disaster victims of the Sichuan earthquake of May 12, 2008, when 69,000 died and 374,176 suffered injury. The first on the scene, her volunteers distributed 100 tons of supplies. By 2013, she directed ten million volunteers to perform merciful work in 129 countries including blood drives, rehabilitation for the handicapped, Earth Day and recycling, parenting classes, protective equipment for medical workers, palliative home care, and tsunami and typhoon relief in Sri Lanka, Indonesia, India, Thailand, and the Philippines. The following year, she received a nomination for a Nobel Peace Prize. In spring 2021, she motivated volunteer aid to fire-damaged homes in Dallas, Texas, and posted 129 food packages to St. Maarten, where the covid epidemic inundated Pond Island. In March 2022, she mobilized aid to victims of the Ukraine War.

Source

Cheng Yen. *The Essence of Infinite Meanings.* Hualien, Taiwan: Jing Si Publications, 2015.
_____. "Wisdom at Dawn," www.youtube.com/watch?v=ljZGXl1RjAs.
Tulfo, Ramon T. "A Buddhist Foundation Inspired by Catholic Nuns," *Manila Times* (17 December 2020).
"Tzu Chi Gives Food Packages to 129 Pond Island Families," (St. Maarten) *Daily Herald* (3 May 2021).

Tatishvili, Tsisana Bezhanovna (December 30, 1937– September 23, 2017)
opera singer, folk dancer
Georgia

A People's Artist of the Soviet Union and vocal educator, lyric and dramatic soprano Tsisana Bezhanovna "Tsiso" Tatishvili starred in classic European operatic roles demanding emotional range and flexibility from piano to fortissimo. Born in the Sololaki district in the southeast of Georgia's capital city of Tbilisi on December 20, 1937, she was the sister of actor and designer Gogi Tatishvili, the children of university student Ketevan Zandukeli and Bezhan Tatishvili, a military commissioner whom authorities arrested and shot. In girlhood, she studied folk song and dance and emulated great singers, particularly actor Luise Rainer, the star of the 1938 film *The Great Waltz*, a biography of Johann Strauss II.

Tsisana Tatishvili auditioned at age fifteen at Tbilisi's Sarandzhishvili Conservatory, revealing powerful delivery and rich virtuoso overtones. At Gogi's urging, she moved directly toward a musical career and excelled at costume roles enriched with jewelry and makeup. Of character parts, she claimed to have delved into personalities as they evolved in the milieu and chose Egyptian Princess Amneris in Giuseppe Verdi's *Aida* as her favorite. A shapely, aristocratic presence on stage, in her third year of study, she debuted as a suicidal Cinderella character, the peasant Ethery, opposite dramatic tenor Zurab Andzhaparidze in Zacharian Paliashvili's *Abesalom and Eteri,* which she recorded in German in 1971. In a subsequent year of training, she played Maro in a folk tale of frustrated romance, Paliashvili's *Daisi* (Sunset), the first opera performed in Soviet Georgia.

FINDING HER PLACE

With a conservatory degree in voice, at age twenty-six, Tsisana Tatishvili joined the Georgian National Opera and Ballet Theater troupe at one of Europe oldest opera houses. Her initial roles as the flirty Flora in Verdi's *La Traviata* and a Polovtsian (Turkish nomad) in Alexander Borodin's *Prince Igor* preceded a concert performance of Pierre Arditti's fantasia "La Valse" (The Waltz). The diapason and filigree of Donna Anna in Mozart's *Don Giovanni* at the Maria Imperial Theatre in St. Petersburg, Russia, earned the soprano the nickname "Orpheus" for her mythic melodious voice. She rejected invitations to escape Soviet control of Georgia to sing with Moscow's Bolshoi Theatre or the Grand Opera in Paris. Instead, she returned home to Tbilisi.

In a one-shoulder Egyptian gown, the singer took the star part of Amneris in a 1969 presentation of *Aida* and again in 1986, a year-long project that taxed her health and broke her foot from entanglement on a stage set. The production earned from the *Metropolitan Opera Review* the term "incomparable." In 1977, she recorded for youth *Five Vocal Poems by Galaktion Tabidze,* a Georgian writer. Two years later, she joined local singers for the recording *Pesnja o Tbilisi* (Song of Tbilisi). In 1981, she married pianist Giorgi "Gogi" Totibadze, principal of the Academy of Fine Arts, and continued popularizing opera in Tbilisi, despite offers to relocate to European culture centers.

For thirty-eight years, Tsisana Tatishvili performed works by Georgian musician Aleksandre Machavariani, the lead in Revaz Lagidze's *Lela,* and the medieval queen Tamar in Otar Taktakishvili's *The Abduction of the Moon.* She accepted concert parts opposite Zurab Sotkilava as Amelia, the king's secret love in Verdi's *Masquerade Ball,* Verdi's *Requiem,* Giacomo Puccini's "O Mio Babbino Caro" (O My Daddy Dear) from *Gianni Schicchi* and his "Addio, Mio Dolce Amor" (Goodbye, My Sweet Love) from *Edgar,* and Beethoven's "Ode to Joy." Under the surveillance of the KGB, she was careful in accepting lead parts—Floria Tosca in Puccini's *Tosca,* Desdemona in Verdi's *Otello,* Eboli singing "O Don Fatale" (O Terrible Gift)

in Verdi's *Don Carlo*, and, at the Bolshoi Theatre, Leonora's "Tacea la Notte" (Silent the Night) from Verdi's *Il Trovatore*. She named as most complicated the sell-out stagings of Richard Wagner's *Lohengrin*, in which she sang the pagan Ortruda, and the premiere presentation of the ingénue Senta in *The Flying Dutchman*. She played Santuzza opposite Nodar Andguladze at Berlin's Komisch Opera in Pietro Mascagni's *Cavalleria Rusticana*. More female leads included the title character from Vincenzo Bellini's Roman tragedy *Norma*, and the rejected Tatiana in Peter Tchaikovsky's *Eugene Onegin*. The role of the musician Liza in Tchaikovsky's *Pique Dame* (Queen of Spades) paired her with dramatic tenor Zurab Sotkilava, with whom she issued *Vocal Recital*, recordings of Sergei Rachmaninov's and Verdi's art songs.

Global Recognition

Invitations took the soprano to Berlin, Vilnius, St. Petersburg, Sofia, Kiev, Budapest, Riga, Munich, Bonn, Frankfurt, Lisbon, London, Athens, Prague, Cologne, and Moscow and on tour in Poland, Sweden, Austria, and Czechoslovakia. Her collection *Russia Melodiya* for Wanderer records allied Puccini with Verdi. In a retrospect of her career, she regretted never playing the lead in Georges Bizet's *Carmen* or singing in Puccini's *Turandot*. At the collapse of the Soviet Union, she was the first Georgian performer to sing in Russia the title role of Richard Strauss's *Salome*, involving a demanding, one-of-a-kind series of arias that crowned her career. She continued the post–SSR series in Europe with dramatic sopranos Birgit Nilsson and Montserrat Caballé. In 1991, she joined major opera stars in *Christmas 1991*, consisting of an opera excerpt of "Fidelia's Aria" from *Edgar* and seasonal melodies sung in Czech, French, German, Italian, Russian, and Welsh. In 1998, she played a suicide, the title figure in Amilcare Ponchielli's *La Gioconda*.

Despite stardom and adulation, Tsisana Tatishvili maintained a humble love for Georgian rural music. Her honors included a 1973 People's Artist, the 1979 Paliashvili Prize and a Soviet People's Artist, the Order of National Merit, a 2012 Knight of the Presidential Order of Excellence, membership in the Georgian Academy of Humanitarian Sciences, and a knight of the Swiss Order. At her retirement in 2000, she continued mentoring singers for the Georgia State Opera and served the Artistic Council. She achieved a star in front of the opera house on January 8, 2010, shortly before her husband's demise.

Five years before her death at age 79 on September 23, 2017, the beloved and much-photographed "Georgian prima donna" supported the drive for a democratic nation and accepted the state Order of Honor for defending her homeland. She received a state burial at the Didube Pantheon of Writers and Public Figures and a posthumous celebration at the state theater. On April 5, 2019, the Tbilisi opera house launched a reprise of *Tosca* in her name.

Source

"My Sweet Georgia," sweet-georgia.org/georgia/news/?act=nov&news_id=853 (3 April 2019).

"Tsisana Tatishvili," www.youtube.com/watch?v=127edk.o5fl.

Shimshi, Siona (July 14, 1939–October 16, 2018)
textile designer, embroiderer, set designer, ceramicist, sculptor, mosaicist, painter, writer, columnist
Israel

A diversified artist from Tel Aviv born on July 14, 1939, Siona (also Ziona) Shimshi designed interiors for Israeli industry and decorated jewelry, building facades, and interiors of New York's Kennedy and El Al terminals. She and older sister Sara were the only children of Lithuanian immigrant Aharon Avraham Shimshi and Chaya Rivka Kuklanski. At age seventeen, she entered the Avni Institute of Art and Design to study the human form. In 1959, she enrolled in pottery at Alfred University in rural New York and assisted the Greenwich House Pottery commune in Greenwich Village. During her studies, she married Israeli scenarist and cinema critic Jachin Hirsch, father of their daughter Dafna-Rona Hirsch, who became a computer engineer.

The artist contributed original works to the Jewish Museum, Rabun and Dugith galleries, and Patel Fabrics, including shadowy life-size figures; historically accurate jugs; and whimsical human heads with cartoon balloon dialogue, droopy ears, and blindfolds. Three years after completing training, she formed 10+ Group, an art enclave enlivened by other Tel Aviv potters. Once more in Israel, she designed in clay and embroidery for the Maskit fashion house crafts league, made wall and floor rugs for interior decorators, and coordinated annual textile exhibits. She curated a showing of works by Romanian interior designer Dora Gad at the Tel Aviv Museum of Art. For a sculpture based in Goren Goldstein Park, she received the 1988 Arieh El Hanani Prize for Art in Public Places.

THE PUBLIC ARTIST

Siona Shimshi's creative works adorn the King David Hotel, a five-star accommodation in Jerusalem, and a Tel Aviv Hilton dining room, which she surrounded with batiking. For the cafeteria of the Shalom Meir office tower, the nation's first skyscraper, she painted burnt clay wall tiles with witty details. Her 1967 traveling show "Design of Israel" toured seven U.S. states. In the late 1960s at the height of her career, she engineered a double-sided glass relief, transferred batik insignia to wood, and designed wool carpeting for the Four Seasons Hotel in Natanya in north central Israel. Her handiwork won a 1968 Israeli Design Institute acclaim for innovation. For the Ohel Dvora (Bee Tent) synagogue, she mounted a ceramic facade. A German award for the Israeli pavilion came from curators of the "Partners Des Fortschritts (Partners in Progress) Fair" in Berlin.

In 1970, the designer provided the ceramic display "New Totem" at the Tel Aviv Museum of Art. More public buildings claimed her carpets, Queen of Sheba ceiling rug, and sculpted chandeliers from the Dan Caesarea Hotel and Red Rock Hotel Eilat on the Red Sea. Her installation at Jerusalem's Israel Museum in 1973 offered "Gulliver Me & You" for youth. More public art placed carpet at the Hilton and Plaza hotels and painted glass walls at Ben Gurion Airport. The American Israel Culture Foundation gallery mounted batiking and sculptures for the 1974 "Early Summer" exhibition. More public carpets, tiling, glass mosaics, printed panels, and ceramic reliefs upgraded the Kennedy Airport and Hilton Hotel in Queens, New York.

In 1975, the Israel Museum displayed the artist's linen prints for the exhibit "Works in Threads." She completed prize-winning posters and record covers for the 28th Israel Independence Day on May 14, 1976, featuring a scrolled border and multiple stars of David enwreathed in primary colors. The Plaza at Tiberias and Shalom Memorial Park in Palatin, Illinois, acquired Shimshi's individualized carpeting and sculpture. Her 1978 submissions to a forty-artist sculpture tour traveled southeast Asia. Siona Shimshi's sets at the Habimah (The Stage), Israel's National Theater in Tel Aviv, anchored Shmuel Yosef Agnon's adapted novella *A Simple Story,* winner of a play of the year award. She repeated the feat in 1984 by costuming and staging Agnon's novel *Yesterday.*

NEW CHALLENGES

At Bezalel Academy, a Jerusalem art center specializing in ceramics and tiles, in her forties, from 1979 to 1988, the sculptor taught classes and chaired the design department. She continued arranging thirty-three solo exhibits, forty-two symposia, and thematic expositions that included a painting display in Paris, a swimming pool for the Hilton Hotel, fiberglass sculptures for Haifa University, and batiking for Israel's ocean liner S.S. *Shalom* (Peace). More flooring, tiles, reliefs, and mosaics completed public areas of the Chen Ramada in Thailand, Jerusalem's Laromme Hotel, and Migdal (Tower) Insurance building in Tel Aviv. A trend in wall rugs brought commissions from the Lewinstein Rehabilitation Hospital in Ra'anana, Carlton Hotel in Herzliya, Singapore's Boulevard Hotel, Rabin Hospital in Petah Tikva, and Mizrachi Bank and Diamond Exchange at Ramat Gan.

In addition to lecturing at Shenkar College in Ramat Gan, Siona Shimshi composed an essay and designed a cover for the November 1981 issue of *Architecture & Arts* magazine. From supplying Radius Gallery in Tel Aviv with the floor clay installation "Against the Lebanon War," she returned to wall carpeting, curtains, and wood and glass walls for hotels. She began a decade of culture columns for the *Haaretz* (Country) daily newspaper, provided *Moznaim* (Hidden) magazine and *Architecture Quarterly* with cover and article, advised Israeli TV and radio on art trends, and printed media posters. Commissions took her to Connecticut, Germany, South Africa, Southeast Asia, Turkey, Italy, Thailand, and Japan.

At Holon on the Mediterranean coast in 1998, Siona Shimshi sculpted a stone piece celebrating the nation's fiftieth anniversary and decked the grounds with shapes on columns and memorials to Holocaust victims. In 2004, Tel Aviv officials decorated city hall with her portraits of Mossad spy Eli Cohen and Natan Alterman, a Zionist journalist. She co-authored the book *Read the Walls,* centering commentary on the Jewish history of Paris. From 2012 to 2014, she managed the Israeli Internet Art Biennial. Seven years after her husband's death, she died in Tel Aviv on October 16, 2018, at age seventy-nine. Art historians credit her generation of sabras—native-born Israeli Jews—with ignoring the gendered "women's art" constraint and the search for nonfunctional embellishment.

Source

Levine, Angela. "Distinctive Pottery," *Jerusalem Post* (2 February 1991).

Neiman, Rachel. "11 Beautiful Posters from Israel Independence Days Past," *Uncovering Israel* (9 April 2018).

Nezer, Orly. "The Search for Localism and Abstract Expressionism in Israeli Ceramics in the 1970s," *Craft Research* 10:1 (2019): 69–90.

Shimshi, Siona. *Read the Walls.* Ra'anana, Israel: Even Hoshen, 2007.

Trajtenberg, Graciela. "Art Criticism and Its Power Over Women Artists—An Inquiry into the Sources of Gender Discrimination in Jewish Palestine/Israel, 1920-1960," *Journal of Historical Sociology* 31:4 (2018): 469–482.

9

1940–1944

Menon, Anjolie Ela (July 17, 1940–)
muralist, painter, glass worker
Bengal

An award-winning watercolorist, miniaturist, collage master, and muralist at New Delhi in north central India, Anjolie Ela Dev Menon esteems women's individuality, endurance, and spirit. She illuminated noble women in the Divine Mothers Series, featuring mother with son in "Maya with Gautama." Born in western Bengal at Burnpur on the Damodar River, she claims American and Bengali parents—Eunice Ela and Omar Dev, an army surgeon and builder of treehouses for his daughter. She completed Lovedale's Lawrence School, a 750-acre co-ed boarding academy in the Nilgiri Mountains of Tamil Nadu state and alma mater of two prime ministers, Jawaharlal Nehru and Indira Gandhi. After switching majors from architecture to art, she sold her first paintings in 1955, a year after her mother's death and the arrival of her Boston grandmother, Ethel Gupta. From preparatory school, she relocated to the Sir J.J. Institute of Applied Art, a commercial training center at Mumbai, and completed a degree in English literature at Miranda House College, a rapidly expanding women's wing of Delhi University.

A maverick of the art world, Anjolie Ela Menon declared, "I have been really driven to paint, in fact it is the only thing that I am driven to do" (Kalla, 2003). She gravitated to Indian cubists, Hungarian-Indian modernist Amrita Sher-Gil, and Italian portraitist Amedeo Modigliani. Her pensive, elongated figures tend to look into the distance or pose behind windows as though seeking liberty or adventure. Following her first show of fifty-three canvases in 1958, on a French scholarship, the eighteen-year-old enrolled in fresco at the Atelier Fresque of l'École des Beaux-Arts (The Fresco Studio of the Beaux-Arts School) on the Rue Bonaparte opposite l'Ile de la Cité in Paris. The studio introduced her to mural art.

At age twenty-one, the experimenter toured galleries of Byzantine and Romanesque art throughout Eurasia and felt the power of medieval Christian icons. The focus and tone of religious art inspired some of her untitled watercolors of Christ, Mariam (Virgin Mary), Eve, Brahmins and Hindus, *maulvi* (Muslim doctor of laws), *Ram Bhakt* (a devotee of Rama), prophets, and *visarjan* (baptism). She featured an acolyte and a Mother Teresa figure during a blessing ritual in "The Canonization"

and tending a moribund patient for "Pietá (Devotion)." She wed Admiral Krishna Raja Menon, a submarine expert and maritime strategist. With sons Aditya and Rajaraja, the couple settled at temporary navy installations in Japan, Soviet Russia, Europe, and the U.S. By age forty, she received offers from Britain, France, and the U.S. to continue producing erotic and melancholy studies.

SETTING A PACE

To achieve balance, the painter set a work pace of fifteen hours per day and varied human torsos and faces with sea settings, a child masking, crows, parrots, cats, and herders with goats and sheep. She chose masonite—steamed hardboard—as a basis for translucent oil paintings burnished in thin glazing, the style of "Unquiet Landscape," "The Magician Story," "Shabnam (Dew)," and "Legend of the Seafarer's Wife." For the showing *Painted Objects,* she began with a portrait sketched on a chair. The Apparao Galleries at Chennai on India's east central coast commissioned the decoration of forty-four more objects, which included a framed image of warmly lighted faces on fiberglass. Latticed works in 1981 depicted rounded glass inserts or squares divided into eight or nine views, the geometric backdrop of "Bandwala (Banded)."

In addition to murals, Anjolie Ela Menon eventually worked in vigorous watercolors, computer graphics, and ethereal fiberglass models of murano glass. For the collection *The Sacred Prism III,* she studied at Murano outside Venice with Antonio Da Ros, a master glass artist. Over thirty months, she sculpted abstracts, Buddha, Madonna and Child, and Indian iconography of the Hindu god Krishna, oval lingams (phalluses) representing the universe, and Ganeshas, a divinity in elephant shape. Exhibits of her Murano creations received praise in Delhi and Mumbai, San Francisco, and London.

INNOVATIONS

The Renaissance and impressionist works by Paul Cezanne, Vincent van Gogh, and Paul Gauguin influenced the artist's portraiture, nudes, and religious scenes, which she rendered in stark tones. Forty solo exhibits took her to Bonn, Dubai, Japan, London, Paris, Kuala Lumpur, Russia, and Washington, D.C. Defying controlling symbols, in 1992, for the exhibition *Mutations,* she introduced India to kitsch and found art—cupboards, chairs, refrigerators—and digitized outtakes from past canvases for etchings on cabinets, window frames, and trunks. After her husband's retirement, in November 1995, she authored *Paintings in Private Collections* and chose Buddhist themes for an exhibition at Hong Kong's Maya Gallery. She was already a global art maven in 1996, when she isolated figures from her oeuvre for digitizing and painting in oils and acrylics. The *Times of India* mounted an overview of her career in 1998 for the Jehangir Art Gallery in Mumbai.

Anjolie Ela Menon impacted national design with public works for the Kolkata Metro, Mumbai and Delhi airports, and the Imperial Tobacco Company, Hyatt, and Taj Hotels. On Republic Day, January 26, 2000, at age sixty, she received the Padma Shree (Noble Blossom), a civilian award from the Indian government for introspective arts. She toured New York in 2000 with the exhibit "Gods and Others," which contrasts the divine with the everyday. Two years later, she assembled a show for the Karnataka Chitrakala Parishad Gallery in Bangalore and Mumbai's National Gallery of Modern Art, which issued the critical volume *Anjolie Ela Menon: Four Decades*.

Following the painter's Karma sketches of faces in 2004, a triptych, "Yatra (Travel)," inspired a six-month exhibit at San Francisco's Asian Art Museum. Another at the Alcon Gallery in Palo Alto, California, in 2006 coincided with a career synopsis, *Celebration: Paintings by Anjolie Ela Menon*. Her collection "Menongitis—Three Generations of Art" in 2008 preceded "Landscape," a Dali-esque geometric analysis of a viewer through a fence and windows. The works anticipated the collection "In Search of the Vernacular" in 2009. She arranged a retrospect, *Anjolie Ela Menon: Through the Patina*; "Of Gods and Goddesses" in 2011; "Nizamuddin Basti (Colony)" in 2014; and "Goatherd" in 2017.

After completing the "I Am the Tiger" series, the painter accepted a 2013 citation from the government for lifetime achievement, an honorary doctorate from Rabindra Bharati University in Calcutta, and a Kalidas Samman prize for visual arts with a purse of $2,741.01. In 2018, Penguin Books in New York edited a review under her name. In addition to representing India at global art shows in Sao Paulo, New York, and Algiers, as the nation's greatest living woman painter, she advised the Indira Gandhi National Centre for the Arts and New Delhi's National Gallery of Modem Art. After a life of changing addresses, she lives at Nizamuddin East in southeastern New Delhi. During the covid lockdown, she continued to paint at home, producing a portrait of son Aditya and a home mural, "Celestial Being," a communion table shared by people of different races and faiths opposite a peacock, universal symbol of pride.

Source

"Artist Anjolie Ela Menon Conferred the Kalidas Award," *Indian Express* (1 July 2018).
Banerjee, Devashruti. "Anjolie Ela Menon," *Zingy Homes,* www.zingyhomes.com/thought-leaders/anjolie-ela-menon/ (9 April 2014).
Kalla, Avinash. "Anjolie's New Collection of Glass Art," *www.the-south-asian.com*/April%20 2003/Anjolie%20-%20Glass%20art-2.htm.
Prakash, Uma. "Anjolie Ela Menon: The Extraordinariness of the Ordinary," *Punch* (13 June 2020).
Zaman, Rana Siddiqui. "Painting the Heart Red," *The Hindu* (27 November 2009).

Radi, Nuha al- (January 27, 1941–August 31, 2004)
diarist, painter, ceramicist, sculptor
Iraq

A twentieth- to twenty-first-century anti-war reporter of the Gulf War, author Nuha Mohamed Saleem al-Radi attested to the brutality of air attacks on

a defenseless people. Born in Baghdad on January 21, 1941, she claimed as ancestors the Turkish prime minister Mahmood Shawkat Pasha, an Ottoman ruler; Suleiman Faik Beig, a distant great grandfather; and a wealthy land-rich maternal grandfather. She was the daughter of a Kurdish Sunni mother, Suad Munir Abbas, and Mohammed Selim al-Radi, a diplomat trained in agriculture in Texas. After a childhood with sister Selma and brother Abbad al-Radi in a palm orchard shading citrus groves, she followed her father's postings to Iran in 1947 and India until 1958. She studied English at private schools in Delhi and Simla and learned Arabic in Alexandria, Egypt. The boarding school experience ended abruptly in October 1957 with the Second Arab-Israeli War, when her father retired from the foreign service.

At age seventeen, on July 14, 1958, Nuha al-Radi survived the violent overthrow of the Iraqi monarchy. At London's Byam Shaw School of Art, she studied ceramics, which she created for the Chelsea Pottery cooperative. The projects emphasized Arab folklore about a magic carpet from *1,001 Nights* and the Persian control of the Fertile Crescent. Her works went on display at the British Museum in London and in Iraq, Italy, Jordan, Kuwait, the United Arab Emirates, and Yemen. After the pan–Arab Ba'ath party came to power in 1969, the al-Radi household left Baghdad for Beirut, Lebanon. She enrolled at the American University, where Selma taught archeology. With a fine arts degree, Nuha taught ceramics and practiced her art for four years. In a residence overlooking the Mediterranean Sea, she relaxed among friends, gardened, and rescued stray cats.

The Artist in Wartime

On April 13, 1975, the Lebanese Civil War forced Nuha al-Radi's evacuation from Beirut back to Baghdad. Family travel required petitions for delayed permissions and passports to enter and exit countries and to seek permanent Iraqi residence. She aimed a satiric sculpture show at tyrant Saddam Hussein and commiserated with vulnerable birds and fish amid the upheaval. The Iraqi government commissioned her timely ceramic tableaus for official settings. The exhibit "Embargo Art" recycled feathers, decrepit auto mufflers, and shards of wood into demonstrators protesting a failed government and unfair policies of the United Nations Special Commission on Iraq.

In mid–January 1991, Nuha al-Radi began chronicling the first three days of bombing during Operation Desert Storm, which Hussein had ignited by invading Kuwait the previous August. She humanized characters with uncomplicated names—Ma, maternal aunt Naira "Needles" Munir Abbas Jabbar, Saddam "Suds" Hussein, and dogs Bingo and Salvador "Salvi" Dali—and with American GIs broiling in the sun. She complained about wartime exigencies—roving dog packs, rats, garbage, petrol lines, embargoes on food and drugs, freakish births, looting, mass graves, and nightly bomb forays. Her diary proclaimed the dehumanization of

women and children "the equivalent of five Hiroshimas" (al-Radi, 2003, 30). Fluent in English, she at age fifty-one produced for *Granta 42* the *Baghdad Diary*, which later appeared in Dutch. By composing regular entries, in 1998, she completed a first-person view of the Gulf War, its environmental effects, and economic sanctions.

ANTI-WESTERN COMMENTARY

Reissued and renamed on May 6, 2003, the tart, witty *Baghdad Diaries* critiqued the American-British invasion and occupation during the Second Iraq War, which continued until December 15, 2011. The author warned of growing Middle Eastern animosity: "I don't think I could set foot in the West again. If someone like myself, who is Western educated feels this way, then what about the rest of the country" (*ibid.*, 18). She blamed the military for covering up a failed American economy and charged U.S. forces with favoring the oil industry, faulty knowledge of the enemy, and inept security measures.

While devoting herself to painting during self-exile in Beirut and Amman, Jordan, the diarist offered even-handed blasts at Arabs for lack of unity. To outflank border closures in Syria from Iraq and Jordan, she requested transport by an ABC-TV convoy from Amman at 4:00 a.m. On the way, she learned from a fellow traveler the possibility that Baghdad and Kurdistan might become divided sovereignties like North and South Korea and East and West Berlin. She cringed at the sight of Baghdad's destruction, disoriented birds, and Saddam's attempt to disguise bomb craters with gaudy mosques and glitzy home architecture.

While her archeologist sister Selma al-Radi protected historic buildings in Yemen and urban planner brother Abbad al-Radi redesigned Toronto's public transportation system, Nuha al-Radi expressed concern for Baghdad's orange groves contaminated by barium. She reported a nationwide cancer rate of thirty percent and urged patients to sue the U.S. for disseminating radioactive particles. During a month's visit to Iraq in March 2004 following seven years away from her homeland, she visited her aunt and mother at their home on the Tigris River to take fruitcake and dark coffee in the rose garden. Nuha died on August 31, 2004, at age sixty-three from pneumonia and leukemia. Survivors alleged that toxic anti-tank weapons that exploded spent uranium into soil, air, and water on farms west of Basra caused widespread cancer among Iraqis. Unwed and childless, she was buried in a Beirut pine forest perfumed with jasmine.

Source

"'Baghdad Diaries' Author Nuha Al Radi Dies in Beirut," *Gulf News* (8 September 2004).
Gomaa, Dalia. "Re-membering Iraqis in Nuha al-Radi's Baghdad Diaries: A Woman's Chronicle of War and Exile," *Feminist Formations* 29:1 (Spring 2017): 53–70.
"Memory of Late Nuha al-Radi Lives on through Her Art," (Lebanon) *Daily Star* (8 September 2004).

"Nuha al-Radi," *Guardian* (6 September 2004).

Radi, Nuha al-. *Baghdad Diaries: A Woman's Chronicles of War and Peace.* New York: Vintage Books, 2003.

_____. "Baghdad Diary," *Granta* (1 December 1992).

_____. "Twenty-Eight Days in Baghdad," *Granta 85* (12 November 2003).

Kark, Ruth (March 28, 1941–)
historian, editor, biographer
Palestine

A geographic historian, writer, and college professor, Ruth "Ruti" Kleiner Kark specializes in colonialism, diaspora, and the settlement of Israel. A native of Petach Tiqwa southeast of Herzliya, Palestine, on the central Mediterranean shore, she was born on March 28, 1941, seven years before Israel achieved statehood. At age seventeen, she served the Israel Defense Force as a sergeant. Her Ukrainian parents, Avraham Kleiner, a partisan from Khorostkov, and Shoshanna Motchan Kleiner of Brody, sent her to Jerusalem to major in geography at Hebrew University, where she thrived as an honor student. On the tennis court in 1960, she met her future husband, South African epidemiologist and public health specialist Jeremy "Jem" David Kark, father of musician Guy Kark and two daughters, psychologist Ronit Kark and Salit Kark, a specialist in conservation and biodiversity.

With completion of a master's degree in 1972, at age thirty-six, the author began a thesis on the growth of Jaffa and Jerusalem from 1840 to 1917, which satisfied Ph.D. requirements. Data from diaries and autobiographies appeared in the article "The First World War in Palestine: Biographies and Memoirs of Muslims, Jews, and Christians," which incorporated testimonials and eyewitness accounts of attacks on the Suez Canal and Gaza. The historian's output of twenty-one scholarly volumes and 250 articles in *International Studies in Turkish Studies, Pe'amin* (Times), *International Journal of Middle East Studies, Geographical Journal, Jerusalem Quarterly,* and *Ofakim ba-Geografiya* (Horizons in Geography) began in 1974 with a study of Jewish settlers on the Negev frontier from 1880 to 1948.

A Global Reputation

In 1982, the historian aided London's University College as a research fellow. Groundwork involved histories of commoners in Jerusalem districts, agrarianism in the Holy Land, the question of indigenous tribal rights in the 1983 article "Napoleon to Allenby: Process or Change in Palestine," and—in 1984—a 128-year chronicle of Jaffa's growth. In 1986, she served Harvard University as a visiting scholar on Jewish studies. For the journal *Israel Affairs,* she submitted answers to questions contrasting Jewish values with universal public school curriculum.

In 1988, Ruth Kark joined the faculty of her alma mater as associate professor and continued detailed chronicles on Sephardic investors and on the impact of

Protestant Missionary Societies. She produced scholarly theses on Palestinian history and American consuls in the Ottoman Middle East and a biography of Zionist powerhouse Yehoshua Hankin, a Jewish land baron in Palestine. In 1991, she accepted a visiting scholar post at the University of North Carolina at Chapel Hill followed by a senior fellow position at Oxford and teaching fellow at Haifa's The Technion. Dartmouth in Hanover, New Hampshire, presented her with the 1996 Brownstone Lecturer prize. She continued contributing to Jewish Studies at Stanford University in California.

TRACKING JEWISH DYNASTIES

Ruth Kark's interest in genealogy summarized the Amzalak clan in 1991 and, in 2005, probed seven generations for *Sephardic Entrepreneurs in Jerusalem: The Valero Family 1800–1948,* an exploration of a public-spirited clan. Founded by Portuguese-Turkish financier Yaakov Valero and wife Bechora, the lineage "advanced economically through the provision of indispensable services to foreign merchants" (Kark, 2008). The research covered other Sephardic immigrants in the Amzalak, Eliachar, and Navon households and their roles in the Jewish diaspora. The overview earned from the Ottoman Bank Archives and Research Center $15,000 for best monograph, which she shared with co-author Joseph B. Glass, an expert in global geography. Her histories covered contrasting Bedouin and Jewish representation in ethnographic museums and the nomads and settlers of the Jezreel valley under Ottoman rule.

Adept at Middle Eastern languages, agrarian and socioeconomic trends, property disputes, and archival land transfers, Ruth Kark attained a reputation for accuracy. She edited scholarly books on the birth of Israel in 1948, preservation of historic cities in the midst of crushing tourism and pilgrimages, and the role of Jewish women in furthering Hebraic culture and Zionism. Critics lauded her academic objectivity and hesitance to take sides. Her expertise in 2012 refuted a Bedouin claim to Rahat in the Beersheba district.

On Jerusalem Day on May 9, 2013, the writer accepted the Yakir Yerushalayim (Worthy Citizen of Jerusalem) citation for commitment to substantiating the city's history. The 2014 Herzl bronze trophy from the World Zionist Organization recognized her knowledge of Israel's frontier. In 2016, the Israeli Geographical Society contributed to her accolades, which range from a Jerusalem Bank citation to a Fulbright scholarship. After her husband's death from myeloma in Jerusalem on May 24, 2018, she founded the annual Kark Legacy Prize for Academic Excellence to benefit researchers at the Hadassah School of Public Health and Community Medicine.

Source

Glass, Joseph B., and Ruth Kark. *Sephardic Entrepreneurs in Jerusalem: The Valero Family 1800–1948.* Lynbrook, NY: Gefen, 2005.

Kark, Ruth, ed. *Jewish Women in Pre-State Israel: Life History, Politics, and Culture.* Waltham, MA: Brandeis University Press, 2008.

_____. *Transformation of the Jezreel Valley.* Mamaroneck, NY: Israel Academic Press, 2018.

Katz, Itamar, and Ruth Kark. "The Greek Orthodox Patriarchate of Jerusalem and Its Congregation," *International Journal of Middle East Studies* 37:4 (November 2005): 509–534.

Paraszczuk, Joanna, and Sharon Udasin. "Court Rejects 6 Beduin Negev Land Lawsuits," *Jerusalem Post* (19 March 2012).

Romm, Jamie. "Israelis Win Turkish Prize for Financial History Research," *Jerusalem Post* (14 December 2009).

Tram, Dang Thuy (November 26, 1942–June 22, 1970)
diarist
Vietnam

A trauma surgeon and casualty of the Vietnam War, Dang Thuy Tram left behind an eyewitness account of a medical officer's ambivalence toward war. A Hanoi native born on November 26, 1942, she grew up influenced by the ideals of a cultured family. Amid three girls—Hien, Phuong, and Kim Dang—and one brother, Hong Quang Dang, she was the eldest born to Doan Ngoc Tram, a lecturer at the Hanoi School of Pharmacology, and surgeon Dang Ngoc Khue, on staff at Saint Paul General Hospital. At Chu Van An High School for gifted students, she played guitar and violin in her spare time and indulged a bent for noble goals. At age sixteen, she fell in love with 22-year-old Khuong The Hung or "Do Moc," whom she called M. She began a career at Hanoi Medical University and graduated in 1966 with a specialty in ophthalmic surgery.

Out of a sense of duty, on December 23, 1966, Dang Thuy Tram left M, her devoutly Communist lover, and carried a backpack for three months over the Troung Son Mountains. She continued through hill tribes along the Ho Chi Minh Trail to a former center of rebellion against the occupying French. Traveling southeast through rice-growing farms along Route 1, she passed the divide of north and south Vietnam in late March 1967. She joined the staff of Duc Pho Hospital in Quang Ngai and treated casualties among guerrilla fighters she called brothers. As "blood pours, bone shatters," she pledged to die for the human nonentities that "bloodthirsty Americans" dismissed as dinks, slopes, and gooks (Dang, 2007, 27, 149). At age twenty-five on April 8 during the 1968 Tet Offensive, the diarist volunteered with the National Liberation Front to save lives. She operated on patients in a hidden hospital and, temporarily, under the thatched roof in a poorly equipped c linic.

Constant Pressures

Lonesome and isolated over a year away from home, the surgeon treasured letters, but concealed the stress of field work from her mother. Despite yearning for Hanoi and worrying over disregard by the Communist Party, she traveled by truck

to a battlefield at Quang Binh Province, a target of toxic U.S. defoliants and mortars. She received appointment to chief of staff at a mountain field hospital, where she admitted up to eighty patients at a time. During service to the People's Army of Vietnam, men who had participated in the Battle of Ia Drang the previous year, the first major clash with Americans, she witnessed evidence of affection from Vietnamese soldiers. Of their goodness, she concluded, "A clear conscience is the most valuable medicine" (*ibid.*, 11).

Over the rumble of jets and Hueys, Dang Thuy Tram scorned the Nixon regime's political agenda cloaked in wrongheaded ideologies and propaganda. After evacuating the compound on April 27, 1969, she returned to work to find a shambles caused by U.S. air strikes. Her sorrow generated a dream of peace and liberty "burning in the hearts of thirty million Vietnamese and in millions of people around the world" (*ibid.*, 111). On March 29, 1970, she cringed at "yellow rain" (herbicides) staining trees and the bombardment from Chop Mountain that spewed shrapnel into the operating theater. On June 20, she craved "so much a mother's hand to care for me" (*ibid.*).

Until Dang Thuy Tram fell to a bullet in the forehead from an American GI on a Ba To jungle trail on June 22, 1970, five years before war's end, she made regular emergency house calls over the highway, moved patients on her back, and kept wartime observations in two hand-stitched diaries covered with cardboard. Details of amputations and the raw burns caused by phosphorous explosions dramatized the urgency of war injuries. The first diary, seized by American troops in December 1969, preceded her last words on the war, retrieved by military intelligence officer Frederick "Fred" Whitehurst, a veteran of three Vietnam tours. The interpreter, Sergeant Nguyen Trung Hieu, urged Fred to spare the diary from document extermination.

FRED'S RESCUE

For more than three decades, Fred absorbed the diarist's visions of ongoing atrocities in a divided nation. In 1999, the surgeon's lover, advanced to Colonel M, died without knowing what happened to her or that she had written about their relationship. Fred's location of Dang Thuy Tram's eighty-two-year-old mother through Quakers in Hanoi in March 2005 introduced Doan Ngoc Train to a side of her daughter too damaged to absorb in a single read. Recognizing the handwriting, she clutched the relic and mourned that "Her corpse is in Vietnam, but this is her soul" (Phan, 2005). With the mother's permission, Fred started the text on the way to publication under the title *Last Night I Dreamed of Peace* with notes by the diarist's younger sister, Dang Kim Tram.

Young Vietnamese devoured the bestseller for elucidating a war that ended before their births. Dang Thuy Tram's folk heroism rivaled that of Ho Chi Minh. Fred and his older brother Rob formed a close friendship with the Dang family and traded visits to Hanoi and Texas Tech University Archive in Lubbock. The first English translation of the surgeon's diaries in September 2007 preceded more

editions in sixteen languages and a cinema version in 2009 under the title *Do Not Burn It*. Her close-ups of mortal suffering and patriotic purpose defied American claims of a just cause in fighting a nation that lost some four million people, one-fourth of them missing with no clue to their whereabouts.

According to anthropologist Christina Schwenkel at the University of California Riverside, Dang's insights into trauma and her compassion for victims subvert the "narcissistic myths of the war as a U.S. tragedy" (Schwenkel, 2009, 39). A 2012 compendium, *The Literature of War*, compiled the surgeon's distaste for massacre and maiming alongside similar anti-war commentary by authors John Hersey, Mary Jane Seacole, Shelby Foote, Abraham Lincoln, Che Guevara, Martha Gellhorn, and Henry David Thoreau. Media reviews in the *Chicago Tribune, Times Picayune, National Public Radio, USA Today, Baltimore Sun*, and *Los Angeles Times* acknowledged the value of the diaries for broadening the "Americacentric point of view" and for shredding the caricature of the Vietcong as ruthless, contemptible demons (Paddock, 2006). Critic Quan Manh Ha, a teacher of ethnic studies at the University of Montana, lauded Dang Thuy Tram's diaries for their immediacy because they "bear faithful witness to the past and transcend its deadly limits" (Ha, 2016, 482).

Source

Dang Thuy Tram. *Last Night I Dreamed of Peace*. New York: Harmony Books, 2007.
Fox, Diane Niblack. "Fire, Spirit, Love, Story," *Journal of Vietnamese Studies* 3:2 (2008): 218–221.
Ha, Quan Manh. "When Memory Speaks: Transnational Remembrances in Vietnam War Literature," *Southeast Asian Studies* 5:3 (December 2016): 463–489.
Paddock, Richard C. "Day to Day among the Viet Cong" *New York Times* (4 August 2006).
Phan, Aimee. 2005. "A Daughter Returns Home—Through Her Diaries," *USA Today* (12 October 2005).
Schwenkel, Christina. *The American War in Contemporary Vietnam: Transnational Remembrance and Representation*. Bloomington: Indiana University Press, 2009.

Hassan, Riffat (1943–)
writer, theologian, essayist, orator
Pakistan

An expert on Islamic philosophy and law, Riffat Hassan spearheads research and dissemination of Islamic feminist theology. Born in the midst of World War II in 1943 at Lahore, she learned to weigh opposing interpretations of scripture from her warring parents. She acquired a literary background from a maternal grandfather, Urdu poet and dramatist Hakim Ahmad Shuja, translator of the Koran into Punjabi, and took pride in kinship with the prophet Mohammed. Her mother rejected the traditional gender roles outlined by an overbearing father, who arranged marriages for Riffat Hassan's two older sisters. She vacillated between wrestling with patriarchy and admiring her father's humanity, which he derived from his father, Saiyyad Faizul Hassan, founder of Muslim Town.

Gravitating toward Anglican views in childhood, Riffat Hassan studied under

missionaries at Cathedral High School and, in 1956, published a first title at age thirteen. On departure for London at age seventeen, she majored in English literature and philosophy at St. Mary's College, a branch of Durham University in northeastern England south of Newcastle. She refuted classical scriptural analysis by citing the historic groundings of the Koran on seventh-century gender controversies. Completion of a doctorate degree with honors in 1968 began with research into the life of the academician Muhammad Iqbal, a mystic philosopher and advocate of reason and self-esteem.

GOD AND REASON

A devout Muslim, Riffat Hassan taught at the University of Punjab in Lahore for a year before joining the Ministry of Information and Broadcasting as deputy director. In fall 1974, she began a decade of reinterpreting the Koran and compiling *The Sword and the Sceptre* and *The Bitter Harvest*, both published in 1977 under the punitive rule of Pakistani president Muhammad Zia-ul-Haq. After the thirteen-month Islamic Revolution of Iran from January 7, 1978, to February 11, 1979, she investigated anti-female discrimination and the men who covered their sins by twisting Koranic verses to condemn modernity. At age twenty-nine, she moved to the U.S. for a lengthy classroom career in the religion departments at Oklahoma State, Harvard, University of Pennsylvania, Villanova, Iliff School of Theology in Denver, and Louisville Presbyterian Theological Seminary. Until her retirement in 2009, she campaigned at the University of Louisville against bigotry and ignorance founded on androcentrism.

During a two-year sabbatical that included the birth of daughter Mehrunnisa Hassan, fathered by Jehan Dawar Burki in 1983 in Lahore, the theologian observed the violent crushing of poor, undereducated women. Under mounting suppression, she feared a heightened suppression of women's full citizenship. A personal trust in Muslim progressivism emerged from her respect for freedom, fairness, education, and privacy and disgust for devaluation and vengeful mistreatment of females by all-male cults. In May 1984, she summarized scriptural research before the Pakistan Commission on the Status of Women. The pro-woman stance advanced pro-choice feminism and access to contraception.

Through the founding of the International Network for the Rights of Female Victims of Violence in Pakistan in February 1999, Riffat Hassan combatted the maligning of women as inferior and pinpointed honor killing for adultery as premeditated murder. Her appearance on the BBC documentary *Murder in Purdah* disclosed the extent of victimization against Pakistani women and girls. While daughter Mehr advanced a career in singing, dancing, and acting and son Omar pursued film production in Florida, Riffat Hassan set up expectations for recipients of the annual Louisville Grawemeyer Award in Religion for upholding spirituality. After the September 11, 2001, terrorist attacks on the U.S., she wrote eight books; published 195 chapters and articles; and spoke in churches and classrooms and at

U.N. symposia in Cairo, Copenhagen, Istanbul, and Beijing. Her topic--the need for interfaith tolerance and understanding—influenced research on Christianity, Islam, and Judaism in Germany, Holland, and Indonesia.

A Crusade for Justice

In an interview on May 16, 2001, the writer charged males with dominating scriptural scholarship and legitimizing a rigid, legalistic theocracy dating to the medieval thinking of the 600s CE. The question of the *hijab* (enveloping dress and veil), according to the authority, affirmed the intent of Saudis to clap manacles on all females and immure them at home. To prevent anti–Muslim bias, she led programs from 2002 to 2009 to boost interfaith communication on such anti-woman concerns as wife beating, divorce, loss of child custody, exclusion from mosques, and inheritance. Her even-handed guidance of conflicting opinions earned the 2003 Distinguished International Service Award from the University of Louisville.

Riffat Hassan's fresh, forward-thinking leadership promoted funding from the U.S. State Department for two exchange programs, beginning with "Islamic Life in the U.S." (2002–2006). Her answer to curbing extreme militant fanatics—the Taliban, ISIS, and the Islamic Armed Group—was an empowerment of women through education and social justice, two of the subjects of a "Building Bridges" seminar in Doha, Qatar, organized by Sheik Hamad bin Khalifa. At the time of her husband's death in 2004, she published *Scriptures in Dialogue: Christians and Muslims Studying the Bible and the Qur'an Together* and supplied a chapter for *Transforming the Faiths of Our Fathers: Women Who Changed American Religion*. In 2006, she headed a second exchange campaign, "Religion and Society: A Dialogue" (2006–2009). On April 15, 2019, at age seventy-six, she traveled to San Francisco to accept the Amel Zenoune-Zouani Rights and Leadership Award from the International Action Network for championing gender equity. In the September 7, 2019, issue of *USA Today*, she pursued global responsibility for brutality by warning of Indian mercenaries marching into Kashmir.

Source

Hasan, Khalid. "The Hijackers of Islam," (Lahore) *Friday Times* (14 February 2003).
Hassan, Riffat. "Are Human Rights Compatible with Islam?," www.religiousconsultation.org/hassan2.htm.
_____. "Chapter 11," *Transforming the Faiths of Our Fathers*. New York: St. Martin's Press, 2004.
_____. "Islam and Human Rights," *Dawn* (14 November 2002).
_____. "Members, One of Another," www.religiousconsultation.org/hassan.htm.
Mubarak, Hadia. "Classical Qur'anic Exegesis and Women," *The Routledge Handbook of Islam and Gender*. New York: Routledge, 2020: 23–42.

Akiner, Shirin (June 16, 1943–April 6, 2019)
historian, translator, linguist
British India

A renowned scholar of Central Asian studies, Shirin Ahmad Akiner enlightened the world on the history of Kazakhstan and Uzbekistan. She was born the

third of four children at Dacca (now Dhaka), capital of East Bengal (now Bangladesh) in British India to ambassador Ziauddin "Zia" Ahmad of Bengal's Fergana Valley, the Silk Road link between Kashgar, China, and Samarkand, Uzbekistan. Her mother, Welsh musician Mary Jones, was the daughter of a 1917 World War I recruit killed at Ypres, Belgium. She described the Ahmad-Jones ancestry as "Asian/Muslim-European/Christian background, with very distant roots (dating back some 500 years)" (Akiner, 2005, 42). A paternal grandmother introduced her to Islam; her parents nurtured respect for Hinduism, Roman Catholicism, and Anglicanism.

Shirin was four years old at the August 15, 1947, partition of British India into Muslim and Hindu nations, a chaotic division that forced the couple to flee Pakistan with their daughter. While Zia Ahmad worked for the foreign service in London, she attended a Kew prep school and St. Paul's Girls' School, Hammersmith, and learned the violin. At age eleven, she accompanied her parents to Shillong, Assam, India, and enrolled at the Loreto Convent in Darjeeling. Zia Ahmad's posting to the Hague in 1956 placed Shirin at the Dutch International School in Kijkduin on the North Sea, the Amsterdam Muzicklyceum, and the Moscow State Conservatoire. After marrying a Turkish Cypriot, ambassador Murat Akiner, in Moscow, she settled at Ankara, Turkey.

At seven months of pregnancy in August 1965, Shirin Akiner survived a car accident in Ankara that killed Murat and three family members. Two months later in October, under the care of her brother John Ahmad in London, she gave birth to son Metin Murat Akiner. At London University, she studied Turkic language and literature and Slavic philology, the introit to writings and lectures on ethnography, politics, philology, and religion in Central Asia. For a decade she compiled an English-Belarussian and an English-Uzbek dictionary. At age thirty, in spring 1973, she wed British businessman and civil engineer Dr. David Malcolm Mitchell and made their home in a three-story flat at 22 Sydney Street, Chelsea.

ACADEMIA IN SERVICE

Shirin Akiner's 82 academic articles and monographs in ten languages included commentary on Kazakhstan, the Tatars of Belarus, and Uzbekistan for the *Journal of Central Asian and Caucasian Studies*, which she advised. Fluent in Russian and some Uzbek, she completed a doctorate at University College London in Belarusian Polish–Lilthuanian Tatar history and, in 1980, began a quarter century of visits to Uzbekistan. Speeches and seminars on Islam, gender, ancient Persian writings, the Silk Road, ethnicity, security, and conflict took her to BBC radio and television studios and before audiences in Abu Dhabi, the Hague, Izmir, Moscow, Ottawa, Rome, Stockholm, Tbilisi, Tehran, Tokyo, and Washington, D.C. Documentaries for the BBC include *Kazakhs of Xinjiang, Man Without a Horse*,

Gift of God, and *The Crescent and the Star.* In her early forties, she issued a translation of "Miniature" by Polish author Sokrat Janowicz along with *Islamic Peoples of the Soviet Union* (1983) and "Modern Belarusian Writers in Poland" (1984).

From 1988 to 1997, Shirin Akiner served UNESCO as a historian on the "Integral Study of the Silk Roads." While teaching university courses on Central Asia, she achieved recognition from the Royal Institute of International Affairs, Cambridge Central Asia Forum, and the Uzbek Foreign Ministry. Visiting professor status honored her at Uppsala University, Sweden; Oberlin University, Ohio; Kazakh University and National University, Almaty; and National University of Seoul, South Korea. She continued publishing informative works at a steady pace: *Cultural Change and Continuity in Central Asia* (1992), *Central Asia: New Arc of Conflict?* (1993), *Resistance and Reform in Tibet* (1994), *Political and Economic Trends in Central Asia* (1994), *The Formation of Kazakh Identity: From Tribe to Nation-State* (1995), *Resistance and Reform in Tibet* (1996), *Minorities in a Time of Change* (1997), *Sustainable Development in Central Asia* (1998), and *Languages and Scripts of Central Asia* (1998). She broached the subject of belief systems in "Religion's Gap" in the March 22, 2000, issue of *Harvard International Review* and followed with *Tajikistan: Disintegration or Reconciliation?* (2001).

The *Journal of Peace Research* declared Shirin Akiner's *The Caspian: Politics, Energy, Security* (2004) a timely assessment of oil supplies and prices in a region she called "the world's next Arabia" (Akiner, 2004). The preface refuted Western fantasy about the region with political realism disclosing damage to the "fragile ecology of the sea" and fishing industry and crises generated by Japanese investors, deep drilling, an oil pipeline to Batumi, Georgia, on the Black Sea, and the "sudden demise of the Soviet Union" (*ibid.,* 10, 11). This and other works, available in Arabic, Chinese, French, German, Kazakh, Persian, Russian, Spanish, Turkish, and Turkmen, bore Akiner's impeccable bibliographic lists and commentary.

Controversy over the author's 2005 documentary *Violence in Andijan, 13 May 2005: An Independent Assessment* on an eastern Uzbekistan massacre leveled charges of bias and propaganda concerning religious extremism and human rights violations by President Islam Karimov. Of a radical confrontation involving Muslims and Jews at Hokimiyat Jail that killed some two hundred, wounded six hundred, and freed five hundred prisoners, she introduced ungarnished facts: an armed insurgent jailbreak on May 12 at 10:50 p.m. and response by security forces shortly after midnight on May 13. To rebut sensationalism by Australian, British, Canadian, and Turkish media, she divulged inflation in numbers of rioters and alleged secret burials. On May 24–25, she drove through the Ferghana Valley to Adijan to measure the city square; interview eyewitnesses and residents; and scrutinize a hospital, prison, and graveyards.

A Long Career

Disputation did not halt Shirin Akiner's scholarly output. On May 26, 2005, she hosted NATO-funded research in Tashkent, Uzbekistan. For expounding politics in the Caspian states, the Kazakh identity, and minorities in a time of change, in 2006, the Royal Society for Asian Affairs honored her with the Percy Sykes Memorial Medal given to distinguished travelers and writers. She published "Regional Cooperation in Central Asia" for the 2007 journal of the School of Oriental and African Studies. For impeccable histories, she received an *Ancien* Association fellowship from the NATO Defense College at Rome.

The scholar's dissertation reached print in 2009 as *Religious Language of a Belarusian Tatar Kitab* (Book), which surveyed the Golden Horde in the fifteenth century and formation of Slavic languages for use in religious manuscripts. In 2013, while chairing the British-Uzbek Society and teaching at the School of Oriental and African Studies, she completed a compendium, *Tajikistan: The Trials of Independence*. The introduction conveyed the intricacy of peace-keeping and conflict "when the downfall of a totalitarian system generates hopes of a radical improvement in individual lives" but results in "economic collapse and gross violations of human rights" (Akiner, 2013). In the same year, the Interparliamentary Assembly awarded her the Chingiz Aitmatov Prize and a purse of $30,000. For the *Astana Times,* she wrote an op-ed predicting Turkmenistan's future wealth from networking trans-Asia natural gas pipelines to Azerbaijan, China, India, Kazakhstan, Russia, and Uzbekistan. In July 2016, she published *Kyrgyzstan 2010: Conflict and Context*, in which the author commiserated with a "fractured, vulnerable society" (Akiner, 2016, 8).

Depleted by illness at age seventy-five, she died on April 6, 2019.

Source

Akiner, Shirin. *The Caspian: Politics, Energy and Security.* London: Routledge, 2004.

_____. *Kyrgyzstan 2010: Conflict and Context.* Washington, D.C.: Central-Asia Caucasus Institute and Silk Road Studies Program, Johns Hopkins University–SAIS/Institute for Security and Development Policy, 2016.

_____. *Religious Language of a Belarusian Tatar Kitab.* Wiesbaden: Harrassowitz, 2009.

_____. *Tajikistan: The Trials of Independence.* London: Routledge, 2013.

_____. "Turkmenistan's Pipeline Strategy: Building a Diversified Export Infrastructure" (Nur-Sultan, Kazakhstan) *Astana Times* (17 November 2015).

_____. *Violence in Andijan, 13 May 2005: An Independent Assessment.* Washington, D.C.: Johns Hopkins University-SAIS, 2005.

10

1945–1950s

Aung San Suu Kyi (June 19, 1945–)
orator, essayist, poet, translator, letter writer, biographer, children's author
British Burma

At 106 pounds, the Nobelist and global-class orator and essayist, Aung San Suu Kyi, the first female foreign minister of Myanmar, holds the world's attention on a struggle to place the Burmese in a sound democracy. A native of Rangoon and descendent of the 250-year-old Pagan (or Bagan) dynasty, she is the youngest daughter of Khin Kyi and rebel Aung San, the founding father of British Burma. Her essay "Old Songs" describes him as a student of the Japanese army on Hainan Island in 1941. Born on June 19, 1945, three years before Britain liberated Burma from colonialism, she grew up below Rakhine, contested territory later identified with Muslim Bangladesh. She was two years old when her monastery-trained father, an anti–British nationalist, rose to prominence. He served the crown colony as premier until his shooting death on July 19, 1947, in the council room by assassins (Aung San, 2010, 91). The London *Independent* reflected that, in September 1988, she commemorated his integrity with "admiration for him as a patriot and statesman" (Aung San, 2016, 100).

While her mother represented the country as legate to India and Nepal, at age fifteen, Aung San Suu Kyi attended the Lady Shri Ram College in New Delhi and became a devotee of Mohandas Gandhi's principle of non-violent compromise. With degrees in economics, politics, and philosophy from the University of Delhi and St. Hugh's College, Oxford, she relocated to New York City in 1968. At the U.N. Secretariat, she worked for the financial department as an assistant secretary while volunteering to help poor hospital patients each night.

At age 27, the activist married Southeast Asia expert and educator Michael Vaillancourt Aris, father of sons Kim and Alexander. Her writing career focused on children's travelogues of Bhutan, Burma, and Nepal. For three years at London's School of Oriental and African Studies, she researched Burmese culture and her father's biography. She served Kyoto University as visiting scholar and, in 1987, published "Socio-Political Currents in Burmese Literature, 1910–1940."

Light for Liberty

On March 31, 1988, Aung San Suu Kyi repatriated to Burma to tend her mother during recuperation from a stroke and to join her husband in rallying support for democracy. A month later, her distinctive calls for peace filled two letters to Amnesty International. An open letter petitioned the government to sanction multiple-party elections. With quotations from her father, a debut speech on August 26 rallied a half million citizens and maroon-clad monks amassed at the Shwedagon Pagoda, a sacred Buddhist stupa in Rangoon opposite Kandawgyi Lake. The opening line of her broadside esteemed student demonstrators who "have shown their willingness to sacrifice their lives" (Aung San, 1991, 8).

Aung San Suu Kyi extended oratory to audiences throughout the country, even in range of military rifles aimed at her. When house detention under martial law on University Avenue clamped down on July 20, 1989, she held a three-day hunger strike, the reason for Norway's 1990 Rafto Human Rights Prize. Her scholarship turned to Buddhist concepts of compassion, beneficial harmony, and stoicism. With strict parallel structure, the essay "Teachers" stressed that good teaching demonstrated "right understanding, right thought, right speech, right action, right livelihood, right effort, right mindfulness, and right concentration" (Aung San, 2010, 159).

Global Admiration

The activist received the 1990 Sakharov Prize of €50,000 from the European Parliament for defending human rights and, on October 14, 1991, a Nobel Peace Prize for civil courage plus a $1.3 million purse to uplift education and health for the nation. At Oslo, her son Alexander Aris delivered an acceptance address on December 10, International Human Rights Day. The oration aimed "to build a nation founded on humanity in the spirit of peace" (Aung San, 1991). For the essay "Freedom from Fear," printed in eight global newspapers, including Iceland and Norway, the famed speaker championed security and fulfillment, sources of individual virtue. The doctrine contained a five-line poem picturing freedom fighters with "splinters of glass/In cupped hands" (Aung San, 1990). She urged the Burmese to uphold courage and endurance and to defeat fear, which "is not the natural state of civilized man" (*ibid.*).

The author and her husband collaborated on "Notes on the History of the Mon-yul Corridor" (1979), *Letters from Burma* (1995), and *Freedom from Fear and Other Writings: Revised Edition* (1996), shortly after Michael Aris's last visit with his wife. Her genres ranged from memoir and a biography to *Voice of Hope* and the pieces she submitted after 1995 to Tokyo's *Mainichi Daily News*. Alongside the carefully reasoned essay "Intellectual Life in Burma and India under Colonialism," she appended original verse, citations from English poet T.S. Eliot, and translations of Japanese poems and songs. To force her ouster, the military dictatorship refused

to allow Michael Aris entry during his treatment for terminal prostate cancer and tempted her with permission to visit him at Oxford. Lest she be barred from home, she rejected the offer. Her husband died in London on March 27, 1999.

THE MARTYR'S REWARDS

Following nineteen months of house arrest, Aung San Suu Kyi survived a mob assault in May 2003 and received detention in Insein Prison, notorious for unsanitary conditions and torture. The military junta deflected charges of arbitrary arrest by declaring her jailing a protective custody and released her in 2007 for a hysterectomy. Additional incarcerations occurred in 2007 and 2009 on charges of insurrection and promoting criminality, which resulted in print and electronic silencing.

After release from house arrest on November 13, 2010, Aung San Suu Kyi reunited the family in Burma and smuggled lectures to London for broadcast in June and July 2011. The U.S. Congress presented her with a Congressional Gold Medal on May 6, 2008; her alma mater, Oxford; the University of Bologna; University of Sydney; Seoul University; and the University of Johannesburg awarded her honorary PhDs. More honoraria poured in from institutions in Toronto, South Africa, Wellington, Melbourne, Newfoundland, Scotland, Ulster, Dublin, San Francisco, Taiwan, and Johns Hopkins. The films *The Lady, Freedom from Fear,* and *Beyond Rangoon* and Richard Shannon's stage play *The Lady of Burma* dramatized her heroism.

THE PUBLIC PODIUM

The author's oration at Kawhmu on March 22, 2012, rallied support for "prisoners of conscience and other inmates of jails all over Burma" (Aung San, 2010, 48). Before the British parliament, she delivered an appeal to London University to develop a research culture to upgrade Burma's advanced education. At Seoul University, a 2013 speech "Democracy and Development in Asia" reminded the audience that liberty for the Burmese did not equate with the economic success enjoyed in Europe, the U.S., Thailand, and Korea. In place of material gain, she urged formation of a nurturing democracy. In this same period, outsiders challenged her denial of a Muslim Rohingya genocide, an impasse that biographer Michal Lubina calls a "Fall from Grace" (Lubina, 2021, 115). In the 2015 general election, her party, the National League for Democracy, won 86 percent of assembly seats, but a constitutional injunction prevented her from assuming the presidency.

On April 6, 2016, a special bill allowed the populist advocate to take the post of state counselor, a five-year office. Author Thant Myint U stated that "freshly released from long years under house arrest, [she] appeared set to finally lead her country" (Myint-U, 2020, 1). In Burma's defense, before the International Court of Justice at the Hague, on December 11, 2019, Aung San Suu Kyi at last assessed the violations in Rakhine by outlining colonial history and the purpose of national reconciliation.

Her oration asked that people give justice time to "overcome distrust and fear, prejudice and hate, and end longstanding cycles of intercommunal violence" (Aung San, 2020). In fall 2022, a court sentenced her to hard labor for election fraud.

See also Ma Su Zar Zar Htay Yee (1979).

Source

Aung San Suu Kyi. "Because of My Father I Feel a Deep Responsibility for the Welfare of My Country," (London) *Independent* (7 October 2016): 100.

————. "Democracy and Development in Asia," *Asian Journal of Peacebuilding* 1:1 (May 2013): 117–127.

————. *Freedom from Fear*. New York: Penguin, 1991.

————. "Freedom from Fear," *New York Times* (9 July 1990).

————. "Give Myanmar Time to Deliver Justice on War Crimes," *Financial Times* (23 January 2020).

————. *Letters from Burma*. New York: Penguin, 2010.

————. *The Nobel Prize*, www.nobelprize.org/prizes/peace/1991/kyi/26191-aung-san-suu-kyi-acceptance-speech-1991/

Lubina, Michal. *A Political Biography of Aung San Suu Kyi: A Hybrid Politician*. London: Routledge, 2021.

Myint-U, Thant. *The Hidden History of Burma*. New York: W.W. Norton, 2020.

Saudi, Mona (October 1, 1945–)
sculptor, writer, poster artist, scenarist, painter, silk screen printer, poet
Jordan

A respected Jordanian-Palestinian artist and art promoter, Mona Saudi gained a following in her homeland for organic works, which she carved in stark geometrics with hammer and chisel and smoothed with sandpaper. Born the second daughter of eight children on October 1, 1945, in Amman, she spent early girlhood investigating the city's public pool, columns, and fountain, urban amenities near the Hashemite Plaza dating to the reign of Roman Emperor Antoninus Pius in 161 CE. Her Syrian mother, Yusra Saudi, dismissed the imperial ruins as sinners whom God locked in stone. At age eight, grief for a deceased older brother pressed her to grasp at dreams. For exemplars, she chose two powerful North Africans, Sheba and Cleopatra.

At age twelve, the neophyte artist mused on the mysticism incorporated in her poems and ink drawings. At age fourteen, she enhanced understanding the British Council Library, where she read the magazine *Shi'r* (Poetry) and T.S. Eliot's age-defining verse *The Waste Land*. Her authoritarian father, Abdulmajid Saudi, disallowed a university education for girls and motivated her to leave home to establish an art career. In 1962, the teenager hired a cab and fled through Israel 136 miles to a boarding school at Beirut, Lebanon, and the care of her brother.

A respected member of urban art salons, Mona Saudi found encouragement to pursue earth's primary material. With the fervor of Michelangelo, in modernist style, she disclosed life, radiance, fecundity, and joy in smooth, sturdy curves, a clue to her hope for Arab unification. She furthered the placement of art in public

spaces, such as "The Geometry of Soul," a ten-foot standing piece outside the Institut du Monde Arabe (Institute of the Arab World) in Paris. With proceeds from a first showing of the oil painting "Lovers" at Cafe de la Presse, she paid passage to Paris in February 1964 by sea through Cairo and Alexandra and by train from Marseilles. She roomed for a dollar a day in the Saint-Germain district opposite l'Ile de la Cité and studied African and Greek sculpture at the Louvre. At age twenty-eight, she graduated from the Beaux-Arts de Paris (Paris Fine Arts) with a specialty in stone carving, which she developed by spending half a year in Carrara, Italy's famous marble quarry. From the experience, she shaped in imperfect ivory marble "Mother and Child," a complex pairing of female shapes and an illusion of both permanence and space.

A MYTHIC FOUNDATION

With inklings of Arab culture and materials from global quarries, the sculptor focused on planetary foundations revered by the Aztec and Etruscans. She began in 1965 with "Mother/Earth," based on the abstractions of Egyptians, Nabataeans, and Sumerians and the inspiration of modernist Romanian pioneer Constantin Brancusi. She chose universal images for titles: "The Spring," "The Dawn of Creation," "Waves," "Nocturne," "Woman/Bird," and "Rivers of Sadness." After vindicating the Palestinian cause in May 1968, she published a treatise in French, "In Time of War: Children Testify." The collection of drawings at a Baqa'a refugee camp bombarded by Israelis featured heavenly bodies as signs of hope and continuity.

The 1970s aroused fervid leanings in Mona Saudi and a longing for peace in the Middle East, which she furthered with mottoes in Arabic, Chinese, English, French, German, and Japanese. In an interview about borders in the Middle East, she stated, "I don't like frontiers. For me, the whole earth is one. We have one sky, one sun, one moon and I belong to that" (Kumar, 2018, 47). Following a 1970 Palestinian Liberation Organization post card series featuring women and weapons, she progressed to Paris exhibitions and shooting the 1972 film *Testimony of Palestinian Children in Wartime*. In 1973, she booked the first of four shows in Beirut.

REALITY IN MODERNISM

The Lebanese Civil War of 1975 brought home the fragility of life and art when bombs exploded in Mona Saudi's garden, where she maintained a variety of sculptures amid palms, cactus, lemon trees, ferns, and ambient birdsong. She dubbed the damaged pieces "victims" of civil war. She mused, "What is painful is the killing of people" (*ibid.*). Recognizing May 15 as the day of Palestinian struggle, she provided the quarterly *Palestinian Affairs Magazine* with a cover featuring a scimitar-shaped dove and olive branch. The motif dominated the ink drawings of the 1976 poster "Land Day in Palestine" alongside barbed wire and munitions framing mothers who

shelter children. In contrast, the textured limestone carving "Formation" pictured centering amid layering of varied shapes, a representation of diversity. In 1978, she gave birth to Lebanese calligrapher and designer Dia Batal, sired by husband Hasan al-Natal, a political journalist for *Al-Ayyam* (The Days).

The sculptor's return to Amman's Alia Art Gallery in 1983 preceded displays of her oeuvre in Abu Dhabi, Dubai, Jordan, Kuwait, London, Paris, Moscow, Ontario, and Oslo. She brought renown to Jordanian arts at the National Museum of Women in the Arts in Washington, D.C., and in a 1994 exhibition for trans-Arab artists. In her mid-fifties, she dabbled in Yemeni alabaster and black Syrian diorite. She chose flecked black marble for "City" and lightly polished Jordanian jade for the sculpture "Growth," a pearlescent figure suggesting self-defense and human gestation. In this same period, she collected forty-three Arabic and English poems in a first anthology, *An Ocean of Dreams,* a title rife with nature and its possibilities. The multi-genre concept reverberated in a silk screen print series *The Petra Tablets.* For her expertise, King Hussein presented her Jordan's 1996 National Honorary Award for the Arts.

At a studio in working-class Ouzai in her sixties and seventies, Mona Saudi completed a swirl of Amman limestone hues in "Sunset in Pink," a precise balance in "The Seagull," and a collection called "Poetry in Stone" for the art museum opposite the city's Art Square in the Emirati town of Sharjah. In addition to the monograph *Mona Saudi: Forty Years of Sculpture,* she riveted critical attention with a series of asymmetric circles entitled "The Seed," perhaps her most stunning project for its soft lines a mellow gold tones drawn from coffee beans and wheat heads. In 2014, Nicholas Blincoe, a journalist for the *Guardian,* credited the artist's Jordanian cinema and posters with stimulating the Palestinian Revolution.

Source

Blincoe, Nicholas. "When Artists Go to War," *Guardian* (12 May 2014).
Hussein, Muhsen Ali. "Domination and Motivation in Mona Saudi Sculptures," *Al-Academy Journal* 87 (2018): 5–28.
Kalsi, Jyoti. "Mona Saudi Creates Poetry in Stone," *Gulf News* (24 June 2015).
Kumar, N.P. Krishna. "Mona Saudi's Aesthetic Journey," *Gulf News* 15 (28 March 2018): 47.
Porter, Venetia. *Reflections: Contemporary Art of the Middle East and North Africa.* London: British Museum, 2020.
Saudi, Mona. *Mona Saudi: Forty Years of Sculpture.* self-published, 2006.
Teller, Matthew. "Finding the Essence," *Aramco World* 61:3 (May/June 2010).

Sadeghi, Fatemeh "Jamileh" (October 26, 1946–)
belly dancer, actor, comic
Iran

Screen actor and high-wattage stage entertainer Fatemeh Sadeghi (also Fatimah Sadiqi) adopted the name Jamileh (Beautiful) for a revival of *motrebi* (popular) belly dance. A native of Tehran born on October 26, 1946, she claims a musical lineage, beginning with her mother, an itinerant dancer. Her uncle, Morshed Nasrollah, a

roving raconteur and *zarb* (goblet drum) player, and her father, Rajab Vaksi, a wal-
nut dealer and actor, influenced her childhood practice of urban style *raqs-e arabi*
(Arab dance), Egyptian and Middle Eastern folk steps. Pliant and subtle, she began
as a cafe performer of *bandari* (belly dance), a torso-undulating rhythm from Per-
sian Gulf fisherfolk. To the repertoire, she added *qasemabadi*, a chain dance of
Gilaki rice harvesters on the northern Caspian shores that incorporates the flail's lift
and swing.

From a first marriage to J.R., a musical comedy singer and heroin addict, Fate-
meh Sadeghi moved on to matrimony with the owner of the Mulan Ruzh (Mou-
lin Rouge) nightclub, Mohammad Arbab, who bribed the drug user to abandon his
wife. In addition to opening the Lidu cabaret, she performed flirty sets on television
in the 1960s and 1970s in glitzy coin-edged kerchiefs, jumpsuits with cutouts, fringe
accentuating shoulders and hips, and finger cymbals. An improvisational comic, she
teased club goers with repartee and capers on chairs and tables. The presentations
influenced theatrical, restaurant, and bar dance styles and gained popular support
in the countryside at concerts and private parties.

From Stage to Film

The dancer's two-stage career of athletic dancer-actor-fighter debuted on screen
in the film romance *Nasim-e Ayyar* (Nasim the Scoundrel, 1967). The choice of the
independent women subverted stereotypes of the sniveling bedmate crawling to
her ill-tempered man. She progressed to cinema roles in the history film *Gohar-e
Shab-cheragh* (The Glinting Gem, 1967) and a string of titles by her husband's pro-
duction company, Ferdowsi Film: the crime drama *The Gambler* (1968), the romance
Donya-ye Abi (Blue World, 1969), and the biopic *Khashm-e Koli* (The Gypsy's Ire,
1969), a showcase of male envy and unbridled vengeance available in Arabic and
Farsi. Through Arbab's influence, she gained a reputation for artistry and profes-
sionalism rather than the titillation of earlier performances. According to Ida Mef-
tahi, an expert on sexuality and gender in Iranian entertainment at the University of
Maryland, the upgraded presentation validated discretion in other pop stars.

In a six-year span, Fatemeh Sadeghi acted in the musical adventure *Zan-e
Vahshi-e Vahshi* (Wild, Wild Woman, 1969), *Na Madari* (The Attack, 1970), the
crime drama *Dukhtar-e Zalim Bala* (The Girl Despot, 1970), and *Khoshgeltarin Zan-e
'Alam* (The Most Beautiful Woman in the World, 1971), upholding fictional artist
Sitarah (Star) for refusing exploitation. Widowed in 1973, the performer poured her-
self into acting, playing the title ex-con and cabaret dancer Nesaa in *Bandari* (Impu-
dent Girl, 1973), the singer Reza in *Mahboob-e Bacheha* (Loved by Kids, 1973), and
the crime adventurer in *Kaka Siah* (Nigger, 1973). Roles took on greater psycholog-
ical significance: as Mahboobeh in *Ghoul* (1973), and as the irresistible performer
who sidetracks the police investigation of a corrupt nightclub owner in *Kaj Kola
Khan* (The Man in the Tilted Hat, 1973). For the crime drama *Mitris* (Mistress, 1973),

she posed as the sorrowing clown who danced to relieve grief until she changed professions to enter nursing.

Migration to America

Fatemeh Sadeghi's grueling schedule continued with the part of Farideh in ‘Arus-i Pabirahneh (The Barefoot Bride, 1974), a martial arts role, and the coy title figure singing "You Know Who I Am" in the romantic comedy Gulpari Jun (Dear Golpari, 1974), a gesture to a successful twin sister. She appeared as Zari in Sharaf (The Honor, 1975), as Nazi in Rande-shode (Sporty Hair, 1975), in the frenetic Farrash-bashi (Head Servant, 1975), and as Goli in Jedal (1976). In media interviews, she claimed to refuse gratuitous dance unless the script called for it. She rose to the highest earnings in her class, in part from the mastery of jaheli, a Persian choreography dating to the 800s CE. Dancers accompanied by drumming on darabukka (stemmed drum) and tanbak (hand drum) resisted Mongol and Turkic interlopers in eastern Iran with a shrugging, mustache stroking, orgasmic lip shimmy, hip-wagging handkerchief dance mimicking tough-guy laborers.

Because of the 1979 Iranian Revolution and strict anti-entertainment laws, especially for women, the performer migrated from Tehran to Los Angeles and flourished as a celebrity dancer at Cabaret Tehran on Ventura Boulevard in Encino. In addition to double-time torso rolls, the cooler, sexier jaheli style required a kerchief, fluid neck rolls, macho shirt and pants, and a rakish black fedora. The film Raqs-e (Songs) illustrated a range of styles, notably the baba karam (Daddy Karam), a chain choreography acting out a domestic servant's yearning for a king's harem girl. An entertainer of notables Ari Onassis and Henry Kissinger, she won from Iranian viewers the nickname "goddess of the dance."

Source

Breyley, G.J., and Sasan Fatemi. Iranian Music and Popular Entertainment from Motrebi to Losanjelesi and Beyond. New York: Taylor & Francis, 2015.

Friend, Robyn C. "Jamileh: The Goddess of Iranian Dance," Habibi 16:1 (Winter 1997).

Meftahi, Ida. Gender and Dance in Modern Iran. New York: Taylor & Francis, 2016.

Talattof, Kamran. Modernity, Sexuality, and Ideology in Iran: The Life and Legacy of a Popular Female Artist. Syracuse, NY: Syracuse University Press, 2011.

Walker, Philip. "Raqqas or Jamileh: Contrasting Perspectives on Dance in Iran," Habibi 15:2 (Spring, 1996): 10.

Zarsanga (1946–)
folksinger
British India

Petite Pashto folksinger Zarsanga (or Zar Sanga) of Khyber Pakhtunkhwa, Pakistan, rose to super stardom by presenting folk concerts on ancient nomadic themes of love, wartime glory, nature, and Sufi mysticism. She was born in 1946

in trans-Indus British India, on Afghanistan's northeastern border at Bannu. A nomadic herder of Afghan lineage, she and the Kutanree tribe trekked annually from Bannu east to Punjab and south to Sindh. The walled city, established as a fort in 1848 by Anglo-Bengal fusilier Herbert Benjamin Edwardes, gained tourist fame for the domed Meryan Gate, an architectural landmark of the British Raj and popular wedding site.

Kutanree singers collected mountain *gharhi* (devotionals), desert arias, and the haunting Pashto folk melodies of shepherds who, from 500 BCE, pastured flocks from the Indus Valley to the rocky Khyber Pass. They performed on an all-purpose *hujra* (open air stage) to the bowing of the *rabab* (also rubab or lute), two-headed *dholak* drum, and paired *tabla* drums, with later additions of flute and harmonium, a portable pump organ. According to Véronique Mortaigne, a culture writer for *Le Monde,* the tribal strand of Pakistani music reflects ancient Persian and Indian influence and frontier clan culture. Merchants traded at the Bannu bazaar in cloth, wheat, wool, cotton, and tobacco and carried away the legendary Pashto folk music. Called Bannu wall songs, peasant ballads laid the foundation of Zarsanga's legendary career, which pleased listeners along the Durand Line on both sides of the Afghan-Pakistan border.

Professional Beginnings

The daughter of Tekidar, a tabla drummer, the folksinger grew up illiterate, but steeped in rhythm and melody. Named "Golden Branch" in Pashto, an Iranian language, while living with a paternal aunt, she evolved a unique style based on ear training. She explained to Mortaigne: "I began singing while I watched sheep in the fields," a one-woman musicale accompanied by tambourine (Mortaigne, 2014). Against her father's dicta, she learned popular spring melodies for Nawroz (New Year) and Eid al-Fitr, the conclusion to the Ramadan fast. Peasant audiences saluted familiar lines with explosions of shotguns. In 1965, she eloped with composer and tabla drummer Mula Jan of Naurang, who sired their four daughters and six sons. From age twenty, she dedicated her clear, rumbling mezzo-soprano to historic musicology.

In Lakki Marwat, a producer found Zarsanga performing solos at a wedding and expressing women's perspectives on love. The debut of "Da Bangriwal Pa Choli Ma Za (Go to Bangariwal)" on Radio Peshawar and Islamabad TV at Pindi began with a favorite, "Shinwari Lawangeena (Where the Waters Meet)." The show revolutionized radio programming with an emergence of female singers. Assertive chants, soulful euphony, charismatic voicing, and gentle gestures embracing affection and peace drew stage and YouTube audiences, shoutouts from appreciative prisoners in the Peshawar Central Jail, and buyers for her 1,200 albums. Cloaked in richly patterned native dress topped with an embroidered voile head drape, she sang on Mashriq TV in Peshawar and toured Saudi Arabia, Iran, Iraq, Dubai, Morocco,

Belgium, France, England, Russia, Japan, Canada, and the U.S. in hopes of reviving the Pashto folk values and cultural birthright.

A National Treasure

The Pashto music industry profited from the intensity of Zarsanga's voice and her sweet articulation, aided by partner Khan Tehsil, with whom she performed for a half century until his death in March 2016. In London, she sang the lively "Ro Ro Keda (Don't Cry)" and presented a mountaineer's tune about a gypsy. In 1988, when her daughters began singing in her style, their father carped about violating tradition. In mid–July 1989, Zarsanga appeared for the first time in France at the Festival d'Avignon, held in the Palais des Papes (Popes' Palace) courtyard, and performed "Waravi Lasoona (Dancing Nomads)" in French director Yves Billon's documentary *The Music of Baluchistan.*

Zarsanga achieved global respect and won the 1990 Pride of Performance Award from Pakistan, a Presidential citation made by Ghulam Ishaq Khan, who set up a small fund for her. The media dubbed her varied stage names—"Mother of Pashto Song," "Voice of the Pathan (Pashto speakers)," "Bob Dylan of the Pakhtuns (Pashto speakers)," "Golden Voice Queen," and "Desert Queen of Pashtun Folklore." On March 7, 1991, she began a two-week performance at the Jashan-e-Bahaar (Celebrate Spring) festival of the arts that extended to a tour with heartthrob baritone singer Fazal Malik Akif to London, Birmingham, Greenwich, Hackney, and Manchester and over BBC media. After her presentation in Paris, newspaperwoman Mortaigne declared the singer "une poétess de la voix" (a poet of the voice) (Mortaigne, 2011).

In summer 1993, Zarsanga recorded ten gypsy classics in Afghanistan on a first solo studio album, *Chants du Pashtou* (Pashto Songs). At age fifty, she arranged and performed "Gula Sta de Kilie (To Soothe the Throat)" as a model of Pashtun folk music on the album *The Rough Guide to the Music of India and Pakistan.* Jon Pareles, a journalist for the *New York Times,* reported on Zarsanga's performance at a 1997 Asia Society gathering on Romeo-and-Juliet love plaints in a voice "austere and forceful" from "quavers, trills, breaks and yelps ... impassioned and steely" (Pareles, 1997, 5). The next morning, she took part in a symposium on Pakistan's contribution to ethnomusicology.

Penury in Old Age

On February 4, 2009, the former shepherdess enlarged the repertoire to include classic *ghazals*, Arabic odes or love poems composed of independent couplets and repeated rhymes. Jean-Luc Gandec, a reporter for *La Terrasse* (The Terrace), cited her zest for "the fragrance of brotherhood, freedom, and pride" (Gandec, 2009, 44). To relieve demands of seven children, the singer worked as a domestic while her

husband migrated to the lower Punjab in search of work. In widowhood her earnings supported the children and two orphaned granddaughters.

In late summer 2010, a 16-inch monsoon flooded the Indus River Valley. At Nowshera east of Peshawar, waters swept away Zarsanga's musical instruments and jewelry and destroyed her five-room clay rental house. Along with 800,000 refugees, for two years, she camped in a borrowed tent at a roadside deemed unsafe for women and girls. Supporters raised cash for her in late June 2011 with an auction of local paintings. The Peshawar *Frontier Post* cited the singer's disappointment in modern trends: "We are poor and old but our hearts are young and can still spellbind the audience through our melodious voices. It is a sad fact that Pashtuns don't give us due regard" ("Popular," 2012).

Career Upsurge

The singer's future looked brighter after Afghan President Hamid Karzai donated a residence, car, and jobs for her family. The offer motivated Pakistani Prime Minister Imran Khan to promise a house in her own country, where she could recover from chronic pulmonary ailments. The European itinerary took her and a son, drummer Shahzad, to the Théâtre de la Ville in Paris on October 7, 2011, to recite *landays* (Sufi love poems) and sing nomadic melodies, billed as "musical traditions of the Silk Route." In Tangier on the Strait of Gibraltar on June 29, 2012, she sang sounds of Pashtu and Sind at Hotel Husa Solazur for Tarab Tangier (Tangier Fun), a showcase of traditional global music. In 2013, she revealed to Sher Alam Shinwari, a journalist for *Dawn*, that she longed for the peace and safety of a brick house. Dressed in a softly feminine fringed shawl in turquoise and white and modest jewelry, she sang at Place du Châtelet in Paris's Théâtre de la Ville on March 22, 2014, with rabab instrumentalist Ghulam Hussein, Akbar Khamisu Khan on the *alghoza* (double flute), and tabla drummer Siar Hashimi.

After Zarsanga's French tour in March 2014, German fans at Wiesbaden welcomed her back following a five-year hiatus. At the Walhalla Theater on April 26, 2014, she won an international singing competition in company with son Shahzad on the tablas. She offered a duet with Kamar Gulla in Peshawar in 2014 on Pakistan TV. More blessings restored Zarsanga's optimism in February 2017 with the naming of a cultural center in Lok Virsa, Islamabad, "Zarsanga Hall." The title lasted only two years before its cancellation by the National Institute of Folk and Traditional Heritage. Three months later, an audience of varied ages applauded a Pakistan National Council of the Arts tribute to Zarsanga.

Revival

While vendors profited from baby clothes, T-shirts, coffee mugs, pillows, and totes bearing the name Zarsanga, the singer lapsed into poverty because of a

criminal home invasion. By late July 2017, five armed extortionists rifled her house for valuables; gashed the left side of her face and right arm; and beat three of her six sons, a daughter-in-law, and two grandsons. Sick with asthma, she pled for financial and medical aid from Minister Mahmood Khan and proposed relocating to Kabul. The *Balochistan Times* at Quetta and the *Frontier Star* at Karachi published demands for her assailants' arrest, which officials accomplished by July 27.

At age 72, Zarsanga modernized by performing with young musicians. In mid–August 2018 at the Coke Studio music venue, she teamed with Gul Panra to perform "Rasha Mama (Bad Mama)" to backup by a mainstream keyboardist and subtly controlled percussion. Two years later, she aided the Pakistan National Council of the Arts with an online concert intended to please citizens and remunerate performers left penniless because of the covid lockdown. The live performance from her home at Kohat south of Peshawar reached urban and rural listeners, who reclaimed her in March 2020 as "the soul of Pashtun people."

Source

"Festival Tarab Tanger," *Tanger Pocket* (August/September 2012): 28.
"Folk Singer Zarsanga Enthralls Online Audience," (Karachi) *Express Tribune* (22 April 2010).
Gandec, Jean-Luc. "Zarsanga," *La Terrasse* (4 February 2009): 44.
Mortaigne, Véronique. "Les chants mystiques soufis et ceux des tribus pakistanaises vivent encore," *Le Monde* (31 January 2009).
_____. "On aurait tort de résumer le Pakistan au cliché austère de l'intégrisme," *Le Monde* (7 October 2011).
_____. "Zarsanga, la voix d'or pachtoune," *Le Monde* (21 March 2014).
Pareles, Jon. "Two Style in Pakistan: For Lovers and Sufis," *New York Times* (21 October 1997): 5.
"Popular Pashto Folk Singers Zarsanga, Khan Tehsil Sing Their Woes," (Peshawar) *Frontier Post* (19 March 2012).
"Popular Pashto Singer Laid to Rest," (Karachi) *Dawn* (9 March 2016).
"Report of Zarsanga Attack Registered, Six Arrested," (Lahore) *Right Vision News* (24 July 2017).
Rummery, Ariane. "Jalozai Camp Population Swells as Pakistan's Displacement Crisis Deepens," www.unhcr.org/en-us/news/latest/2009/2/4992d5a62/jalozai-camp-population-swells-pakistans-displacement-crisis-deepens.html (11 February 2009).
Shinwari, Sher Alam. "Nomad Melody Queen Has a Dream," (Karachi) *Dawn* (27 January 2013).
Zarsanga, www.youtube.com/watch?v=1z5ZVBCsIt4.
Zarsanga (film). Pakistan: One Ten Films, 2018.

Dodkhudoeva, Larisa (1947–)
art historian
Tajikistan

Dodkhudoeva, Lola (1951–)
art historian
Tajikistan

Siblings Larisa Nazarovna Dodkhudoeva and Lola Nazarsho Dodkhudoeva preserve in treatises, lectures, and journal articles the historic achievements of

Tajikistan. The daughters of Soviet economist and secret service agent Nazarshoh Dodkhudoev received quality education in their hometown of Dushanbe, the Tajik capital. During girlhood, they witnessed the expansion of an art school and museums and the secularization of mosques into the Rakhat and Sa'dat teahouses in Stalinabad, the socialist name of Dushanbe. Workers adorned facades with customary ninth century CE Samanid Persian wood carving, ceramics, and painting updated with oriental touches. Artisans restricted themes from classic mythology to Soviet-approved imported modernism.

While their father served as Tajik prime minister, the sisters studied in Russia. Larisa Dodkhudoeva specialized in Persian art miniatures at the Repin Academy of Arts in Leningrad and the Institute of Oriental Studies in Moscow before deepening her research in Islamic culture at the University of Nebraska at Lincoln. At the Leningrad State University, younger sister Lola Dodkhudoeva followed with achievement in Arabic Sufism and politicized Islam. She earned a doctorate in 1983 while heading the Department of Medieval Studies at the Institute of History, Ethnography, and Archaeology in their hometown. Her dissertation interpreted inscriptions on the Uzbek Chakar-diza Cemetery monuments in Samarkand along the Silk Road from the 800s to the conclusion of the Middle Ages in 1400.

A Consuming Essence

The Dodkhudoeva sisters maintained an interest in Eurasian culture into the present. On a UNESCO scholarship, at age forty-one, Larisa advanced to a Ph.D. in ethnography at the Tajikistan Academy of Sciences. As chair of the Department of South Asia, she persevered in the examination of Persian art and served as associate director of the Institute of World Economy and International Relations. Her sister Lola worked for the Ministry of Education and, in 2000, led UNESCO as secretary general of the Tajik commission in the 2006 study of unemployment rates, which neared 52 percent. She continued exploration of Central Asian religious customs during the Middle Ages and the role model of thirteenth-century empire builder Genghis Khan on Renaissance governance. At age sixty-five at the Rudaki Institute in Dushanbe, Lola led a survey of the Persian language.

Academicians applauded Larisa Dodkhudoeva's career in 1992 for documenting Tajikistan's founding and, in 1985, for indexing and classifying by one hundred themes some 3,360 miniatures painted on 245 manuscripts. She earned a 1999 citation from the University of Nebraska for furthering peace through reconciliation. Two years later, she won 2001 awards from Zoroastrian College in Bombay for recognizing religious themes and from Vienna's Central European University for fostering Eurasian culture. Critics noted her revived interest in Ismail Samani, Emir of Transoxania and Khorasan, the late ninth-century dismantler of feudalism and founder of Tajikistan. Lola Dodkhudoeva attracted academic attention for rifling the Bibliotheque Nationale de France in 1998 for the neglected manuscripts

of Khwaja Muhammad Parsa, a fourteenth- and fifteenth-century Sufist reformer at Herat, Afghanistan, and subsequent Timurid arts patron. In February 2007 on a Fulbright Visiting Scholar grant, Lola researched pre–Mongol statuary.

High Achievers

The Dodkhudoeva sisters impacted scholarship with writings on indigenous art, beginning in 1971 with Larisa's book on Tajik graphics and sculpture and a monograph on Tajik festivals for Mehrgon (festival of love god Mithra), Nawruz (New Year's Day), and Sada (celebration of good over evil), holidays derived from Iranian mythology and nature worship. Her remarks on the Koranic images of heavenly light in 2005 focused on the allegorical use of gold for illuminating auras on scriptural pages. After the 2007 success of the *Atlas of Central Asian Artistic Crafts and Trades,* she broadened art critiques in September 2020 to an essay on wood carving, crafting musical instruments, basketry, and wickerwork.

In the mid–1980s, Larisa Dodkhudoeva issued *Tajik Artists* and *Nizami Poems in Medieval Persian Miniature Painting.* The compendium inventoried lavish illustrations in manuscripts of thirteenth-century romantic epic *Khamsa* (The Hand) by Nizami Ganjavi. The scholar's scrutiny of cultural shifts included the influence of Zoroastrianism in Islamic art and late Renaissance Koran reproduction and painting in central and southern Asia. Her sister Lola ventured into twentieth-century Islam and its post-secularism. She referred to the socio-political upheaval in the 1990s as an effort to "withstand and create" in an era of "enormous changes in the Muslim world" (Lola Dodkhudoeva, 2015, 20).

In a November 15, 2011, speech at Colgate College in Hamilton, New York, and the 2013 essay "Everyday Life of Tajik Women," Larisa Dodkhudoeva appraised late twentieth-century interest in women's studies and the disparate responsibilities and amusements of rural and agrarian men and women. She disclosed a truism about aging: "The older the woman, the more likely she was to play a role in family decision-making, as well as report her husband's assistance with household chores" (Larisa Dodkhudoeva, 2013, 403). She surmised that education and employment favored women under Communist rule, a fact buried in unpublished works in a Tajik archive. At the collapse of the USSR on December 26, 1991, however, females returned to low-status roles as housewives, farm drudges, and victims of domestic abuse. In 2020, Larisa noted the lack of female interest in socialism and the predominance of universals in Tajik art—mythology, dance, and beauty.

Source

Bargel, Johann Christophe, and Christine van Ruymbekei. *Key to the Treasure of the Hakim.* Amsterdam: Leiden University Press, 2011.

Dodkhudoeva, Larisa. "Everyday Life of Tajik Women," *Codrul Cosminului* 19:2 (2013): 399–406.

———. "Monumental Painting in Tajikistan," *Bulletin of MIHO Museum* 7 (2008): 47–53.

Dodkhudoeva, Larisa and Lola. "Manuscrits Orientaux du Tadjikistan: La Collection Semenov," *Cahiers d'Asie Centrale* 7 (1999): 39–55.

Dodkhudoeva, Lola. "ANAMED Senior Fellow Lola Dodhkudoeva," www.youtube.com/watch?v=mKJjWpLYwfs.

_____. "La Bibliothèque de Khwaja Muhammad Parsa a Boukhara," *Cahiers d'Asie Centrale* 5–6 (1998): 125–142.

_____. "Tajikistan: Socio-Cultural Code of the Epoch and Popular Islam," *Russia and the Moslem World* 1:271 (2015): 18–24.

Kosremelli, Simone (1950–)
architect, writer, orator, jewelry designer
Lebanon

A Lebanese architect and lecturer with a global following developed over three decades, Simone Kosremelli achieved fame by defeating mediocrity. She achieves by incorporating Arabic features, topography, and Middle Eastern materials into residences, villas, condominiums, and public and commercial structures. A Christian educated in French schools, she set a course on architecture and thrived at drawing and math. In 1974, she became the second female to earn a degree from Beirut's American University School of Architecture. After interning with architect Assem Salam in the junior year, she visited Aleppo on his advice and completed a thesis plan for a children's holiday village in the mountain town of Baskinta. A group project introduced early 1900s multifamily dwellings place-specific to the shops and cinemas of suburban Achrafieh.

On a Fulbright scholarship, the designer studied urban planning at Columbia University. In 1975, the first year of the Lebanese civil War, she toured New York's brownstone neighborhoods to explore the recycling of antique buildings. Before joining the Dar al Handasah (House of Engineering) consultancy in 1977, she surveyed heirloom buildings in Morocco and Spain. The tour produced a revelation of colors, room and window proportions, ponds and water gardens, and unconstricted light. After a one-year partnership with the Beirut Municipal Authority, in 1978, she resettled near her mother in war-torn Lebanon and dodged a shell and a sniper while managing her own construction company at Ain el Mraisseh (Where Is Mercy). Committed to a "closeness to and a kinship with the Mediterranean as well as to the local architectural heritage," while teaching at American University, she became Lebanon's only female building designer (Kosremelli, 2011, 11).

A Vigorous Start

Premiering upscale interiors at Faqra on Mount Lebanon in 1979 with the Saba Nader Chalet, Simone Kosremelli honed a penchant for comfortable, enjoyable structures that integrated with local settings. She took a cue from serene countryside dwellings and summarized standard Lebanese elements: "red-tiled roofs, regular courses of stone, arcaded openings … external staircases, and breezy loggias" (*ibid.*, 10). A lecture in May 1980 stated the influence of Islamic constructions in the

Alhambra, a palace fortress completed in 889 CE at Granada in south central Spain. A program followed in April 1981 reflecting on Lebanese styling at the Kennedy Center in Washington, D.C.

In May 1981, the designer opened an office accommodating ecologically sound, coherent construction based on regional legacies in Saudi Arabia, Lebanon, and Milan, Italy. Opposite the university campus in Hamra, she exhibited at the Makhoul Street Festival. In six months, she formed a company in Beirut and accepted contracts in London and at Abu Dhabi in the United Arab Emirates. A growing reputation for originality identified her with the vernacular mode, reinterpretation without sentimentality, and authentic ashlar (dressed stone) crafted by skilled masons. The beauty of rough gray stone grounded the Samir Boustani House in Bkechtine, a model of fidelity to indigenous materials.

The architect established a discernible esthetic. She rejected the reinforced concrete of the mid-twentieth century, one of the "globalizing trends that are creating a new phase of anonymous international building of the kind that many of us hoped had long since been put behind us" (*ibid.*, 8). Her stone facades featured arched alcoves and entrances. In 1988, she added the Nagib Zeidan structure to her resume, followed the next year by Beirut's De Mette Furniture Gallery, forerunner of Galerie Semaan (Quail Gallery), a furniture showroom. Interspersed with residences, she completed the Les Créneaux (The Slots) Sports and Cultural Club in Ashrafieh and Bank Audi D-Block in Beirut's financial district. In Damascus in 1996, she equipped the Dar al Mamlouka (Mamluk House) Boutique Hotel with a Turkish *hammam* (steam bath) and restored the Melrose Building damaged when a suicide bomber struck Lebnon's Bab Idriss district on April 18, 1983. The explosion also destroyed the U.S. Embassy; cut her arms, back, and head; and aroused fears for Youmna, her five-year-old niece. Undeterred by war, at the end of the first decade, the architect opened a branch firm in Abu Dhabi.

PRESERVATION AND MODERNITY

Following Simone Kosremelli's design of the Khalil Arab Residence in Tyre in 1999 and the rehabilitation of the Malia Group Office in Nahr el Mott in 2000, she extended description into the 2000s with panel discussions of architectural reclamation and a UNESCO seminar in Cairo on safeguarding folk housing elements. Simultaneously, she wrote professional articles for *Architectural Review, Mimar* (Master Builder), *Design Diffusion News,* and *Deco.* In December 2002, she reinforced female roles in engineering and building, a topic she revisited at the Acquario Romano museum in 2002 and in July 2007 in Utrecht, Holland. The following May, she received a distinguished alumna citation from American University.

In *Deco* and in contemporary compendia on urbanism and Middle Eastern design, the architect's writings disseminated her views on modernity within traditional spaces. In Ghalghoul, she submitted a competition entry for the Centre for

Arts and Culture. Her exhibit in June 2006 at the Musee Emmanuel Paul Guiragossian preceded completion of the Hotel Damascus and the First National Branch Bank of Jounieh, a jewelry show in February 2010 in Bahrain, and the exhibit of minimalist cubic rings, men's baubles, and blue agate pendants in the Gemmayzeh district at the Dehab Jewelry Gallery, which she directs. In 2011, she issued a monograph, *A Lebanese Perspective,* a comprehensive analysis of famous designs and rehabilitations along with a biography. At her alma mater in November 2013, she presented the lecture "Old Souks: Past Glories and Present Tragedy." Plans in progress include a carved rock cellar at the Massaya Winery in Faqra and a technical school in north Lebanon at Akkar as well as the initial stages for projects in Montenegro, Morocco, and Switzerland.

Source

Boustany, Nora. "Fifty Shells a Minute: After 14 years of Civil War, Beirut's Worst Week," *Washington Post* (2 April 1989): C1.
Kosremelli, Simone, and Sylvia Shorto. *A Lebanese Perspective: Houses and Other Work.* Victoria, Australia: Images Publishing, 2011.
The Phaidon Atlas of Contemporary World Architecture. Paris: Phaidon Press, 2004.
"Un Refuge de Luxe dans la Montagne," *Harmonies* (December 2001/February 2002).
Stoughton, India. "Simone Kosremelli: At Home with the Old and the New" (Beirut) *Daily Star* (18 August 2012).

Alif Laila (1952–)
sitarist, watercolorist, muralist
Bangladesh

A Muslim painter and sitarist proclaimed a *vidushi* (master) musician, Alif Laila reveres the playing of sitar expert Annapurna Devi of British India and the watercolors, traditional garden greenery, and sublime designs of Bangladesh. Together, the inspirations ground a canon of classical Indian music. Shy from childhood, she was born Afiqur Rahman in 1952 to Shehida and Major M.R. Haque in Dhaka (Dacca), where the family included older brother Shahudul and younger siblings Shahidul and Reaz H. Haque. She learned voice from her young Aunt Bulbul, who sang the lyrics of Bengali rebel poet Kazi Nazrul and dramatist Rabinadranath Tagore. Her mother encouraged practice of traditional North Indian dance and song as well as the sitar. The elite court instrument dates to the 1100s CE and became popular during the Mughal era. By the late nineteenth century, music schools enrolled women in sitar training.

While visiting Aunt Bulbul in Calcutta, the seventeen-year-old musician bought a first instrument, a teak wood sitar with twenty-three strings and twenty frets. Sitar notes saluted her aunt in 2007 in the CD *Celebrating Bulbul.* From an uncle, father, and stringed instrument expert Ustad Alauddin Khan, over eight years of training, she developed a devotion to the traditional sound. She respected that, for some nine centuries in Afghanistan, Bengal, India, Iran, Pakistan, and Turkey, the

hypnotic pairing of drone with plucked strings alongside the *tabla* (hand drum) had advanced Indian meditation, spirituality, dance, and yoga.

WIFE AND SITARIST

With awards for watercolor and a music degree from Dhaka's College of Fine Arts, in 1981, Alif Laila and her husband, economist Amit L. Rahman, relocated to Kuwait and then to Maryland, where he took a job. She recalled, "I came to America in 1988 and had to face a lot of struggles" with cultural differences (Hossein, 2020). While rearing sons Amrit and Shurid, she devoted four hours daily to improvising ancestral sounds and learning folk songs. Under the influence of Ravi Shankar, a global music star of classical Indian music, she practiced techniques. Of the mystique of string tunes, she stated, "You're in a spell. You can't figure out what it is" (Luxner, 2020). She described sitar music among Buddhists, Hindus, and Muslims as healing and stressed that bright, sharp, sensitive reverberations, paired with the *tabla* (Indian hand drum) promoted reverie, unity, and calm.

For thirty years, Alif Laila gave secular, nationalistic, and religious recitals in her homeland in Calcutta and the Bhopal Tribal Museum and in Kuwait, London, Liverpool, Paris, and Landau, Germany. She became a full-time performer in 2000 and recorded ten albums, including *Inner Voice,* the solo collection *Meditation with Sitar, Amma* (Mom), *Romance of Raags & Songs in Bengal, Chakra* (Cycle), *Ekavali* (The Connecting Thread), *Hrydayaragam* (Heartbreaking), *Sangam* (Coming Together), and *I Am a River.* For the CD *Devotion,* she teamed with Anindo Chatterjee, a world-class tabla expert, to present the raga *Puriya Dhanashri* (To Understand Lakshmi, Goddess of Wealth). She appeared in American venues—Yale, Brooklyn, New York's Metropolitan Museum of Art; Parsippany, New Jersey; and Washington, D.C.'s Smithsonian and Shakespeare Theatre—before her major presentation on August 20, 2017, at the Kennedy Center.

UNION OF ARTS

Under the stage name Alif Laila (One Thousand and One Nights), the musician incorporated visual arts into distinctive recordings. She painted her own covers in watercolor with serene tones of green, yellow, blue, purple, and lavender. With a watercolor light show, she illustrated programs of *raga* or improvisational Indian melody in mood music, performed with cello, percussion, violin, flute, and saxophone. To journalist Kelsi Loos of the Frederick, Maryland, *News-Post,* she explained, "Both art forms are the same as expressions of emotion with creativity ... with its overlap of tones, textures, improvisations, spontaneity" (Loos, 2015).

Currently located in Silver Spring, Maryland, Alif Laila decks the studio in murals, framed watercolors, and geometric rugs in the hues of her homeland. The video *Strings of Resonance* won a November 2010 citation for the best classical music

in Bangladesh. For promoting women's rehabilitation through music, she won a 2012 excellence award from the American Speech-Language-Hearing Association. In 2015 at her two-story residence at 1403 Mimosa Lane, Bethesda, she founded a music school, *Sitar Niketan* (Home of the Sitar), where she teaches individuals and ensembles. During the covid lockdown in 2020, the Alif Laila Book Bus Society directed Roshan the camel laden with books to home-schooled children.

Source

Hossain, Amina. "In Tune to the World" (Dhaka) *Daily Star* (3 December 2020).
Loos, Kelsi. "Interview" *Frederick* (MD) *News-Post* (2 April 2015).
Luxner, Larry. "Sitar Master of Maryland," *Aramco World* (November–December 2020).

11

1960s

Zana, Leyla (May 3, 1961–)
prison writer, orator, journalist
Kurdistan

An advocate of peaceful coexistence and women's emancipation and a martyr to Kurdish liberties, culture, and language, author Leyla Zana, the "Kurdish la Pasionaria (The Passionate Kurd)," published a female prison narrative on a decade of persecution (Taheri, 2015, 36). Born in the geo-cultural region known as Kurdistan on May 3, 1961, she is a native of Silvan in the Diyarbakir Province, considered the Kurdish capital. At age fourteen, she wed Mehdi Zana, a thirty-four-year-old tailor, poet, and socialist mayor of Diyarbakir from 1978 to 1980. The couple have two children, actor daughter Ruken and actor son Ronay.

For sponsoring venues for the Kurdish language, Mehdi Zana was criminalized as a security risk and endured torture in a Turkish military prison from 1980 to April 1991, which he described in *Prison No. 5*. When the family visited him, guards beat Leyla and her children for speaking Kurdish. In 1988, authorities detained her for a week of interrogation. Stripped naked, she faced a brutal beating, the cause of a first protest. She used the time apart from Mehdi to finish high school, learn Turkish, join the Human Rights Association, and forge women's groups in her hometown and Istanbul.

THE BUDDING POLITICIAN

While writing for the *Yeni Ülke* (New Country), newspaperwoman Leyla Zana developed an astute perspective on democratic principles and the genocide of Kurds, who constitute 20 percent of Turkey's population. At age thirty, she won 84 percent of the popular vote and moved to Ankara as a representative of the Social Democratic Populist Party in Turkey's Grand National Assembly. The first female Kurdish-speaking deputy, she marked the occasion by wearing nationalist colors—green, red, and yellow—and pledging in Kurdish, "I shall struggle so that the Kurdish and Turkish peoples may live together in a democratic framework" ("Leyla," 2005).

After a speech in Cizre on the Syrio-Turkish border on October 18, 1991, the activist's defiance cost her legislative immunity and two more weeks of questioning

about involvement in the outlawed Democracy Party. Her children fled threats and assaults by Turkish authorities. After her revelation of Kurdish persecutions before the U.S. Congress in 1993, in September 1994, she went on trial before the Ankara State Security Court as a separatist traitor. For a stand on brotherhood, democracy, and personal and labor rights, she won the 1994 Rafto Memorial Prize in Bergen, Norway. Convicted in December 1994 on charges of treason and divided loyalties, she began a fifteen-year sentence in the Ankara Central Closed Prison after tortured witnesses testified to her subversive activism.

Before the State Security Court, Leyla Zana facilitated nonviolent vindication of Kurds in Turkey and surrounding countries. She spent cell time composing letters and articles for a collection, *Writings from Prison,* which anthologized "On Trial for Being a Kurd," "Before the Turkish Inquisition," and "Facing the Death Penalty in Ankara for My Beliefs." In defense of an ethnic birthright, she wrote, "Nothing in the world could get us to give up our mother tongue" (Zana, 1999). After Mehdi Zana's return from jail in 1994, he represented his wife by accepting the 1995 Sakharov Prize from the European Parliament for defense of free thought and human rights. As a personal manifesto, she assured the Sakharov committee, "I do not feel hatred for anyone. My only passion is justice" (Semanick, 2004, 49).

The Austrian foundation for the 1995 Bruno Kreisky Prize for Human Rights presented Leyla Zana a purse of € 30,000 ($36,723). When her liver faltered and osteoporosis worsened, she refused a release for treatment. For submitting a newspaper article in 1998 on the Kurdish holiday of Nowruz (also Nawruz, New Year), she received an additional one-year sentence, during which her husband resided in Sweden and Germany. In token of her courage, in 1995 and 1998, European and U.S. legislators nominated her for the Nobel Peace Prize.

INTERNATIONAL NEGOTIATIONS

Turkey reversed a July 2001 verdict from the European Court of Human Rights demanding Leyla Zana's release and banned the Kurdish language in the media and schools. In March 2003, she declared, "I am a woman first of all, then a mother, and then a politician. In all these capacities, I vow that I will fight for the fraternity of Turkish and Kurdish people" (Kurkcu, 2003). For her candor, Amnesty International identified her as a prisoner of conscience deserving swift release. Spanish-Peruvian scenarist Javier Corcuera filmed the trial under the title *The Back of the World.*

Because the European Union berated Turks in 2004 for sexism and cultural and human rights violations, an appeals court exonerated the activist on June 9, 2004, in the tenth year of her jailing. Her husband returned from self-exile to tour U.S. universities and plead her case; years after announcements of honoraria, she collected the Sakharov and Rafto awards. A settlement with Turkish authorities in January 2005 awarded her € 9,000 ($11,001.69) for violations of freedom of speech and free association with separatists.

On August 17, 2005, Leyla Zana joined supporters in establishing the Democratic Society Party. Their platform proposed creation of Kurdistan as a federal Turkish state for its twelve million ethnic minorities. By April 2008, she returned to a cell in punishment for identifying the Kurdish leaders in Iraq and Turkey. Within eight months, her speeches earned ten more years in prison for allegedly inciting terrorism, yet, she vowed to continue protesting a repressive Turkish government. Her public oratory continued on July 28, 2009, at the University of London to students of Asian and African studies.

Courts exonerated the freedom fighter from another fifteen months of incarceration. The following December, Turkey's constitutional court banned her from party activities for five years. Still allied with the independence movement and demand for a multicultural society, she returned to parliament on June 12, 2011, and negotiated in private with Prime Minister Recep Tayyip Erdoğan a year later. She faced arrest in November 2016 for illicit political membership in the PKK (Kurdistan Workers Party). Even though she gained acquittal for terrorism, jailing caused her to miss two hundred parliamentary sessions. Persistent absenteeism into 2017 resulted in loss of her assembly seat.

Source

Karlsson, Helena. "Politics, Gender, and Genre—The Kurds and 'The West': *Writings from Prison* by Leyla Zana," *Journal of Women's History* 15:3 (Autumn, 2003): 158–160.

Kurkcu, Ertugrul. "Defiance Under Fire," *Amnesty Magazine* (20 December 2003).

"Leyla Zana, Prisoner of Conscience," *Amnesty International USA*, www.amnestyusa.org/action/special/zana.html, 2005.

Semanick, Kevin. "An Uncommon Bond, Mehdi and Leyla Zana's Commitment," *Clamor* 27 (July/August 2004): 49.

Taheri, Amir. "A People Stuck in Center of a Maelstrom," *New York Post* (18 October 2015): 36.

Zana, Leyla. *Writings from Prison*. Watertown, MA: Blue Crane, 1999.

Compestine, Ying Chang (March 8, 1963–)
novelist, children's author, historical novelist, food writer, editor, magazine writer, memoirist
People's Republic of China

An immigrant Chinese-American living in Lafayette, California, Ying Chang Compestine thrives at hosting television shows and writing books on children's folklore, diet, history, and Asian culture. She was born the last of three on March 8, 1963, in Wuhan, Hubei. In south central China overlooking the Yangtze River, she enjoyed the luxuries of the well-to-do supplied by her mother, herbalist and acupuncturist Xiong Xi Guang, and surgeon father Chang Sin Liu, whom missionaries educated. The parents worked at the city hospital in a slum. She avoided embroidery training and girlish fan dancing. She and two older brothers survived the food and lamp oil rationing, power outages, long supply lines, cold, and hunger and struggled to light the apartment kitchen coal stove during the April 1966 Cultural Revolution,

when Chairman Mao Zedong's Red Guard stripped the family of wealth, burned books and photos, kidnapped neighbors, and trampled her only doll.

While Ying Chang Compestine's brothers worked in factories because Communism denied them entry to high school, she walked to school and to a work assignment two-hours away, for which her grandmother packed a rice ball. She listened to Voice of America on an illicit radio under a blanket and dreamed of visiting the Golden Gate Bridge. Against Maoist law and constant surveillance, she and her friends networked and circulated underground book collections. She copied favorite passages into notebooks and learned grammar and vocabulary from *Advanced English, Book 1*. To obtain a three-volume pirated copy of *Gone with the Wind*, she traded *Robinson Crusoe* and the surviving half of *Jane Eyre* and loaned out her only homemade dress for the final volume.

Rather than read Chairman Mao's required *Little Red Book*, Ying Chang Compestine hid contraband works under Communist propaganda manuals. She began writing by filling in for missing pages and debated with other children their versions of tattered volumes. At age eight, she published a magazine article. During her father's two incarcerations in the Wuhan jail for spying, she lived with grandparents and developed skill at food shopping and cookery for a family of seven, the start of her career in dietary writing.

An American Writer

An education in American literature and English at Wuhan's Central China Normal University in 1984 enabled the author to teach English classes in China and interpret for the Bureau of Seismology. At age forty-seven, she immigrated to the U.S., preserved the Chinese translation of *Gone with the Wind* in her luggage, and delighted in free libraries. On March 5, 1990, she married an American software designer, Greg M. Compestine of 863 Birdhaven Court in Lafayette northeast of Berkeley, California. In Boulder at the University of Colorado, Ying Chang Compestine earned a master's degree in sociology while spending sleep time dreaming of home. The deaths of both parents in 1996 and 1997 cut her personal links to China. She continued classroom teaching in sociology at the International School of Beijing and in Westminster, Colorado, at Front Range Community College, for which she won two master teacher commendations in 1992 and 2000. After giving up the teaching post, she joined other grievers for companionship and helped unescorted women escape Communist China.

During pregnancy with son Vinson Ming Da, Ying Chang Compestine discovered the dangers of obesity from a fatty, sugary American diet. She reclaimed the vegetables, tofu, and rice menus of girlhood in a compendium of 130 recipes, *Secrets of Fat-Free Chinese Cooking*, followed by *Cooking with Green Tea, Secrets from a Healthy Asian Kitchen*, and articles in *Men's Health, Self, Cooking Light, Delicious Living, Diablo, Eating Well*, and *Ski*. For authenticity, she caught fresh trout and prepared them

with herbs and spices. Her command of language and kitchen craft won spots on Detroit Fox News, the Discovery Channel, Food Network, Home and Garden TV, Mercury TV News, NPR *Morning Edition*, Phoenix TV, San Diego NBC, and Showcase Minnesota as well as sponsorship by Celestial Seasoning and Nestle's Maggi line. She edited *Whole Living*, Martha Stewart's lifestyle magazine on diet and wellness, and practiced tai chi as a way to stay fit.

FOLKLORE AND HISTORY

From girlhood experience Ying Chang Compestine composed a young adult novel, *Revolution Is Not a Dinner Party*, set in 1972 with vibrant family dialogue. The publisher rewarded her with a lavish banquet in New York of Asian delicacies. Banned in China but popular in the U.S., Europe, and U.K. as a curriculum model, the memoir won a 2007 *Publisher's Weekly* and a 2008 American Library Association best books for children citation as well as awards from the *San Francisco Chronicle*, California Book Award, New York Public Library, Parents' Choice, Chicago Public Library, and National Council for the Social Studies. More commendations poured in from Capitol Choices, International Reading Association, National Council of Teachers of English, and Women's National Book Association.

A zest for folk tales yielded a food play tale, *The Story of Noodles*; alphabet practice in *D Is for Dragon Dance*; *The Chinese Red Riding Hood*; *The Singing Wok*; and *The Real Story of Stone Soup*, a humorous revision. *The Runaway Rice Cake* turned New Year's traditions into a blessing from the Kitchen God, protector of family and hearth. The focus shifted from *Crouching Tiger* and magical New Year's lore in *The Runaway Wok* to one-dish meals and *Cooking with an Asian Accent*. In collaboration with Vinson in 2014 after a tour of China's disparity between rich and poor, Ying Chang Compestine published *Secrets of the Terra Cotta Soldiers*, recipient of a Golden Dragon Book shortlisting and praise from Bank Street College and the Allentown, Pennsylvania, *Morning Call*.

Ying Chang Compestine delivered "Rising Above Adversity," the keynote address to the World Residence at Sea consortium, demonstrated food skills on Crystal Cruises and Holland America, and wrote full time. Her titles advanced from the ghost story *Boy Dumplings* and the origins of kites and the bilingual history of chopsticks and paper in the inventive play of the Kang brothers, Kuai, Pan, and Ting. From Chinese mythology as old as 200 BCE, she extracted eight menu-centered titles for *A Banquet for Hungry Ghosts*, winner of an AARP citation and a Children's Literary Assembly notable book. In 2018, critics for *Children's Book Review*, Bank Street College, and Parents' Choice lauded the picture book *The Chinese Emperor's New Clothes*, which reveals the influence of Hans Christian Andersen.

Source

Compestine, Ying Chang. "In China, Hoping for a Father's Love," *Christian Science Monitor* (26 February 2008): 14.

_____. *Revolution Is Not a Dinner Party.* New York: Holt, 2007.

_____. "A Test of Character," *Knowledge Quest* 36:1 (September/October 2007): 58 59.

Kehe, Marjorie. "When Politics Bring Childhood to an End," *Christian Science Monitor* (20 November 2007): 14.

McMahon, Regan. "Ying Chang Compestine Revisits the Cultural Revolution," *San Francisco Chronicle* (12 June 2012): 1–4.

Spiegel, Jan Ellen. "Chinese Cook Returns to Roots," *Orlando Sentinel* (23 October 2017): 89.

Yoder, Glenn. "From Food Rations in China to a Career in Food," *Boston Globe* (29 January 2014): G16.

Pilika, Pisith (February 4, 1965–July 13, 1999)
ballerina, actor
Cambodia

A celebrity actor and proponent of traditional Khmer court dance in Cambodian karaoke videos, advertisements, and film drama, Pisith "Pili" Pilika died at the height of fame. She suffered from Khmer violence that killed both parents and her, ending a successful career at age thirty-four. Princess Bopha Devi declared the assassination "a huge loss to national culture," which had survived artists' massacres of the 1970s through the efforts of refugees hiding from the military (Sotheacheath, 1999). Born Oak Eap Pili at Svay Rieng in southeastern Cambodia, Pisith Pilika and sisters Daro and Divina were the children of a French professor at the University of Korokosoi. Their parents, Meng Mony and Oak Harl, died under the Khmer Rouge communist tyranny. Fostered by Aunt Meng Sonali and Uncle Sao Pili, the sisters took his surname.

At age fifteen, Pisith Pilika began learning heavily stylized *robam* folk dance under the mentoring of an aunt, Meng Sonali, on staff at the Department of Arts and Spectacles for the School of Fine Arts. After mastering the narrative gestures, combinations, and transitions of limbs, the performer played the lead in *Robam Tep Monorum* (Dance of Heavenly Bliss, 1986) and *Levels of Hell Horror* (1986) before scoring a hit with *Sro Moal Khmao* (Big Strong Peasant, 1987), a summation of Khmer genocide under Prime Minister Pol Pot from 1975 to 1979. Following graduation in 1988, she served the school as prima repertoire dancer and appeared in gold and beaded bodice, jewelry, spired headdress, and embroidered silk collar. The Burmese temple ritual costume suited a leading role in the *Anuksavary Angkor* (Nature Music) Golden CD, an ancient choreography listed by the UNESCO World Heritage project. After starring in *Smomoul Ataka* (Dark Shadow), a retrospect of the Pol Pot era, by age 24, she chose Piseth Pilika as a stage name. In 1990, she wed Khai Praseth, co-star in a first music video, *Bomram Kromum*; the legend *Sno Dombong Pich*; and the drama *Soben Mok Pno* (1991). A year after entering the fine arts faculty, she bore son Kai Seth Lesak.

A CAREER PEAK

Frequently partnered with film heartthrob Tep Rundaro in musical skits, Pisith Pilika produced twenty-five videos, eight of them in 1992, and eighteen films,

one-third of them in 1993. The list included the monster movie *Pov Malis Lea*; the Cinderella fairy tale *Moranak Meada* (Mother Death); and musical *Chnam Oun 16* (I'm Sixteen), the Romeo and Juliet tragedy *Teav Jole Malop*, and *Chan Kreufah* (King Kreufa, in which she performed a classic routine from 1990s choreography). The melodrama *Pramath Pramong* (Children Killer) in 1994 featured her in a noir child dismemberment story from the era of Genghis Khan. For the musical *Kchong Sul Tida Peus*, the actor starred opposite Kai Prasith as Uma Reangsey, the world's most beautiful woman. For the folk witch tale *Kon Uhy Madai Arb* (Son, Your Mother Is a Witch), she played a supernatural mother of a human son. The folk tale *Picheyvongsa* preceded a classic cinema role in *Rehu Chapchan* and sorcery mythology in *La En Beysach*. In some of the folklore, she performed with traditional Phom Penh actor-folksinger Touch Sunnix.

A member of Cambodia's royal ballet, Pisith Pilika toured China, Denmark, France, India, Indonesia, Italy, Japan, Korea, Russia, Singapore, Vietnam, and the U.S. and danced to a *pinpeat* (ensemble) of drum, xylophone, and flute melodies. At age thirty-one, she starred in *Robam Reamke* (The Greatest) and began filming a series of nine music videos. She appeared in Angkor Wat on November 29, 1997, at the International Ramayana Festival and topped the performers from eleven other Asian countries in recreating Sanskrit stories of Rama, a human manifestation of the Hindu god Vishnu. Following a revealing interview describing her parents' starvation and death during the Khmer Rouge regime, Pisith Pilika ignored warnings of a stalker. Her marriage ended in divorce in 1998, a year after her last film, *Prolung Areak Onteak Nesai* and final video, *Snae Duong Chan Rasmey Neakreach*.

A SORDID DEATH

On the morning of July 6, 1999, the film star strolled the Orussey Psar (market), a massive four-story bazaar in Phnom Penh on Oknha Tep Phan Street selling produce, poultry, fish, makeup, kitchenware, electronics, toys, art, medicine, fabrics, and domestic linens. She encountered a male shooter at close range who targeted her, sister Divina, and Divina's seven-year-old daughter Saren Sereiman. He fired a bullet into the child's spine while she shopped for a bicycle. For a week, Pisith Pilika survived surgery to remove bullets in the spine and died on July 13.

For the audacious daylight crime to the "people's princess" and the permanent damage to a child, the *Myanmar Times* named Cambodia Asia's assassination capital (Sotheacheath, 1999). Some ten thousand fans along with Princess Bopha Devi, a ballet promoter, and the star's grandmother, artists, and rice farmers mobbed the lying in state at Phnom Penh University School of Dance. As the princess prepared to light the pyre, they crowded the cremation service with tears and flowers out of love and respect.

A documentary, *Akasa Neak Srey Pisith Pilika* (Memories of Pisith Pilika, 1999), reviewed the tragedy. Excerpts from a diary, published in January 2003 as *Piseth*

Pilika; A True and Horrible Story, uncovered a love affair with "Darling Sen," Prime Minister Hun Sen, a former Khmer Rouge soldier twelve years the ballerina's senior (Mydans, 1999, A4). The dancer reported telephone wooing, gifts of a house and car, cash, and secret trysts until he ended the affair on April 11. A staff lieutenant attested to threats of murder from Hun Sen's wife, nurse Bun Rany, mother of seven children. Hun Sen alleged that his political enemy, Sam Rainsy, concocted the diary. The case remains unsolved. Buyers popularized the book, which police and plain-clothes police immediately seized from sale. Choreographer Sophiline Shapiro of Long Beach, California, immortalized the dancer in a ten-minute solo, "Glass Box."

Source

"Cambodia Nostalgia," cambodianostalgia.wixsite.com/khmermediaarchive/films.
Mydans, Seth. "A Strongman, a Slain Actress and a Tell-All Diary," *New York Times* (3 December 1999): A4.
"Respect Our Sovereignty," *Asiaweek* 25:47 (26 November 1999).
Saroeun, Bou, and Phelim Kyne. "Pelika's Murderers Remain Free Two Years Later," *Phnom Penh Post* (6 July 2001).
Sotheacheath, Chea. "Piseth Pelika: The Life and Death of a 'People's Princess,'" *Phnom Penh Post* (23 July 1999).
Willemyns, Alex, and Kim Chan. "Amid Latest Sex Scandal, Many Recall Piseth Pilika" (Phnom Penh) *Cambodia Daily* (28 March 2016).

Ham, Kyungah (1966–)
computer artist, ceramicist, weaver, photographer, videographer, sculptor
South Korea

A spirited textile art maven and social activist who breaches borders and taboos, Kyungah (also Kyung-ah) Ham promotes Korean unity by mapping out abstract pastel computer graphics for North Koreans to embroider by hand or machine. In girlhood, she participated in the anti–Communist retrieval of propaganda flyers distributed by helium balloons from North Korea and turned them in at school for a reward. She began her career with a degree from Seoul National University College of Fine Arts in 1989 and mounted a 1990 solo show in Seoul's Kwanhoon Gallery. She enrolled in 1992 at the Pratt Institute in Brooklyn, New York. An M.F.A. from the School of Visual Arts in New York City extended her range from acrylic on playful canvas portraits of North Korean defectors posed as the Mona Lisa to fabric, fringe, and silk fabrications of mushroom clouds over Hiroshima and Nagasaki.

The artist's imaginative projects include "Phantom Footsteps," a whimsical glimpse of failed ideologies that still haunt world citizens. Her exhibitions received notice in 1989 and traveled to Taipei, Berlin, Hamburg, Paris, Vienna, Tokyo, Bonn, Sydney, Kyoto, Seoul, Düsseldorf, Liverpool, Singapore, Guangzhou, and Aarhus, Denmark. One cluster of traditional delft blue Asian pottery topped by automatic weapons molded in ceramics illustrates the theme "Distorted Such Killing AKs." Another collection graces London's Victoria and Albert Museum with works that challenge an obdurate authority. For her promise as a conceptualist, she received

Korean culture and arts fellowships in 2001, 2002, and 2007; a residency in Tokyo in 2004; and the 2006 Korea Art Prize of 40 million won ($35,000). Her uplifting picture narratives and satires earned a 2008 Rockefeller Bellagio fellowship and invitations to the 2009 Asia Pacific Triennial in Brisbane, 2011 Tournai International Triennial in Belgium, 2012 Liverpool Biennial, 2012 Guangzhou Triennial, a 2013 residency in Hagen, Germany, and the 2016 Taipei Biennial.

Binational Motivation

The artist conceived a collaborative art project in 2008 after finding propaganda leaflets for former North Korean President Kim Jong-il at the gate of her parents' yard in Seoul. To Diana d'Arenberg, an interviewer for *Ocula* (Eyes) magazine, in July 2016, she explained, "I wanted to share this feeling by using my own artwork, developing imagery that represents me and is my avatar, in order to reach North Koreans and help them learn things" (d'Arenberg, 2016). By smuggling pixel schematics across the north-south boundary at the Demilitarized Zone via Chinese or Russian intermediaries and bribing guards, she relieved isolation and despair in anonymous North Korean women, who receive no news of global art. Stitching in secret, crafters completed the chromatic silk needlework on cotton backing in 1,600 hours or 67 days of meticulous sewing; four embroiderers could finish a panel as large as nine by twelve feet in 2,200 hours or 92 days.

Images of chandeliers epitomized resistance via shining a light on tyranny. Female embroiderers, producers of the age-old *chasu* (art stitchery) dating to Paleolithic seamstresses, wielded bone needles and animal hair from 45,000 BCE. The artisans reinterpreted Kyungah Ham's original pastels into explosions of metallic and Crayola hues. By distributing the designs to the five cities—Hiroshima, Kokura, Kyoto, Niigata, Yokohama—declared targets during the July–August 1945 Potsdam Conference dividing Korea, the artist delivered a tactile message. According to *Artnet News* critic Ben Davis, luxuriant patterns called to mind Winston Churchill at Buckingham Palace, Harry S. Truman in the White House, and Joseph Stalin in the Kremlin: "The chandeliers and their impending state of collapse evoke the grandiose rooms in which foreign powers decided Korea's fate, and suggest that the golden age of such influence has passed" (Davis, 2020).

Korean Camaraderie

Embedded in a maze of tints and shapes lay knowledge suppressed by the North Korean media about poverty, militarism, and faceless power structures. Kyungah Ham balanced grimmer themes with straightforward slogans of good will, such as "Greedy Is Good," "If You Are Like Me," "Are You Lonely Too?," "Banga Banga (Hello)," "Never Sleep," "Imagine," "Some Diorama," and the empathetic "I'm Sorry" and "Big Smile," a visual tease in the exhibit "Needling Whisper, Needle Country."

The lengthy wait for each embroidered piece ended with secret transport through China to the South Korean artist, whose contemporary portrayals illustrate the fragility and wonder of human lives. A blatant 2017 critique, "Persuasive Mr. K's Crude Humor with Swimming Glucosamine Like a Snake," carried anti-presidential slurs toward Kim Jong-un to a higher level. A write-up of her unique efforts earned acclaim on an internet posting: "The invisible story of the working process beyond the visible images of the works lends greater gravitas to her artistry" ("Ham," 2018).

At "What You See Is the Unseen," an exhibit in Pace Gallery, Hong Kong, in November 2018, Kyungah Ham mounted six geometric likenesses of shimmering chandeliers. Davis called the solo show "delegated handicraft" for its fulfillment by unknown volunteer needleworkers in a closed state (Davis, 2020). The panels defied North Korean art suppression by mounting elegant stitchery on a black background, a suggestion of the individual's furtive love of liberty in an overbearing totalitarian state. The interweaving of luminous filament saturated each light fixture with glints illustrating the power of individual minds to boost hope in a sterile environment one sparkle at a time. She spoke more openly to a divided Korea with the 2019 allegorical show "Negotiating Borders" in London and the 2021 display "Active Threads" in Düsseldorf. Looking to the future, she mused on the value of subversive creativity: "What if North and South Korea unify and North Korea's history disappears? I think my art can record their lives in case this happens. Almost like a time capsule" (Lee, 2016).

Source

d'Arenberg, Diana. "Interview," *Ocula* (28 July 2016).

Davis, Ben, "The Asia Society Triennial Has a Lot of the Same Problems Most Biennials Do. But It Also Crystallizes a New Trend in Art," *Artnet News* (25 November 2020).

"Ham Kyungah," www.pacegallery.com/exhibitions/ham-kyungah/, 2018.

Lee, Becky. "Understanding North Korea," *University Wire* (27 November 2016).

Segal, David. "An Artist Unites North and South Korea, Stitch by Stitch," *New York Times* (26 July 2018).

Nini, Noa (June 23, 1969–)
drummer, guitarist, composer, singer, poet
Israel

Awad, Mira (June 11, 1975–)
actor, singer, composer, guitarist
Israel

A culturally authentic combo from Israel, Mira Anwar Awad and Achinoam "Noa" Nini use music to boost universal coexistence and allay Arab-Israeli strife. Mira Awad was born one of three in Rameh, Galilee, on June 11, 1975, to Christian parents. Her Bulgarian mother, Snejanka Awad, manages a battered women's shelter.

Her Arab father, Anwar Awad, a physician, operates a free clinic and the Galilee Society for Health Research and Services. In girlhood, Mira joined a band, wrote verses, and planned a musical career despite everyday anti–Palestinian incidents of name calling and rock throwing.

Noa Nini claims a Jewish-Yemenite heritage and birth in Tel Aviv on June 23, 1969. The duo have contrasting educations: While intending to study medicine, Mira learned improvisational jazz, rock, blues, folk, and pop music at the Rimon School in Ramat HaSharon northeast of Tel Aviv and at workshops in Great Britain and Israel. Noa mastered American English and studied Hebrew and percussion at Manhattan's Ramaz High School. At age sixteen, she repatriated from New York to Israel in 1985 to serve the Israeli army as a troop entertainer.

CREATING A CAREER

By 1991, Mira Awad was soloing with the experimental band Samana (Face-to-Face) and pursued roles in the television comedy *Arab Labor* and the films *The Bubble, Forgiveness,* and *Lemon Tree.* She acted in stage productions of *The Return to Haifa* and at the Tel Aviv Opera House as Eliza Doolittle in a Hebrew translation of *My Fair Lady.* Simultaneously, Noa Nini enrolled at the Tel Aviv school and partnered with acoustic guitarist Gil Dor, her future accompanist.

Noa Nini's folk-based delivery appealed to a mainstream audience. With the September 1993 album *Achinoam Nini and Gil Dor,* she toured the U.S. with Hebrew and English songs. For a soundtrack from *Notre Dame de Paris* (Our Lady of Paris), she sang the part of the seductive gypsy dancer Esmeralda, a French Roma. More movie backup parts dubbed her voice to the films *Babel, GoldenEye,* and the Oscar winner *Life Is Beautiful.* In 1994, she sang "Ave Maria" at the Vatican for Pope John Paul II.

Contemporaneous with winning a bridge builder Crystal Award in Davos, Switzerland, Noa Nini followed with *Both Sides of the Sea* in 1998, a Western disc tinged with Middle Eastern scale, Hebrew lyrics, and emotional acuity. A favorite, "Keren Or" (Ray of Light) featured a melodic minor common to desert nomads. Her 2000 recording "Blue Touches Blue" earned critical acclaim in Germany and Italy for its original tune "Beautiful That Way." Her global audiences have gathered at the Israel Philharmonic Orchestra in Tel Aviv, Switzerland's annual July Montreux Jazz Festival on Lake Geneva, Paris supper clubs and the Olympia concert hall on Boulevard des Capucines. More concerts drew thousands to the Roman Colosseum, Barcelona's Palau de la Music Catalana opposite the Tosca Palace, Stockholm's August Water Festival, and New York's Avery Fisher Hall and Carnegie Hall.

CAMPAIGNING FOR PEACE

After the second intifada (Palestinian uprising) in July 2000, Noa Nini joined Mira Awad in 2001 in a duet of the John Lennon and Paul McCartney 1965 hit "We Can Work It Out." Mira also claimed an excellence rating in October 2001 from the Acco Festival at Acre, Israel, for starring in the play *Briah* (Creation), the story of

Spain's Golden Age poet Solomon Gabirol and his formation of a woman, a variation of Ovid's Pygmalion myth. For the United Nations Food and Agriculture Organization, in October 2003, Noa Nini accepted the title of Goodwill Ambassador for Israel. Freemasons selected her on April 3, 2005, as the first female recipient of the Galileo Galilei order promoting the scientific discoveries of a Florentine saint. In 2005–2006, she received the Gemona Commune Seminar Prize of €2,000 ($2,422.83), knighthood from the Italian Stella de la Republica (Star of the Republic), and the Sanremo Song Festival critics' plaudit for performing "Un Discorso in Generale" (Speech in General).

Noa Nini and Mira Awad's talent for languages enriches lyrics in Arabic, English, French, Galician, Hebrew, Italian, Neapolitan, Sardinian, Spanish, and Yemenite. For the May 12–16, 2009, Eurovision song contest in Moscow, the duo collaborated on the Arabic, Hebrew, and English words to "There Must Be Another Way." The union of an Israeli voice with a Palestinian singer to Gil Dor's guitar aroused petitions and warnings the preceding February from extremists, intellectuals, and artists. Nonetheless, the threesome performed during the Gaza Strip war to an audience of 100 million as an inducement to Middle East peace.

Mira Awad, the first Arab to represent Israel at the international competition, revealed to *New York Times* journalist Ethan Bonner, "I am so worried by the drift to the extremes on both the Israeli and Palestinian sides" (Bonner, 2009). She followed with the solo album *Bahlawan* (Acrobat), a collection of original compositions, a contract with Sony, and competition on the Israeli adaptation of *Dancing with the Stars.* In 2010, she refused to perform on Israel Independence Day because of death threats from conservative Jews and Arabs. In March 2015, Noa Nini met hecklers at the Ben-Gurion Airport charging "enemy of Israel" for her activism in the Center for Jewish-Arab Education in Israel, Peace Now, Ta'ayush (Living Together) Arab Jewish Partnership, and OneVoice. Similar opinions in 2016 declared Mira Awad a threat from within when she sang on television "Bahlawan," a description of walking the tightrope of discord with no safety net. When Noa Nini traveled to Krakow, Poland in July 2016, she received a hug from Pope Francis for proposing ongoing conciliation.

Source

Awad, Mira. "Palestinian Israelis Are Often Dismissed," (London) *Guardian* (10 March 2016).

Bonner, Ethan. "Musical Show of Unity Upsets Many in Israel," *New York Times* (24 February 2009).

Kraft, Dina. "Israeli Eurovision Singers Condemned as 'Traitors,'" (London) *Telegraph* (2 February 2000).

Satrapi, Marjane (November 22, 1969–)
graphic memoirist, novelist, illustrator, children's author, film director
Iran

Writer and illustrator Marjane "Marji" Satrapi jolted the graphic fiction genre with the autobiographical *Persepolis,* her memories of the ouster of Shah

Mohammad Reza Pahlavi, Iran's last king. He had already occupied the famed pea-
cock throne for twenty-eight years when she was born on November 22, 1969. A
native of Rasht, she claims as great grandfather the Persian emperor Ahmad Shah
of Tabriz, who ruled from 1909 to 1925, and Great Uncle Fereydoon, who was exe-
cuted. The author is the only child of a couturier, Taji Satrapi, and an engineer and
photographer, Ebi Satrapi, moderns who violated strict sharia law by employing a
maid, drinking wine, and driving a Cadillac. She grew up in Tehran in a Marx-
ist household and excelled at French and math. Her mother urged her to admire
independent role models physicist Marie Curie and novelist Simone de Beau-
voir. She viewed Ingmar Bergman's films and Pablo Picasso's drawings and read
Victorian romanticist Emily Brontë and the histories of Che Guevara and Leon
Trotsky.

At age ten, the preteen endured oppression by conservative Muslims, who
forced girls into veiling. In the text, she begs to accompany her parents to public pro-
tests, which evolve into massacres. The anti–Jewish bombing of the Baba-Levy house
next door and her friend Neda's death bring terrorism close to home, where Neda's
dismembered arm lies in the rubble. She chooses a paternal uncle, Anoosh Satrapi,
as a heroic survivor of political jailing and exile for espionage before his execution
as a Communist spy. His death shatters her belief in God. Her uncle Taher dies of
a heart attack while awaiting a forged passport to enable his escape to a European
hospital.

Migration to Europe

At the onset of the eight-year Iran-Iraq War, Marjane Satrapi's co-ed school
closed because of its secular attitude toward capitalism and the West. Bombing sent
the family to the basement. By 1983, the author's teen rebellion against modest dress
and music banning caused her parents to send her to the Lycée Français de Vienne
in Austria to study decorative arts. Before the departure, her paternal grandmother
urges her to be dignified and true to herself. Family discord with an old friend
resulted in her placement in November 1984 in a convent boarding house.

Concealing her nationality and drifting from residence to residence, Marjane
Satrapi fell into drug and sex habits and attempted suicide by taking pills with vodka
and slitting her wrists. She lived homeless for three months and contracted pneumo-
nia from exposure to the cold. In 1990, she was briefly wed to Reza Jabbari, an athlete
and fellow art student. She left home again to enroll at an Alsatian school, the Haute
Ecole des Arts Décoratifs (High School of Decorative Arts) in Strasbourg, France,
and began a freelance career in design. An introduction to Art Spiegelman's graphic
novel *Maus* altered her attitude toward cartooning.

Repatriated to Tehran, the graphic artist majored in media communication in
the north of the city at Islamic Azad University in June 1994 and mastered Farsi,
French, Swedish, English, German, and Italian. She briefly illustrated an economics

journal. In the essay "How Can One Be Persian?," she characterized Iranian countrymen as "pissed at the West" (Satrapi, 2006, 20). With second husband Mattias Ripa, a Swedish actor, she made their home in Paris and chose an art career over having children. Along with gardening and painting above her studio overlooking Montmartre and Sacre Coeur Basilica, she wrote the children's books *Sticheleien* (Teasing), *La Amistad de Un Oso* (A Bear's Friendship), *Les Premiers Jours* (The First Days), and *Ajdar*, the story of a girl who accepts the king's assignment to question Ajdar, an angry dragon living underground. She submitted articles to the *New Yorker*, *Elle*, *Women's Studies Quarterly*, *Variety*, *Virginia Quarterly Review*, *Literature of War*, *International Herald Tribune*, *Women's Review of Books*, *Time*, *Writing*, *Guardian*, *Read*, *Globe and Mail*, *Newsweek*, and *New York Times*.

Drama and Cinema

At age thirty-four, Marjane Satrapi published a graphic coming-of-age classic, the memoir *Persepolis*, a reflection on girlhood and family unity conflicted by the Islamic Revolution from January 7, 1978, to February 11, 1979. The sorrow of losing Uncle Marti Anoosh ended storytelling from a former prisoner. The protagonist declared, "Naturally, I loved him immediately" (Satrapi, 2003, 54). At his execution in November 1984, she rebelled, claiming "Nothing scared me anymore" (*ibid.*, 143). She fearlessly rebutted a religion teacher's lies about Islamic benevolence. As she prepared to board a plane out of Tehran, she saw a line of boys escaping the military draft. The blend of sardonic humor and coming to knowledge about religious fanaticism and persecution won an American Library Association Alex Award and a 2004 comic industry Harvey for an American adaptation of a foreign subject.

Persepolis won the Angoulême Coup de Coeur (Heartbeat) Award for best debut comic book and a second plaudit for top scenario. It was a *San Francisco Chronicle* and *Los Angeles Times* bestseller as well as a *Time* Magazine "Best Comix of the Year"; received a *New York Times* notable book citation; and was translated into twenty languages, including Romanian, Portuguese, Japanese, Greek, Polish, Galician, and Catalan. She produced *Persepolis 2*, a sequel about her return to Tehran that preceded the next family history, *Chicken with Plums*, set in November 1958 and winner of a 2005 prize from Angoulême, France. The story characterized the death of *tar* (lute) player, Nasser Ali Khan, based on her great uncle. Shortly after repatriation to Iran in 2005, her bawdy, subversive dialogue in *Embroideries* in 2006 introduced the Satrapi women and their private thoughts about the operations that restored lost virginity to a ruptured hymen. She progressed to a children's bedtime picture book, *Monsters Are Afraid of the Moon*, about a girl who snips the moon out of the sky to protect her room.

The author adapted *Persepolis* into an animated film premiering at the May 2007 Cannes Film Festival and starring Catherine Deneuve, Sean Penn, and Gena Rowlands. Despite hostility from Iran, in 2007, she became the first female nominee

for an Oscar and winner of a Los Angeles film critics citation for animation, a 2008 César and a Gat Perich International Humor Prize from Spain, nomination for a Golden Globe and an Animated Film Society's Annie Award, and third place in *Variety's* best animation of all time. Her film expertise resulted in honorary doctorates from the Katholieke Universiteit Leuven and Université catholique de Louvain in Belgium. In 2011, while writing a fairy tale, *The Sigh,* she filmed a second graphic work, *Chicken with Plums*. It opened at La Pate Theatre on Rue de Theatre in Paris, competed at the Venice International Film Festival, and gained another accolade—a best cartoon from the 2013 Noor Iranian Film Festival in Los Angeles.

In her forties, the author-director filmed the screen version of her 2012 original play *Gang of the Jotas,* starring her husband, Mattias Ripa. She followed with the noir comedy *The Voices* and *Radioactive,* a cinema biography of Marie Curie that debuted on Amazon Prime. The bio-cinema won a Golden Globe nomination for Satrapi's direction and an Evolution Mallorca International Film Festival vision prize. To survive the covid lockdown, she immediately began another film project. In September 2022, *Persepolis* appeared on the list of the 100 best animated films of all time.

Source

Foussianes, Chloe. "Interview," *Town and Country* (1 August 2020).

Naghibi, Nima, and Andrew O'Malley. "Marjane Satrapi's Persepolis," *a/b: Auto/Biography Studies* 35:2 (2020): 305–309.

Root, Robert L. "Interview," *Fourth Genre* 9:2 (Fall 2007): 147–157.

Satrapi, Marjane. "How Can One Be Persian?," *My Sister, Guard Your Veil; My Brother, Guard Your Eyes*. Boston: Beacon, 2006.

_____. *Persepolis*. Paris: L'Association, 2003.

_____. *Persepolis 2*. Paris: L'Association, 2004.

_____. "The Way Forward," https://www.talkhouse.com/the-way-forward-marjane-satrapi-is-getting-back-to-creativity-in-post-quarantine-paris/(27 July 2020).

12

1970s–1980s

Alem, Raja'a (1970–)
journalist, novelist, playwright, short story writer, biographer, children's author
Saudi Arabia

Alem, Shadia (1970–)
painter, illustrator
Saudi Arabia

A Saudi resident of Paris and the great-great-granddaughter of scholar Yusuf Alem, Raja'a Alem flourishes in classical Arabic dervish lore, storytelling, Koranic prophecies, history, shapeshifting, noir police procedurals, and Sufism set in early Mecca. She, twin sister Shadia, and brother Osama, natives of Mecca, were born to calligrapher Muhammad Alem in a traditional Muslim clan at a time when the Hejaz region of Saudi Arabia struggled to modernize. The trio grew up in the seven-story house of their grandfather Abd al-Lateef, the Sheik of the Zamzam Water Carriers from a holy well. Raja'a Alem reflected on less restrictive times when "our grandmothers rode on camels, donkeys, and horses, of course. They were a sort of knights in shining armor" (McDonough, 2008).

The Alem women looked forward to permission to own and drive vehicles. Their mother, a speaker of the Turkic language of Khazar, and Aunt Zubayda made and sold *keffiyehs* (pilgrim head coverings). Raja'a Alem concentrated childhood reading on ancient atlases and city water main charts stored in the basement and joined painter and photographer Shadia Alem in reading favorites by Hermann Hesse, Boris Pasternak, Jean-Paul Sartre, Georg Friedrich Hegel, and Immanuel Kant alongside Shakespeare, Greek myths, Latin and Russian classics, and Arthur Rimbaud's poetry. On school days, she risked disgrace for carrying European fiction in her book bag.

During the month of *hajj* (pilgrimage), Raja'a Alem dressed in white and joined seekers, male and female, in processing around the Kaa'ba, a sacred sanctuary. As a pre-teen, she observed the urban renewal of medieval Mecca and replacement of antique districts with high-rise apartments. A skilled embroiderer like her mother, she began writing in 1985 and profited from female influences of two grandmothers

and Aunt Aminah, who generated reverence for the Arabic past in oral narratives. With a bachelor's degree in English literature from King Abdulaziz University, Shadia pursued the arts while Raja'a began a writing career with essays submitted to the daily *Riyadh*. Presentation to Raja'a Alem of the 1991 Ibn Tufail Prize of the Spanish-Arabic Cultural Centre in Madrid presaged rapid critical notoriety that included the Al-Yamamah (The Dove) medal and a Khalda Saed prize for creativity.

SURE-FOOTED AUTHOR

At home in Jeddah on the Red Sea coast, Raja'a and Shadia founded the Cultural Club & Recreation Center to nurture imagination and literacy in Mecca's girls. After the positive response from readers to Raja'a's short story "The Boa" in the 1994 collection *Nahr Al-Hayawan* (The River of Life) and her 1995 novel *Tariq al-Harir* (The Silk Road), she began producing more short fiction, novels, biography, children's publications, and the experimental drama *The Final Death of the Actor* about a renegade doll named Zarqa. At age twenty-seven at a women's photographic workshop, she joined Shadia in posing for portraits of veiling and dressed in a Western wedding gown to satirize the concealment of women's faces.

A master of ambiguous storytelling, Raja'a Alem contributed the magic fantasy "One Thousand Braids and a Governess" to the anthology *Voices of Change,* which earned praise from *World Literature Today.* Distracted from the lurid seventeenth-century tale of sorcerers, genii, and scorpions in *Haza Haza Haza* (This, This, This), she published *Mawqid al-Tayr* (Bird Furnace). She and translator Tom McDonough completed the feverishly surreal parable *Fatma* (Nurse) in 2003, with Shadia's cover art and Raja'a's first text in English. The following year, when Raja'a Alem published *Sitr* (Veil), she toured New York. Toronto's International Author's Festival conferred on her the 2005 Arabic Women's Creative Writing Prize of $50,000 commemorating the establishment of UNESCO.

After relocating to Paris in 2006, Raja'a Alem entered a streamlined phase with *Thouqoub fi el-Dahr* (Holes in Eternity), *Al-raqs ala sinn al-Shouka* (Dance on the Fork), *Masra Ya Rageeb* (Rageeb the Egyptian), and *Khatem* (Ring), the story of an androgynous protagonist and the contrasting lives of aristocrats and slaves. The author's woman-centered writings viewed modern trends in the 2007 autobiographical novel *Sidi Wadhána* (Sir Death, original title of *My Thousand and & One Nights*), recipient of kudos from the *California Literary Review* and the 2008 Lebanese Literary Club Prize in Paris. Of the language choice, she explained, "I write in English in order to force myself to write more straightforwardly, to pull away from the ancient desert culture, to reach another world accessible to readers of English as well as Arabic" (McDonough, 2008). For clarity, she declined to reread her works in the Arabic original.

In 2010, Raja'a Alem's allegorical murder mystery *Tawq al-Hamam* (The Dove's Necklace) made her the first female to gain the International Prize for Arabic

Fiction. Speaking through observations of the Lane of Many Heads, the story chronicled the investigation of Detective Nasser al-Qahtani and the efforts of Aisha, a mortuary worker, to maintain ancient spirituality in Mecca among disempowered women. Dedicated to her grandfather's house, she regretted the razing of a residence to make a parking garage. According to critic Lori Feathers of *Words Without Borders*, the pro-woman theme questions gender taboos under which

> local women, even when completely covered, must remain inside their homes and away from doorways and windows so as not to be seen. Books other than the Qur'an and religious tracts are forbidden, as is any form of self-expression, like wearing nail polish, a colored hair ribbon, or a string of beads [Feathers, 2016].

World-Class Writer

The fiction writer experimented with a variety of subgenres, including the psychological novel *Hubba* (Happiness), which oscillates between reality and fantasy. She created a time traveler in the sci-fi thriller *Hyattombs Hyattombs,* the tale of Hyat, a Mecca native named "Life" who evaluates ancient mausoleums—a visual representation of Mecca's long history. The story captures her nightly reactions in embroidery based on myth and magic from past lives, a representation of the writer's contemplation of Arab women's history.

In fall 2018, Raja'a Alem contributed a story to the premiere issue of *ArabLit Quarterly* and in October, published *Sarab* (Mirage). The tale, which took over a decade to write, dramatized a cross-dressing rioter at Mecca's Grand Mosque in the historic November 1979 "fight to the death," which the author and her family witnessed from their windows (Alem, 2018, 1). She recalled, "The siege of the Grand Mosque was like a wound in the heart of my city, and all along I was going around with this wound but not daring to touch it, because it is so painful" (Ermelino, 2018). From June 4 to November 27, 2011, she and sister Shadia Alem stirred interest in the "Black Arch," a Saudi pavilion at the Venice 54 art biennale epitomizing coming to knowledge. The author's works, which appear in English, German, Spanish, Polish, French, and five other languages, earned her membership in PEN International. Her fiction intrigued fans by smashing stereotypes.

Source

Aghaei, Mehrdad. "Narrative Structure and Characterization in Raja Alem's *The Ring of Pigeons,'" Studies in Arabic Narratology* 1:2 (Spring & Summer, 2020): 120–142.

Alem, Raja'a. "All Kinds of Veils," web.archive.org/web/20061116075618/http://www.cbc.ca/ideas/features/arabian_style/veils.html

_____. *The Dove's Necklace.* Casablanca: Al Markaz Al-Thakafi Al-Arabi, 2011.

_____. *My Thousand & One Nights.* Syracuse, NY: Syracuse University Press, 2017.

_____. *Sarab.* Cairo: Hoopoe Fiction, 2018.

Ermelino, Louisa. "Open Book: A Siege, a Soldier, a Jihadi, a Love Story," *Publishers Weekly* (20 April 2018).

Feathers, Lori. "Raja Alem's *The Dove's Necklace," Words Without Borders* (March 2016).

McDonough, Tom. "Raja Alem," *BOMB 103* (1 April 2008).

Jansz, Frederica (1972–)
journalist, editor, orator
Sri Lanka

A brave Colombo native of Dutch-Sri Lankan lineage, Frederica Jansz accepted an editorship immediately after the assassination of her predecessor and maintained credible reportage despite threats to survival. A lover of travel throughout southern Asia, she graduated from Methodist College in 1987 and, at age twenty-two, from St. Thomas Aquinas University and College in communications and media. With the outbreak of the ethnic Sri Lankan civil war on July 23, 1983, she began combat reportage for Reuters's *Visnews,* an international news agency based in London. The bulk of battlefield assignments consisted of interviewing soldiers and Tamil Tiger guerrillas. While anchoring morning TV news, she investigated the state parliament. Her research narrowed in 1994 with a post at the newly formed English-language *Sunday Leader* as an independent newswoman.

The female reporter trained for the post under editor-in-chief and human rights author Lasantha Manilal Wickrematunge. She turned heads in chic outfits and high heels and often appeared on the BBC or Al Jazeera to report government malfeasance. For defense of media independence and three TV documentaries on domestic violence, she won the 2002 newspaperwoman of the year and a 2004 Journalist of the Year title from the Editor's Guild and Newspaper Publishers Society. She witnessed an era of on-site harassment and arson of printing presses in October 2005, the year that assassins killed fourteen news reporters. The core dissent charged that Prime Minister Mahinda Rajapaksa mishandled charitable donations to tsunami relief. Masked raiders burned the press on November 2007. On June 8, 2008, she pinpointed Defense Secretary Gotabhaya Rajapaksa as a predator of media freedom. Following the assassination near an army checkpoint of fifty-year-old Wickrematunge with a bullet to the head shot by a four-man gang on motorbikes on January 8, 2009, Frederica Jansz saw him die, yet chose to replace him.

PERILOUS POST

In the wake of sixty reporter ousters, death threats in the same handwriting as those targeting Wickrematunge three weeks earlier began arriving at the new executive editor's office. Her muckraking commentary at the end of the civil war in May 2009 classified criminal tendencies in Defense Secretary Gotabhaya Rajapaksa, the chief intimidator. Two years later, she angered him by disclosing that the Rajapaksa regime accepted a $9 million payoff from China. She later reported,

> In Rajapaksa's Sri Lanka … no Tamil could walk free. Thousands would be stopped at any given moment and if found to be Tamil, they were frisked and often arrested with no compunction—based entirely on their ethnicity [Jansz, 2017].

On October 20, 2009, an anonymous letter threatened to dismember her corpse. Her response was to reject a security detail or a flight out of Sri Lanka. The London *Guardian* presented her with the 2009 Index on Censorship Award. A year later, when she fielded rumors of a murder plot by the bureau of military intelligence in Karandeniya, she received the backing of Amnesty International, the Committee to Protect Journalists, and Reporters Without Borders, which defends media personnel from prison, persecution, and torture.

Within two months, Frederica Jansz testified to war crimes after President Mahinda Rajapaksa's rape, torture, and massacre of forty thousand Tamil rebels who sought to surrender by waving white flags. Among them, the Rev. Francis Joseph disappeared at the Vadduvaakal bridge on May 18, 2010. U.N. journalists and Human Rights Watch corroborated her claims. PEN International reported that, on July 8, 2012, Gotabaya Rajapaksa, the president's brother, shrieked into the telephone, "Your dirty fucking shit journalist!" (King, 2013). He promised to jail her for testifying against army commander Sarath Fonseka for war crimes. She riposted by publishing verbatim claims by the secretary that Sri Lankans wanted her dead. To Al Jazeera, she charged, "The ruling Rajapaksa clan led by President Mahinda Rajapaksa and his coterie of brothers have continued to persecute journalists" and blamed them for curtailing free speech (*ibid.*).

ESCAPE

While PEN International offered support, Frederica Jansz faced a new ploy: a Rajapaksa backer, sports director Asanga Seneviratne, used government funds to purchase 72 percent of *Iruresa,* a controversial Sinhalese weekly, and the *Sunday Leader,* Sri Lanka's last independent news source. Because the editor criticized the Rajapaksas' corruption, she incurred surveillance by men on motorbikes and menace to herself and two sons. She continued writing a treatise, *The Consequences of Another War in Sri Lanka*, issued in January 2012. After the impounding of her passport, she, like thirty other Sri Lankan journalists, sought asylum: she applied for a humanitarian visa to relocate to Australia. According to TamilNet, publisher Asanga Seneviratne fired her on September 21, 2012. Within days, Australian immigration rejected her request.

Aided by U.S. ambassador Michele Jeane Sison, Frederica Jansz moved to Seattle, Washington, to evade an arrest warrant, jail time, and further torment after nine attacks on her staff. As a political refugee, she enrolled her twenty-year-old son in Pierce College and her six-year-old in elementary school and began looking for jobs in public relations and marketing. She enrolled in finance and home design at the Seattle Art Institute in 2013 and took an editorship at the *Seattle Globalist,* for which she wrote warnings about tyrannic president Donald Trump and his corruption, nepotism, racism, and deportation of immigrants.

In March 2015, the former editor's speech "Sri Lanka's Deadly Profession"

informed the Oslo Freedom Forum on the ongoing danger to objective news reporters in Sri Lanka. She testified in five hundred court trials as an expert on political corruption in the Maldives, Pakistan, and Sri Lanka and assisted refugees in finding medical treatment while airing deplorable conditions in hospitals. In June 2016, she began a two-year stint as senior staff member of the Institute of Commonwealth Studies in London, where she exposed challenges to global freedom of the press. In October 2020, she achieved U.S. citizenship.

Source

Jansz, Frederica. "Frederica Jansz," https://oslofreedomforum.com/speakers/frederica-jansz/.
_____. "I Fled to the U.S. after My Government Threatened My Life," *Seattle Globalist* (15 February 2017).
_____. "Sri Lanka's Missing," Salem-News.com. http://www.salem-news.com/articles/february 192012/lanka-missing-fj.php.
King, Tim. "Interview," Salem-News.com, salem-news.com/articles/january152013/frederica-interview-tk.php.

Dastango, Fouzia (1975–)
storyteller
India

A professional *dastango* (storyteller), Fouzia is India's first female raconteur, an art dominated by men. A student of drama and stage and a devotee of Urdu, she spoke the laboring class brogue of Bhopal, Bareilly, and Sahranpur. She and her brother lived in a modest Old Delhi home supported by their father's repair of motorbikes in the walled city. At Pahari Bhojla (the citadel) off Turkman Gate, she and her cousins grew up in a shrinking milieu of street vendors calling their wares in the karkhandari folk dialect, the household idiom of their grandmothers. At the Sunday book market, one granny took Fouzia and her brother to spend a few coins on comic books and the monthly issue of *Khilona* (The Toy), a colloquial children's magazine offering cartoons, verse, myths, sagas, and jokes.

After enrolling in a K–12 Urdu school, Fouzia Dastango had to finance textbooks and supplies and fill her shelves with storybooks, fables, fantasy, detective stories, witch magic, and history. She began a career in New Delhi at grade seven as a language tutor each evening until ten o'clock. She presented readings in the old language, a Persianized form of Hindi, which dates to seventeenth-century guilds of butchers and bakers and their work-related vocabulary. In the eleventh grade, she witnessed a first stage play, *Rustom aur Sohrab* (Sohrab and Rustum), a father-son tragedy from Ferdowsi's Persian epic *Shahnameh* (The Book of Kings). With advanced degrees in sociology and school administration from Jamia Millia Islamia (National Muslim University) in Okhla on the Yamuna River, she fit a niche in curriculum planning and began supporting the household.

In Love with Narrative

In 2006 at Dayal Singh College, a coeducational wing of the University of Delhi on Lodhi Road, Fouzia Dastango observed a *dastangoi* (storytelling) stage show and began learning the Persian oral art. Dating to the 1200s, oral narrative entertained Persian and Mughal courtiers with tales of magic, wars, and journeys and episodes from *The Arabian Nights*. From lecturer at the State Council of Educational Research and Training, she progressed to stage storyteller at *Discovery* in Gurgaon in southwestern New Delhi and reviver of an 800-year-old art that once drew crowds of men to the stone steps of the Jama Maasjid mosque. The telling of the Amir Hamza Persian hero legends about Muhammad's uncle aided the spread of Islam during the reign of Emperor Akbar the Great, himself a master epic teller.

Lacking theatrical sets and props, Fouzia Dastango enchanted audiences with hand gestures, voice modulations, and expressive eye movements accentuated by white native garments and mat. Paired with historian Fazal Rashid of Bhopal and supported by her brother's enthusiasm, she mastered a repertoire of allegories and romances, including Gandhi's biography, the epics Mahabharata and Bhagavad Gita, Robert Browning's fool tale "The Pied Piper of Hamelin," "Kijari Gaye (Kijari's Journey)," and "Natkat Gadha (The Naughty Mule)." From age thirty-one, she made word pictures until eleven at night—an intense practice she maintained for over nine years. By 2014, she quit the salaried job in educational research. Two years later, after performing seventy shows, she gathered a performing troupe she called Dastango: The Storytellers. To secure a living wage, she began offering tellers' workshops at schools and universities and encouraging females to practice the art in villages and small neighborhoods.

For and About Women

Fouzia Dastango fosters feminist issues by choosing the stories "Akeela Khala (Akeela the Mole)," the popular "Ghummi Kababi (The Wandering Kebab Maker)," and "Nanhi Ki Naani (Tiny's Grandmother)," a satire of pompous religiosity and mistreatment of the poor. She focused on children in April 2017 with a fanciful program at the Oddbird Theatre south of New Delhi, which included Lewis Carroll's *Alice in Wonderland*. In November 2017, she added India's singing bird to the program—"Dastaan-e-Khusro (The Story of Khusro the Poet)," the father of Urdu literature and a medieval icon of Sufi mysticism. With sympathetic stories of Nautch girls (courtesans), she elevated the Indian sex worker by reminding her audience, "Those were the days when people would send their kids to learn etiquette and art from them. Our performance is an effort to give the audience a glimpse into the world of these fascinating women" (Rishabh, 2019)

For the 2020 Samanvay language festival featuring 150 writers at the India Habitat Centre opposite Lodhi Gardens, the teller of tales tapped nostalgia for

semi-literate patois. Her lectures focused in laborers and their speech—"Dilli ke dhobiyon ki zubaan (Delhi Washerwomen and Their Dialect)" and "Dilli ki nay-eeyon ki zubaan (The Dialect of Delhi Barbers)." Her amusing models promoted the female dialect of begamati zubaan (women's Urdu), the frank, sometimes earthy speech of female networks and relatives in purdah (seclusion) that discusses female sexuality, fertility, marriage, and friendship.

Source

"A Dastango Who Spins Tales for the Modern Age," (New Delhi) *Hindustani Times* (29 April 2017).

Minault, Gail. "Begamati Zuban: Women's Language and Culture in Nineteenth-Century Delhi," www.columbia.edu/itc/mealac/pritchett/00urdu/umraojan/txt_minault_begamatizaban.pdf (September 2008).

Nair, Malini. "In the Narrow Lanes of Old Delhi, a Unique and Flavoursome Dialect of Urdu Is Going Extinct," *Scroll.in* (5 February 2021).

Rishabh, Deb. "We Are Giving Back the Tawaifs the Izzat Which Is Their Due," *Calcutta Times* (6 March 2019).

Khedouri, Nancy Dinah Elly (1975–)
historian, essayist, orator
Bahrain

An interfaith advocate, scenarist, essayist, and lecturer, Nancy Dinah Elly Khedouri surveyed her country's religious background in *From Our Beginning to Present Day,* a chronicle of Sephardic Jewish-Bahraini history. The granddaughter of Naji Haron Cohen, a textile mogul, and Gurgia Rouben of Basra, Iraq, and only child of Claudate Cohen and Elly Joseph Khedouri, a hotelier and immigrant from Rio de Janeiro, Brazil, she was born in 1975. According to traveler and diarist Benjamin of Tudela, Spain, the Kadoories, one of Asia's wealthiest families, controlled Bahraini pearl trade from the 1100s. They constituted a three-generation Arab money-changing and mercantile clan based in Shanghai and Hong Kong. As operators of the Peninsula hotel chain, they promoted colonial trade with British protectorates and specialized in bed and kitchen linens and tablecloths imported from the U.K.

Convent-trained, Nancy Dinah Elly Khedouri graduated from the Sacred Heart School in 1991 with honors in English literature and impeccable recitations from Koran lessons taught by a Sudanese expert. At age eighteen, she earned certification of excellence in English, history, and economics at an international girl's boarding academy, North London's Mount School, and a bachelor of laws degree from the University of London, Bloomsbury, a cultural hub in the West End. In 1996, she replaced her deceased father as owner and managing director of J.E. Khedouri & Sons, which supplies beauty salons, hotels and motels, retail needs, cleaning services, the fishing industry, water treatment, and barcoding.

One of eighty National Assembly parliamentarians since 2010, assistant

secretary-general of the Shoura (upper house), and member of the Supreme Council for Women and Youth Affairs Committee, Nancy Dinah Elly Khedouri profited from the open-mindedness of King Hamad bin Isa Al-Khalifa (1999–) in diversifying society by ethnicity, faith, and gender. She fostered his plan to open a museum featuring religious tolerance and raised cash for a women's crisis center. Like her attorney cousin, U.S. ambassador Houda Ezra Ebrahim Nonoo, the first Jewish legate from any Arab nation, Nancy Dinah Elly Khedouri advocated for Middle Eastern Jews, the state of Israel, women's empowerment, and ecumenical collaboration and respect. She served on the Foreign Affairs, Defense, and National Security Committee to liberalize laws affecting families. To further diplomacy, on April 23–25, 2017, she attended the World Jewish Congress at its fifteenth plenary session at the New York Hilton Midtown, where six hundred delegates from ninety countries asserted remembrance of the Holocaust and promoted Middle East peace.

Bahrain's History

The historian avoided a stifling list of dates and names by composing a personalized survey of oral narratives, photos, and memories of a dynamic congregation. She noted the presence of Bahraini Jews since the early seventh century CE. Key to local commemoration, a small Semitic cemetery accepted Jewish remains from its beginning in 1873 to its last use in 2001. The graves abut burial sites for Christians and Muslims. She opened simply, "The Jews of Bahrain trace their roots back to the first Jewish people," a reference to "Saleh Eliyahou Yadgar and family, Iraqi tobacconists and textile traders who arrived mainly in the 1880s, under the reign of Shaikh Isa Bin Ali Al-Khalifa" (Naar, 2017). The historian noted that, while selling the long black women's abaya, they populated Bahrain "in search of a better quality of life.... There was never any segregation" (*ibid.*). The Yadgar perfumery, Halwachi confections, and Nonoo banking concerns began an influx of investors.

Inland from the Persian Gulf, the Khedouris settled in Manama on the Bahraini archipelago among Aramaic-speaking farmers, Shia and Sunni Muslims, Sikhs, Christians, Buddhists, Zoroastrians, and Hindus. The bulk of immigrant Jews—around 1,500—left the upper Middle East and India for the archipelago in the 1920s simultaneously with the founding in 1928 of the first all-female school in the Persian Gulf, Muharraq of Khadija Al Kubra Intermediate Girls School. A point of pride, in the 1930s, the local synagogue, the Sa'sa'ah Avenue Shul (synagogue) near Souq Bab al-Bahrain (Market Door of Bahrain), became the world's only Arab-Jewish worship center, a gathering place for 1,500 worshippers.

Valuing Tolerance

The writer treasured the unity of all Bahrainis and the sharing of ceremonies, sabbath gatherings, and circle dancing around the bimah (podium) to *Am Yisrael*

Chai (The People of Israel Live), a patriotic lyric. New arrivals opened a commercial link with their roots in the ancient pearl fisheries and added textiles, olive oil, tobacco, sweets, electronics, movies, travel, and banking to a business bonanza. Donations by the Cartier clan in 1935 underwrote services of a rabbi at Manama's new synagogue. On December 5, 1947, Muslim rioters assaulted members, vandalized and torched the synagogue, and looted shops on Al-Mutanabi Road in protest of the U.N. Partition Plan.

The historian analyzed how the setback accompanying the 1948 Arab-Israeli War fed anti-colonialism and anti-Semitism and spawned an exodus of some 60 percent of Jewish residents. Most made new lives in Haifa, Israel, Bombay, India, and the U.K. A greater emigration occurred after the riots following the June 5–10, 1967, Six-Day War, a spark to nationalism, displacement of Palestinians from the West Bank and Gaza, and expansion of the Jewish diaspora. By August 15, 1971, the British protectorate attained liberation from colonialism in time to profit from the oil boom and the financial clout of Bahrain over Beirut, Lebanon, the former banking nexus.

Artistic and Political Acumen

In an interview with journalist Ismaeel Naar of Dubai's *Al Arabiya*, Nancy Dinah Elly Khedouri praised early Jewish Bahrainis for their contributions to finance, health, diplomacy, education, and midwifery, spearheaded by birthing coach Um Jan. In 2008, King Al-Khalifa summoned expatriate Jews back to their homeland. Of national hospitality on "the island of a million palm trees," she asserted, "The Jews of Bahrain are proud to be Bahraini, proud to be Arab" (Slackman, 2009). In the spirit of global cooperation, she volunteered to head the Bahrain-Japan business consortium and served the Bahrain-British Business forum and national historical and archeological society. Her participation in the festival "Pray for Bahrain" yielded prayers in thirty languages. In 2010, she co-authored *Bahrain & Japan: Decades of Friendship.*

In her forties, Nancy Dinah Elly Khedouri became a familiar face in global headlines. In May 2014, she coordinated an Inter-Civilization Conference emphasizing service to humanity and advanced in 2015 to editor of publications of the Shura (Council), which she continued to serve until 2022. On March 4, 2016, she attended a U.N. conference in New York City on religious inclusion. As a special guest of the Sacred Heart School, she returned to her alma mater in June 2018. To stave off unemployment, in fall 2019, she challenged workers to take part in a career fair and train the jobless.

Nancy Dinah Elly Khedouri attested to Arab-Jewish pride by contributing ritual and cultural details to the thirteen episodes of *Umm Haroun* (Aaron's Mother) for Kuwaiti TV, which recognizes a Jewish-Kuwaiti nurse in the early 1940s. The series debuted in 2020 with glimpses of real people affected by the events arising from the 1948 Palestinian exodus at the height of Zionism. Well-rounded in the arts

and liberal global travel, she championed the role of Bahrain TV in returning local students from covid-ridden campuses. For National Day, she lectured on religious coexistence and led *This Is Bahrain,* a roadshow in Paris, Jerusalem, and Rome. Her speeches celebrated identity: "We feel more Bahraini than anything else" (Bew, 2009).

Source

Bew, Geoffrey. "Palestinian Crisis 'a Humanitarian Tragedy,'" (Manama, Bahrain) *Gulf Daily News* (23 January 2009).

"Jewish Bahrain Shura Council Member Supervised *Umm Haroun* Series, Contributed to Finest Details," *Bahrain Mirror* (6 May 2020).

Khedouri, Nancy Dinah Elly. *From Our Beginning to Present Day.* Manama, Bahrain: Al Manar Press, 2008.

_____. "Peace, Religious Pluralism, and Tolerance: A View from Bahrain," *IDEAS,* www.jewishideas.org/article/peace-religious-pluralism-and-tolerance-view-bahrain.

Naar, Ismaeel. "Retracing Bahrain's Jewish Contributions to Gulf Economics and Politics," (Dubai) *Al Arabiya* (26 February 2017).

Slackman, Michael. "In a Landscape of Tension, Bahrain Embraces Its Jews. All 36 of Them," *New York Times* (5 April 2009).

Roy, Anurupa (March 10, 1977–)
puppeteer, children's author
India

A third-generation master of India's dramaturgy, Anurupa Roy combines adroit use of percussion, masking, sculpting, toys, and found art costumes to energize leather and wood puppets, shadow figures on sticks, and miniature glove characters. Models of string and rod figures, such as the protagonist of her children's book *I Am a Puppet,* vary to ten meters tall, the focus of *Magic Blue.* A native of New Delhi, she was born on March 10, 1977, and began manipulating wood dolls in 1984. Her puppets imitated an amusement developed in southwest India at Maharashtra in the first century CE and, in the 1500s, amused the court of Amar Singh Rathod of Naguar in north central India. Largely self-taught, she gravitated to film and a puppet club while attending the K–12 curriculum of Sardar Patel Vidyalaya school before obtaining B.A. and M.A. degrees from Lady Shri Ram College, the women's wing of the University of Delhi.

Early in her career, Anurupa Roy educated herself at the Putul Yatra (Figure Journey) puppet festival in New Delhi on pre–Hindu traditions. She directed *The Flowering Tree,* a woman-centered folk myth, and *Her Voice,* a feminist segment of the Mahabharata, a Hindu epic. In 2001, she completed a degree in puppet drama from the Swedish Dramatiska Institutet for Film, T.V., Drama and Radio at the University of Stockholm, where she researched *bunraku,* a Japanese puppet drama introduced in Osaka in the 1500s. Following coaching at Neville Tranter's theater in Holland, in 2002, she amplified studies at La Scuola Della Guaratelle (School of Traditional Glove Puppetry) in Naples, Italy.

The designer mastered the anatomical arts of joint articulation, kinesthetics, and sensory expressions. Her figures imitated physical movement and gestures of living beings to recitations of oral lore. She developed some twenty-five presentations of parade, hand, stick, and truck puppets, who delighted rural viewers with satire and social mockery in *Bollywood Bandwagon*. Her philosophy stressed the value of stage programs for children and their demand for authenticity. She engineered the online show *Teelapur ka Rakshsha* (Raksha of Tilpur in northwestern India), a project organized through Helios Theatre, a *kulturbahnhof* (culture station) at Willy Brandt Platz in Hamm, west central Germany.

MULTIPLE ARTS

From age twenty-one, Anurupa Roy lent her knowledge of world folklore, stage direction, flexible design, papier-mâché, carving, martial arts, and anatomy to Katkatha (Wood Story) Puppet Arts Trust, an entertainment consortium that bases its style on bunraku. The stage shows enlighten all ages with allegory, clowning, and tales from the Mahabharata and Ramayana, the Puranas, an adaptation of Shakespeare's *Twelfth Night*, and, in 2010, *Anecdotes and Allegories* from the *Humayun-Nama*, a dynastic chronicle composed in Agra in 1557–1587 by Mughal biographer Gulbadan Banu Begum. In addition to casting real actors alongside jointed wood figures and learning the ancient dramas of *tolu bommalatam* (two-dimensional doeskin figures) on bamboo rods, she reclaimed shadow puppet storytelling from Persian and Mughal sources, first presented by nomadic troupes against a white cloth screen in Maharashtra, south central India, in the 1700s.

Oral lore rendered by some fifty figures took five years to construct and appealed to audiences throughout southeastern Asia and Europe. Into plots punctuated by rhythm on the *mridangam* (two-skinned drum), Anurupa Roy incorporated information about juvenile delinquency, women's rights, HIV and AIDS, global warming, and strife in Kashmir, Manipur, and Sri Lanka. For contrast, another musician played villains and demons on the *pavra* (mouth organ). The puppeteer jingled ankle bells and banged a wood plank on the floor for variances in tone and atmosphere. Of the blend of global trends, she explained, "Combining different arts and bringing in new subjects really helps to promote puppet theatre…. It brings a fresh lease of life to puppetry" (Adak, 2013).

The innovator judged the Bratislava 2003 International Children's Film Festival in Slovakia and traveled the world to festivals and workshops in Israel, Spain, South Africa, and Taiwan to observe professional strategies and the many modifications to the Ramayana. In 2004, she earned the Asia Pacific Performing Arts Fellowship for a collaborative training session in Bali. Two years later, an India Foundation for the Arts promoted *About Ram,* her interpretation of Ram's love for Sita, a goddess of purity. Every Sunday at the north central Indian village of Jaitpur, she introduces children to reference books about string marionettes, animation, acting, music, and

dance. The chosen stories appeal to imagination, such as *The Arabian Nights* and the Icelandic tale *Half a Kingdom,* an account of Signy's search for Prince Lini, heir to half a realm.

Enthusiasm Rewarded

Anurupa Roy accepted the 2007 Yuva Puraskar (Youth Award) of $342.57 to a youthful presenter of puppetry and folk shadow drama. Her set design for the Urdu film *Bol* (Speak) in 2012 shaped a surreal allegory about Saifi, an intersex child. For artistic integrity and advocacy of peace, health, and learning at school and juvenile homes, she won the 2016 Sangeet Kala Kiran Puraskar (Citation) for most promising theater artist and the 2017 Shankar Nag Theatre Award and the Mahindra Excellence in Theatre Award for Best Director and Best Production of the Mahabharata.

The performer reached out to the Pro Helvetia Swiss Arts Council in Zurich and as a lecturer on puppet activism at the University of California at Los Angeles. At age thirty-four, she researched jointed dolls at the French International de la Marionette in Charleville and the Deutsche Forum in Bochum, Germany. At the December 15–20, 2019, Serendipity Arts Festival in Goa, India, she demonstrated the elements of optics and movement. During the covid epidemic, her YouTube play "The Girl in the Pink Frock" posed questions of life, heroism, journeys, and death as they apply to a killer bat stalking an actual migrant family, illustrated with paper cut-outs. In September 2020 at Shiv Nadar University in Noida southeast of Delhi, she trained dance majors in dramatic pedagogy with professional marionettes as a segment of "Body, Gesture, and Performance."

See also Gulbadan Banu Begum (1523).

Source

Adak, Baishali. "A Lifetime of Puppetry," *Deccan Herald* (16 October 2013).
Bhardwaj, Lata, and Swati Chauhan. "Feminism in Mahabharata: The Unheard Voice of Draupadi," *IJRAR* 7:1 (February 2020): 441–446.
Nair, Malini. "Puppets Come to Life in These Masterly Hands," *The Hindu* (30 December 2017).
Roy, Anurupa. *The Girl in the Pink Frock* (film), www.youtube,com/watch?v=RycAYgtGblg.
_____. *I Am a Puppet.* MumbaiPratham Books, 2019.
Skipitares, Theodora. "A New Aesthetic in Indian Puppetry," *PAJ* 35:3 (September 2013): 61–68.
"A Story of Puppetry," https://junoontheatre.wordpress.com/2018/07/25/storyofpuppetry/ (25 July 2018).

Phengmixay, Bouakham (1979–)
silk weaver
Laos

A specialist in intricate, hand-woven Lao silk art, Bouakham "Boua" Phengmixay sets an example of non-mechanized industry for a Communist society. Encouraged by her grandmother at Laotian markets, she learned from a

woman-to-woman matrilineage that served wealthy urban families who ordered original luxury satins and twills. Beginning with woven borders at age seven, she labored for five years, concentrating on warp to become a top-ranked programmer by 1991. To master heirloom motifs stored on a template, she wove the way Laotians learned in 820 CE from Yunnan Chinese artisans. At age eighteen, she began doing garden work to earn a living.

Via cottage industry painstakingly crafted on a weaver's bench, Bouakham Phengmixay and other employees produced lucky infant swaddling and the funereal fabrics that indicated the social class of the deceased. Their simple wood frame anticipated the jacquard loom, bar coding, and computer programs. Artisanal intensity deformed spines and hands, but yielded cherished, exalted fabrics for court, palace, and altar decor. Some of the eco-fashion projects incorporated lion and elephant animism and shamanic Buddhist hands, butterflies, dragons, lotus, and peacocks. Weavers featured the mythic Naga guardian snake from plain or interlocking drawings and digital images chosen by customers. In an open-air atelier on a treadle loom, through complex mathematics, Bouakham Phengmixay advanced geometric chevrons, lanterns, and diamonds at little more than .79 inches per day or two feet per month. To enhance figure-ground brocades, she added a supplemental nylon weft to the surrounding weave. By raising and lowering a wooden weaving sword, she tightened the intertwine on each high-resolution project.

THE LAO SILK INDUSTRY

The Tai tribes of northeast Laos suffered the heaviest losses during 580,000 U.S. bombing missions. From 1964 to 1973, violence destroyed the fabric industry and forced traditional rural weavers of silk and cotton to migrate to Vientiane. In 1990, Bouakham Phengmixay joined the forty artisans at Carol Cassidy's workshop in a reclaimed mansion of French governor Paul Blanchard de la Brosse. For a job founded by a U.N. Development Program to upgrade women's opportunities, the weaver received training in a wide range of fiber techniques, some of which the manager imported from Mozambique, South Africa, Zambia, and Zimbabwe. The individual projects, completed at the rate of some thirty to fifty per month, ranged in price from $150 to $1,800. In contrast to the national income of less than $30 per month, she earned $2,400 a year along with health benefits, maternity leave, and pension, a family enhancement that stirred resentment in low-earning husbands. She taught a nine-year-old daughter contemporary versions of the craft in 2011, but stirred no enthusiasm for handicrafts in the younger generation.

At Lao Textiles in Vientiane on the Thai border, Bouakham Phengmixay smoothed raw fiber with a bamboo comb and slipped a matte silk skein from a wood shuttle across the heddles of the backstrap loom before tightening the layers with a horizontal batten or beater bar. Hand control contributed a subtle texture to the surface. The yellow, orange, and lavender chemical dyes from Germany mimicked the

lye and alum mordants and less stable colors of native clay, insects, betel nut, indigo, and saffron. The palette retained Laotian traditions that dated to the ninth century CE. By 2001, the workshop's output won a Preservation of Craft Award presented by Aid to Artisans and a Certificate of Excellence from UNESCO for integrity, durability, hue, and motif.

The weaver's silk designs developed into a fringed head scarf or shawl, sash or obi, tie, vest, skirt, sarong, tassel, or pouch; longer pieces yielded bedspreads, tablecloths, and pillow shams. More expansive lengths completed on a Swedish loom formed bespoke upholstery, window shades, wall hangings on rosewood racks, and drapes. Blending classic patterns with contemporary concepts, the works adorned residences and the fashion houses of Armani, Barney's, Burberry, Chanel, Dior, Donna Karen, Valentino, and Vuitton in Bangkok, Hong Kong, Japan, Kathmandu, London, Milan, Paris, Singapore, Sydney, and Tokyo. Exhibits of pure silk pieces intrigued viewers at museums and venues in the Carolinas, New York, Philadelphia, San Francisco, Washington, D.C., and Westport, Connecticut.

PRESERVING ASIAN ARTS

At a hand spinning wheel, the hand-crafter kept national heritage in mind as she wound indigenous silk thread from three thousand sericulture farms in north Laos into a clean hank. First, she boiled fibers to remove trash and irregularities and weighted the loom with rocks. Processing continued with time and temperature-controlled dyeing and weaving into pedal-loomed brocade (raised pattern), ikat (tie-dyed), and tapestry (interlocking weave) developed by the Tai Lui in the mountains of north Laos. The raw material came from Nam Bak, where a rural villager rolled fiber onto a yard-long bobbin. Employment of 485 families provided tuition for sanitary water systems, electricity, schooling, and medical care at the same time that silk production replaced opium poppies as a lucrative crop.

Bouakham Phengmixay remarked the modern techniques that threatened loom artistry: "In my village in the north, the incentive to produce silk is dying because of the imports from Vietnam" (Perlez, 2018). When fine supplies dwindled from caterpillars fed on mulberry leaves, she opted for Thai and coarser Vietnamese stock fed on cassava, but she rejected glossy, synthetic goods from China. The criteria for the best thread to make a one-of-a-kind piece called for hand-twisted skeins to create the variety needed for folk art.

Along with weaver Somphone Pasithiphone and ikat specialist Simone Khamdypaphanh, Bouakham Phengmixay demonstrated Lao textiles artistry on April 5–8, 2017, at Columbia University in New York City. Visitors observed technological control of warp and woof on the long vertical heddle system. On January 31, 2018, close-up photos of her hands trimming threads on a gold lozenge pattern illustrated an article in the *New York Times*. She continued demonstrating precise patterned

loom technology in 2018 at the National Silk Museum in Hangzhou, China, the eastern end of the Silk Road.

Source

Cassidy, Carol. "Weaving Cognition, Technology, Culture" (video), www.youtube.com/watch?v= zAeMZE5L=PLSYL9MBIDfZTTmg (5 June 2017).

Cumming-Bruce, Nick. "Lao Textiles," *International Herald Tribune* (7 May 2005).

Feng, Zhao, Sandra Sardjono, and Christopher Buckley, eds. *A World of Looms: Weaving Technology and Textile Arts.* Zhejang, China: Zhejang University Press, 2019.

Perlez, Jane. "The Woven Art of Laos," *New York Times* (31 January 2018).

Postrel, Virginia. *The Fabric of Civilization: How Textiles Made the World.* New York Basic Books, 2020.

Yee, Ma Su Zar Zar Htay (1979–)
harpist, textbook author
Myanmar

An ethnomusicologist and arts educator at Rangoon's National University of Arts and Culture, Ma Su Zar Zar Htay Yee became one of Myanmar's few professional performers. From age nine, she yearned to play the *saung* (also *sang gauk* or *sang auk*), the Burmese lap harp that often paired improvisations with vocals, *wa* (clappers), and *si* (timing bells) for royal courts. Arched in a gracefully shaped tree root like a long-necked goose, the wood frame with sixteen horizontal strings ordered tuning pegs on the upper half. It dated to sixth-century Bengal and became the king of instruments for the stark beauty of mica and gilt on red and black lacquered base.

Since 900 CE in the Pyu dynasty of central Burma, harp chamber melodies contributed to national identity. Plucked sounds flourished in the early 1700s in the pre–Konbaung era, Burma's pre-colonial dynasty, when they inspired China's Qing court music. Another era of saung presentations emerged from tourist demands for traditional Burmese music, for which Western classification provided modern notation in the 1900s. Unfortunately for art history, there exist scant archival details or performer biographies of classical musicians Alinka Kyaw Swa U Ba Than and Inlay U Myint Maung, the instrumentalist's favorites.

Ma Su Zar Zar Htay Yee's family feared that involvement in harp lessons would reduce her academic standing. By pressing her sister's teacher to tutor her as well, in 1988, she began a life-long immersion in harp music on a miniature instrument. Within two years, she soloed on Burma Broadcasting Service and Myanmar Radio and Television. Year after year, she medaled at state-sponsored competitions. She pursued music degrees from the National University of Arts and Culture and the Tokyo National University of Fine Arts and Music, where she joined the music guild Heaven's Artists and the faculty as an English teacher.

MUSICOLOGY TRAINING

In adulthood, despite a failing marriage, Ma Su Zar Zar Htay Yee reared a daughter and son, born five years apart. She offered pupils in-home trial lessons to establish a feel for harping and continued performing in New Delhi, India, in a 2006 music video shown at the Magic String Exhibition. Fluent in Burmese, Japanese, and English, in 2008, she relocated to Japan's Saitama University on Honshu on a prestigious Monbusho state scholarship to study improvisational techniques, which she compiled in Japanese. During a seven-year absence from home, she grieved to leave her children and ailing mother to a sister's care.

The harpist gained confidence and serenity from performing twenty-five recitals and organizing festivals throughout Japan. Her aesthetic lectures advocated the inclusion of music in the primary school core curriculum. As a performer in the Association of Southeast Asian Nations Caravan of Goodwill, in May 2011, she left Jakarta on complementary Thai and Air Asia flights. She played the lap instrument at charity concerts for March earthquake and tsunami victims stranded in rescue centers at Ishinomaki, Japan. Resettled in Myanmar, by 2015, she became the first Burmese citizen to earn a doctorate on a foreign campus and the first PhD in music. To elude sexism, she served the Royal Music Academy on Pyi Thar Yar Street in Rangoon's commercial district as traditional music director and violated custom by cutting her hair and playing for male audiences.

GLOBAL IDEALS

In a country lacking small venues, Ma Su Zar Zar Htay Yee rehearsed harp songs for rituals, funerals, and weddings. She teamed for duets with violinist Gabriel Lee, Vietnamese *dan bau* (zither) player Ngo Tra My of Hanoi, and singer, percussionist Pat Savage, who played *kyeezee* (finger bells) and bamboo clapper for the "Tay Shin Song." She aided national music training by teaching at Tokyo University, supervising coursework, and compiling a first-year textbook. She revered the effects on children because "Art inspires people to be gentle and softhearted" (Tin, 2017).

Because Ma Su Zar Zar Htay Yee's philosophy rejected prejudices toward one style or tradition, she joined the March 2018 Kuricorder & Friends project for a tour of Japan, Indonesia, Laos, Myanmar, and Thailand. Their schedule took them to Rangoon's National Museum, Hua Hin's Performing Arts Theater in Thailand, Vientiane's Plaza Hotel and Luang Prabang's Royal Ballet Theater in Laos, and Tokyo's Koto Cultural Center. In May 2019, she delivered a lecture "The Improvisational Techniques of Myanmar Music" characterizing the *Maha-Gita* (anthology of royal songs), a collection of Burmese, Mon, and Pyu hymns and dirges once inscribed on palm leaves around 1370 CE.

As a proponent of enlightened expression at the August 9, 2019, Music Society of Myanmar festival and workshops, the harpist asserted that "There is no

color, no Western nor Eastern in music. Music is complete purity" (*ibid.*). Her skill in Japanese aided the filming of Burmese author and orator Aung San Suu Kyi, a global champion of human rights. She continued an outreach during the 2020 covid epidemic and improvised a prelude on October 4, 2020, for a live streamed worship service at the Forest Hill Presbyterian Church in Cleveland Heights, Ohio.

See also Aung San Suu Kyi (1945).

Source

"Learn Traditional Burmese Harp," www.youtube.com/watch?v=ydssZFsEMe0.

Tin Htet Paing. "Harpist Hopes to Improve Music Education," *The* (Rangoon) *Irrawaddy News* (11 July 2017).

Yee, Ma Su Zar Zar Htay. "The Improvisational Techniques of Myanmar Music," *MURC 2019* (24 May 2019): 194.

Mak, Anaïs (1981–)
fashion designer
Hong Kong

Newcomer Asian couturier Anaïs Mak Chun-Ting of Jourden for Women has made a name for low-key lines in *kirakira* (glistening) fabrics that add a crystalline aura to dress-up silhouettes. A native of Hong Kong, she grew up in the city among girls who liked wearing designer brand outfits. They followed the lines of Christian Lacroix, Dries Van Noten, Issey Miyake, and Tom Ford featured at the Joyce Boutique, a trans-China retailer. She perused trends in *Vogue* and *Teen Vogue* and robbed her mother's closet of bodysuits and a Kenzo pleated costume in bronze taffeta. A quiet, shy dreamer, she imagined wardrobes for legendary characters. She identified her hometown as a stressful environment fueled by strivers exuding an unsettling electric vibe and a mania for shopping. In her teens, she wrote for *City Magazine* and chose Chanel, Miu Miu, Ryan Lo, and Miuccia Prada as glamour ideals. In 1999, she interned with Rem D. Koolhaas, a Dutch designer of radical shoes.

Anaïs Mak relocated to classes in haute couture at Studio Berçot at 29 Rue des Petites Écuries north of the Pompidou Centre in Paris, where she explored a culture grounded in heritage and a harmonized work-play atmosphere. In Europe's fashion heart, she clarified the aims of an Asian designer amid Western styles by focusing on unisex contours both casual and tailored with touches of smocking, embroidery, and gathers. With French mentoring, she graduated and, in 2012, founded the Anaïs Jourden label, an androgynous brand manufactured by Hong Kong tailors rather than in Chinese factories. Among the standard details she preferred long sleeves, casual flats, Mary Janes, and thigh-high leather boots. She collaborated with Nike on studded sneakers and in customizing with eye-catching fabrics Air Force Ones; the Swoosh bra; and the svelte Air Max 2090, a cushioned running shoe.

Two Worlds

The uniqueness of the designer's clothes derived from the two fashion hubs that spawned her—Hong Kong and Paris. She described a personalized control: "We do all the images, art direction, and graphic co-branding in-house" (Jiang, 2017). Her élan earned the approval of pop singer Ariana Grande and Hilary Tsui, co-owner of Liger boutiques, who bought out Anaïs Mak's unadvertised collection of twenty leather pieces. Anaïs Mak described the debut as an impulsive experiment by a couturier unfamiliar with deadlines, pricing, and delivery. She later developed savvy about commercial trends, discounts, and business downturns.

Anaïs Mak was one of twenty-six runner-ups for the 2014 LVMH (Louis Vuitton-Moët Hennessy) Young Fashion Designer Prize of €300,000 ($365,100) and was selected as an emerging artist and winner of *Vogue Italia*'s Who Is on Next, which awarded her a photo shoot. On January 28, 2017, during Chinese New Year, a premiere showing marked Paris Fashion Week. Photographers disclosed comfort and girlishness tinged with chic in the retro 1960s studded biker jacket and hot pants. The response earned a spot on *Forbes*'s 2017 "30 under 30" list. Media reports of Hong Kong street riots in fall and winter 2019 failed to dim her enthusiasm for the runway. She stressed that "the developments and changes on the television and radio have been a soundtrack to my work" (Agnew, 2019).

The Hong Kong clothier opened the atelier to innovations, including the juxtaposition of textured materials. She plotted a game app called "Colette Arcade," which allowed players to undress and dress models in modish apparel. For the autumn-to-winter showing at Hong Kong Centrestage on September 4–7, 2019, Jennifer Weil, fashion commentator for *Women's Wear Daily*, noted the designer's development of earlier concepts. Some seven thousand buyers from seventy-four countries energized the four-day event. On a darkened stage, Anaïs Mak advanced original looks with sex appeal, elegance, and maturity. Of the strategy, she explained, "I thought about our relationship with the earth and environment. Upcycling is also like a recollection of sentimental values" (Weil, 2020).

Professional Compromise

Because of obstacles caused by covid's lockdown of factories and stores, for the Paris spring-to-summer show in 2020, Anaïs Mak resorted to technology. She made a video featuring Hong Kong athletes, musicians, and photographers set in ruffly attire against local backdrops—"places I really love from my home. It's the most personal collection that I've ever done" (*ibid.*). She incorporated electronic razzle-dazzle on a giant screen—digitized avatar models in six original designs, a gesture to video game aficionados of the fantasy princess motif. She explained the need for an eclectic focus on femininity: "I think girls and their desires are more complex than we

understand…. During my creative process, my only inspiration is 'girls of the present'" (Jiang, 2017).

Twelve modernistic garments tended toward feminine—a polka dot coat-dress, dramatic head-to-toe black mantilla dotted with blue flowers, and drop-waist afternoon dresses, two with self-bow at the shoulder. Clothes mavens remarked on the self-confident air of women's wear made from lustrous artisanal fabrics—metallic foil print and knits, dotted lace, raw fleece, fishnet, plissé, transparent voile, and tulle with asymmetric hems. She experimented with silver appliqué on A-line skirts, such as the blue with black and solid white see-through tiered skirts topped with sedate double-breasted blazers and a revamping of the idea with bolero suits, two with bare-waisted tops. A cocktail dress in sheer Austrian drape grouped bows at shoulders and breast. A commanding gold metallic top above a black ruffled skirt produced the most stunning statement of her vision. The creations retailed at forty locations, notably, Alaric's Lafayette, Isetan, Lane Crawford, Le Bon Marche, Liger, and Shopbop. In September 2020, she progressed to experienced designer and judge of the year's Young Fashion Designers' Contest.

Source

Agnew, Charlotte. "Hong Kong Designer Anais Mak Turns the City's Energy into Fashion," *i-D* (26 September 2019).
"Anais Mak," *Forbes*, https://www.forbes.com/profile/anais-mak/?sh=657060d02d3d.
"Anais Mak," https://issuu.com/burda2/docs/prestige_40u40_nov_ebook/s/11285742.
Jiang, Ricky. "Coffee with Anais Mak," *China Daily* (12 September 2017).
Verner, Amy. "Anais Jourden," *Vogue Runway* (1 March 2020).
Weil, Jennifer. "Anais Jourden RTW Spring 2021," *Women's Wear Daily* (3 October 2020).

Buriad, Narantulga (October 9, 1981–)
cartoonist, painter, children's book illustrator, editor
Mongolia

A force for female equality, Mongolian graphic artist Narantulga Buriad collaborates with Asian feminists to invigorate women with direction and goal setting. The daughter of an artist, she was born on October 9, 1981. She gravitated toward her father's pencils and paper and, at age five, drew a camel, her first whole image. In elementary school, she envisioned becoming a ballet dancer. She advanced to puppetry training and made a pair of dancers fixed to wood laths. After graduating in 1998 from the Rajiv Gandhi Polytechnic College of Industry, in 2005, she founded Jangar (Warrior), a children's press for Monsudar Publishing that she served as editor-in-chief.

Narantulga Buriad studied realist painting at the Mongolian State University of Arts and Culture in Ulaanbaatar, her hometown. She mastered acrylics as the medium of children's book illustrations and graphics and became a reading activist and Mongolia's first art psychotherapist. For two years, she researched nursery-preschool education through imagery and visual stimuli for her debut

publication, *My First Book,* which she issued in 2009. A multihued poster pictured children climbing a book stack to access a flying horse, dragon, mice, and myriad fun ideas and adventures through reading.

A Varied Career

The painter's first showings in Italy featured "Ghosts and Get Away" on September 15, 2008, at a prestigious international book illustration competition in Chioggia, Italy, and "Cannonball Lady" in May 2010 at a global traveling exhibition opening in Venice. The following year, for Young Women for Change Mongolia, a campaign led by attorney Zolzaya Batkhuytag, Narantulga Buriad promoted a crusade for female sexual and reproductive rights. She illustrated *The Lily,* a comic book series on domestic violence picturing glimpses of women in varied states of life, including old and young, LGBT, and disabled. Her allegorical characters included Ms. Candidate, Ms. Curiosity, and Ms. Solution, contemporary figures depicting three facets of political participation. In a fictional scenario at a museum, the women question wall paintings limited to male citizens, beginning with Genghis Khan, twelfth-century founder of the Mongol Empire. The second comic book stressed gender abuse, a perplexing issue among Mongolians, who tend to conceal domestic strife from police. The third issue, "How to Have Great Sex," reached print on Valentine's Day 2018. Wry panels dramatized males as clueless manipulators of women who disregard demands upon wives for childcare and cooking.

The painter returned home at age thirty-one to freelance as a graphic artist and to exhibit "For the Nature Environment of Sea" and "Clouds Sound" at Art Space 976 in Ulaanbaatar in south central Mongolia. In 2013, she completed a masterwork, "Autumn of Love," a study of a couple in a protective grove of trees. At Treviso, Italy, on July 9, 2015, she contributed to *Imago Mundi* (World Image), a collection mounted by Luciano Benetton to recognize contemporary world artists. At the Fondazione Benetton Studi Ricerche (Benetton Foundation Research Studio) in Rome from November 20, 2015, to January 11, 2016, her paintings joined a kaleidoscope of miniature glimpses in a 10 cm. × 12 cm. (4 inch × 4.7 inch) format. The exhibition featured "Map of the New Art," the legacy of humankind. Her projects appeared in the "Unexplored Territory" section of a catalogue, *Mongolia: Spirit of the Gobi.*

Art and the Mind

After four years of psychology training, Narantulga Buriad completed a master's degree in 2016 at the National University of Mongolia by researching the stress of divorce of females. Currently an art therapist at the Aryamed Applied Neuroscience Center, a psychological rehabilitation hospital on Chinggis Avenue near the university, since October 2016, she has supported painting, mask making, and dance as forms of post-traumatic recovery and motivation. A proponent of Art Therapy Without

Borders, Inc., a humanitarian wellness effort founded in 2010, she experimented with mask making as a relief from frustration and phobias. By instructing participants in painting the inside and outside of face coverings, she elicited significant features that revealed obstacles to self-expression. At a presentation on "The Effectiveness of Art Therapy in Cancer Patients" in November 1–3, 2019, she shared techniques in Beijing at "Harmony in Diversity," the annual Art Therapy International Forum.

In January 2021, the art therapist launched a consultancy on psychiatric diagnostics. For survivors of catastrophes, she outlined therapeutic books for child witnesses to validate distressing memories. Her textbooks range from a math workbook for first through third grade to contoured fold-out storybooks that appeal with texture and color images of dogs, cats, bunnies, and ducklings. In addition to teaching art therapy to graduate students, she painted a series of children's portraits for the Narrative Drawing Intervention Institute picturing a boy and girl giving gifts and decorating a Christmas tree.

The artist's upbeat imagery optimizes children's curiosity and energy. Rosy-cheeked characters in folkloric coats, hats, and boots dramatize the video "Mother Earth, I Give You My Whole Heart." A set of winter-themed Christmas postcards presents the same children building a snowman and hauling a tree by pony cart. The painter connects the children and their dog with a yurt (a round felt or hide tent), camel, and reindeer, icons of an East Asian dwelling that suits a nomadic horse culture in the steppes. Her books *My Special Friend* and *Friends of the Little Ones* aimed solace at members of the Wheelchair Users Association, especially underserved Kazakhs of the Ural Mountains. While sharing her home with artist husband, son, daughter, and her mother, Narantulga Buriad continues schooling with an online course from Australia on medical art therapy, a means of comforting patients through wordless pictures.

Source

Cengel, Katya. "The Strong Women of Mongolia Are Ready to Take on the Patriarchy," *Nevada Public Radio* (27 September 2017).
"Harmony but Different: 2019 Art Therapy International Forum," *KKNews* (25 October 2019).
Mongolia. Spirit of the Gobi. Treviso, Italy: Fabrica, 2014.
"These Women Are Challenging Mongolia's Gender Norms with Comic Books," *The Lily*, www.thelily.com/these-women-are-challenging-mongolias-gender-norms-with-comic-books/(7 December 2017).

Zhang Xiaobai (December 19, 1982–)
cartoonist, painter
People's Republic of China

An award-winning manga aficionado and animator of video games, Zhang Xiaobai (also Jian Xiao Bai) achieved a gold medal for fantasy portraiture and graphics recapturing the scope and details of classic Chinese art. A native of Anshan, Liaoning, China, west of North Korea, she was born on December 19, 1982, after

the Cultural Revolution of 1966–1976. She graduated from Renmin University, a research facility in northwestern Beijing, with a background in graphics and illustration in delicate watercolor and calligraphy. For self-satisfaction, she began drawing vulnerable girl figures with swirling hair and wistful, downcast eyes.

From age nineteen, Zhang Xiaobai's hybrid exotica featured slender, long-haired females and naughty girls in the Western ideal of bulging breasts, bare navels, tiny waists, and unicorn horns, a symbol of uniqueness. She sketched noir amazons according to pop culture's taste for lurid crime. Dreamscapes ranged from straightforward nature to patterned geometrics and hints of Indian and Tibetan styling. A member of the Beijing Assassin Tattoo Organization, she followed new-generation experimenters from the 1960s who appealed to millennials and their love of animation and visual stimulus. She mastered subtle contrast in female transformations and lesbian representation suitable for media covers, wallpaper, iPhone backgrounds, Etsy gift purchases, posters, and online games.

FEMININE STYLE

Zhang Xiaobai surrounded richly expressive subjects with white-feathered birds and furs, wings, lotus pods, fish, poppies, and fruit blossoms, icons of fragility and evanescence. Characters displayed brushed Chinese characters on their flesh and brandished swords and shields, bow and arrows, daggers, and guns. The image in "Spirit of Aquamarine" placed a tender belle with pierced eyebrow behind curtains overdrawn with twining ivy and a red salamander, a suggestion of subversion with a hint of rebellion. Other surreal illustrations include "Gemini," "The Servant of the Underworld," "Qinghua" (Blue and White), "Luohuamengbi" (Falling Flower Dream Pen), "Jian Jia" (Undo), and "Space-Time Prisoner," a retro concept based on Victorian Gothic male dominators jailing women. The warrior cartoon "Light of Hope" reflected Star Wars episodes and gymnastics conventions.

For tattoo caricature with a fairy tale flavor, Zhang Xiaobai favored bare skin, long nails, and glamorous touches of Asian eye makeup, kabuki masks, bandeau tops, tassels, and samurai headdress underscoring pensive, inviting expressions. From world folklore, she chose Little-Red-Riding-Hood outfits and cloaks and Cinderella poses. At times, altered mirror images suggested guile similar in tone to the wicked stepmother in Walt Disney's *Snow White*. She placed buxom geishas pole dancing, belly dancing, and flaunting seductive corsets, bras, and garter belts or holding unfurled fans or opium pipes. Colors tended toward pink and rose, rouge red, violet-blue, and black against creamy white.

COMICS AND FILM

By her early twenties, Zhang Xiaobai had amassed a following for transgressive art that enraged by breaching moral standards. In 2006, her *manhua* (comic book)

Ni Hao (Hello) placed first in the Fifth China Manhua competition. After issuing a major work in French on March 5, 2010, she had original designs tattooed on her right thigh. She became the first Chinese woman animator to earn a top citation for Kana publishers in Paris in 2011 with *Si Loin et Si Proche* (So Far and So Close) at the Fourth International Manga showing. The Japanese Minister of Foreign Affairs Taro Aso funded the gold medal to promote non–Japanese animators.

Printed in Belgium, Zhang Xiaobai's drawings vied against 189 entries from thirty-nine lands, including Taiwan, China, Thailand, Belgium, France, Spain, and the U.S. They featured a wide-eyed, long-haired waif in contemporary dress posed among pigeons, birds suggesting innocence and purity. Online reviewer Faustine Lillaz declared the work similar in color and style to a tableau:

> Les dessins ont un rendu très réaliste, que ce soit à travers les personnages qui sont très expressifs et ont des tenues très actuelles ou bien à travers les décors de la Chine, ce qui donne une dimension plus vivante au récit.
>
> (The designs have a very realistic rendering, whether through expressive characters and current costume or through Chinese settings, which offer a livelier dynamic to the story [Lillaz, 2021].)

Readers found the high-quality designs fetching and the story droll. Critics lauded its expertise for a catchy originality and youthful strokes. The time travel plot placed Li Wei, a seventeen-year-old from the future, with his birth mother, Xiao Tian, a Beijing college freshman.

In her early thirties, Zhang Xiaobai issued a cult classic after Ginkgo Press collected her paintings for *Fantasy Tattoo Art* in September 2013. In 2015, she posted original paintings at the Royal Victoria Dock for the London MCM Comic Con, a multi-genre display of speculative fiction, sci-fi, fringe costuming events, video games, and other venues of pop culture. From medieval Song dynasty lore, *The Legend of the White Snake,* a 2019 television series adapted from a 1954 anime feature film, she created Qing She (Green Snake), a recumbent siren tattooed with coils covering her back. The plot depicted a millennium of separation between a demon and his human love. The 2019 Cannes Film Festival in Nice, France, featured the cartoon.

Source

"China's Good Girls Want Tattoos," *China File* (10 March 2015).

Lent, John A., and Xu Ying. "Chinese Women Cartoonists: A Brief, Generational Perspective," *Women's Manga in Asia and Beyond*. London: Palgrave Macmillan, 2019, 229–251.

Lillaz, Faustine. "Review: Si Loin et Si Proche," *Planete BD,* www.planetebd.com/manga/kana/si-loin-et-si-proche/-/9791.html, 2021.

Loo, Egan. "Xiao Bai's Si Loin et Si Proche Wins 4th Int'l Manga Award," *Anime News Network* (12 January 2011).

So, Stella. "Manga in Hong Kong," *Women's Manga in Asia and Beyond: Uniting Different Cultures and Identities* (2019): 353.

Zhang Xiaobai. *Cartoon Classic*. Shanghai: Fine Arts Publishing House, 2013.

_____. *Fantasy Tattoo Art*. Berkeley, CA: Ginkgo Press, 2013.

Bahlani, Safiya al (1986–)
graphic designer, embroiderer, painter, animator, portraitist
Oman

An Omani painter, graphic designer, and spokeswoman for rights of the disabled, Safiya al Bahlani advocates artistic outlets for the handicapped. Born without hands, she made a career of painting and embroidery using congenitally deformed legs, a deaf ear, and short arms. In 1989, Kenyan public health educator Sabah al Bahlani, a single mother and child advocate, adopted her from an Omani couple, a choice that drew social criticism in the Middle East. Because orphanages rejected impaired children, the birth mother had concealed the baby under a blanket. The adoptive mother ended the child's three-year stay at a hospital and took her to Sweden.

American grandparents welcomed the child with a doll and left her to paint in peace on their patio. Special shoes, eating utensils, and abstract painting eased daily obstacles and frustrations, such as cutting with scissors, designing henna motifs for hands, and dodging judgments of her afflictions. Sabah al Bahlani discouraged her daughter's tendency toward perfectionism and shared social service projects at the Dar Al Aman (House of Peace) residential center in Wadi Al Khoudh overlooking the Gulf of Oman, where Safiya painted children's rooms for the severely crippled.

From family encouragement, Safiya al Bahlani developed a philosophy of self-esteem: "I learnt something from my aunt, who was also adopted, that I am the chosen one unlike those who had no choice and are born in a family" (Vaidya, 2013). Sabah al Bahlani transported Safiya to the U.S. for speech therapy and limb surgery to ready her for a prosthetic right knee to improve mobility. From childhood storytelling, poetry, diary keeping, and sketching, by age fourteen, she chose art as a career, in part because of positive responses from experts.

Determination

Despite congenital phocomelia causing the shortening of limbs at birth and a learning dysfunction that prevented memorizing even daily prayers, Safiya al Bahlani attended classes with nondisabled pupils. To jeers at "hot dog hands," she poured daily anguish into healing arts (*ibid.*). Her pictures developed a love of Omani culture, architecture, flora, and dress. Human forms in pointillism developed patience with slow progress. She sketched a portrait for her mom on Mother's Day. On settling in Oman, she learned Arabic and barely passed science and math, but succeeded at music and swimming.

With a degree from the American International School of Muscat, Safiya al Bahlani pursued graphic design of logos, storage and packaging, greeting cards and envelopes, wedding favors, handbags, and travel posters. For the home, she created pillows, fabrics, tile, and dinnerware. She applied a broad spectrum of techniques and media in a palette of strong colors for such domestic items as Arabian mosaic,

antique doors and shutters, and water fountains. To heighten texture, she added tactile elements—collage, braid, fabric, and stitchery.

At age twenty-one, the designer relocated to Sound Audio and Engineering (SAE) Australian University in Jordan to learn computerized animation and film making and to volunteer for Sam Global University events and UNICEF projects. In February 2010 in a first solo art show, she exhibited thirty-eight acrylic and oil paintings that she completed during three years in Amman, Jordan. On return to Oman to find a job, in March 2011, she learned to use an iPad and mastered portrait art and Arabic calligraphy. With a fashion expert, she collected twenty dresses and forty paintings illustrating the oratory of Sultan Qaboos bin Said, the Middle East's longest serving leader. She adorned sharply detailed canvases with traditional weaving, burkas, head scarves, tassels and fringe, and embroidery.

An Outpouring of Art

The artist became a joiner. She collaborated with local and global participants in the March 2012 First International Art Symposium in Muscat and, in May, told her life story through childhood drawings at Pecha Kucha (chitchat), a storytelling platform on the Internet. At the Bank Muscat under the title "The Growing Journey," her output grew in December 2012 with seventy paintings on faces and hands, nature and animals, still life, and windows and entrances. On the halls of the Al Bandar (Harbor0 Hotel, she followed with another solo exhibition, "Beneath the Surface," in early April 2013 at Shangri-La's Barr al Jissah Resort and Spa on the Gulf of Oman, where she featured mixed media. For the sake of disadvantaged artists, on November 23, 2013, Safiya al Bahlani became Oman's only motivational speaker. She and her mother delivered a TEDx talk, "The Chosen: Sabah al Bahlani and Sofia al Bahlani at TEDx." The second TEDx appearance at Institute Le Rosy in Roseville, Switzerland, on January 25, 2014, stressed "Challenge Is Your Weapon."

At age thirty in January 2016, Safiya al Bahlani amassed "Flashback," a showing at the Centre Franco-Omanais in Muscat. Her story joined ten others in the anthologized biographies in Mohammed Mahfoodh Alardhi's *Arabs Unseen*. A continuing expression of self through art won a 2017 Al Mar'a (Not Visible) Excellence Award for Fine Arts. Her next solo, "Art Speaks," on May 1, 2017, included an oration at Virginia Commonwealth University Art School in Doha, Qatar. Her fostering of creativity won a national 2017 artist of the year title. At Safiya Arts Gallery in Muscat, she became a mainstream entrepreneur and shared space with jewelry designer Hannah al Lawati, who trained at the London College of Fashion. In 2018, Safiya al Bahlani broadened graphic works to designs for Studio Media Production Films and to brand transportation carts for Al Mouj (The Wave) Muscat with original motifs painted on the metal frames.

In mid–September 2019, Safiya al Bahlani opened a first-semester session at the Sultan's School and began teaching evening classes for infirm children. She

participated in the annual Muscat Festival and COMEX 2012, a promotion of computerized drawing. For the journalistic series "Arabian Stories," she reset her outlook to a single perspective: Embrace your real self, a restatement of Shakespeare's "To thine own self be true." Over November 19, 2020, her motivational speech concluded the five-day World Innovation Summit for Health (WISH). Extensive service to Omanis earned her an Inspiring Woman award.

Source

Al Bahlani, Safiya, and Sabah al Bahlani, "The Chosen," www.youtube.com/watch?v=BHkTiPEbUh8 (24 November 2013).

"Bank Muscat Hosts Safiya al Bahlani's Exhibition Celebrating Life Through Art," *Pressreader* (25 December 2012).

Fontes, Suzy. "Safiya Bahlani: Talent Unlimited," *Yumpu* (16 October 2012): 32–33.

"Paintings by Inspirational Artist Chosen to Brand the Walk Buggies," *Oman Observer* (4 September 2018).

"Safiya al Bahlani Launches a New Art Gallery in Muscat," *Oman Magazine* (19 November 2018).

Vaidya, Sunil K. "A Woman of Substance Inspires Omanis," (Dubai) *Gulf News* (6 April 2013).

Koh, Caryn (1987–)
muralist, print maker, writer
Malaysia

A former physician in Kuala Lumpur, Caryn Koh Hooi San abandoned medicine to pursue introspective public art. In childhood, she painted murals, a preface to serious study of physiological emotions reflected in faces, hands, and posture. In college, she joined a cheerleading squad and choreographed dance. During hospital residency, she felt stretched thin before entering a second year. Considering a switch to the pharmaceutical industry, she returned to school to take fine art courses at Dasein Art Academy, where she studied the connectedness of human tissue. Braving a variety of media and subjects, the self-taught artist preferred painting on walls or canvas.

From nostalgic memories of elementary school, Caryn Koh featured emotions in installation art, drawing, video, and murals. She acquired critical regard for the "Sekolah" (School) series—illustrations in colored pencil and pen of a girl in a blue pinafore. Koh identified the subject as a part of herself. She revealed to Dinesh Kuma Maganathan, an interviewer for the Kuala Lumpur *Star,* that art exorcised ghosts of the past. To journalist David Crossley of the *Ulverston Now,* she explained the focus on cerulean blue pencil as "introspective in nature, a selection of my past self and sometimes my present take on certain social or taboo matters" (Crossley, 2017, 21). She collaborated on a book, *Micro Malaysia,* illustrating the backstories of her works.

A 2015 arts calendar presented Caryn Koh's works "The Secret Hub," "Young Women Making Change," "ONE × ONE," "Be My Protector," "Secret Crack," "Potluck," and submissions to the Coffee Art Fringe Festival Asia Exhibition featuring

her expressive brush strokes. For "The End," commemorating a Malaysian airline crash on March 8, 2014, she aided two men at the Publika 321 Studio on a mural picturing the legend of the prayerful origami specialist who folded 1,001 paper cranes, some in the airline's colors. With "Nirvana," an acrylic on plywood view of a man swamped by butterflies, the artist imagined escapism into a dream world. Still close to home in 2016, she mounted wall art at the city's "Mapfest Mural," "Futurama," the Hin bus depot Mampu Art Market, "Shell's 125th Anniversary Mural," and the GAUL Collaborative, a shared effort to improve coverage of ancient Gaul on Wikipedia. The year's effort received a cash prize from the Tanjong Heritage Competition for printmaking. In September 2016, she won shortlisting in the Nandos Art Initiative "Your Art, Your Story."

To the UK

In Ulverston, north England, at the 2017 Lakes International Festival, Caryn Koh presented "Creation," a ghoulish anatomical study. More exhibits in home territory involved her on Kuala Lumpur's Times Square with the Asia Illustrations Collection and at Georgetown's Mampu Art Market II, a spur to collectors. A busy year intrigued audiences at "Primer for a Language," "Unsung Heroines," "Collective Individuals I & II," and "Space of Time," an international women's exchange in Georgetown, Penang. She won another shortlisting for the painting of the year by an emerging artist and an outstanding achievement citation in fine art from Dasein Art Academy, a private Malay college.

West of Newcastle, Caryn Koh and husband Jay moved to Dalton, England, to engage the UK energy and enthusiasm for art. She gained shortlisting for the Derwent Art Prize with works in pencil, colored pencil, and water-soluble and pastel chalk. For Artemis Art Gallery, in 2018, she soloed with the October 13 exhibit "As Deep as I Could Remember, as Far as I Could See," an examination of fluid emotions and memories. The collection—"Mirror," "Armour," "Fragments," "Cling," "Guard," "Linger"—pictured women in tentative poses drawn in acrylics, oils, graphite, charcoal, and textured paste. Focus on drying with towels and choosing garments, jewelry, shoes, and flowers contrasted the oil painting "Unspoken," a visual challenge from closed eyes and lower face obscured by two sets of hands, one male, one female. "Wanderer" offered a more intimate view of a woman on a bed beside a guitar, thong sandals, and a dead flower in a vase. The show incorporated "Right Here," a 13-minute video on immediacy.

Titikmerah (Red Dot), Caryn Koh's art collective, sponsored a 2019 one-woman showing of "Bonds," a perusal of mother-daughter relations based on the symbolic umbilical cord. At the Millennium Hotel in Taichung, Taiwan, the July 19, 2019, art show incorporated an exploration of human nature, a teasing revelation that hides more than it shows. In Manila, Philippines, she collaborated with Artemis Art on an annual expo and the September 2019 Xavier Art Fest in San Juan del Monte. She

returned to Kuala Lumpur to present "Sama Sama (Same, Same)," "Get-Go," "Small Small World," and "Nothing Gold Can Stay," the title of a Robert Frost poem.

New Home

The artist progressed to Mams Gallery in Swindon, England, in September 2020 and joined group exhibitions in London, Kuala Lumpur, and Georgetown. She displayed a timely collection—"Within These Walls," an oil on canvas study of solitude during the covid lockdown. The crowd scene "The Last Holiday" grouped fifteen somber faces pondering the epidemic. In contrast to terror of masked people in "More Than Me" and boredom and despair in "Breathe Easy," the montage "Birthday Party" featured cheer and fellowship.

Carolyn Koh also assimilated drollery into her perusal of disease. "Leap of Faith I, II" added men skydiving while clinging to masks. Her drawing "Reality I, II, III," a graphite and colored pencil sketch of a medical worker hanging fresh-washed masks on a clothesline, won a design contest in Petaling Jaya, Malaysia. Additional views in "Strength I, II" pictured flowers emerging from standard blue surgical masks. She provided murals for walls in Jakarta, Philippines, and England and painted "Fairy Tale," a dream sequence for Torrefarrera, Spain. A collaboration with artists from Canada, Holland, Russia, and Ukraine to cover mall containers refurbished dowdy neighborhoods with vivid wall paintings. One of the most expressive, "Art Spirit," outlined a female painter's splash of rainbow hues at Kinrara resort in Puchong, Malaysia. On March 10, 2021, at the Penang International Container Art Festival, her four-part mural posed a fisherman in a boat and a woman holding a braided rope, direct reference to the show theme "Connections."

Source

Crossley, David. "From Kuala Lumpur to Dalton," *Ulverston* (UK) *Now* (December 2017).
Koh, Caryn. *Micro Malaysians*. Petaling Jaya, Malaysia: Buku Fixi, 2017.
Maganathan, Dinesh Kuma. "UK-Based Artist Caryn Koh Faces Ghosts of the Past Through Her Art," (Kuala Lumpur) *Star* (24 October 2018).
Nathan, Yvonne T. "Exhibition an Effort to Bring Together Street and Academic Art," (Kuala Lumpur) *Star* (20 March 2015).
Tan, Jeremy. "Container Installations Breathe New Life to Urban Art in Penang," (Kuala Lumpur) *Star* (13 January 2020).

13

1990s–2000s

Zimbiri (1991–)
painter
Bhutan

The first female painter in Bhutan to mount a solo exhibition, Zimbiri grew up in an art-minded household at the capital of Thimphu. Drawing and designing, encouraged by her father Dasho Ugyen Tshechup, dominated girlhood activities. In high school, she varied her interests with reading, movies, boxing, and basketball. Influenced by grandparents Dochen Zam and Dasho Drukpen and aunt Sonam Choden Dorji, she developed ambitions beyond the reduced scope of her mother's domestic canvases. In a report to interviewer Shruti Kapur Malhotra of *Platform 15*, the artist explained, "It was just a series of steps that led me to where I am today" (Malhotra).

With majors in fine arts and economics from Wheaton College in Norton, Massachusetts, Zimbiri pursued Western modernism by studying galleries in Boston and New York and by experimenting with upscale materials. At age twenty-two in 2013, she returned to her native land, where the Wangchuck dynasty preserved and promoted mythical visualizations based on profound Vajrayana Buddhism, which celebrates human indestructibility, and the Tantric esoterica of medieval India and Tibet based on magic. She recalled, "As a child, I would visit temples with my parents in Bhutan. I would be fascinated with the beauty of the temples and the idols but was terrified of the masks" until she learned that they warded off evil (Dundoo, 2015).

THE SINGLE WOMAN ARTIST

Embracing Bhutanese culture for inspiration, the artist flourished in an andocentric art realm and relied on a limited supply of materials to document concepts of mortality and protection. She applied the *tsapa* strategy of piercing lines to transfer shapes to a wall for copying. Pictures covered minimalist hand-woven *rhay-shing* (canvas strung on wood) surfaces in charcoal outlines. For "Me-flower," she mastered traditional *saa-tshen* (earth paints) in black, gray, blue, and red, shades of fragility. In 2014, she completed "Mask," a grouping of contrasting faces on a red field.

She asserted, "We also need courage to let down our guard, take off our masks now and then to connect to others" (*ibid.*).

Before a Bhutanese audience, Zimbiri groups uncluttered canvases under a controlling theme, a modern concept that violates static male-only decorative artistry. Her reductive method uses brushes and scrubs to scour and texturize the paint. At the Royal Textile Academy in Thimphu, Bhutan, in August 2015 and at the Taj (Crown) Deccan Hotel in Hyderabad, India, the collection "Faces" surveyed social screening of the real self. Inspired by Shel Silverstain's ironic poem "Every Thing on It," she based eye variances and triangular teeth on the three-eyed Mahayana Mask revealing impermanence. A second series at the Royal Textile Academy, "Found Icons" reflected mundane objects modified for effect, as with "Swastika" (Maker of Goodness). She remained close to home from 2014 to 2016 with the series "Her Expression I–III."

Branching Out

A resident of a small country bordering Bangladesh, India, Nepal, and Tibet, Zimbiri grew venturesome. She toured Asia and spoke on art at the December 8, 2017, Live to Love Hong Kong retreat. She submitted canvases to a booth at the Serendipity Art Festival in Goa, India; "Her Expression IV" at Thimphu, Bhutan; and the India Art Fair New Delhi in February 2017. The next year, she posted "Lateral Thinking" in New Delhi in fall and "Nature Morte" at Art Basel Hong Kong, featuring the square canvas of "Tshey" (Limits), "Lok Lenn" (Reclaim), "Mitakpa" (Evanescence), and "Loksu" (Apart). For Delhi Contemporary Art Week in September 2019, somber, yet dramatic paintings "Boxed 1–3," "Head in the Clouds," "Jusohnu" (Change), "Amsu" (She), and "Nyep" (Diety) featured the gold and black stripes of tigers, complex myths of strength and danger within nature. Based on English poet William Blake's line "Tyger Tyger, burning bright, In the forests of the night," an intriguing foursome of tigers prowled roots that expanded over a rectangle, a paradox of freedom and imprisonment.

In August 2020, Zimbiri deviated from the biodiversity of "Tiger Skin" and assembled futuristic images in "The Future Is Not Fixed," shown at the Vadehra Art Gallery in New Delhi. "Bhitta (Portion), A Step into the Future" greeted audiences in 2020 at Tulikaa, Nepal. Beyond Asia, Zimbiri displayed "Art on a Postcard, All Bright" at Mayfair, London, in February 2020 and an October–November showing at the Grosvenor Gallery for London's East Asian Art Week. Balanced colors and fade-outs to black and white on the 24" × 24" canvas "Head in a Box" reiterated mythic reference to fierce, proud tigers, emblems of Bhutan's past.

Source

Dundoo, Sangeetha Devi. "People and Their Masks," *The Hindu* (19 December 2015).
"In Conversation with Bhutanese Contemporary Artist Zambiri," www.youtube.com/watch?v=-1Xi8-xuChDo (29 May 2016).

Malhotra, Shruti Kapur. "Platform 15," https://www.platform-mag.com/art/zimbiri.html.
Singanporia, Shahnaz. "40 Artists under the Age of 40," *Vogue India* (December 2018).

Subay, Haifa (1992–)
muralist, photographer
Yemen

Since the rebellious Arab Spring of December 2010, artist Haifa Subay abetted a burst of creativity to vivify women's abilities to curb riots and wars. Born in Dhamar City south of Yemen's capital, she taught herself to draw and paint after her mother, brother, and five other siblings moved to Sana'a in 1993. She gained confidence with populist topics in oils and acrylic and joined a female art consortium. She contributed to protest art and graffiti on blank walls in Sana'a through the Silent Victims campaign—images of a humanitarian crisis she drew beginning August 17, 2017. The effort to elevate art as communication within ordinary life enraged conservative Muslims, who threatened exiling and death to vocal females.

Like an older brother, award-winning graphic artist Murad Subay, who submitted public art to the capital city in 2011 with portraits of forcibly disappeared citizens, Haifa Subay focused on real human victims whom the world media ignored. On the busiest streets, she outlined a pacifist crusade in daylight and signed her paintings. Her brush shaped mesmerizing destruction of city infrastructure. In rubber gloves extending plastic cups of paint, she invited pedestrians, journalists, soldiers, and onlookers to express nonverbal opposition. On the internet and on city sites still undamaged by war, the "Dove Campaign" depicted a demand for peace with a black poster centered with a white dove and olive branch under the slogan "Peace for Yemen."

When the Yemeni civil war erupted on September 16, 2014, Haifa Subay at first thought it would end in months. When it progressed to years of hours-on-end bombing, she lost her job in 2016 at an import-export business and began shaping scenes of warfare. In March 2017, she blacked in the silhouettes of two men armed with automatic rifles. The ominous weapons suggest the involvement of Saudi and Iranian insurgents and the U.S. sale of tanks, drones, and helicopters to Arabia. A mother-and-son pose pitied a refugee with a bundle on her head and the title "My Nationality Is Displaced." In obedience to repressive sharia (scriptural) law, the artist covered all females head to toe.

Within three years, the conflict caused 60,600 military deaths and 7,000 civilian losses and forced the flight of 4.3 million Yemenis, half consisting of underage women and girls. Another mural projected a globe behind a veiled face pinched, blank-eyed, and elongated like the arresting portraits of Amedeo Modigliani. A barefoot girl under the heading "Peace Finder" stoops to contemplate a cluster of birds while a barefoot boy watches her. A photo-like double portrait of a boy, one view frowning, one smiling, illustrated "The Rest Days of the Year" [sic] with the

frown on 364 days and the smile on a single date, Universal Children's Day every November 20.

Champion of the Weak

On August 17, 2017, the muralist resumed city street art alone, then accepted aid from children and women. Together, they examined Yemeni culture from the perspective of the most vulnerable, including a red-eyed face portraying "Childhood of Pain." She declared her work inclusive of all classes: "My illustrations of war touch the hearts of every Yemeni" (Ahmado, 2019). On March 1, 2018, she added a sixth panel, "Just a Leg," her famed image of a boy holding his detached limb protruding from a wrapped package. The loss occurred in a landmine explosion, a common victimizer of children. She stressed the accusation of stark, bold eyes and unflinching countenance, which seem to blame indiscriminate air strikes for wrecking the economy and countryside and ending education for two million pupils.

Haifa Subay made pointed connections between individual sufferings and the nation's decline as a whole. For the title "War Rhythm," a glimpse of an open-mouthed child in pain from July 19, 2018, inflated the suffering by adding a map and sketch of battlefields on his chest. On August 3, 2018, she esteemed International Women's Day with a veiled woman hiding her mouth and eyes with her hands, a pose suggesting the silencing and displacement of Yemeni females in a patriarchal society. The face speaks for those forced to sacrifice meals, stay indoors out of sight, and drop out of school and marry in early childhood.

Haifa Subay's steely art received global support from Reuters, BBC, and Forever Muslim and an interview in February 2019 with Al-Arabi television. Reports exalted her empowerment through mercy devoid of politics. Child soldiery, hunger, water shortages, child marriage, spousal abuse, landmines, and disappearance extended city analyses in Singapore. Murals and photos built good will with a photo of a school reduced to rubble by war. The survivors study textbooks while sitting cross-legged in wreckage. She stated to Kurdish interviewer Nisan Ahmado on April 17, 2019, "I wanted to send a message of peace, a plea to stop the fighting and alleviate the suffering caused by the ongoing war" (Ahmado, 2019).

War Themes

While galleries, museums, and other cultural venues disappeared, Haifa Subay continued to paint walls despite death threats, media censorship, tool confiscation, and panel defacement. After a month's urging, she negotiated a permit for the capital city's 2019 "Open Day of Arts." Working in Aden proved less harassing to painters who brandished the word "peace." Nine of her murals appeared in the exhibit "War and Humans" at the Singapore Biennale on November 22, 2019, exhibiting

more than seventy world artists. Her sketch of an enlarged bullet hole referred to a real event—a shell that pierced her window.

At the Singapore National Gallery, a sketched featured a child curled in a fetal position, a refugee with backpack picturing a bombed school, and, perhaps her most poignant, a large-eyed baby afflicted with kwashiorkor entitled "Child of Bones." An historic allusion, "The Sheba Doves" referred to destruction of the eleventh-century-BCE temple of Sheba's queen, which bombardment razed. Overhead, doves fluttered in a vain attempt to restore sanity and hope. In late 2019 in Naoshima, Japan, she vied for the twelfth Benesse Prize for art. The winner who experimented with style and critical spirit received three million Japanese yen ($27,631.82).

In April 2020 in the exhibit "Together We Can Defeat It," Haifa Subay symbolized the world epidemic of coronavirus with a red microbe forming a sphere with the Western Hemisphere. In a year when the muralist faced maltreatment by city authorities and quarantining at home, she contributed a cover to *Women Make Peace.* A riveting image of a woman flexing an arm muscle opposite a traffic symbol displayed a red slash over a circle, a perspective that carried protest beyond words. On a wall in Aden City, in the sixth month of pregnancy, she launched "Women and War." The exhibit pictured late-term expectant mothers on a pocked wall background and the slogan, "We will survive together." Now based in Aden, she offset the unidentified figures with photos of herself holding her newborn daughter, a collection intended to convert negative energy to positive.

Source

Ahmado, Nisan. "Yemeni Artist's Murals Depict Costs of War," *Voice of America* (17 April 2019).
Humran, Alya Abdulhakim. "Revolution Is Female," *Al Raida*, 44:1 (2020): 29–36.
Johnston, Patrick. "Street Artist in Yemen Remembers Casualties of War," *Reuters* (1 March 2018).
McDonald, John. "Lure of Ideas over Mass Appeal at 2019 Singapore Biennale," *Sydney Morning Herald* (13 December 2019).
Subay, Haifa. "Women Make Peace," *Singapore Biennale,* www.singaporebiennale .org/art/hai-fasubay, 2019.

Baibosynova, Uljan (fl. 2000–2020)
chanter, storyteller, dombra player
Kazakhstan

Toulepova, Chamchat (fl. 2000–2020)
chanter, storyteller, dombra player
Kazakhstan

Taking her cue from nomadic Kyrgyz *jyrau* (also *zhyrau*, bards or prophets) of the Kazakh steppes in the 1400s, Chamchat Toulepova became the nation's first

live female singer-storyteller, soloist on the *dombra* (or dombyra), a long-necked fretted Kazakh lute, and genealogist of historic figures in guttural *a cappella* verse. Performers mastered the eight-syllable verse line of epics developed from funerary laments and the ninth-century-BCE motifs of Homer's *Odyssey*. Chanters considered the art of declamation a sacred duty. Presentations of ancestral lore from agrarian and non-sedentary tribes exaggerated posture, facial expressions, and eye movements from a sober dispenser of wisdom and advice to the khan and his people.

Chamchat Toulepova passed to the next generation a fount of medieval oral literature such as the Islamic miracle story "Five Ships," the seventh-century Arabo-Persian love saga *Layla and Majnun,* the ninth-century marine epic of *Manas and Alpamysh,* and the classic melodies "Syunsu (The Bride's Lament)" and "Ak Kain (White Birch)." She excelled at romances and wartime tales, epic, shamanic *baqsy* (divination or foretelling songs), didactic and lyric verse, and family trees filling out a tribal unit. The pioneer bard founded a school for female Kazakh narrative and epic reciters, an improvement on self-education by transient Muslim poets reared in rural areas. She inspired a female disciple, mezzo Uljan Baibosynova (also Ulzhan Baybussinova) of Almaty in southeastern Kazakhstan, who learned from her grandparents' music, a critical determiner of central Asian identity.

A New Star

With parental encouragement, Uljan Baibosynova teaches chest-tone epic chant to the strumming and pluck of the dombra. Along with the wood juice harp (or jaw harp) and *gijak* (upright bowed fiddle), performances feature authentic gold and red Kazakh costumes and conical hats with long earflaps. For "Music and Voices of Central Asia," a radio presentation from a Kabul station in 2005, she studied enunciation, accents, and asymmetric rhythm with Bidas agha Rüstembekov, a male teacher at Qyzylorda in central Kazakhstan. A master chanter of *A Journey to Epic Qyzylorda,* he was a pupil of his father Rüstembek and grandsire Jienbai, both *jyraus* in the patrilineal tradition. Bidas's mother blessed him and declared, "The spirit and spiritual power of your grandfather Jienbai has been passed to you. Congratulations! For you, the path to becoming a jyrau is open" (Levin, 2016, 77). Abjuring the man-to-man transference of song, he passed his knowledge to Uljan.

After performing in the stage production of Euripides's *Children of Heracles,* Uljan Baibosynova spread authentic Kazakh entertainment throughout western Europe. She joined a troupe of dancers and singers on September 25, 2004, for a five-week tour from Geneva to London, Essen, Oslo, Turin, and Dijon. She also sang a repertoire at the Asiatic Museum in Nice, France, on May 19, 2007, for the stage show "Nocturnes d'Asie sur les Routes de la Soie" (Asian Night Songs of the Silk Road). A critic commented that the "timbre rugueux de Uljan Baibosynova convient à merveille au chant épique kazakh (the rough quality of Uljan Baibosynova becomes a marvel of Kazakh epic chant)" ("Nice," 2007).

CRITICAL PRAISE

Another tour, the Silk Road Festival funded by the Aga Khan Development Network from September 23 to October 24, 2009, took the chanter and sixteen fellow performers to Britain, Hong Kong, Syria, and eleven U.S. cities to sing the stage show "Spiritual Sounds of Central Asia: Nomads, Mystics and Troubadours." The evocative verse rated high praise for chest tone from the London *Independent.* Her concert at the Reformed Evangelical Church in Ascona, Switzerland, in 2014, reduced output to a near drone, a contrast to more vigorous banquet tunes in 2020. In April 2018, her photo graced the program for the Al Kamandijati Festival of global entertainers in Jerusalem.

As a folk mystic, in May 14–23, 2009, Uljan's mentor, Chamchat Toulepova, joined the Festival des Theatres de l'Est de l'Europe (Festival of Eastern European Theaters) in Nancy, France, where organizers amassed singing prophets from Afghanistan, Azerbaijan, Georgia, Iran, Israel, Kazakhstan, and Uzbekistan. Over February 22–24, 2013, she sang Sufi poetry in Jodhpur, India, at the World Sufi Spirit Festival, held at Fort Mehrangarh. In Uzbekistan from Qaraqalpakstan on the Aral Sea, additional females—Ziada (or Ziyada) Sheripova and Injegul Saburova, chanters and players of the two-string *dutar* (central Asian lute) and *ghirjek* (spike fiddle)—contributed to the growing ranks of women epic reciters.

Source

Church, Michael. "Voices of Central Asia, Coliseum, London," *Independent* (17 September 2011).

Leshchinskiy, Gelya. "Folk Music Once Again Thrives in Central Asia and the Caucasus," (30 November 2007), *Eurasianet,* eurasianet.org/folk-music-once-again-thrives-in-central-asia-and-the-caucasus.

Levin, Theodore, Saida Daukeyeva, and Elmira Kochumkulova, eds. *The Music of Central Asia.* Bloomington: Indiana University Press, 2016.

"Music of Central Asia Vol. 4: Bardic Divas: Women's Voices in Central Asia," *Vimeo,* vimeo.com/groups/667604/videos/58355278.

"Nice Musée des Arts asiatiques Nocturnes d'Asie Nuit des Musées," *Nice Rendez-Vous* (18 Mai 2007).

Vita, Evelyn Birge, and Marilyn Lawrence. "Medieval Storytelling and Analogous Oral Traditions Today: Two Digital Databases," *Oral Tradition* 28:2 (October 2013).

Zhussipbek, Galym, et al. "Foundations of Inclusive Kazakh Religious Identity," *European Journal of Science and Theology* 13:5 (October 2017): 143–154.

Chronology of Asian
Women's Art

2640 BCE Leizu, the legendary wife of the Yellow Emperor of China, invented the reeling of thread from cocoons and the weaving of silk court costumes.

2265 BCE Akkadian princess Enheduanna of Ur became the world's first known poet and hymnographer.

1900 BCE Lamassi of Assur flourished at weaving fabric for the Assyrian caravan trade with Kanes, Anatolia.

1274 BCE Puduhepa advanced to Hittite queen and chief correspondent and liturgist for the Anatolian royal court to Egyptian Pharaoh Ramses II.

1070 BCE The Israelite prophet and poet Deborah led King Barak to victory over the oppressive Canaanites and celebrated with a triumphal song.

33 BCE Wang Zhaojun, a legendary Chinese calligrapher, painter, and lute player, comforted herself by plucking the *pipa* on her way to a political marriage to a Hun nomad on the Eurasian steppes.

29 CE The Judaean dancer Salome performed before Tetrarch Herod Antipas and his guests with the head of John the Baptist on a salver at the Machaerus Palace near the Dead Sea.

313 Miwnay, a migrant wife and mother from Samarkand to Dunhuang, China, composed stylishly polite Sogdian letters of desperation to her mother and absent husband, enclosing letters from Miwnay's daughter Shayn.

504 Syrian child actor and dancer Theodora, friend of the stage performers Antonina and Macedonia, toured the Mediterranean and performed in Constantinople, Alexandria, and Antioch, Turkey before becoming Byzantium's empress.

634 An early Muslim, Syrian poet Khawla bint al-Azwar led women at the Battle of Adnajin and aroused their courage by quoting epic verse as war cries.

699 After the death of lover Tawba al-Humaiyyar in a raid, western Arabian poet Layla al-Akhyaiyya of Najd devoted her verse to elegies and laments.

ca. 730 Hymnographer Sahakdukht Siunetsi of Dvin influenced Armenian liturgy with devotion to the Virgin Mary.

801 Following the death of poet Rabia of Basra, Iraq, her spirit continued to appear to disciples.

ca. 830 At Constantinople, Byzantine hymn writer Kassia began a twelve-year defiance of the Emperor Theophilos's iconoclasm, the destruction of religious statuary.

ca. 1000 A ruler of Bali, Mahendradatta of Kediri, East Java, expressed devotion to the Hindu motherhood goddess Durga by chanting invocations and prayers.

1021 Heian era poet Murasaki Shikibu composed the world's first novel, *The Tale of Genji,* a Japanese romance.

August 15, 1118 At the death of Emperor Alexios I of Byzantium, his daughter, Anna Komnena, retreated from Constantinople to a convent and compiled his biography, the *Alexiad,* the world's first chronicle composed by a woman.

May 5, 1186 The Japanese shogun Yoritomo demanded a dance from Shizuka-Gozen of Tango, the most famous traditional performer of her time, who learned the art from her mother, Iso no Zenji.

1279 Following a business trip from Kyoto to Kamakura, Japanese poet and travel writer Abutsu-ni compiled *Izayoi Nikki* (Diary of the Waning Moon).

1407 At Nanjing in Imperial China, Ming Empress Hsu composed a handbook on women's etiquette.

1475 A South Korean national treasure, *Naehun* (Instructions for Women), was the work of Queen Insu of Goyang, the nation's first female author.

1516 After an arranged marriage, Indian hymnographer and poet Mirabai of Kutki, Jodhpur, wrote erotic songs and suicidal and devotional verse to the Hindu god Krishna.

1539 Amannisa Khan Nafisi of Xinjiang, China, wife of a ruler in the Uighur Autonomous Region, collected and refined indigenous Eurasian music.

1557–1587 Mughal biographer Gulbadan Banu Begum moved to Agra, India, and began writing a family chronicle, the *Humayun Nama*.

1579 Because of her husband's capture and exile, Kashmir Empress Habba Khatoon of Chandrahar became a wandering poet and singer of mournful lyrics.

1640s In Imperial China, embroiderer Han Ximeng and fellow Gu clan member Miao Ruiyan transformed ink brush art into textured scenes on lengths of silk enhanced with painting and ink outlines.

1650–1680 For thirty years, embroiderer Gu Lanyu of Shanghai, China, taught young pupils the intricacies of silk needle art created by the Gu clan.

January 1681 The Mughal Emperor Aurangzeb imprisoned his poet daughter Zeb un-Nissi for life in Delhi at Salimgarh Fort for writing poems to a lover.

1725 After the death of Afghan poet Nazo Tokhi in 1717, her daughter, Zainab Hotaki, continued the family tradition in 1725 with an elegy on her brother Mahmud's execution.

July 12, 1762 *The Memoirs of Lady Hyegyeong* chronicled Crown Prince Sado's murderous insanity and King Yeongjo's decision to execute him at Hanseong (Seoul), Korea.

1818 Turkish calligrapher Fatima Zahra Hanim completed *ta'lik* script on a diamond panel.

1891 Embroiderer and alpana painter Shukumari Devi began teaching Bengali pupils at age seventeen.

January, 1903 Writer Raden Adjeng Kartini composed "Educate the Javanese," a manifesto posted to Willem Rooseboom, the colonial governor of the Dutch East Indies.

1906 Armenian dancer and singer Armen Ohanian debuted at Moscow's State Academic Mall Theatre of Russia and the Georgian National Opera at Tbilisi.

1908 Mentored by folklorist Ubonwanna, her aunt, Queen Dara Rasmi facilitated an original adaptation of *Sao Krua Fa* (Puccini's Madame Butterfly), a favorite of Siam's King Chulalongkorn.

1912 Painter and ceramicist Fan Tchunpi became the first female Chinese art student at an academic setting in Paris.

1913 Shanta Devi and sister Sita Deva of Calcutta translated English stories for the Bengali anthology *Hindusthani Upakatha* (Hindustani Legends).

1918 British Indian educator, fiction writer, satirist, and journalist Rokeya Sakhawat Hossain of Calcutta influenced seven-year-old Sufia Kamal, a future journalist, to challenge tyrannic males.

January 1919 Syrian journalist Nazik Khatim al-'Abid Bayhum launched a women's magazine, *Nur al-Fayha'* (Light of Damascus), that defied arranged marriage and obligatory veiling.

1923 Feminist editor and activist Sufia Kamal of Bengal issued her first short fiction, "Shainik Bodhu" (Soldier's Bride) in the *Taroon* (Youth) magazine.

1926 Artist Indusudhu Ghose of Bengal became the first woman to join the all-male Kanushangha art guild.

1929 Azerbaijan produced its first actress when Izzat Orujova starred in the film *Sevil* about the abuse of an uneducated wife.

1932 Gamar Hajiaga Almaszadeh of Baku, Azerbaijan, became the first Muslim professional ballerina.

1936 Burmese journalist and fiction writer Khin Myo Chit serialized a first work, *College Girl,* for a newspaper, *The* (Rangoon) *Sun.*

1937 Bengali artist and writer Chitranibha Chowdhury defended female freedoms in the essay "In the Bower of Art."

1938 While Gouri Bhanja, a Bengali batik and alpana artist, taught at Kala Bhavana, the fine arts institute of Visva-Bharati University in Santiniketan, her younger sister Jamuna Bose Sen progressed in fresco, modeling, and lino cutting.

1939 Bengali painter Pratima Devi designed stage sets and costumes for her father-in-law, poet Rabindranath Tagore, whose dance dramas extended from 1881 to 1939.

1942 Bengali artist and author Rani Chanda composed *Jenana Phatak* (The Army's Gate) about imprisonment during the Indian Freedom Movement.

1948 Siberian physician Anna Nikolaevna Bek began writing a memoir about her World War II losses and widowhood.

October 7, 1950 The sole female chief of the Lemdha clan, Tibetan nun Ani Pachen, led six hundred guerrilla warriors against Chinese invaders, the subject of the autobiography *Sorrow Mountain.*

1956 At Cathedral High School in Lahore, Pakistani essayist and theologian Riffat Hassan issued a first title.

1959 Kyrgyz prima ballerina Bübüsara Beyşenalieva starred in the Russian cinema *Morning Star,* a witch tale based on Persian folklore.

1966 Pashtun folksinger Zarsanga began rescuing shepherds' folk tunes from British India by performing on Pakistani radio.

1969 Dramatic soprano Tsisana Tatishvili took the star part of Amneris in Verdi's *Aida* at the Tbilisi, Georgia, opera house.

1970 Cheng Yen, a Taiwanese nun, began the Buddhist Tzu Chi (Compassion Relief) Foundation, a global outreach to disaster sites and a media mission through radio and television orations and meditational books.

June 22, 1970 Vietcong war diarist Dang Thuy Tram kept a daybook of army life as an ophthalmic surgeon until an American GI killed her with a bullet to the forehead.

1971 Because Mao's Chinese Red Guard burned books, Ying Chang Compestine learned to write children's tales at age eight.

1974 Master cook Chua Jim Neo published *Mrs. Lee's Cookbook,* an historic compendium of hybrid Singaporean cuisine.

April 13, 1975 Iraqi ceramicist Nuha al-Radi aimed a satiric sculpture show at Saddam Hussein's tyranny.

March 8, 1976 On International Women's Day, March 8, 1976, Nepali sculptor Sushma Shimkhada won first prize at an exhibit of the Nepal Association of Fine Arts.

1979 Because of the 1979 Iranian Revolution and strict anti-entertainment laws, especially for women, Fatemeh Sadeghi migrated from Tehran to Los Angeles and flourished as a celebrity dancer.

April 18, 1983 Within months of injuries sustained in the 1983 bombing of the U.S. Embassy in Beirut, Lebanese architect Simone Kosremelli formed a construction company.

1985 Tajik art historian Larisa Dodkhudoeva indexed themes from 3,360 miniature paintings in 245 manuscripts.

1988 Israeli multi-media ceramicist and batik and flooring designer Siona Shimshi accepted the 1988 Arieh El Hanani Prize for Art in Public Places.

March 31, 1988 Aung San Suu Kyi repatriated to Myanmar to join her husband in rallying support for Siamese democracy.

August 26, 1988 Harpist Ma Su Zar Zar Htay Yee dedicated herself to traditional Burmese music.

1990 Master weaver Bouakham Phengmixay joined a United Nations project in Vientiane, Laos, producing silk fabrics.

1994 Sri Lankan journalist Frederica Jansz began reporting combat news for the island nation's quarter-century civil war.

December, 1994 For a stand on brotherhood, democracy, and personal and labor rights, Kurdish orator Leyla Zana began prison writings revealing torture.

1996 Palestinian poet Shin Shifra compiled from Akkadian a young reader's version of *The Tales of Gilgamesh*.

1997 Japanese dramaturge, author, and child actor, Haruko Wakita summarized Kyoto's parades and purification rites to suppress epidemics by placating the gods.

November 29, 1997 At the International Ramayana Festival at Angkor Wat, Cambodian dancer Pisith Pilika topped the performers from eleven other Asian countries.

1998 Tajik art historian Lola Dodkhudoeva surveyed the Bibliotheque Nationale de France for neglected manuscripts on Sufism.

1999 Pakistani actor, singer, and dancer Mehrunnisa Hassan appeared in her first film.

ca. 2000 Dombra player and chanter Chamchat Toulepova influenced a second female performer, Uljan Baibosynova, to master all-male Kazakh storytelling and epic recitation.

2002 Uighur singer and instrumentalist Ayshemgul Memet became one of the first female soloists and taburists in a minority folk art dominated by men.

2003 Food historian Lee Shermay compiled a new edition of heirloom Singapore cuisine originated by her grandmother, Chia Jim Neo.

2004 Iranian cartoonist Marjane Satrapi published a graphic classic, the memoir *Persepolis*, a reflection on girlhood during the Iran-Iraq war.

May 13, 2005 Shirin Akiner, a scholar and historian from British India, reported on a civil uprising in the controversial treatise *Violence in Andijan*.

2006 Poet Ana Kalandadze, at age 81, received the SABA lifetime achievement award for contribution to Georgian literature.

2007 Bahraini legislator Nancy Dinah Elly Khedouri chronicled the history of her nation's minority Jews.

2008 Kyungah Ham, a South Korean computer artist, sent patterns to North Korean for intimidated embroiderers to follow.

May 12–16, 2009 Mira Awad, a Palestinian Christian, and Noa Nini, an Israeli Jew, represented Israel in Moscow with a duet performed for the Eurovision song contest.

November 2009 The loss of a friend limited outreach to other Andaman islanders, causing linguist and storyteller Boa Sr. to talk to birds in place of direct communication with African progenitors.

January 30, 2011 Historian JaHyun Kim Haboush compiled *Epistolary Korea,* a collection of personal and official communication over 518 years.

June 4, 2011 Saudi fiction writer Raja'a Alem and her twin sister, Shadia Alem, set up "Black Arch," a study of human coming to knowledge at the Venice art biennale.

December 2012 At the Bank Muscat, Omani artist Safiya al Bahlani displayed her life story in art revealing severe birth defects.

2013 Bengali feminist author and attorney Sultana Kamal issued a survey, *Human Right in Bangladesh*.

May 9, 2013 On Jerusalem Day, Palestinian historian Ruth Kark accepted the Yakir Yerushalayim (Worthy Citizen of Jerusalem) recognition for researching the city's history.

2014 The *Guardian* credited Mona Saudi's Jordanian cinema and posters with fighting the Palestinian Revolution.

2015 To further sitar music, Bangladeshi instrumentalist Alif Laila opened a school in Silver Spring, Maryland.

August 2015 Bhutanese painter Zimbiri became the first native woman to mount a solo exhibition.

2016 India's raconteur Fouzia Dastango assembled a performing troupe she called Dastango: The Storytellers.

October 2016 Mongolian cartoonist and graphic artist Narantulga Buriad supported

feminist comic books, painting, and dance as rehabilitation and motivation after trauma.

2017 To symbolize collaboration with Filipino tattooist Grace Palicas and apprentice Ilyang Wigan, Whang-od Oggay began marking clients with three dots.

January 28, 2017 During Chinese New Year, a premiere showing of Anaïs Mak's Hong Kong couturier line energized Paris Fashion Week.

March 2017 Street artist Haifa Subay began protesting the Yemeni civil war in Sana'a with wall graphics featuring endangerment of women and children.

2019 At the Cannes Film Festival, Chinese cartoonist Zhang Xiaobai's TV series *The Legend of the White Snake* portrayed Qing She (Green Snake), a recumbent siren tattooed with coils on her back.

2020 South Korean sitarist and translator Terra Han issued an English edition of *Naehun*, a classic women's primer Queen Insu of Goyang wrote in 1475.

March, 2020 During the covid lockdown in New Delhi, India, Bengali artist Anjoli Ela Menon painted a home mural, "Celestial Being," a communion table shared by people of disparate races and faiths.

Spring, 2020 The YouTube play "The Girl in the Pink Frock," enacted by Indian puppeteer Anurupa Roy, posed questions of life, heroism, journeys, and death.

March 10, 2021 At the Penang International Container Art Festival, Malaysian painter Caryn Koh contributed a four-part mural on the theme "Connections."

Appendix A:
Artists by Genres

Actor

Antonina, Byzantium
Armen Ohanian, Armenia
Awad, Mira, Israel
Hassan, Mehrunnisa, Pakistan
Orujova, Izzat, Azerbaijan
Pilika, Pisith, Cambodia
Sadeghi, Fatemeh "Jamileh," Iran
Theodora, Empress, Syria
Touch Sunnix, Cambodia
Wakita, Haruko, Japan

Alpana Painter

Bhanja, Gouri, Bengal
Chowdhury, Chitranibha, Bengal
Devi, Pratima, Bengal
Devi, Shukumari, Bengal
Sen, Jamuna, Bengal

Animator

Bahlani, Safiya al-, Oman

Aphorist

Cheng Yen, Taiwan
Insu, Queen, Korea
Kassia, Byzantium
Rabia of Basra, Iraq
Salimeh Sultan Begum, Mughal Empire

Architect

Kosremelli, Simone, Lebanon

Autobiographer

Abutsu-ni, Japan
Almaszadeh, Gamar Hajiaga, Azerbaijan
Khin Myo Chit, British Burma
Pachen, Ani, Tibet

Ballerina

Almaszadeh, Gamar Hajiaga, Azerbaijan
Beyşenalieva, Bübüsara, Kyrgyzstan
Pilika, Pisith, Cambodia
Vakiliova, Leyla, Azerbaijan

Batik Artist

Gouri Bhanja, Bengal
Jamuna Sen, Bengal
Pratima Devi, Bengal
Rani Chanda, Bengal
Shimshi, Siona, Israel

Belly Dancer

Sadeghi, Fatemeh "Jamileh," Iran

Biographer

Alem, Raja'a, Saudi Arabia
Aung San Suu Kyi, British Burma
Bek, Anna Nikolaevna, Siberia
Cheng Yen, Taiwan
Gulbadan Banu Begum, Mughal Empire
Haboush, JaHyun Kim, Korea
Kark, Ruth, Israel
Khin Myo Chit, British Burma
Komnena, Anna, Byzantium
Rani Chanda, Bengal

Calligrapher

Amannisa Khan Nafisi, Uighur Autonomous
 Region
Batal, Dia, Lebanon
Cai Wenji, Imperial China
Fan Tchunpi, Imperial China
Hanim, Fatima Zahra, Turkey
Miwnay, Sogdia
Shayn, Sogdia
Sun Duoci, Imperial China

Zeb un-Nissa, Mughal Empire
Wang Zhaojun, Imperial China

Cartoonist

Buriad, Narantulga, Mongolia
Zhang Xiaobai, People's Republic of China

Ceramicist

Chanda, Rani, Bengal
Devi, Pratima, Bengal
Fan, Tchunpi, Imperial China
Ham, Kyungah, South Korea
Radi, Nuha al-, Iraq
Shimshi, Siona, Israel

Chanter

Amannisa Khan Nafisi, Uighur Autonomous
 Region
Baibosynova, Uljan, Kazakhstan
Deborah, Israel
Mahendradatta, Bali
Oggay, Whang-od, Philippines
Saburova, Injegul, Uzbekistan
Sheripova, Ziada, Uzbekistan
Toulepova, Chamchat, Kazakhstan

Children's Author

Alem, Raja'a, Saudi Arabia
Aung San Suu Kyi, British Burma
Compestine, Ying Chang, People's Republic
 of China
Kamal, Sufia, Bengal
Roy, Anurupa, India
Satrapi, Marjane, Iran
Shifra, Shin, Palestine

Children's Book Illustrator

Buriad, Narantulga, Mongolia

Choreographer

Ohanian, Armen, Armenia

Columnist

Bayhum, Nazik Khatim al-'Abid, Ottoman
 Syria
Khin Myo Chit, British Burma
Shimshi, Siona, Israel

Comic

Sadeghi, Fatemeh "Jamileh," Iran

Composer

Awad, Mira, Israel
Kassia, Byzantium
Nini, Noa, Israel

Computer Artist

Ham, Kyungah, South Korea

Costumer

Dara Rasmi, Siam
Devi, Pratima, Bengal
Iso no Zenji, Japan
Shimshi, Siona, Israel

Critic

Haboush, JaHyun Kim, Korea

Dancer

Antonina, Byzantium
Chatrsudha Wongtongsri, Siam
Dara Rasmi, Siam
Hassan, Mehrunnisa, Pakistan
Isso no Zenji, Japan
Macedonia, Byzantium
Oggay, Whang-od, Philippines
Ohanian, Armen, Armenia
Pilika, Pisith, Cambodia
Salome, Judaea
Sen, Jamuna, Bengal
Shizuka-Gozen, Japan
Sunnix, Touch, Cambodia
Theodora, Empress, Syria
Wang Zhaojun, Imperial China

Diarist

Abutsu-ni, Japan
Dang, Thuy Tram, Vietnam
Kamal, Sufia, Bengal
Radi, Nuha al-, Iraq
Shikibu, Murasaki, Japan

Director

Ohanian, Armen, Armenia
Satrapi, Marjane, Iran

Dombra Player

Baibosynova, Uljan, Kazakhstan
Saburova, Injegul, Uzbekistan
Sheripova, Ziada, Uzbekistan
Toulepova, Chamchat, Kazakhstan

Dramaturge

Wakita, Haruko, Japan

Drummer

Nini, Noa, Israel
Shizuka-Gozen, Japan

Editor

Abutsu-ni, Japan
Buriar Narantulga, Mongolia
Compestine, Ying Chang, People's Republic
 of China
Jansz, Frederica, Sri Lanka
Kark, Ruth, Israel
Kemal, Sufia, Bengal
Khedouri, Nancy Dinah Elly, Bahrain
Khin Mio Chit, British Burma
Shifra, Shin, Palestine
Wakita, Haruko, Japan

Embroiderer

Alem, Raja'a, Saudi Arabia
Bahlani, Safiya al-, Oman
Bhanja, Gouri, Bengal
Devi, Pratima, Bengal
Devi, Shukumari, Bengal
Ghose, Indusudha, Bengal
Gu Lana, Imperial China
Han Ximeng, Imperial China
Koutchoulou, Georgia
Miao Ruiyan, Imperial China
Sen, Jamuna, Bengal
Shimshi, Siona, Israel

Epicist

Komnena, Anna, Byzantium

Essayist

Abutsu-ni, Japan
Aung San Suu Kyi, British Burma
Bek, Anna Nikolaevna, Siberia
Chowdhury, Chitranibha, Bengal
Hassan, Riffat, Pakistan
Hossein, Rokeya Sakhawat, British India
Kartini, Raden Adjeng, Java
Khedouri, Nancy Dinah Elly, Bahrain
Ohanian, Armen, Armenia
Sei Shonagon, Japan

Fabric Artisan

Dara Rasmi, Siam

Fashion Designer

Mak, Anais, Hong Kong
Zeb un-Nissa, Mughal Empire

Film Narrator

Haboush, JaHyun Kim, Korea

Film Star

Beyşenalieva, Bübüsara, Kyrgyzstan

Flautist

Oggay, Whang-od, Philippines

Folk Dancer

Tatishvili, Tsisana, Georgia

Folklorist

Pirboudaghian, Heguine, Armenia
Ubonwanna, Siam

Folksinger

Zarsanga, British India

Food Historian

Compestine, Ying Chang, People's Republic
 of China
Chua Jim Neo, Singapore
Lee, Shermay, Singapore

Fresco Artist

Devi, Pratima, Bengal

Glass Sculptor

Menon, Anjolie Ela, Bengal

Graphic Designer

Bahlani, Safiya al-, Oman

Graphic Novelist

Satrapi, Marjane, Iran

Guitarist

Awad, Mira, Israel
Nini, Noa, Israel

Harpist

Yee, Ma Su Zar Zar Htay, Myanmar

Historian

Akazome Emon, Japan
Akiner, Shirin, British India
Dodkhudoeva, Larisa, Tajikistan
Dodkhudoeva, Lola, Tajikistan
Haboush, JaHyun Kim, Korea
Kark, Ruth, Israel
Komnena, Anna, Byzantium
Khedouri, Nancy Dinah Elly, Bahrain
Wakita, Haruko, Japan

Historical Novelist

Compestine, Ying Chang, People's Republic
of China
Khin Myo Chit, British Burma

Hymnographer

Deborah, Israel
Enheduanna, Akkadia
Kassia, Byzantium
Mirabai, India
Puduhepa, Anatolia
Siunetsi, Sahakdukht, Armenia

Ikat Specialist

Khamdypaphanh, Simone, Laos

Illustrator

Alem, Shadia, Saudi Arabia
Satrapi, Marjane, Iran

Jewelry Designer

Kosremelli, Simone, Lebanon
Lawati, Hannah al, Oman

Journalist

Alem, Raja'a, Saudi Arabia
Hossein, Rokeya Sakhawat, British India
Jansz, Frederica, Sri Lanka
Khim Myo Chit, British Burma
Mayhem, Nazik Khatim al-'Abid, Ottoman
Syria
Zana, Leyla, Kurdistan

Leather Worker

Bhanja, Gouri, Bengal
Chanda, Rani, Bengal

Lecturer

Akiner, Shirin Ahmad, British India
Khedouri, Nancy Dinah Elly, Bahrain

Letter Writer

Abutsu-ni, Japan
Aung San Suu Kyi, British Burma
Izumi Shikibu, Japan
Kartini, Raden Adjeng, Java
Miwnay, Sogdia
Puduhepa, Anatolia
Shayn, Sogdia

Linguist

Boa Sr., Andaman Islands

Lino Artist

Chanda, Rani, Bengal
Devi, Pratima, Bengal
Ghose, Indusudha, Bengal

Lute Player

Wang Zhaojun, Imperial China

Lyrist

Ohanian, Armen, Armenia
Siunetsi, Sahakdukht, Armenia

Magazine Writer

Compestine, Ying Chang, People's Republic
of China

Media Orator

Cheng Yen, Taiwan
Khedouri, Nancy Dinah Elly, Bahrain

Memoirist

Bek, Annan Nikolaena, Siberia
Chanda, Rani, Bengal
Chowdhury, Chitranibha, Bengal
Compestine, Ying Chang, People's Republic
of China
Hyegyeong, Lady, Korea
Ohanian, Armen, Armenia
Satrapi, Marjane, Iran

Metal Worker

Chanda, Rani, Bengal

Mime

Theodora, Empress, Syria

Moralist

Insu, Queen, Korea

Mosaicist

Shimshi, Siona, Israel

Muralist

Alif Laila, Bangladesh
Chowdhury, Chitranibha, Bengal
Koh, Caryn, Malaysia
Menon, Anjolie Ela, Bengal
Subay, Haifa, Yemen

Musician

Ayshemgul Memet, Uighur Autonomous
Region
Han, Terra, South Korea

Mythologist

Khin Myo Chit, British Burma

Novelist

Alem, Raja'a, Saudi Arabia
Compestine, Ying Chang, People's Republic
of China
Devi, Shanta, Bengal
Devi, Sita, Bengal
Hossein, Rokeya Sakhawat, British India
Ohanian, Armen, Armenia
Shikibu, Murasaki, Japan

Oil Painter

Devi, Shanta, Bengal
Sun Duoci, Imperial China

Opera Singer

Tatishvili, Tsisana, Georgia

Orator

Aung San Suu Kyi, British Burma
Bayhum, Nazik Khatim al-'Abid, Ottoman
Syria
Hassan, Riffat, Pakistan
Jansz, Frederica, Sri Lanka
Kosremelli, Simone, Lebanon
Pachen, Ani, Tibet
Zana, Leyla, Kurdistan

Painter

Bahlani, Safiya al-, Oman
Buriad, Narantulga, Mongolia
Devi, Pratima, Bengal
Fan Tchunpi, Imperial China
Ghose, Indusudha, Bengal

Han Ximeng, Imperial China
Menon, Anjolie Ela, Bengal
Radi, Nuha al-, Iraq
Saudi, Mona, Jordan
Shadia, Alem, Saudi Arabia
Shinshi, Siona, Israel
Sun Duoci, Imperial China
Wang Zhaojun, Imperial China
Zhang Xiaobai, People's Republic of China
Zimbiri, Bhutan

Photographer

Chowdhury, Chitranibha, Bengal
Ham, Kyungah, South Korea
Shimkhada, Sushma, Nepal
Subay, Haifa, Yemen

Playwright

Alem, Raja'a, Saudi Arabia
Dara Rasmi, Siam

Poet

Abutsu-ni, Japan
Akazome Emon, Japan
Akhyaliyya, Leyla al-, Arabia
Amannisa Khan Nafisi, Uighur Autonomous
Region
Arnimal, Kashmir
Aung San Suu Kyi, British Burma
Cai Wenji, Imperial China
Daini no Sanmi, Japan
Deborah, Israel
Enheduanna, Akkadia
Gulbadan Banu Begum, Mughal Empire
Habba Khatoon, Kashmir
Hotaki, Zainab, Afghanistan
Iazumi Shikibu, Japan
Kalandadze, Ana, Georgia
Kamal, Sufia, Bengal
Kassia, Byzantium
Khawla bint al-Azwar
Khin Mio Chin, British Burma
Koshikibu no Naishi, Japan
Mirabai, India
Nazo, Tokhi, Afghanistan
Noa, Israel
Ohanian, Armen, Armenia
Rabia of Basra, Iraq
Saudi, Mona, Jordan
Sei Shonagon, Japan
Shifra, Shin, Palestine
Shikibu, Murasaki, Japan

Siunetsi, Sahakdukht, Armenia
Suō no Naishi, Japan
Zeb un-Nissa, Mughal Empire

Portraitist

Bahlani, Safiya al-, Oman
Chowdhury, Chitranibha, Bengal
Shimshi, Siona, Israel

Poster Artist

Saudi, Mona, Jordan
Shimshi, Siona, Israel

Print Maker

Koh, Caryn, Malaysia

Psalmist

Enheduanna

Publisher

Bayhum, Nazik Khatim al-'Abid, Ottoman
 Syria

Puppeteer

Roy, Anurupa, India

Quilter

Devi, Shanta, Bengal

Religious Writer

Abutsu-ni, Japan
Puduhepa, Anatolia
Rabia of Basra, Iraq

Satirist

Akhyaliyya, Layla al-, Arabia
Hossain, Rokeya Sakhawat, British India
Humayda bint Numan ibn Bashir, Arabia

Scenarist

Khedouri, Nancy Dina Elly, Bahrain
Saudi, Mona, Jordan

Sculptor

Ham, Kyungah, South Korea
Radi, Nuha al-, Iraq
Shimkhada, Sushma, Nepal
Shimshi, Siona, Israel

Set Designer

Shimshi, Siona, Israel

Short Story Writer

Alem, Raja'a, Saudi Arabia
Chanda, Rani, Bengal
Devi, Shanta, Bengal
Devi, Sita, Bengal
Hossain, Rokeya Sakhawat, British India
Khin Myo Chit, British Burma

Silkscreen Printer

Saudi, Mona, Jordan

Singer

Amannisa Khan Nafisi, Uighur Autonomous
 Region
Awad, Mira, Israel
Ayshemgul Memet, Uighur Autonomous
 Region
Boa St., Andaman Islands
Chowdhury Chitranibha, Bengal
Dara Rasmi, Siam
Hassan, Mehrunnica, Pakistan
Iso no Zenji, Japan
Nini, Noa, Israel
Sunnix, Touch, Cambodia

Sitarist

Alif Laila, Bangladesh
Chowdhury, Chitranibha, Bengal
Devi, Annapurna, British India
Han, Terra, South Korea

Stage Designer

Devi, Pratima, Bengal

Storyteller

Baibosynova, Uljan, Kazakhstan
Boa Sr., Andaman Islands
Dastango, Fouzia, India
Gulbadan Banu Begum, Mughal Empire
Saburova, Injegul, Uzbekistan
Sheripova, Ziada, Uzbekistan
Toulepova, Chamchat, Kazakhstan
Ubonwanna, Siam

Taburist

Amannisa Khan Nafisi, Tajikistan
Ayshemgul Memet, Uighur Autonomous
 Region

Tambourinist

Ohanian, Armen, Armenia

Tanpurist

Mirabai, India

Tattoo Artist

Oggay, Whang-od, Philippines
Palicas, Grace, Philippines
Wigan, Ilyang, Philippines

Textbook Author

Hsu, Empress, Imperial China
Insu, Queen, Korea
Khin Myo Chit, British Burma
Yee, Ma Su Zar Zar Htay, Myanmar

Textile Designer

Shimshi, Siona, Israel

Translator

Akiner, Shinir Ahmad, British India
Aung San Suu Kyi, British Burma
Dara Rasmi, Siam
Devi, Shanta, Bengal
Haboush, JaHyun Kim, Korea
Han, Terra, South Korea
Kalandadze, Ana, Georgia
Ohanian, Armen, Armenia
Shifra, Shin, Palestine
Zeb un-Nissa, Mughal Empire

Travelogue Writer

Abutsu-ni, Japan
Aung San Suu Kyi, British Burma
Chanda, Rani, Bengal
Ohanian, Armen, Armenia

Videographer

Ham, Kyungah, South Korea

Watercolorist

Alif Laila, Bangladesh
Chanda, Rani, Bengal
Chowdhury, Chitranibha, Bengal
Fan Tchunpi, Imperial China
Menon, Anjoli Ela, Bengal
Sun Douci, Imperial China

Weaver

Ham, Kyungah, South Korea
Lamassi, Assyria
Leizu, Imperial China
Pasithiphone, Somphone, Laos
Phengmixay, Bouakham, Laos
Ubonwanna, Siam

Woodcarver

Chowdhury, Chitranibha, Bengal

Woodcut Artist

Chanda, Rani, Bengal
Chowdhury, Chitranibha, Bengal

Writer

Alem, Raja'a, Saudi Arabia
Devi, Pratima, Bengal
Ghose, Indusudha, Bengal
Haboush, JaHyun Kim, Korea
Han Ximeng, Imperial China
Hassan, Riffat, Pakistan
Kamal, Sultana, Bengal
Koh, Caryn, Malaysia
Kosremelli, Simone, Lebanon
Nazira Zayn al-Din, Lebanon
Ohanian, Armen, Armenia
Saud, Mona, Jordan
Sei Shonagon, Japan
Zana, Leyla, Kurdistan

Appendix B:
Artists by Place

Afghanistan
Hotaki, Zainab
Tokhi, Nazo

Akkadia
Enheduanna

Anatolia
Puduhepa

Andaman Islands
Boa Sr.

Arabia
Akhyaliyya, Layla al-

Armenia
Ohanian, Armen
Pirboudaghian, Heguine
Siunetsi, Sahakdukht

Assyria (now Iraq)
Lamassi

Azerbaijan
Almaszadeh, Gamar Hajiaga
Orujova, Izzat
Vakilova, Leyla

Bahrain
Khedouri, Nancy Dinah Elly

Bali
Mahendradatta

Bangladesh
Alif Laila

Bengal
Bhanja, Gouri
Chanda, Rani
Devi, Pratima
Devi, Shanta
Devi, Shukumari
Ghose, Indusudha
Kamal, Sufia
Menon, Anjolie Ela
Sen, Jamuna

Bhutan
Zimbiri

British Burma (now Myanmar)
Aung San Suu Kyi

British India (now Pakistan)
Akiner, Shiri
Devi, Annapurna
Zarsanga

Burma
Khin Myo Chit

Byzantium
Antonina
Kassia
Komnena, Anna
Macedonia

Cambodia
Pisith, Pilika
Sunnix, Touch

Dutch East Indies
Kartini, Raden Adjeng

Georgia

Kalandadze, Ana
Koutchoulou
Tatishvili, Tsisana

Hong Kong

Mak, Anais

Imperial China

Cai Wenji
Fan Tchunpi
Gu Lanyu
Han Ximeng
Hsu, Empress
Leizu
Miao Ruiyan
Sun Duoci
Wang Zhaojun

India

Dastango, Fouzia
Mirabai
Roy, Anurupa

Iran

Sadeghi, Fatemeh "Jamileh"
Satrapi, Marjane

Iraq

Rabia of Basra
Radi, Nuha al-

Israel

Awad, Mira
Deborah
Nini, Noa
Shimshi, Siona

Japan

Abutsu-ni
Daini no Santi
Iso no Zenji
Koshikibu no Naishi
Sei Shonagon
Shikibu, Murasaki
Shuka-Gozen
Suō no Naishi
Wakita, Haruko

Jordan

Saudi, Mona

Judaea

Salome

Kashmir

Arnimal
Habba Khatoon

Kazakhstan

Baibosynova, Uljan
Toulepova, Chamchat

Korea

Haboush, JaHyun Kim
Hyegyeong, Lady

Kurdistan

Zana, Leyla

Kygyrstan

Beyşenalieva, Bübüsara

Laos

Khamdypaphanh, Simione
Pasithiphone, Somphone
Phengmixay, Bouakham

Lebanon

Batal, Dia
Kosremelli, Simone
Nazira Zayn al-Din

Mongolia

Buriad, Narantulga

Mughal Empire

Gulbadan Banu Begum
Salimeh Sultan Begum
Zeb un-Nissa

Myanmar

Yee, Ma Su Zar Zar Htay

Nepal

Shimkhada, Sushma

Oman

Bahlani, Safiya al-
Lawati, Hannah al

Ottoman Syria

Bayhum, Nazik Khatim al-'Abid

Pakistan
Hassan, Mehrunnisa
Hassan, Riffat

Palestine
Kark, Ruth
Shifra, Shin

People's Republic of China
Compestine, Ying Chang
Zhang Xiaobai

Philippines
Oggay, Whang-od
Palicas, Grace
Wigan, Ilyang

Saudi Arabia
Alem, Raja'a
Alem, Shadia
Humayda bint Numan ibn Bashir

Siam
Chatrsudha Wongtongsri
Dara Rasmi
Ubonwanna

Siberia
Bek, Anna Nikolaevna

Singapore
Chua Jim Neo
Lee, Shermay

Sogdia
Miwnay
Shayn

South Korea
Ham, Kyungah
Han, Terra

Sri Lanka
Jansz, Frederica

Syria
Khawla bint al-Azwar
Nazira Zayn al-Din
Theodora, Empress

Taiwan
Cheng Yen

Tajikistan
Dodkhudoeva, Larisa
Dodkhudoeva, Lola

Turkey
Hanim, Fatima Zahra

Uighur Autonomous Region
Amannisa Khan Nafisi
Ayshemgul Memet

Uzbekistan
Saburova, Injegul
Sheripova, Ziada

Vietnam
Dang, Thuy Tram

Yemen
Subay, Haifa

Glossary

abaya loose black robe worn by Muslim women

a cappella Italian for unaccompanied by a musical instrument or additional voice

acrostic a word puzzle that begins each line with a letter spelling out a theme or topic

adagio Italian for slow, stately music or dance

alghoza Arabic double flute

alpana a paint for sacred motifs and geometric art using rice and flour paste in the Bengali style

anchorite religious recluse

anime Japanese animated film

antiphon Byzantine musical one-sentence response

ashlar dressed stone veneer for facing buildings

atman the Hindu concept of the soul *See also* paramatman.

baba karam Iranian chain choreography

backstrap loom sticks, rope, and a strap worn around the weaver's waist

bandari Persian belly dance

baqsy Kazakh divination songs

batten or **beater bar** a horizontal tool that presses the weft thread firmly against woven lengths

bespoke made to order for an individual client

bhajan a prayerful Hindu hymn

bhakti the Hindi term for emotional union with a supreme god

bimah Hebrew for a synagogue podium

broadside a strongly stated censure or denunciation

bunraku a Japanese puppet drama introduced in Osaka in 1500

burqa Islamic woman's hood and robe

chadrovaya Azerbaijani for veil

chaklag Filipino tattooed torso pattern

Chap Goh Meh the Chinese Lantern Festival on the fifteenth day of the new year

chasu Korean art stitchery

chiaroscuro an Italian art term for the balance of light and dark

compline Catholic term for evening prayer

dalan Filipino for rice bundle

dan bau Vietnamese zither

darabukka Iranian stemmed drum

dastangoi Hindi for storytelling

dholak Pashtun for two-headed drum

dhulak a small drum in the ensembles of India

diapason a musical term for a swelling harmony

diaspora the spread of a people from an indigenous homeland to other countries

dombra a long-necked two-string Kazakh lute

Doxastichon Eastern Orthodox vesper or evening doxology

dramatic irony a revelation of sarcasm to the audience, but not to the characters

dramatis personae a character list for a stage production

dramaturge a literary researcher or historian who supports stage projects

dutar two-string long-necked lute of the Afghans, Tajiks, Turkmen, and Uzbeks

eco-fashion textile arts that use sustainable raw materials and dyes

en pointe a ballet term for posing on toe with the aid of toe shoes

epistolary in letter format

eshraj a Punjabi stringed instrument played with a bow

exegesis interpretation of scripture

fatok Filipino for tattooed beauty marks on women

filigree a musical term for intricate, delicate ornamentation

gharhi devotional Muslim songs and prayer chants

ghazal an Arabic or Tajik poem composed of independent couplets and repeated end rhymes

ghirjek Uzbek spike fiddle

gijak bowed Khazak upright fiddle

gnomic verse profound or instructive lines meant to improve behavior

guqin seven-string Chinese zither

guxiu silk embroidery in Imperial China of historical and nature scenes on silk

guohua the ancient Chinese painting style blending ink and wash

hafiza Kashmiri for singer

haiku a short Japanese poem focused on a single word

hajj Muslim pilgrimage to a holy shrine at Mecca, Mohammed's birthplace

hammam Turkish steam bath or spa

hanjungnok Korean for autobiography

heddles dividers at the top of a loom to separate warp threads

hijab restrictive Islamic clothing and head scarves that inhibit women's social freedom

hilye-yi serif Turkish manuscript

hisuwa Anatolian term for purification

holograph a copy of original handwriting

houri a beautiful virgin in Muslim paradise

hujra Pashtun for open air stage

hujum Azerbaijan for assault

iconoclast a Byzantine image smasher who removed statues from sanctuaries

iconoclasm Greek for the destruction of religious statues

ikat a Laotian weaving technique that aligns tie-dyed yarn to create a complex image

ingénue a naive or innocent girl in opera, theater, or cinema

intifada Arabic for a Palestinian uprising

jaheli ninth-century Persian choreography

jin Chinese for multicolored woven silk

jinn a supernatural being in Muslim mythology

juice harp a metal frame held in the teeth to resonate sounds from lips and jaws

jyrau folk bards or prophets of the Kazakh steppes from the 1400s

Kaa'ba God's house, a shrine of Allah at Mecca

Kabuki stylized Japanese dance-drama

kamancha bowed lute in Azerbaijani, Kurdish, and Persian folk music

kamdum Assyrian brushed wool

kana a Japanese adaptation of Chinese character writing

karkhandari a folk dialect of India

karum an Assyrian trading depot for woven woolens

katha stitchery storytelling needlework

kayageum a Korean autoharp or plucked zither

keffiyeh Arabic for a pilgrim head covering

kirakira Japanese term for glittery or glistening

kitab Arabic religious book

knar ancient Greek lyre

koto Japanese zither

ktsurds Armenian antiphonal anthems

kulturbahnhof German for culture station

kutanum Assyrian napped wool

kwashiorkor Ghanian word for severe malnutrition

Kyaikhtiyo Burmese for Golden Rock

kyeezee Burmese finger bells

lakhon northern Siamese dance theater

landau a stand-alone Afghani couplet of twenty-two syllables introduced by Indo-Aryans in 1700 CE. Common to female nomadic and agrarian lore, it is rich in satire of traditional gendered customs

landay Sufi love poems

lost wax method designing with melted paraffin to prevent dye from permeating background

madrasa Arabic for school

mambabatok Filipino for master skin artist

manga stylized Japanese comics and graphic fiction aimed at a teen or adult audience

manhua Chinese comic book

marathi an Indic language

mashrap Uighur harvest celebration

monogatari Japanese for epic saga

mordant a fixative to hold dye in fiber

Mossad Israeli military intelligence

mridangam a two-skinned drum in Tamil Nadu, India, for tapping out the rhythms of shadow puppet shows

muquam traditional Turkic folksong mode

Naga mythic half-human snake and guardian spirit of Buddhists and Hindus

new generation art experimentation by the millennial generation in animation and visual stimuli

Noh classical Japanese masked dance-drama about ordinary lives

Nyonya a unique hybrid culture blending Chinese ancestry with Malayan

ode a refined lyric verse addressing a particular subject

orihon Japanese literature produced in an accordion shape

pada Hindi for verses

Padavali Hindi for a song collection

pagoda a tiered Buddhist worship center in China, Japan, Korea, Myanmar, or Vietnam

panegyric public praise

p'ansori Korean narrative songs and storytelling of folk opera performed with a *puk* (two-membrane barrel drum)

paramatman the Hindu concept of the universal soul of Krishna. *See also* atman.

pavra a mouth organ in Tamil Nadu, India, imitating movements of demons and villains in shadow puppet shows

pipa Chinese four-stringed lute played by plucking

pirikannu Assyrian term for fleece

pointillism painted figures shaped from dots rather than brush strokes

Polovtsian Turkish nomad

porphyria purple, a symbol of imperial Byzantine heredity

qaseeda Indian ode or praise hymn rhyming aaaa

qi laoxian a Chinese contour stitch in Guxiu embroidery that conceals straight lines

rabab (or rubab) an Afghani lute that serves as the nation's favorite instrument

raga in traditional Indian music, an improvisational melody

Ram Bhakt Hindi for a devotee of the deity Rama

raqs-e arabi Egyptian and Middle Eastern belly dance

rekhta macaronic diction mixing two languages

rempah coriander, tamarind, ginger, lemongrass, and cumin crushed in a mortar for Singaporean flavoring

rhay-shing Bhutanese charcoal art on canvas strung on wood

ritha Arabic term for elegy or lament

robam classical stylized dance of Cambodian court ritual

RTW ready to wear

rubai Persian verses of four-line stanzas

saa-tshen Bhutanese earth paints

sabra a native-born Israeli Jew

samurai medieval Japanese warrior

Sanduq Persian for treasure chest

sanyasi mendicant Hindu pilgrim or hermit

sarakaner Armenian hymns

satar Uighur long-necked bowed lute

sati the suicide of a Hindu wife on her husband's funeral pyre

saung a lap harp played in Burmese royal courts

scimitar a typically Middle Eastern sword with a curved blade

sekolah Malay for school

Sephardic referring to Jews deriving from Iberia

sericulture Asian silk farming

shamisen three-stringed Japanese instrument plucked with a plectrum

sharakan ritual Armenian songs and chants

Shinpyu Burmese for initiation

Shirabyoshi a Japanese court dancer who sings and performs "white rhythm" in men's attire

shul Hebrew for synagogue

si Burmese timing bells

Silk Route ancient trade roads that connected China and the Pacific rim with countries in the Middle East and the Mediterranean

som a Kyrgyz coin worth 6¢

Souq Arabic for marketplace

stupa a Buddhist shrine shaped like a dome for housing relics

Sufism the Islamic search for mystic oneness with the almighty

sumi ink an east Asian calligraphy medium made from lamp soot or the residue of burned pine mixed with animal glue

sutra a Buddhist scripture

tabla the Indian hand drum, often paired with the sitar

tableau vivant a stage performance of an historic or mythic scene

tabur a stringed instrument bowed or strummed to accompany the Uighur music of Tajikistan

ta'lik Ottoman Turkish script, a thirteenth-century cursive style suited to Persian writing

Tanakh a Jewish scriptural text from the ninth century CE

tanbak Iranian goblet drum *See also* zarb.

tanbar a Kurdish lute

tanpura a long-necked string instrument that supplies a single tone to Hindu music

tapestry an interlocking weave developed by the Tai Lui in the mountains of north Laos

tar a long-necked Iranian lute

thar an Armenian lute

threnody a death dirge, hymn, or memorial

tolu bommalatam Tamil for doeskin figures used in shadow puppetry

tongali Tagalog for the Philippine nose flute

transgressive art design that enrages by breaching moral standards

triodion three-part Byzantine Easter rite

triptych an artwork composed of three related frames

troparion a one-verse refrain or Byzantine hymn

tsapa Bhutanese method of piercing lines to transfer shapes to a wall

ullalim Filipino for chants

veena a Hindu zither

visarjan Urdu for baptism

voje the refrain in Kashmiri lyric verse that rounds out a four-line stanza *See also* watsun.

wa Burmese clappers

waka Japanese poems composed by five lines varying from five to seven syllables each

warp long threads that determine the length of a piece of weaving

watsun in Kashmiri lyrical verse, a three-line stanza followed by a *voje* (refrain)

weft or **woof** cross threads that pass back and forth through the warp to weave a motif

xiushi Chinese for master embroiderer

yoni the Hindu female genitals or mother principle

yurt a round Mongolian tent shaped from felt or hides

zarb Iranian goblet drum

zat pwe Burmese stage plays

Zeitgeist German for the spirit and pervasive motivators of an era

zurna a small woodwind oboe common to Albanian, Algerian, Armenian, Assyrian, Azerbaijani, Bulgarian, Greek, Irani, Iraqi, Serbian, Syrian, and Turkish folk tunes of the Caucasus since the 1100s

Bibliography

Primary Source

Abutsu-ni. "Fitful Slumbers." *Monumenta Nipponica* 43:4 (winter, 1988): 399–416.

Akiner, Shirin. *The Caspian: Politics, Energy and Security*. London: Routledge, 2004.

———. *Kyrgyzstan 2010: Conflict and Context*. Washington, D.C.: Johns Hopkins University, 2010.

———. *Tajikistan: The Trials of Independence*. London: Routledge, 2013.

———. *Violence in Andijan, 13 May 2005: An Independent Assessment*. Washington, D.C.: Johns Hopkins University-SAIS, 2005.

Al Bahlani, Safiya, and Sabah al Bahlani, "The Chosen." www.youtube.com/watch?v= BHkTiPEbUh8 (24 November 2013).

Alem, Raja'a. "All Kinds of Veils." web.archive.org/web/20061116075618/http://www.cbc.ca/ideas/features/arabian_style/veils.html.

———. *The Dove's Necklace*. Casablanca: Al Markaz Al-Thakafi Al-Arabi, 2011.

———. *My Thousand & One Nights*. Syracuse, NY: Syracuse University Press, 2017.

———. *Sarab*. Cairo: Hoopoe Fiction, 2018.

Almaszade, Gamar. "My Life as Azerbaijan's First Ballerina." *Center Stage* (Fall 2002), 56–59.

Alston, A.J. *The Devotional Poems of Mirabai*. Delhi: Motilal Banarsidass, 2008.

Apology of Hattusili, https://lrc.la.utexas.edu/eieol/hitol/60.

Aung San Suu Kyi. "Because of My Father I Feel a Deep Responsibility for the Welfare of My Country." (London) *Independent* (7 October 2016): 100.

———. "Democracy and Development in Asia." *Asian Journal of Peacebuilding* 1:1 (May 2013): 117–127.

———. "Freedom from Fear." *New York Times* (9 July 1990).

———. *Freedom from Fear*. New York: Penguin, 1991.

———. "Give Myanmar Time to Deliver Justice on War Crimes." *Financial Times* (23 January 2020).

———. *Letters from Burma*. New York: Penguin, 2010.

———. *The Nobel Prize*, www.nobelprize.org/prizes/peace/1991/kyi/26191-aung-san-suu-kyi-acceptance-speech-1991/

Begum, Gulbadan. *The History of Humayun*. London: Royal Asiatic Society, 1902.

Bek, Anna. *The Life of a Russian Woman Doctor*. Indianapolis: Indiana University Press, 2004.

Bhargava, Kavita. "A Grave Mistake." (India) *Tribune* (3 June 2000).

Binkley, Roberta. "Biography of Enheduanna, Priestess of Inanna." http://www.cddc.vt.edu/feminism/Enheduanna.html, 1998.

Bly, Robert, and Jane Hirshfield. *Mirabai: Ecstatics Poems*. New Delhi: Aleph Books, 2017.

Bryce, Trevor. *Letters of the Great Kings of the Ancient Near East*. New York: Routledge, 2003.

Cheng Yen. *The Essence of Infinite Meanings*. Hualien, Taiwan: Jing Si Publications, 2015.

———. "Wisdom at Dawn." www.youtube.com/watch?v=ljZGXl1RjAs.

Chowdhury, Chitranibha. "In the Bower of Art." *Art in Translation* 12:1 (January 2020): 71–81.

Compestine, Ying Chang. "In China, Hoping for a Father's Love." *Christian Science Monitor* (26 February 2008): 14.

———. *Revolution Is Not a Dinner Party*. New York: Holt, 2007.

———. "A Test of Character." *Knowledge Quest* 36:1 (September/October 2007): 58–59.

"The Concept of Personal God(dess) in Enheduanna's Hymns to Inanna." www.angelfire. com/mi/enheduanna/Enhedwriting.html, 2001.

Dang Thuy Tram. *Last Night I Dreamed of Peace*. New York: Harmony Books, 2007.

Din, Nazira Zayn al-. *Unveiling and Veiling: On the Liberation of the Woman and Social Renewal in the Islamic World*. Toronto: University of Toronto Press, 1928.

Disse, Dorothy. "Laila Akhyaliyya—Female Voice of Antiquity." fleurtyherald. wordpress.com/2015/02/03/laila-akhyaliyya-female-voice-of-antiquity/

Dodkhudoeva, Larisa. "Everyday Life of Tajik Women." *Codrul Cosminului* 19:2 (2013): 399–406.

———. "Monumental Painting in Tajikistan." *Bulletin of MIHO Museum* 7 (2008): 47–53.

Dodkhudoeva, Larisa and Lola. "Manuscrits

Orientaux du Tadjikistan: La Collection Semenov." *Cahiers d'Asie Centrale* 7 (1999): 39–55.

Dodkhudoeva, Lola. "ANAMED Senior Fellow Lola Dodhkudoeva." www.youtube.com/watch?v=mKJjWpLYwfs.

———. "La Bibliothèque de Khwaja Muhammad Parsa a Boukhara." *Cahiers d'Asie Centrale* 5–6 (1998): 125–142.

———. "Tajikistan: Socio-Cultural Code of the Epoch and Popular Islam." *Russia and the Moslem World* 1:271 (2015): 18–24.

Esteban, Eric. "The Night Crane: Nun Abutsu's Yoru no Tsuru." *Japan Studies Review* 19 (2015): 135–166.

Ghose, Indusudha. "Alankarik Shilpa." *Visva Bharati Quarterly* 8 (Winter 1930–1931).

Glass, Joseph B., and Ruth Kark. *Sephardic Entrepreneurs in Jerusalem: The Valero Family 1800–1948*. Lynbrook, NY: Gefen, 2005.

Haboush, JaHyun Kim. *The Great East Asian War and the Birth of the Korean Nation*. New York: Columbia University Press, 2016.

———. *The Memoirs of Lady Hyegyeong: The Autobiographical Writings of a Crown Princess of Eighteenth-Century Korea*. 2nd ed. Berkeley: University of California Press, 2013.

———. *Women and Confucian Cultures in Pre-modern China, Korea, and Japan*. Berkeley: University of California Press, 2003.

Hassan, Riffat. "Are Human Rights Compatible with Islam?." http://www.religiousconsultation.org/hassan2.htm.

———. "Chapter 11." *Transforming the Faiths of Our Fathers*. New York: St. Martin's Press, 2004.

———. "Islam and Human Rights." *Dawn* (14 November 2002).

———. "Members, One of Another." www.religiousconsultation.org/hassan.htm.

Hoffner, Harry, ed. *Letters from the Hittite Kingdom*. Atlanta, GA: Society of Biblical Literature, 2009.

Jansz, Frederica. "Frederica Jansz." https://oslofreedomforum.com/speakers/frederica-jansz/.

———. "I Fled to the U.S. After My Government Threatened My Life." *Seattle Globalist* (15 February 2017).

———. "Sri Lanka's Missing." Salem-News.com. http://www.salem-news.com/articles/february192012/lanka-missing-fj.php.

Kark, Ruth, ed. *Jewish Women in Pre-State Israel: Life History, Politics, and Culture*. Waltham, MA: Brandeis, 2008.

———. *Transformation of the Jezreel Valley*. Mamaroneck, NY: Israel Academic Press, 2018.

Kartini, Raden Adjeng. *Kartini: The Complete Writings 1898–1904*. Melbourne, Australia: Monash University, 2014.

———. *Letters of a Javanese Princess*. Scott Valley, CA: Create Space, 2012.

———. "The Old Life and the New Spirit." *Atlantic Monthly* 124:2 (November 1919): 591–602.

Katz, Itamar, and Ruth Kark. "The Greek Orthodox Patriarchate of Jerusalem and Its Congregation." *International Journal of Middle East Studies* 37:4 (November 2005): 509–534.

Khedouri, Nancy Dinah Elly. *From Our Beginning to Present Day*. Manama, Bahrain: Al Manar Press, 2008.

———. "Peace, Religious Pluralism, and Tolerance: A View from Bahrain." *IDEAS*, https://www.jewishideas.org/article/peace-religious-pluralism-and-tolerance-view-bahrain.

Khin Myo Chit. *Burmese Scenes and Sketches*. Rangoon: U Thein Tan, 1977.

———. *Colourful Burma*. San Francisco, CA: Moemaka Media, 1976.

———. *Her Infinite Variety and Other Stories*. Rangoon, Myanmar: Parami Bookshop, 2004.

———. *13 Carat Diamond & Other Stories*. Rangoon, Myanmar: U Kyaw Oo, 1965.

Koh, Caryn. *Micro Malaysians*. Petaling Jaya, Malaysia: Buku Fixi, 2017.

Komnena, Anna. *The Alexiad*. New York: Penguin, 1969.

Kosremelli, Simone, and Sylvia Shorto. *A Lebanese Perspective: Houses and Other Work*. Victoria, Australia: Images Publishing, 2011.

"Laila Akhyaliyya." www.poemhunter.com/poem/excerpts-from-laila-s-poems-for-tauba/#content.

Levi, Louise Landes. *Sweet on My Lips: The Love Poems of Mirabai*. New York: Cool Grove, 1997.

Makhfi. *Makhfi: The Princess Sufi Poet Zeb-un-Nissa*. Victoria, Australia: New Humanity, 2012.

Mirabai. *Ecstatic Poems*. Boston: Beacon Press, 2009.

———. *Phraseology*. St. Pete Beach, FL: Palm Leaf Press, 2017.

Murasaki Shikibu. *Murasaki Shikibu: Her Diary and Poetic Memoirs*. Princeton, NJ: Princeton University Press, 1985.

———. *The Tale of Genji*. New York: W.W. Norton, 2016.

Ohanian, Armen. *La Danseuse de Shamakha*. Paris: Bernard Grasset, 1918.

———. "My Uncle Ter-Barsegh." *Asia* 21 (December 1921): 998–999.

Pachen, Ani. *Sorrow Mountain: The Journey of a Tibetan Warrior Nun*. New York: Kodansha International, 2000.

Puduhepa. "The Prayer of Queen Puduhepa to the Sun Goddess or Arinna Tablet." https://libdigitalcollections.ku.edu.tr/digital/collection/GHC/id/694/.

Radi, Nuha al-. *Baghdad Diaries: A Woman's Chronicles of War and Peace*. New York, Vintage Books, 2003.

———. "Baghdad Diary." *Granta* (1 December 1992).

———. "Twenty-Eight Days in Baghdad." *Granta* 85 (12 November 2003).

Roy, Anurupa. *The Girl in the Pink Frock* (film), www.youtube,com/watch?v=RycAYgtGblg.

———. *I Am a Puppet*. Mumbai, India: Pratham Books, 2019.

Satrapi, Marjane. "How Can One Be Persian?." *My Sister, Guard Your Veil; My Brother, Guard Your Eyes*. Boston: Beacon, 2006.

———. *Persepolis 2*. Paris: L'Association, 2004.

———. *Persepolis*. Paris: L'Association, 2003.

———. "The Way Forward." www.talkhouse.com/the-way-forward-marjane-satrapi-is-getting-back-to-creativity-in-post-quarantine-paris/ (27 July 2020).

Saudi, Mona. *Mona Saudi: Forty Years of Sculpture*. Self-published, 2006.

Shimshi, Siona. *Read the Walls*. Ra'anana, Israel: Even Hoshen, 2007.

Singer, Itamar. *Hittite Prayers*. Leiden: Brill, 2002.

Smith, Margaret. *Mahsati, Jahan & Makhfi, Three Great Female Sufi Persian Poets*. Victoria, Australia: New Humanity, 2016.

———*Rabi-a the Mystic and Her Fellow Saints in Islam*. Cambridge, UK: Cambridge University Press, 2010.

Smith, Paul. *Rabia of Basra: Selected Poems*. Victoria, Australia: New Humanity, 2016.

Starr, Mirabai. *Wild Mercy: Living the Fierce and Tender Wisdom of the Women Mystics*. Boulder, CO: Sounds True, 2019.

Subay, Haifa. "Women Make Peace." *Singapore Biennale*, www.singaporebiennale.org/art/haifa subay, 2019.

Wakita, Haruko. "Marriage and Property in Premodern Japan from the Perspective of Women's History." *Journal of Japanese Studies* 10:1 (Winter 1984): 73–99.

———. *Middle Ages as Seen from the Noh*. Tokyo: Daigaku Shuppankai, 2013.

———. *Women and Class in Japanese History*. Ann Arbor: University of Michigan Press, 1999.

Yee, Ma Su Zar Zar Htay. ""The Improvisational Techniques of Myanmar Music." *MURC 2019* (24 May 2019): 194–200.

Zana, Leyla. *Writings from Prison*. Watertown, MA: Blue Crane, 1999.

Zeb-un-Nissa. *The Diwan of Zeb un-Nissa*. London: John Murray, 1913.

Zgoll, Annette. "Nin-Me-Sara: Lady of Countless Cosmic Powers." www.angelfire.com/mi/enheduanna/Ninmesara.html, 1997.

Zhang Xiaobai. *Cartoon Classic*. Shanghai: Fine Arts Publishing House, 2013.

———. *Fantasy Tattoo Art*. Berkeley, CA: Ginkgo Press, 2013.

Articles, Chapters, and Essays

Adak, Baishali. "A Lifetime of Puppetry." *Deccan Herald* (16 October 2013).

Aghaei, Mehrdad. "Narrative Structure and Characterization in Raja Alem's *The Ring of Pigeons*,'" *Studies in Arabic Narratology* 1:2 (Spring & Summer, 2020): 120–14

Agnew, Charlotte. "Hong Kong Designer Anais Mak Turns the City's Energy into Fashion." *i-D* (26 September 2019).

Ahmado, Nisan. "Yemeni Artist's Murals Depict Costs of War." *Voice of America* (17 April 2019).

Ali, Asad. "An Indian Academic's Lone Fight to Save the Great Andamanese." *TRTWorld* (8 September 2020).

Anderson, Elise. "The Construction of Āmānnisā Khan as a Uyghur Musical Culture Hero." *Asian Music* 43:1 (Winter/Spring 2012): 64–90.

"Angara Wants National Living Treasures Award for Whang-od." *MENA Report* (27 February 2018).

"Artist Anjolie Ela Menon Conferred the Kalidas Award." *Indian Express* (1 July 2018).

Awad, Mira. "Palestinian Israelis Are Often Dismissed." (London) *Guardian* (10 March 2016).

"'Baghdad Diaries' Author Nuha Al Radi Dies in Beirut." *Gulf News* (8 September 2004).

"Bank Muscat Hosts Safiya al Bahlani's Exhibition Celebrating Life Through Art." *Pressreader* (25 December 2012).

Basher, Naziba. "Begum: How One Magazine Began a Revolution." (Dhaka) *Daily Star* (20 May 2016).

Bew, Geoffrey. "Palestinian Crisis 'a Humanitarian Tragedy,'" (Manama, Bahrain) *Gulf Daily News* (23 January 2009).

Bhardwaj, Lata, and Swati Chauhan. "Feminism in Mahabharata: The Unheard Voice of Draupadi." *IJRAR* 7:1 (February 2020): 441–446.

Biswas, Prarthita. "Sita Devi-Shanta Devi and Women's Educational Development in 20th Century Bengal." *Paripex* 1:4 (January 2012): 23–24.

Blanchard, Pascal. "Les mondes coloniaux et exotiques dans les grande expositions parisiennes." *Dix-Neuf* 24:2–3 (2020).

Blincoe, Nicholas. "When Artists Go to War." *Guardian* (12 May 2014).

Bonner, Ethan. "Musical Show of Unity Upsets Many in Israel." *New York Times* (24 February 2009).

Boustany, Nora. "Fifty Shells a Minute: After 14 Years of Civil War, Beirut's Worst Week." *Washington Post* (2 April 1989): C1.

Burge, Marjorie. "The Tale of Genji: A Japanese Classic Illuminated." *Japanese Language and Literature* 55:1 (2021): 383–390.

Cengel, Katya. "The Strong Women of Mongolia Are Ready to Take on the Patriarchy." *Nevada Public Radio* (27 September 2017).

Chien Y. Ng, "Historical and Contemporary Perspectives of the Nyonya Food Culture in Malaysia." *Journal of Ethnic Foods* 3:2 (June 2016): 93–106.

"China's Good Girls Want Tattoos." *China File* (10 March 2015).

Christie, Jan Wissman. "Under the Volcano: Stabilizing the Early Javanese State in an Unstable Environment." *Environment, Trade, and Society in Southeast Asia*. Leyden: Brill, 2015, 46–61.

Church, Michael. "Voices of Central Asia, Coliseum, London." *Independent* (17 September 2011).

Clariza, M. Elena. "Sacred Texts and Symbols: An Indigenous Filipino Perspective on Reading." *International Journal of Information, Diversity & Inclusion* 3:2 (2019).

Cohen, Leon. "MSO to Premier Israeli Composer's Oratorio." *Wisconsin Jewish Chronicle* (31 March 2008).

Crossley, David. "From Kuala Lumpur to Dalton." *Ulverston* (UK) *Now* (December 2017).

Cumming-Bruce, Nick. "Lao Textiles." *International Herald Tribune* (7 May 2005).

d'Arenberg, Diana. "Interview." *Ocula* (28 July 2016).

Dasgupta, Debarshi. "Mourning the Death of a Language Amid the Pandemic." *Straits Times* (3 June 2020).

"A Dastango Who Spins Tales for the Modern Age." (New Delhi) *Hindustani Times* (29 April 2017).

Davis, Ben, "The Asia Society Triennial Has a Lot of the Same Problems Most Biennials Do. But It Also Crystallizes a New Trend in Art." *Artnet News* (25 November 2020).

Dundoo, Sangeetha Devi. "People and Their Masks." *The Hindu* (19 December 2015).

Dzyubenko, Olga. "U.S. Criticizes Kyrgyzstan in Hotel Fence Row." *Reuters* (30 July 2008).

Ermelino, Louisa. "Open Book: A Siege, a Soldier, a Jihadi, a Love Story." *Publishers Weekly* (20 April 2018).

Feathers, Lori. "Raja Alem's *The Dove's Necklace*." *Words Without Borders* (March 2016).

"Festival Tarab Tanger." *Tanger Pocket* (August/September 2012): 28.

"Folk Singer Zarsanga Enthrals Online Audience." (Karachi) *Express Tribune* (22 April 2010).

Fontes, Suzy. "Safiya Bahlani: Talent Unlimited." *Yumpu* (16 October 2012): 32–33.

Foussianes, Chloe. "Interview." *Town and Country* (1 August 2020).

Fox, Diane Niblack. "Fire, Spirit, Love, Story." *Journal of Vietnamese Studies* 3:2 (2008): 218–221.

Friend, Robyn C. "Jamileh: The Goddess of Iranian Dance." *Habibi* 16:1 (Winter 1997).

Gandec, Jean-Luc. "Zarsanga." *La Terrasse* (4 February 2009): 44.

Gao, Bingqing. "A Brief Discussion on the Themes of Women's Embroidery in the Ming and Qing Dynasties." *Asian Culture and History* 2:2 (2010): 71–81.

Glaz, Sarah. "Enheduanna: Princess, Priestess, Poet, and Mathematician." *Mathematical Intelligencer* 42:2 (2020): 31–46.

Gomaa, Dalia. "Re-membering Iraqis in Nuha al-Radi's Baghdad Diaries: A Woman's Chronicle of War and Exile." *Feminist Formations* 29:1 (Spring 2017): 53–70.

Gould, Rebecca. "How Gulbadan Remembered." *Early Modern Women* 6 (2011): 187–193.

Ha, Quan Manh. "When Memory Speaks: Transnational Remembrances in Vietnam War Literature." *Southeast Asian Studies* 5:3 (December 2016): 463–489.

Haas, Mary E. "Women and War" in *Women in the Third World: An Encyclopedia of Contemporary Issues*. New York: Garland, 2014, 1716.

Han, Hee-sook. "Women's Life During the Choson Dynasty." *International Journal of Korean History* 6 (December 2004): 113–161.

Hanson, Alex. "At the Hood: Natural Beauty, Political Danger." (Lebanon, NH) *Valley News* (10 October 2013).

Haq, Fayza. "The First Woman Painter of Bangladesh." (Dhaka) *Daily Star* (20 December 2013).

"Harmony But Different: 2019 Art Therapy International Forum." *KKNews* (25 October, 2019).

Harris, Rachel. *Situating the Uyghurs: Between Central Asia and China*. London: Routledge (2007): 69–88.

Hasan, Khalid. "The Hijackers of Islam." (Lahore) *Friday Times* (14 February 2003).

Holtz, William. "The Little House on the—Desert." *Aramco World* 35:6 (November/December 1984).

Hoque, Mofidul. "Sofia Kamal: Her Journey Towards Freedom." *Forum* 6:7 (7 July 2012).

Hossain, Amina. "In Tune to the World." (Dhaka) *Daily Star* (3 December 2020).

Huang, I-Fen. "Gender, Technical Innovation, and Gu Family Embroidery in Late-Ming Shanghai." *East Asian Science, Technology, and Medicine* 36 (2012): 77–129.

Humran, Alya Abdulhakim. "Revolution Is Female." *Al Raida*, 44:1 (2020): 29–36.

Husn, Ma'n Abul. "Khawla Bint Al Zwar." *Al Shindagah* (May-June 2003).

Hussein, Muhsen Ali. "Domination and Motivation in Mona Saudi Sculptures." *Al-Academy Journal* 87 (2018): 5–28.

Ismayilova, Laman. "Azerbaijan to Join Int'l Festival of Ballet Art in Bishkek." *Azernews* (11 May 2016).

"Jewish Bahrain Shura Council Member Supervised *Umm Haroun* Series, Contributed to Finest Details." *Bahrain Mirror* (6 May 2020).

Jiang, Ricky. "Coffee with Anais Mak." *China Daily* (12 September 2017).

Jimenez, Karla. "Korean Professor Haboush Remembered for Love of New York Culture." *Columbia Spectator* (27 March 2013).

Johnston, Patrick. "Street Artist in Yemen Remembers Casualties of War." *Reuters* (1 March 2018).

Kalsi, Jyoti. "Mona Saudi Creates Poetry in Stone." *Gulf News* (24 June 2015).

Kamaker, Protiva Sani. "'Taharei Pore Mone'—Reminiscence of Begum Sufia Kamal." (Dhaka) *Daily Star* (20 June 2020).

Kaptein, Nico J.G. "Two Unknown Letters from the Kartini Family to M.J. de Goeje." *Archipel* 93 (2017): 109–117.

Karlsson, Helena. "Politics, Gender, and Genre—The Kurds and 'The West': *Writings from Prison* by Leyla Zana." *Journal of Women's History* 15:3 (Autumn, 2003): 158–160.

Kazan, Hilal. "A Woman Calligrapher in the Nineteenth Century: Sharifah Fatima Zahra Hanim." *Calligraphy* (25 June 2017).

Kehe, Marjorie. "When Politics Bring Childhood to an End." *Christian Science Monitor* (20 November 2007): 14.

Klapisch-Zuber, Christiane, and Susan Emanuel. "Salome's Dance." *Clio* 46 (2017): 186–197.

Kraft, Dina. "Israeli Eurovision Singers Condemned as 'Traitors,'" (London) *Telegraph* (2 February 2009).

Kumar, N.P. Krishna. "Mona Saudi's Aesthetic Journey." *Gulf News* 15 (28 March 2018): 47.

Kumar, Rakesh. "Women and Literature in Medieval India." *International Journal for Social Studies* 4:12 (February 2018): 1–6.

Kurkcu, Ertugrul. "Defiance Under Fire." *Amnesty Magazine* (20 December 2003).

Lassley Knight, Jennifer. "Herodias, Salomé, and John the Baptist's Beheading: A Case Study of the Topos of the Heretical Woman." *International Social Science Review* 93:1 (2017): 1.

Ledyard, Gari. "Remembering JaHyun Kim Haboush." *Korean Histories* 2:2 (2010): 3–6.

Lee, Becky. "Understanding North Korea." *University Wire* (27 November 2016).

Lee Suan Yew, "Lee Kuan Yew, Singaporean." *Peranakan* 1 (2015): 8–15.

Lent, John A., and Xu Ying. "Chinese Women Cartoonists: A Brief, Generational Perspective." *Women's Manga in Asia and Beyond.* London: Palgrave Macmillan, 2019, 229–251.

Levine, Angela. "Distinctive Pottery." *Jerusalem Post* (22 February 1991).

Loo, Egan. "Xiao Bai's Si Loin et Si Proche Wins 4th Int'l Manga Award." *Anime News Network* (12 January 2011).

Loos, Kelsi. "Interview." *Frederick* (MD) *News-Post* (2 April 2015).

Luo, Michael. "On Dangerous Footing in Iraq, Where Dancing Is a Courageous Act." *New York Times* (30 October 2006).

Luxner, Larry. "Sitar Master of Maryland." *Aramco World* (November-December 2020).

Maganathan, Dinesh Kuma. "UK-Based Artist Caryn Koh Faces Ghosts of the Past Through Her Art." (Kuala Lumpur) *Star* (24 October 2018).

Mahoney, Ursula. "Batik Is Painting in Reverse." *New York Times* (8 June 1975).

Makinoda, Toru. "Trip Through Time: Legendary Beauty's Final Resting Place." (Tokyo) *Japan News* (10 October 2013).

Mao, M.A.O., and Huang Chunbao. "Application of Leizu Culture to Interior Design." *Journal of Landscape Research* 9:3 (June 2017): 33–36.

Martin, Douglas. "Ani Pachen, Warrior Nun in Tibet Jail 21 Years, Dies." *New York Times* (18 February 2002): B7.

———. "Sufia Kamal, Poet and Advocate, Dies at 88." *New York Times* (28 November 1999).

Mayfield, Tyler. "The Accounts of Deborah (Judges 4–5) in Recent Research." *Currents in Biblical Research* 7:3 (2009): 306–335.

McDonald, John. "Lure of Ideas Over Mass Appeal at 2019 Singapore Biennale." *Sydney Morning Herald* (13 December 2019).

McDonough, Tom. "Raja Alem." *BOMB 103* (1 April 2008).

McMahon, Regan. "Ying Chang Compestine Revisits the Cultural Revolution." *San Francisco Chronicle* (12 June 2012): 1–4.

"Memory of Late Nuha al-Radi Lives on through Her Art." (Lebanon) *Daily Star* (8 September 2004).

Michel, Cécile. "Assyrian Women's Contribution to International Trade with Anatolia." *Carnet de Refema* (11 December 2013).

Mohi-ud-Din, Akhtar. "Social Ideals and Patriotism in Kashmiri Literature (1900–1930)." *Indian Literature* 20:3 (1 May 2020): 80–89.

Moore, Karl, and David Lewis. "The First Multinationals: Assyria Circa 2000 B.C." *MIR* 38:2 (1998): 95–107.

Mortaigne, Véronique. "Les chants mystiques soufis et ceux des tribus pakistanaises vivent encore." *Le Monde* (31 January 2009).

———. "On aurait tort de résumer le Pakistan au cliché austère de l'intégrisme." *Le Monde* (7 October 2011).

———. "Zarsanga, la voix d'or pachtoune." *Le Monde* (21 March 2014).

Mubarak, Hadia. "Classical Qur'anic Exegesis and Women." *The Routledge Handbook of Islam and Gender.* New York: Routledge, 2020: 23–42.

Mukaddas, Mijit. "Musique Ouïghoure. Muqam Nava Abdukerim Osman Chimani." *Cahiers d'Ethnomusicologie* 28 (2015): 285–286.

Murshed, Yasmeen. "The Humayun Nama: Gulbadan Begum's Forgotten Chronicle." (London) *Daily Star* (27 June 2004).

"Musical Treasure of the Uygurs." *China Daily* (24 December 2002).

Mydans, Seth. "A Strongman, a Slain Actress and a Tell-All Diary." *New York Times* (3 December 1999): A4

Naar, Ismaeel. "Retracing Bahrain's Jewish Contributions to Gulf Economics and Politics." (Dubai) *Al Arabiya* (26 February 2017).

Naghibi, Nima, and Andrew O'Malley. "Marjane Satrapi's Persepolis." *a/b: Auto/Biography Studies* 35:2 (2020): 305–309.

Nair, Malini. "In the Narrow Lanes of Old Delhi, a Unique and Flavoursome Dialect of Urdu Is Going Extinct." *Scroll.in* (5 February 2021).

———. "Puppets Come to Life in These Masterly Hands." *The Hindu* (30 December 2017).

Nathan, Yvonne T. "Exhibition an Effort to Bring Together Street and Academic Art." (Kuala Lumpur) *Star* (30 March 2015).

"National, Regional Literature Awards Announced." (Anamnagar, Kathmandu) *Himalayan Times* (20 June 2015).

Neiman, Rachel. "11 Beautiful Posters from Israel Independence Days Past." *Uncovering Israel* (9 April 2018).

Nezer, Orly. "The Search for Localism and Abstract Expressionism in Israeli Ceramics in the 1970s." *Craft Research* 10:1 (2019): 69–90.

"Nice Musée des Arts asiatiques Nocturnes d'Asie

Nuit des Musées." *Nice Rendez-Vous* (18 Mai 2007).

"Nuha al-Radi." *Guardian* (6 September 2004).

Osborne, Karen Lee. "Interview." *Literary Review* 30:1 (Fall 1986): 5–23.

Oyler, Elizabeth. "Tonsuring the Performer: Image, Text, and Narrative in the Ballad-Drama Shizuka." *Japanese Journal of Religious Studies* 36:2 (2009): 295–317.

Paddock, Richard C. "Day to Day Among the Viet Cong." *New York Times* (4 August 2006).

"Paintings by Inspirational Artist Chosen to Brand the Walk Buggies." *Oman Observer* (4 September 2018).

Paraszczuk, Joanna, and Sharon Udasin. "Court Rejects 6 Beduin Negev Land Lawsuits." *Jerusalem Post* (19 March 2012).

Pareles, Jon. "Two Style in Pakistan: For Lovers and Sufis." *New York Times* (21 October 1997): 5.

Perlez, Jane. "The Woven Art of Laos." *New York Times* (31 January 2018).

Phan, Aimee. 2005. "A Daughter Returns Home—Through Her Diaries." *USA Today* (12 October 2005).

Polo, Susana Soler. "Inside One of Egypt's Biggest Royal Weddings." *National Geographic History* (1 November 2016).

"Popular Pashto Folk Singers Zarsanga, Khan Tehsil Sing Their Woes." (Peshawar) *Frontier Post* (19 March 2012).

"Popular Pashto Singer Laid to Rest." (Karachi) *Dawn* (9 March 2016).

Prakash, Uma. "Anjolie Ela Menon: The Extraordinariness of the Ordinary." *Punch* (13 June 2020).

Ratiani, Irma. "From War to Peace: The Literary Life of Georgia After the Second World War." *Primary Literature* 42:1 (2019): 89–102.

"Report of Zarsanga Attack Registered, Six Arrested." (Lahore) *Right Vision News* (24 July 2017).

"Respect Our Sovereignty." *Asiaweek* 25:47 (26 November 1999).

"A Revealing Look at Our Women and at What They Say." *Vasudha* 13:10 (1976): 5–7.

Rishabh, Deb. "We Are Giving Back the Tawaifs the Izzat Which Is Their Due." *Calcutta Times* (6 March 2019).

Romm, Jamie. "Israelis Win Turkish Prize for Financial History Research." *Jerusalem Post* (14 December 2009).

Root, Robert L. "Interview." *Fourth Genre* 9:2 (Fall 2007): 147–157.

Rose, Jenny, "The Sogdians: Prime Movers between Boundaries." *Comparative Studies of South Asia, Africa and the Middle East* 30:3 (2010): 410–419.

Rubin, Riva. "Interview." *Esra* 149 (24 November 2012).

"Russian Imports: 'Violin and Roller' and Ballet Film Open." *New York Times* (20 August 1962).

"Safiya al Bahlani Launches a New Art Gallery in Muscat." *Oman Magazine* (19 November 2018).

Sajdi, Dana al-. "Trespassing the Male Domain: The Qasīdah of Laylā Al-Akhyaliyyah." *Journal of Arabic Literature* 31:2 (2000): 121–146.

Sarkar, Sebanti. "Print the Legends." *Business Line* (16 June 2017).

Saroeun, Bou, and Phelim Kyne. "Pelika's Murderers Remain Free Two Years Later." *Phnom Penh Post* (6 July 2001).

Scholz-Cionca, Stanca. "The Noh Ominameshi: A Flower Viewed from Many Directions." *Asian Theatre Journal* 22:1 (Spring 2005): 154–158.

Schulters, Alexandra W. "Subjectivity Politics in *Sorrow Mountain.*" *Genders* 44 (2006).

Segal, David. "An Artist Unites North and South Korea, Stitch by Stitch." *New York Times* (26 July 2018).

Sela, Maya. "Award-Winning Poet, Translator Shin Shifra Dies." *Haaretz* (10 February 2012).

Semanick, Kevin. "An Uncommon Bond, Mehdi and Leyla Zana's Commitment." *Clamor* 27 (July/August 2004): 49.

Shahin, Aram A. "Reflections on the Lives and Deaths of Two Umayyad Poets: Laylā al-Akhyaliyya and Tawba b. al-Humayyir." *The Heritage of Arabo-Islamic Learning.* Leiden: Brill, 2016, 398–443.

Sharma, Parvati. "Gulbadan Begum's Story." (Chennai, India) *The Hindu Business Line* (21 June 2019).

Shaw, Asma. "Lyricism and Desire for Freedom: Habba Khatoon." *Criterion* 7:5 (October 2016): 29–39.

Shinwari, Sher Alam. "Nomad Melody Queen Has a Dream." (Karachi) *Dawn* (27 January 2013).

Silver, Carly. "From Priestess to Princess." *Archaeology* (June 2010).

Singanporia, Shahnaz. "40 Artists Under the Age of 40." *Vogue India* (December 2018).

Skipitares, Theodora. "A New Aesthetic in Indian Puppetry." *PAJ* 35:3 (September 2013): 61–68.

Slackman, Michael. "In a Landscape of Tension, Bahrain Embraces Its Jews. All 36 of Them." *New York Times* (5 April 2009).

So, Stella. "Manga in Hong Kong." *Women's Manga in Asia and Beyond: Uniting Different Cultures and Identities* (2019): 353.

Sotheacheath, Chea. "Piseth Pelika: The Life and Death of a 'People's Princess,'" *Phnom Penh Post* (23 July 1999).

Spiegel, Jan Ellen. "Chinese Cook Returns to Roots." *Orlando Sentinel* (23 October 2017): 89.

Stoughton, India. "Simone Kosremelli: At Home with the Old and the New." (Beirut) *Daily Star* (18 August 2012).

Swaim-Fox, Callan. "Kartini Day." *Meridians* 19:1 (2020): 136–146.

Tan, Jeremy. "Container Installations Breathe New Life to Urban Art in Penang." (Kuala Lumpur) *Star* (13 January 2020).

Teller, Matthew. "Finding the Essence." *Aramco World* 61:3 (May/June 2010).

Tin Htet Paing. "Harpist Hopes to Improve Music Education." *The* (Rangoon) *Irrawaddy News* (11 July 2017).

Trajtenberg, Graciela. "Art Criticism and Its Power Over Women Artists—An Inquiry into the Sources of Gender Discrimination in Jewish Palestine/Israel, 1920-1960." *Journal of Historical Sociology* 31:4 (2018): 469–482.

Tulfo, Ramon T. "A Buddhist Foundation Inspired by Catholic Nuns." *Manila Times* (17 December 2020).

"Tzu Chi Gives Food Packages to 129 Pond Island Families." (St. Maarten) *Daily Herald* (3 May 2021).

"Un Refuge de Luxe dans la Montagne." *Harmonies* (December 2001/February 2002).

Utidjian, Haig. "Esprit d'Arménie." *Early Music Review* 150 (October 2012): 12–14.

Vaidya, Sunil K. "A Woman of Substance Inspires Omanis." (Dubai) *Gulf News* (6 April 2013).

Veenhof, K.R. "Some Social Effects of Old Assyrian Trade." *Iraq* 39:1 (Spring, 1977): 109–118.

Verner, Amy. "Anais Jourden." *Vogue Runway* (1 March 2020).

Vita, Evelyn Birge, and Marilyn Lawrence. "Medieval Storytelling and Analogous Oral Traditions Today: Two Digital Databases." *Oral Tradition* 28:2 (October 2013).

Wakita, Haruko. "Marriage and Property in Premodern Japan from the Perspective of Women's History." *Journal of Japanese Studies* 10:1 (Winter 1984): 73–99.

Walker, Philip. "*Raqqas* or Jamileh: Contrasting Perspectives on Dance in Iran." *Habibi* 15:2 (Spring, 1996): 10.

Wallace, John R. "Fitful Slumbers: Nun Abutsu's Utatane." *Monumenta Nipponica* 43:4 (Winter, 1988): 391–398.

Waterhouse, David. "Woodcut Prints by Suzuki Harunobu as a Source for the History of Japanese Dance." *The World of Music* 30:3 (1988): 85–107.

Weil, Jennifer. "Anais Jourden RTW Spring 2021." *Women's Wear Daily* (3 October 2020).

Weiss, Sarah. "Rangda and the Goddess Durga in Bali." *Fieldwork in Religion* 12:1 (2017): 50–77.

Weren, Wim J. "Herodias and Salome in Mark's Story About the Beheading of John the Baptist." *HTS Theological Studies* 75:4 (2019): 1–9.

Willemyns, Alex, and Kim Chan. "Amid Latest Sex Scandal, Many Recall Piseth Pilika." (Phnom Penh) *Cambodia Daily* (28 March 2016).

Yan Fei. "Legend of Silk." *China Daily* (3 September 2011).

Yang, Shanshan. "Emperor Wu Zhao and Her Pantheon of Devis, Divinities, and Dynastic Mothers." *Journal of Global South Studies* 33:2 (2016): 102–105.

Yang Meiping. "University to Train Embroidery Teachers." (Shanghai) *Shine News* (23 May 2019).

Ying Yu. "Gu's Embroidery." *Asian Social Science* 6:1 (January 2010): 1–79.

Yoder, Glenn. "From Food Rations in China to a Career in Food." *Boston Globe* (29 January 2014): G16.

Yokota, Gerry. "Archetypal Literacy for Intercultural Communication: From Noh to Anime and Beyond." *Rhetoric, Metaphor, Discourse: Language and Culture.* Osaka: Osaka University, 2018.

Zaman, Rana Siddiqui. "Painting the Heart Red." *The Hindu* (27 November 2009).

Zhussipbek, Galym, et al. "Foundations of Inclusive Kazakh Religious Identity." *European Journal of Science and Theology* 13:5 (October 2017): 143–154.

Electronic

"Anais Mak." *Forbes,* https://www.forbes.com/profile/anais-mak/?sh=657060d02d3d.

"Anais Mak." https://issuu.com/burda2/docs/prestige_40u40_nov_ebook/s/11285742.

Banerjee, Devashruti. "Anjolie Ela Menon." *Zingy Homes,* www.zingyhomes.com/ thought-leaders/anjolie-ela-menon/ (9 April 2014).

Cassidy, Carol. "Weaving Cognition, Technology, Culture" (video), www.youtube.com/watch?v=zAeMZE5L=PLSYL9MBIDfZTTmg (5 June 2017).

Das, Shilpi. "Indusudha Ghose: Between Art and Revolution." www.theheritagelab.in/indusudha-ghosh-between-art-and-revolution/

Ganesan, Sharmilla. "Schooled in Art" (video), www.bfm.my/podcast/the-bigger-picture/front-row/schooled-in-art (24 October 2018).

"Gu Embroidery." https://trc-leiden.nl/trc-needles/regional-traditions/east-asia/china/gu-embroidery.

"Ham Kyungah." www.pacegallery.com/exhibitions/ham-kyungah/, 2018.

Hutton, Marcelline. *Resilient Russian Women in the 1920s & 1930s.* Lulu.com, 2015.

"In Conversation with Bhutanese Contemporary Artist Zambiri." www.youtube.com/watch?v=1Xi8-xuChDo (29 May 2016).

Junior Win. "A Memory of My Grandparents." juniorwin-english.blogspot.com/2014/05/a-memory-of-my-grandparents-u-khin_29.html.

Kakar, Palwasha. "Tribal Law of Pashtunwali and Women's Legislative Authority." www.law.harvard.edu/programs/ilsp/research/kakar.pdf (2004).

Kalla, Avinash. "Anjolie's New Collection of Glass Art." www.the-south-asian.com/April%202003/Anjolie%20-%20Glass%20art-2.htm.

King, Tim. "Interview." Salem-News.com, http://salem-news.com/articles/january152013/frederica-interview-tk.php.

"Learn Traditional Burmese Harp." www.youtube.com/watch?v=ydssZFsEMe0.

Leshchinskiy, Gelya. Folk Music Once Again Thrives in Central Asia and the Caucasus." (30 November 2007), *Eurasianet,* eurasianet.org/folk-music-once-again-thrives-in-central-asia-and-the-caucasus.

"Leyla Zana, Prisoner of Conscience." *Amnesty International USA,* www.amnestyusa.org/action/special/zana.html, 2005.

Lillaz, Faustine. "Review: Si Loin et Si Proche." *Planete BD,* www.planetebd.com/manga/kana/si-loin-et-si-proche/-/9791.html, 2021

Malhotra, Shruti Kapur. "Platform 15." https://www.platform-mag.com/art/zimbiri.html.

Mikeladze, Galina. "Ballet—A Worthy Component of Azerbaijani Culture." https://irs-az.com/new/pdf/201301/1358948248505125213.pdf.

Minault, Gail. "Begamati Zuban: Women's Language and Culture in Nineteenth-Century Delhi." www.columbia.edu/itc/mealac/pritchett/00urdu/umraojan/txt_minault_begamatizaban.pdf (September 2008).

"Music of Central Asia, Vol. 4: Bardic Divas: Women's Voices in Central Asia." *Vimeo,* vimeo.com/groups/667604/videos/58355278.

"Musician: Theory and Exchange of Experience." yerajisht.wordpress.com/2013/11/23/female-musician/

"My Sweet Georgia." sweet-georgia.org/georgia/news/?act=nov&news_id=853 (3 April 2019).

"The Poetry Work of Zeinab Hotaki." https://www.facebook.com/notes/afghanistan/the-poetry-work-of-zeinab-hotaki/165822743444288/

"Rethinking Nepali Art History." www.youtube.com//watch?v=m.

Rummery, Ariane. "Jalozai Camp Population Swells as Pakistan's Displacement Crisis Deepens." www.unhcr.org/en-us/news/latest/2009/2/4992d5a62/jalozai-camp-population-swells-pakistans-displacement-crisis-deepens.html (11 February 2009).

Shimkhada, Deepak. "Womb: The Creative Genesis of Sushma Shimkhada." *Rising Junkiri,* https://risingjunkiri.com/womb-creative-genesis-sushma-shimkhada/.

"Sisters in Song: Women Hymn Writers." sistersinsongwhw.wordpress.com/tag/sahakdukht/

The Story of Amanishahan, https://elkitab.org/wp-content/uploads/2018/04/3007_29.pdf.

"A Story of Puppetry." https://junoontheatre.wordpress.com/2018/07/25/storyofpuppetry/ (25 July 2018).

"Sufi Kamal." *Poem Hunter,* www.poemhunter.com/sufia-kamal/biography/.

"These Women Are Challenging Mongolia's Gender Norms with Comic Books." *The Lily,* www.thelily.com/these-women-are-challenging-mongolias-gender-norms-with-comic-books/(7 December 2017).

"Traditional Burmese Harp." www.youtube.com/watch?v=ydssZFsEMe0.

"Tsisana Tatishvili." www.youtube.com/watch?v=127edk.o5fl.

"Women Artists of Bangladesh." www.wikiwand.com/enWomen_Artists_of_Bangladesh.

Woodhouse, Leslie Ann. *Light of a Northern Star: A Foreign Concubine in the Siamese Palace,* static1.squarespace.com/static/5b03626845776e606944deea/t/5b200b17352f537875aa416f/1528826773781/Woodhouse+Dissertation.pdf

Yildrim, Idil. "The Role of Women in Politics in Hittite Society." core.ac.uk/download/pdf/11726036.pdf, n.d.

Zarsanga (film). Pakistan: One Ten Films, 2018.

Zarsanga, www.youtube.com/watch?v=1z5ZVBCsIt4.

Zhwak, Mohammad Saeed. "Women in Afghanistan History." *Afghan Digital Libraries* (1995).

Index

Main entries are indicated by **bold**